ON
THE STAGE
WEDNESDAY MARCH 10th
FOR ONE NIGHT ONLY
at the
ABC-HUDDERSFIELD

MORGAN'S SLIDES LTD.

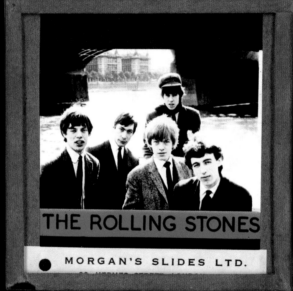

THE ROLLING STONES

MORGAN'S SLIDES LTD.

THE
ROLLING
STONES
— and —
ALL STAR COMPANY

MORGAN'S SLIDES LTD.

THE ROLLING STONES 50

MICK JAGGER

KEITH RICHARDS

CHARLIE WATTS

RONNIE WOOD

WITH OVER 1,000 ILLUSTRATIONS
IN COLOUR AND BLACK AND WHITE

HYPERION

New York

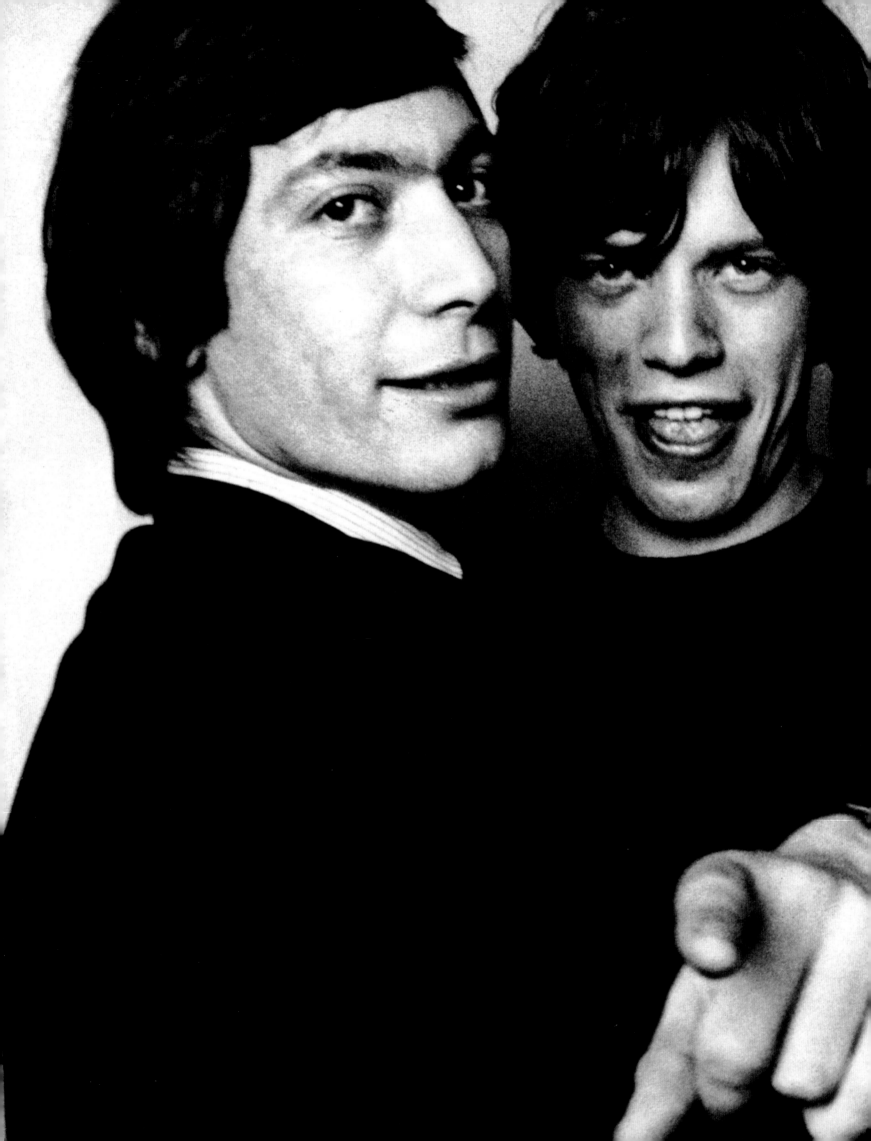

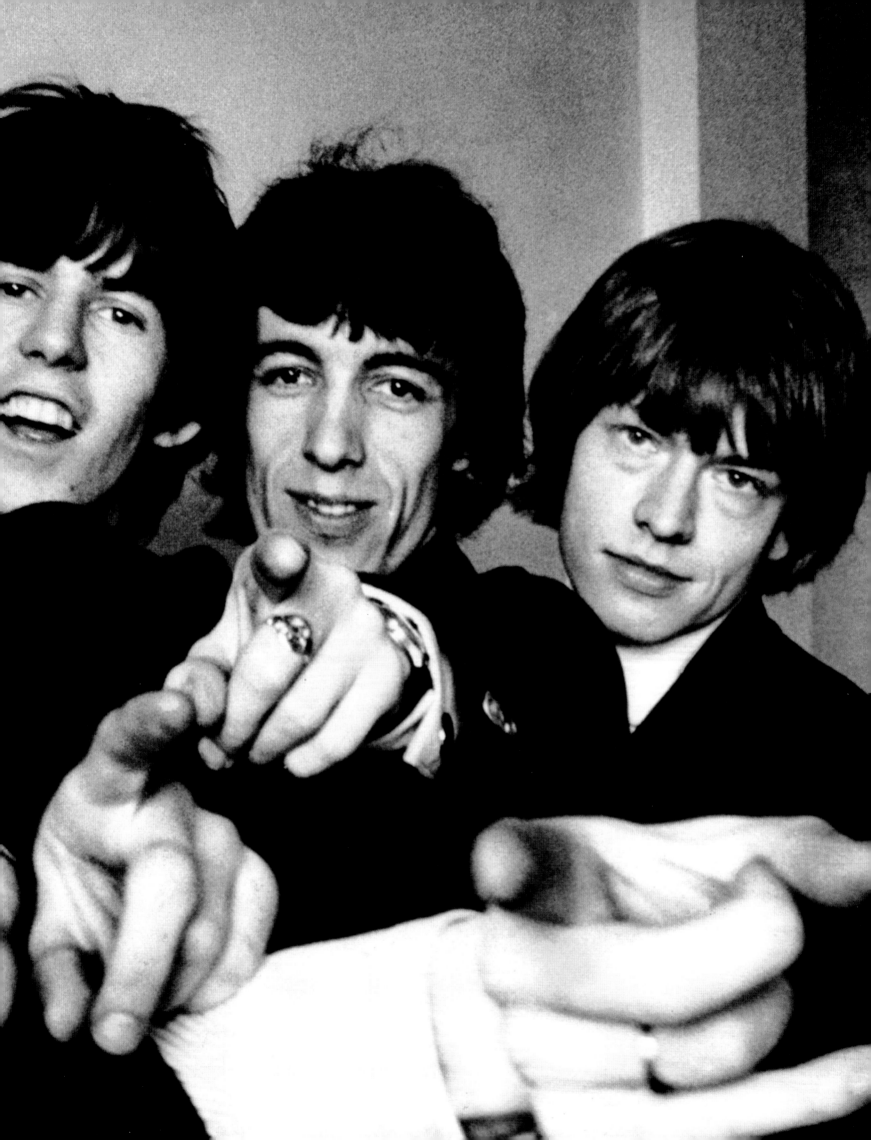

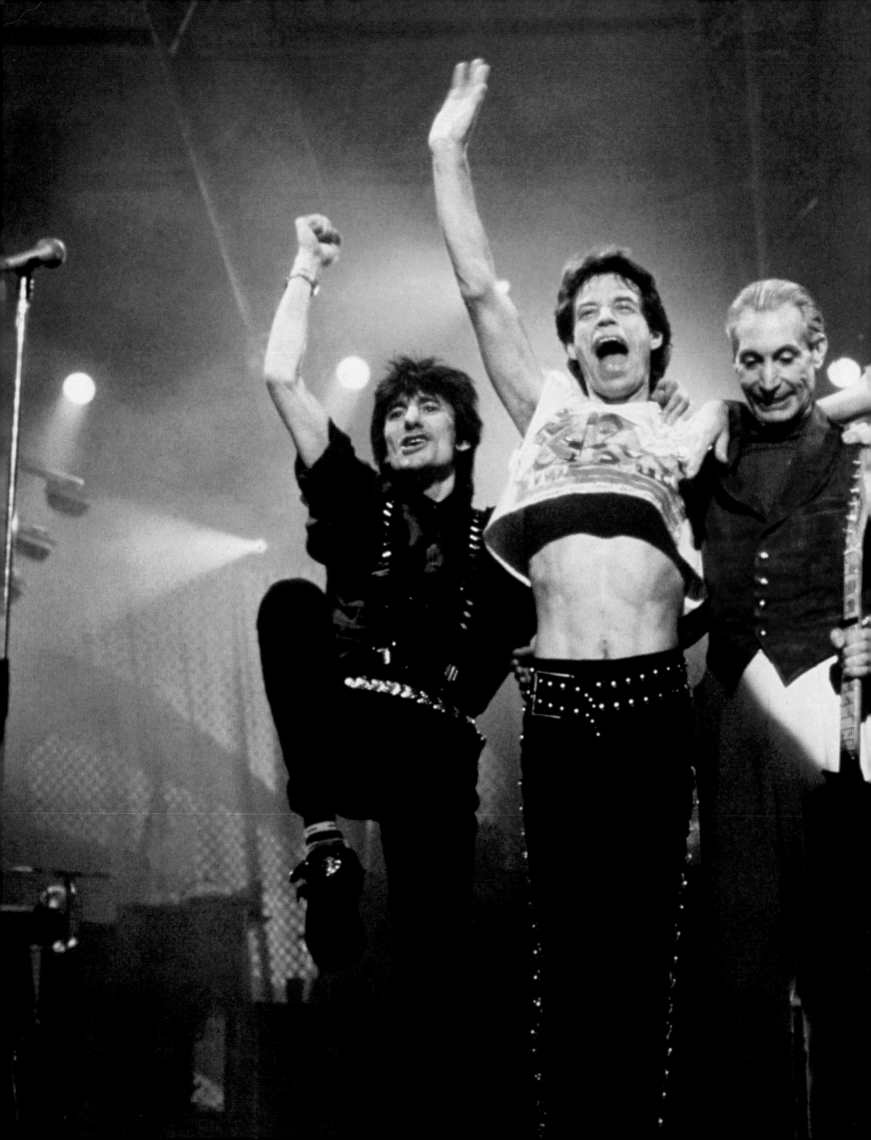

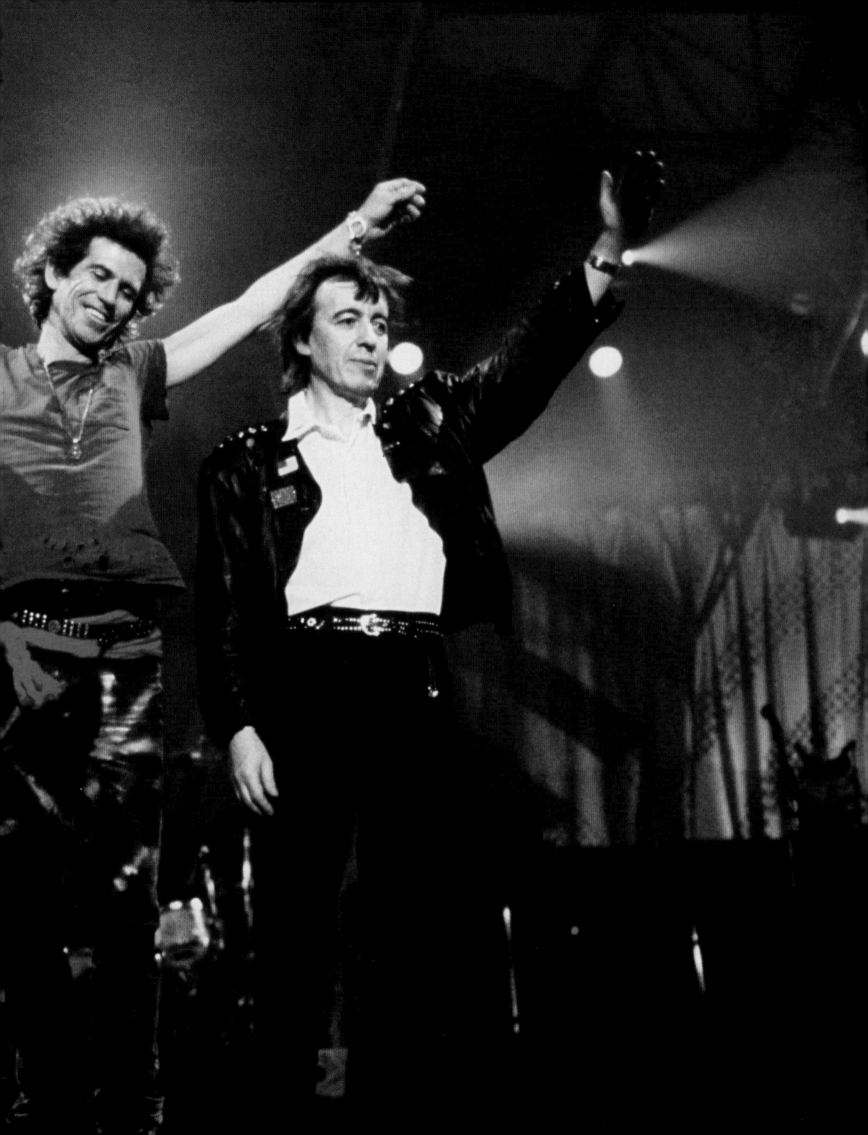

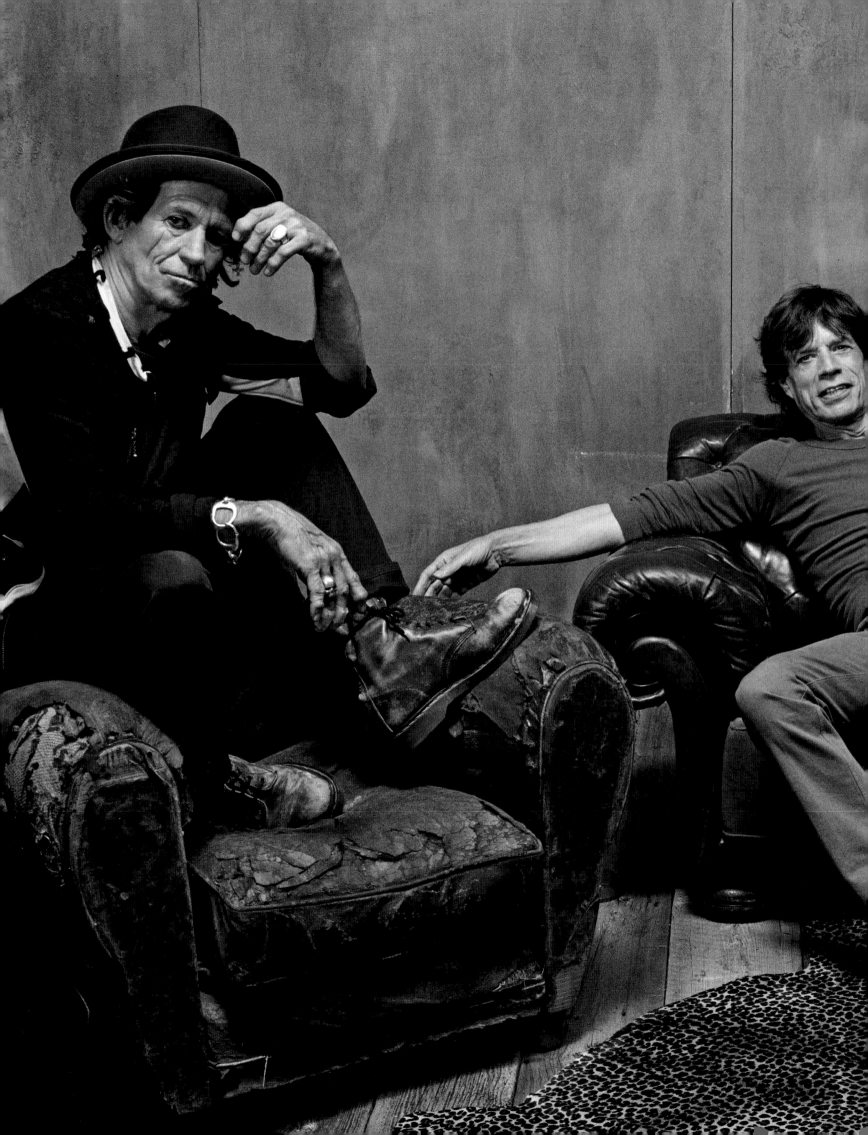

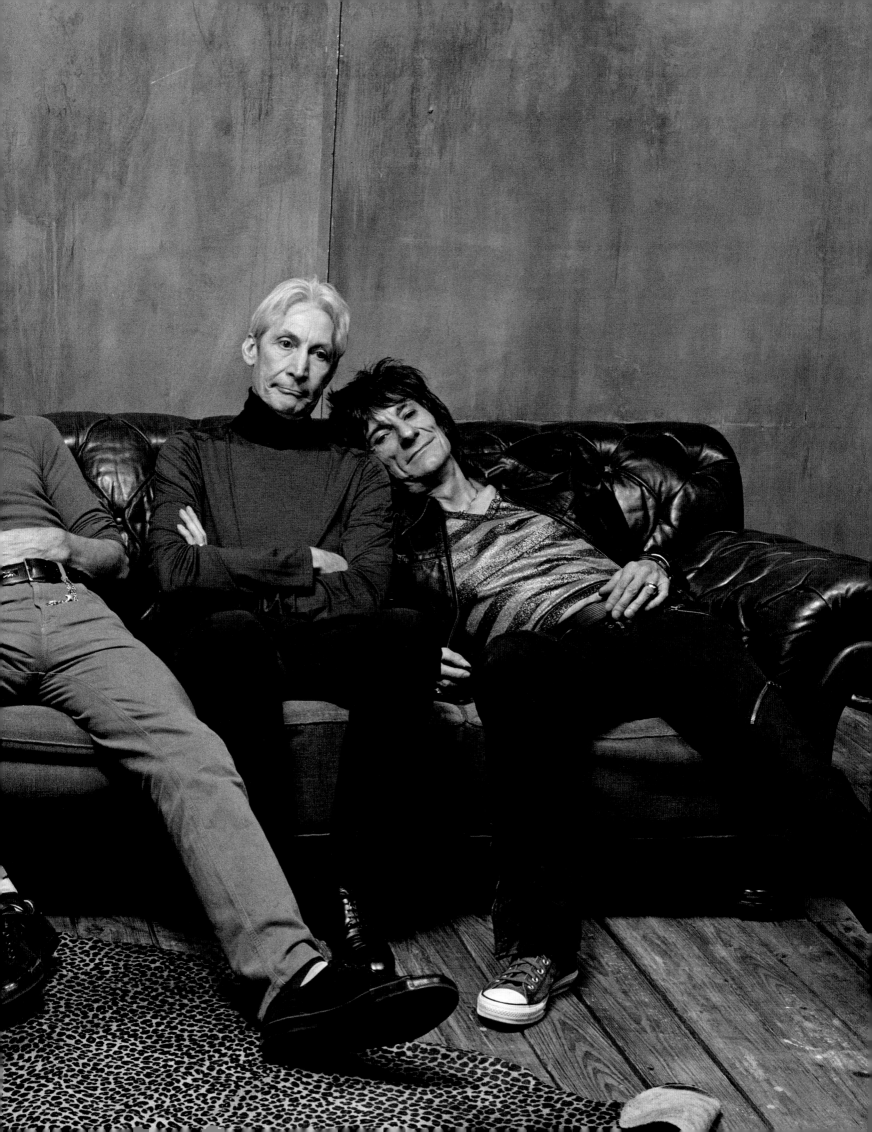

WOODSTOCK

N. CHEAM (BUSES 93

EVERY FRIDAY

R
B

GRAND
OPENING
FRIDAY
AUG. 10TH.

ALEX
BLUES IN

with CYRI

JIVE & LISTEN
7·45 – 11·0 P.M.

MEMBERS 4'.
NON-MEMBERS 5'.

CONTENTS

Introducing:

MICK	12
KEITH	14
CHARLIE	16
RONNIE	18
1960S	20
1970S	204
1980S	280
1990S	294
2000S	322
PICTURE CREDITS	350
INDEX	351
ACKNOWLEDGMENTS	352

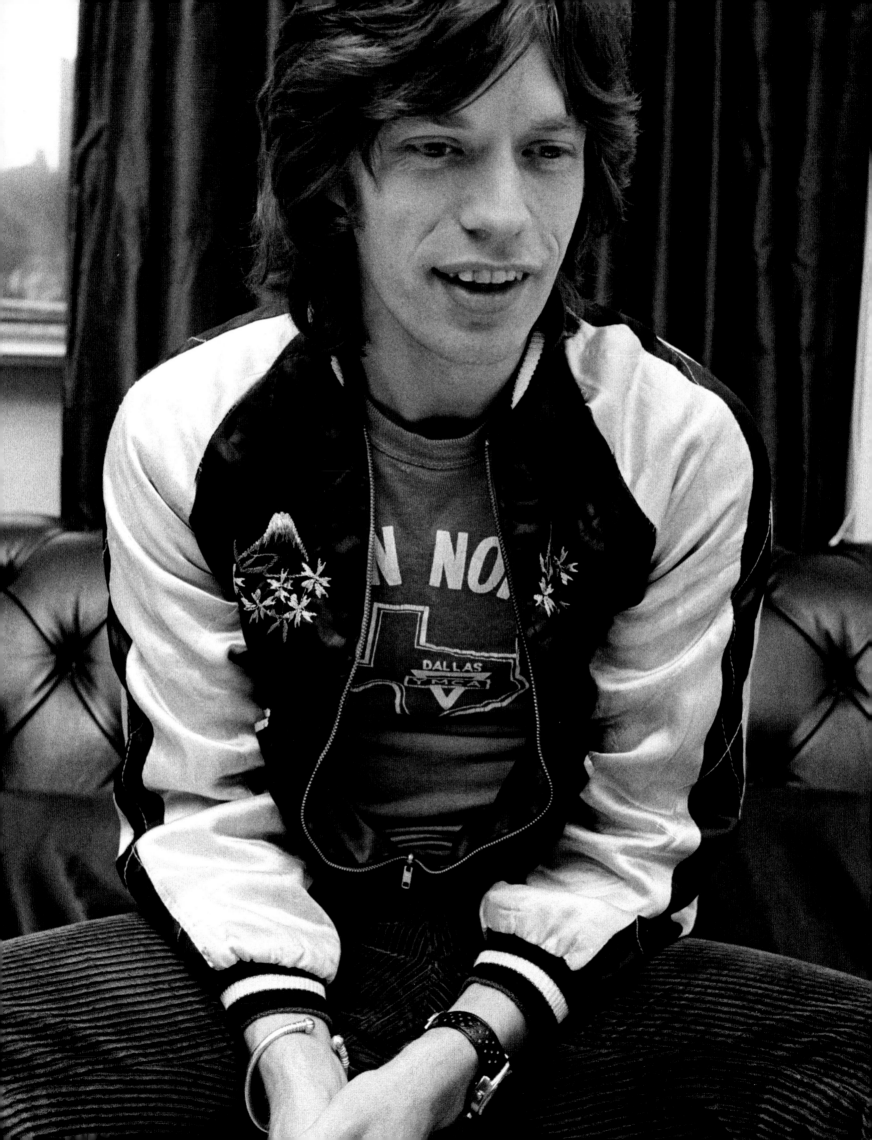

MICK

When I met Keith on Dartford Station in 1961, having lost touch after being at school together when we were very young, I immediately knew we shared a taste for great music. And we soon discovered that we both wanted to do more than just listen to it – we wanted to play music too. Going to the Ealing Club and starting a band together, before joining up with Brian as the Rollin' Stones and playing the Marquee Club in July 1962, we were pursuing a kind of dream, but it was a dream that was not yet fully clear in our minds. It was only after Bill and, soon after, Charlie joined that we began to take seriously the possibility of being a band that got paid for playing the kind of music that very few others in Britain liked to play.

As the sixties became the seventies we had become something bigger than probably any one of us imagined in the beginning. I was sometimes quoted in the press as saying that I couldn't see myself doing what I did for much longer. How wrong could I be? As the decades rolled around we kept on doing what we love the best – playing live and doing a great show. In the late 80s and for the last twenty years our shows have become more innovative, more technically elaborate – but I hope just as exciting, although in a different way, as they were at the Crawdaddy Club in Richmond in 1963.

While I have never been a person who looks backwards, preferring to explore new ideas and concepts in everything from music to staging, I cannot help but do it now that we have reached this amazing milestone in our career. I know many of our fans use our music to date stamp their lives: the first time they heard a particular song or saw us in concert. And so I hope this book will remind you of what an amazing journey it has been. It has certainly reminded me of things that I had forgotten, yet when I see some of the fabulous photography it does almost feel like it was only yesterday.

Having you all sharing our journey and most of all sharing our music has been incredible. We couldn't have done it without you.

KEITH

It's been a lifetime – what a life and what a great time!

People are always asking me what it is that makes us what we are. If I knew that, I'd bottle it and sell it. But I do know that it's an amazing – a unique – chemistry. When all of us get behind our instruments and Mick starts to sing we become like one person. I've pondered over the years what it is that makes the Rolling Stones what we've become and I've come to the conclusion that a lot of it is the driving force of Mick, who is one hell of a guy to play behind. Added to which we really enjoy playing together and we've been good friends for fifty years, at least most of the time, which in itself is no mean achievement.

There's also the feeling that we can always do better. Even now I think there are better shows left in us – shows at which we can still top what's gone before. It's always a great buzz when we work together, and when we don't play for a while I begin to get kind of itchy. Playing with the guys has always been an up, and while it's not quite an addiction it's certainly a habit.

The music keeps us young, and when you add that to the experience we've gained it all goes to make us what we still are. In fact the upside of playing together for so long is that we know each other so well. There are no boundaries to get over when we get together and we start playing music – it's that simple. It's a joy to play with people who fit together so perfectly. There's no one who does not fit in. If there was it would be an uphill struggle, but with the Stones we're always rolling easy.

When we play it's all about the feel; that's the all-important ingredient. The music we play comes out of the blues and you can't play the blues without feeling. As we developed into the pop side of things and then into rock, the blues were ever present, giving us those right feelings. Throughout the last fifty years there's always been a soul machine in the basement, one that has kept driving us forward.

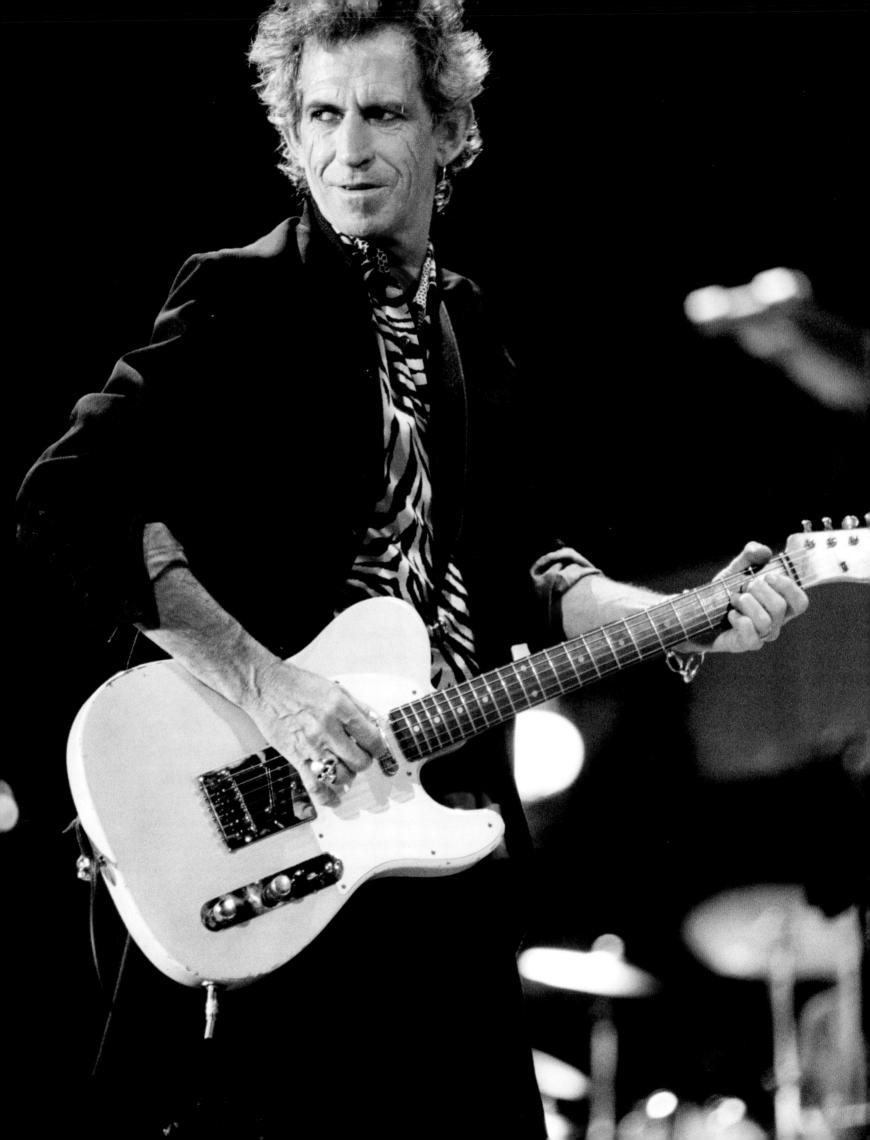

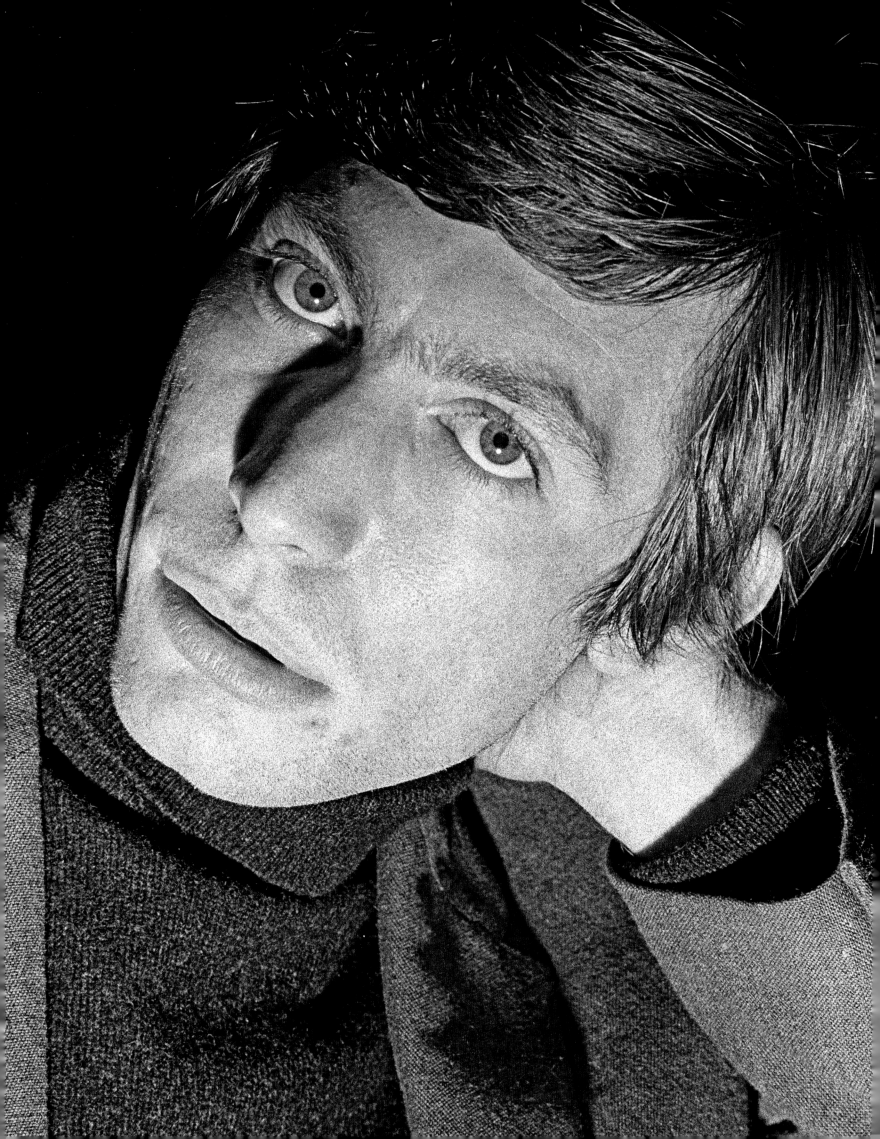

CHARLIE

Ten years of working, forty years of hanging about!

Until someone told me it had been fifty years since the band started I had not really thought about it. It's not something that you think about when you're so closely involved. In fact, my personal fiftieth anniversary with the Stones is January 2013, as my first gig with the band was at the Ealing Club in 1963, although I had met Mick, Keith and Brian in 1962 when I was playing with Alexis Korner and Cyril Davies's band at a hot, sweaty little club in West London and at the Marquee Club in Oxford Street.

Playing with the Stones has been phenomenal, it really has. When we started out I rarely thought about how long it would last. We've been so lucky to be friends for so long and we've worked together for far longer than most people do. I don't suppose any of us thought we could possibly remain this popular for fifty years. These days we don't see so much of each other but when we get together we pick up right where we left off – it's just like always. In the early days we were very close; seeing each other and playing together almost every day was important to how we developed as a band.

We actually take the band very seriously. We all appreciate and honour the Rolling Stones – it is important to us what the fans think about us and we always try to be professional. For me as a drummer I have to work at my job; I have to play regularly to keep myself in shape, which is why I love to play with my jazz band when I'm not playing with the Stones.

While the tours have become such huge affairs, even when we appear at the smaller venues it's still important that we play like we've always played. We still want to do a great show every night. We respect our history, our heritage and our tradition – we always will.

The thing that struck me when we were putting this book together was that the *Daily Mirror* had taken so many photographs; I was even more amazed that they kept them – I'm so glad they did.

RONNIE

I first saw the Stones in 1964. It was in a tent at the Richmond Jazz and Blues Festival; at the time I was in my own band, The Birds. The Stones were headlining on the Friday night. While I watched them playing, absorbing the energy and the excitement, I thought to myself: I'm going to be in that band. It looks like a pretty good job to me – not that you can really call what we do a job.

Later we became mates and they helped me with my first solo album, which is basically how I ended up joining the Stones. However, to begin with Keith said, 'Let's not announce you're in the band, let's just let it gradually filter out.' Well thirty-seven years later I'm still here and I'm still loving it.

People often ask what makes this band what it is. Well to begin with they're dynamite individuals. Usually in a band one person stands out, and of course Mick as the greatest front man in the history of rock is the focal point, but we are much more than just the sum of the parts. Kate Moss said to me recently that each one of us is an interesting individual; that we are a band full of diverse characters who all have so much to offer in their own right, yet when we are together we make something even more fascinating. For me that's a lovely way of summing us up.

Looking through the fabulous photos in this book reminds me of so many great times, from the small, intimate club gigs to the surreal show we played on the beach in Rio de Janeiro. It's the diversity in what we play at these different gigs that helps to keep us fresh. We do tours on which we play clubs, arenas and stadiums – what Keith refers to as 'Fruit of the Loom tours – small medium and large'! Each gig has its own dynamics and that diversity of venue and the way the fans react all helps to energize the band.

For me the Rolling Stones are an institution that must keep going; a ship that must keep sailing and a rock and roll circus that will go on forever.

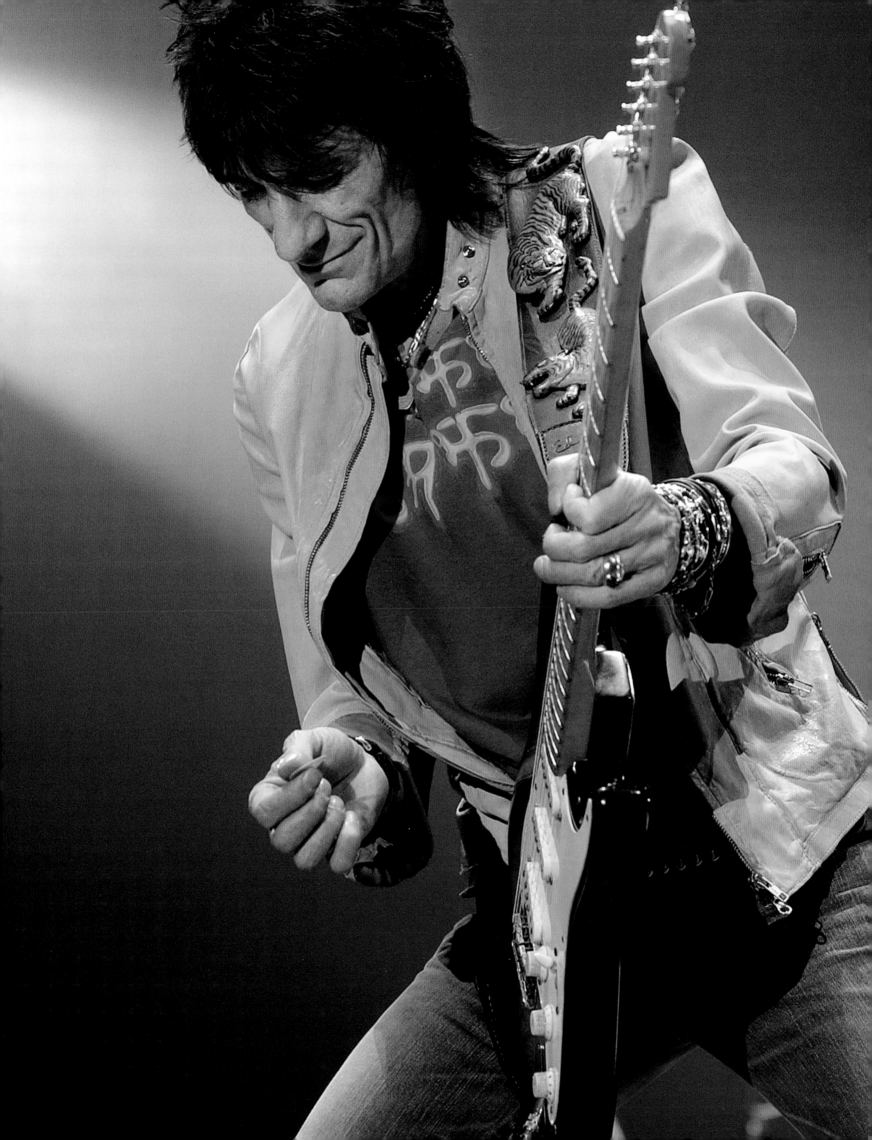

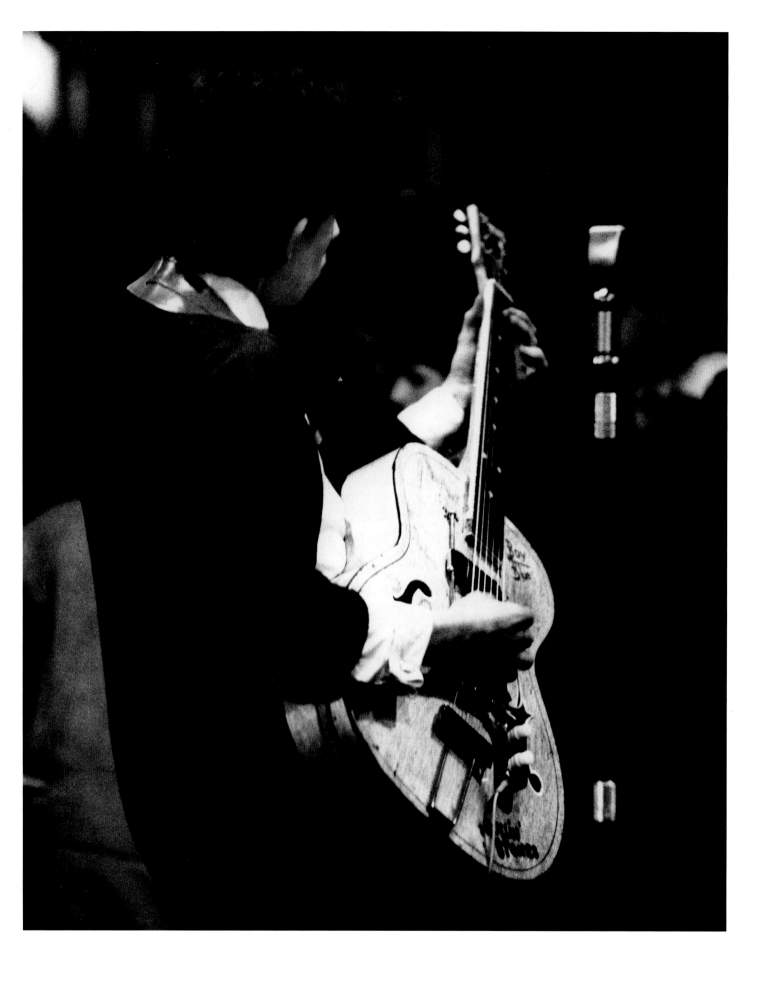

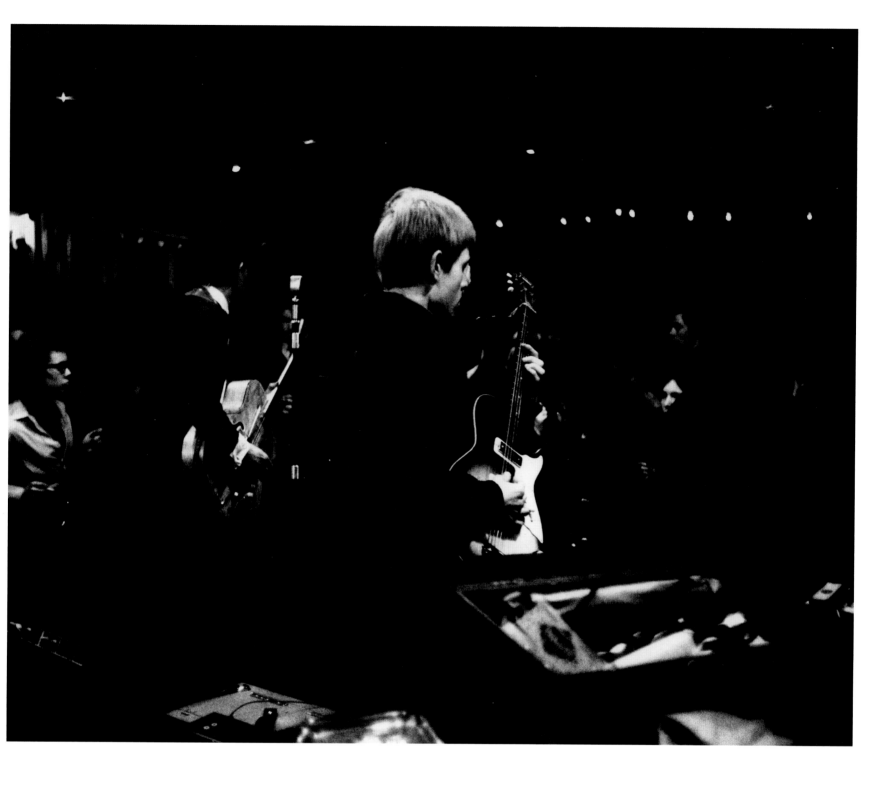

The Marquee Club | London, UK | 12 July 1962

At the time I said, 'I hope they don't think we're a rock 'n' roll outfit.' We weren't back then. We mostly played the blues. MICK

The Marquee's a West End club, where we stood in for Alexis Korner a couple of times. Alexis was packin' 'em in – just playing blues. Very similar to Chicago stuff. Heavy atmosphere. KEITH

I wasn't in the Stones at this point; I was playing with Blues By Six and Alexis Korner's band. I'd met Brian, through Alexis, when he first came up to London from Cheltenham, but initially there was no talk about being in a band. Later they started to try and convince me to join, but I was happy doing what I was doing as the other bands had more regular gigs. CHARLIE

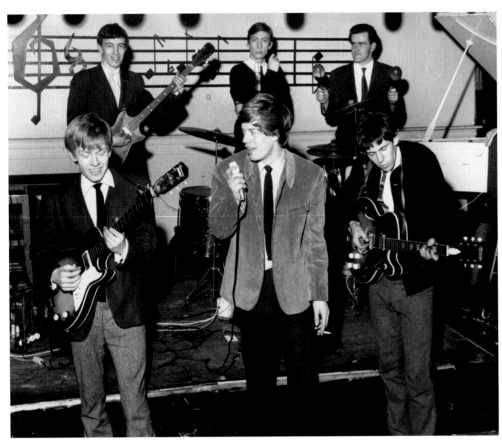 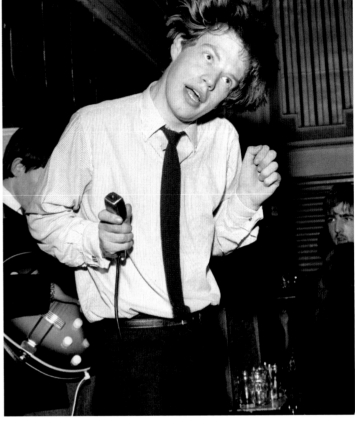

The Crawdaddy Club | Richmond, Surrey, UK | April 1963

Playing the Crawdaddy Club at the Station Hotel in Richmond most Sundays in early 1963 was so important to us. One Sunday the Beatles came to see us play there and invited us to their gig at the Royal Albert Hall the following week. It was also where Andrew Oldham first clapped eyes on us, signing us to a management deal a week later. MICK

I don't think the Stones would have actually coagulated without Ian Stewart pulling it together. Without Stu we'd have been lost. It's Stu at the back on the right, on the left photo. KEITH

They finally convinced me to join and my first time playing with the Stones was in early January 1963 at the Ealing Club. At the Crawdaddy there was no space on stage – that's why Mick used to shake his head and all of that [instead of dancing]. CHARLIE

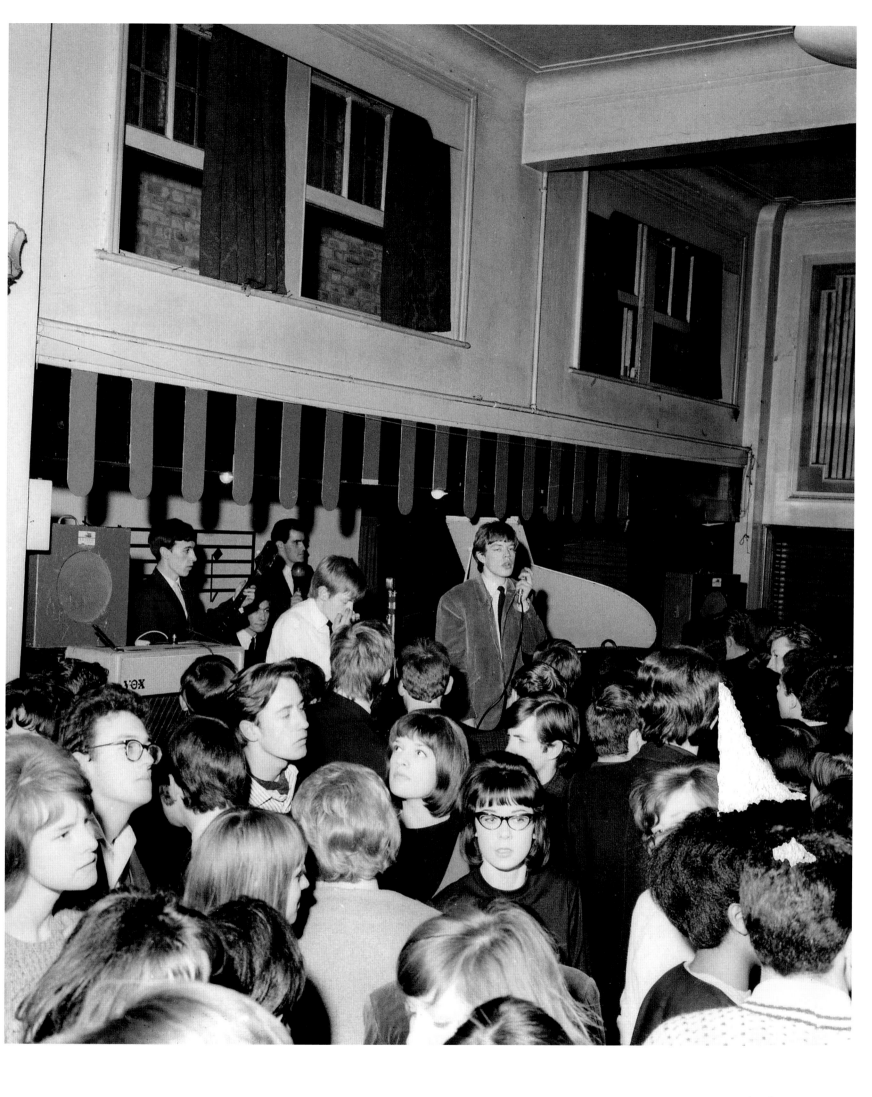

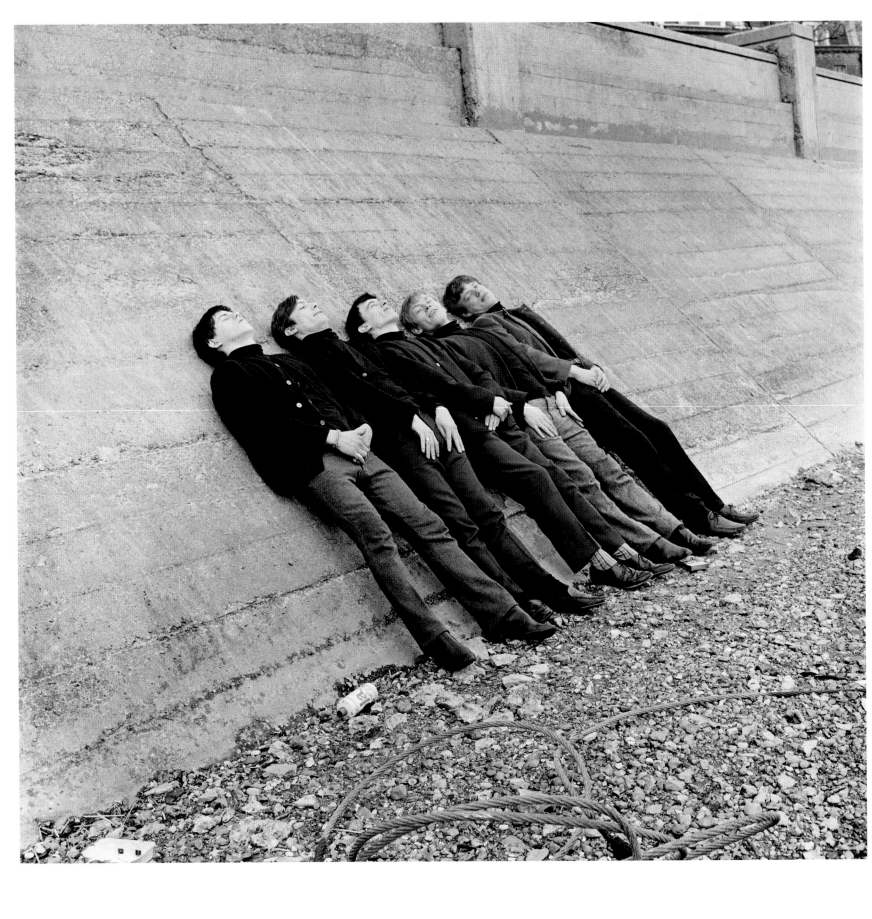

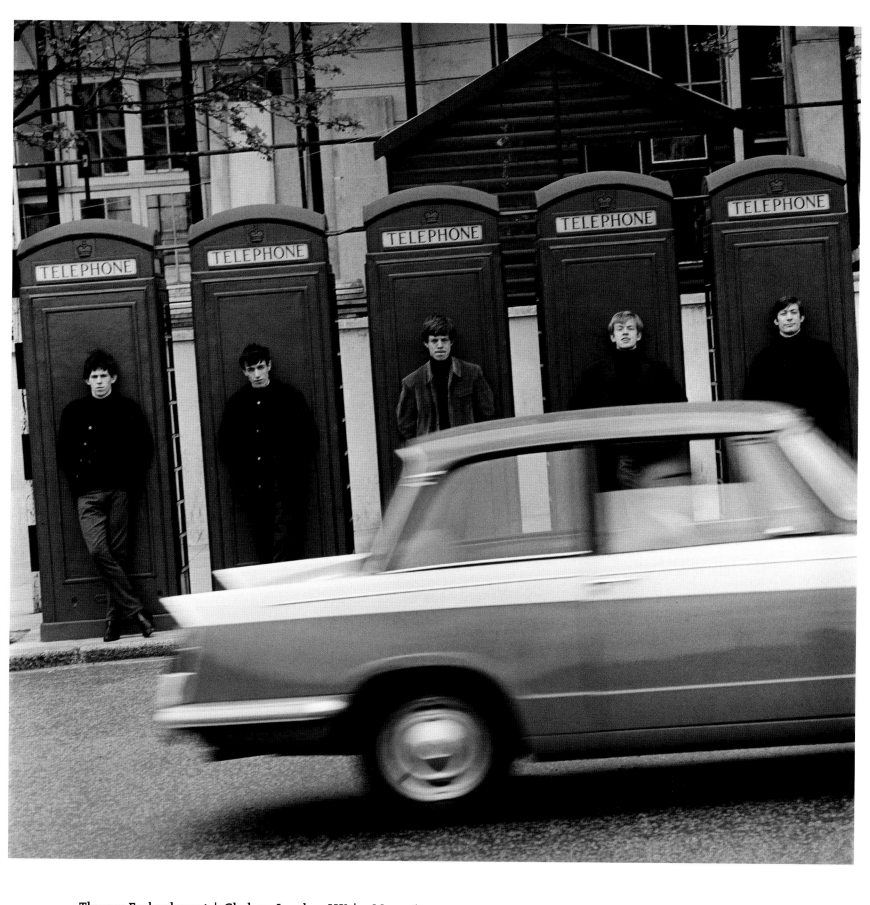

Thames Embankment | Chelsea, London, UK | 4 May 1963

Our very first photo shoot as a band, organized by our manager Andrew Oldham with a photographer friend of his named Philip Townsend.

This photography was a good deal more creative than the average shots that were taken of groups or singers back in the early sixties. Most photographers wanted groups to jump off walls or into the air, which is not really us. Having said that, we did do it a couple of times to keep them happy. CHARLIE

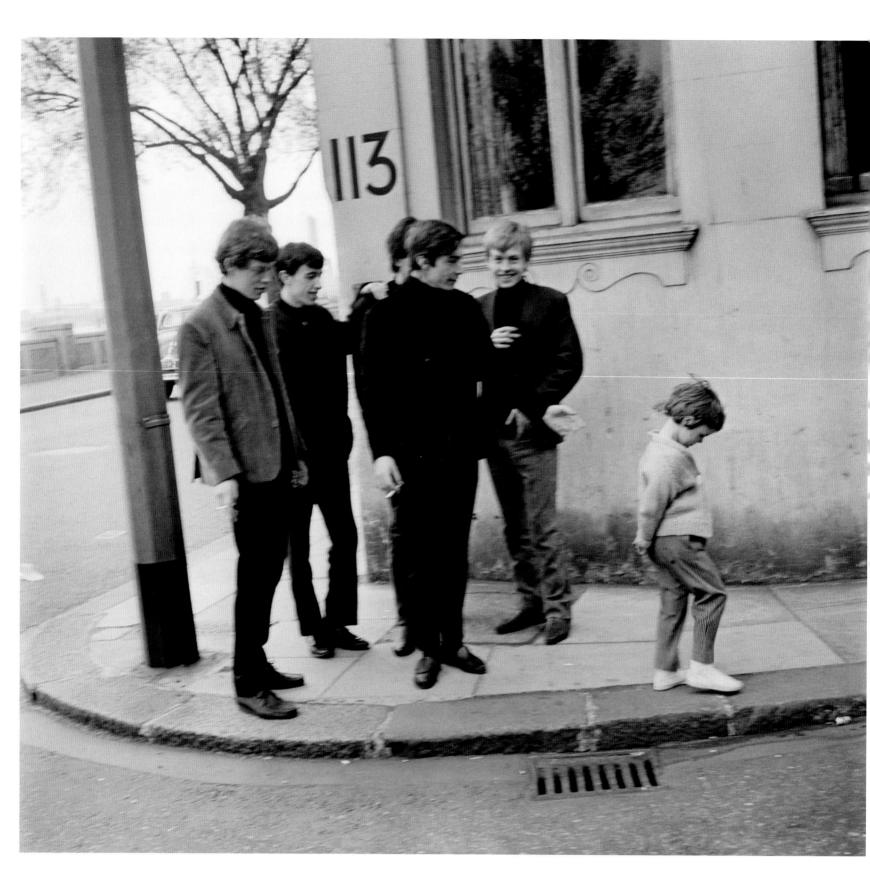

Thames Embankment | Chelsea, London, UK | 4 May 1963

Another thing that made us different from other groups was the
way we dressed. We didn't all wear matching suits and stuff. That
was something that Andrew Oldham thought needed changing.
In these photos we're wearing the black roll-neck sweaters and
jeans that he had bought for us in Carnaby Street. MICK

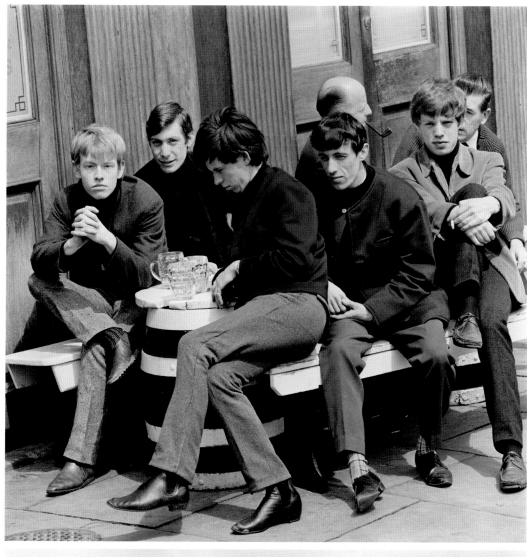

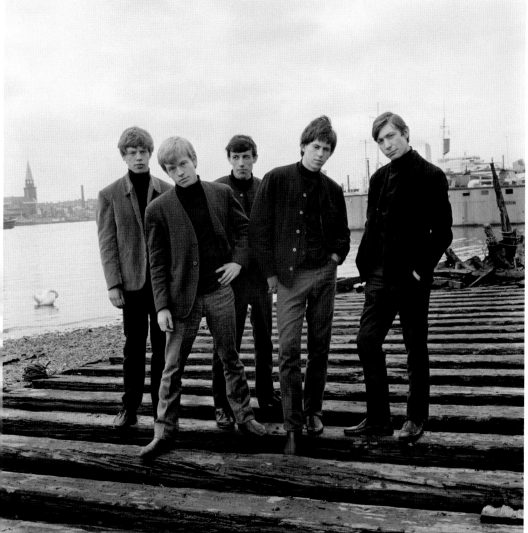

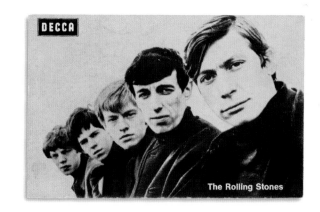

above

Decca promo postcard | June 1964

To coincide with the release of 'Come On' – our first single, that came out on 7 June 1963 – Decca had these postcards printed to promote us so we could sign them at our gigs.

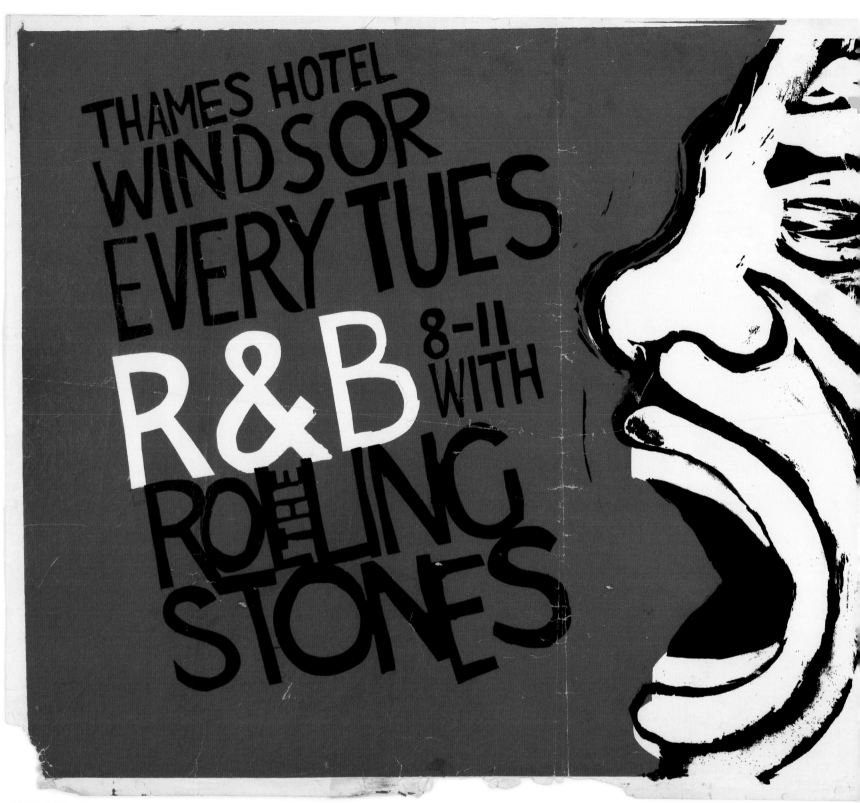

THAMES HOTEL
WINDSOR
EVERY TUES
R&B 8-11 WITH
THE ROLLING STONES

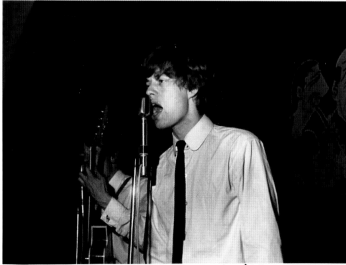

R. Stones, Eel Pie Island, '63

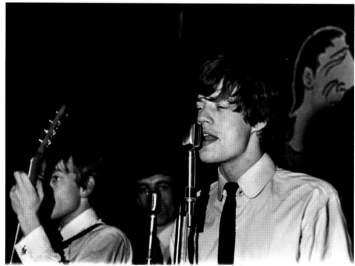

R. Stones, Eel Pie Island, '63

left

The Ricky Tick Club | Windsor, Berkshire, UK | 1963

We started our regular gigs at the Ricky Tick Club in Windsor in January 1963 and, to begin with, we played there most Friday evenings. In August, the club moved to The Thames Hotel and we switched to a Tuesday, but we only played there a few more times before things started to progress for us. MICK

opposite below

Eel Pie Island | April 1963

We first played at Eel Pie Island, which really was an island in the middle of the River Thames between Richmond and Twickenham, in April 1963.

below

***Daily Mirror* | 13 June 1963**

This was our very first mention in a British national newspaper.

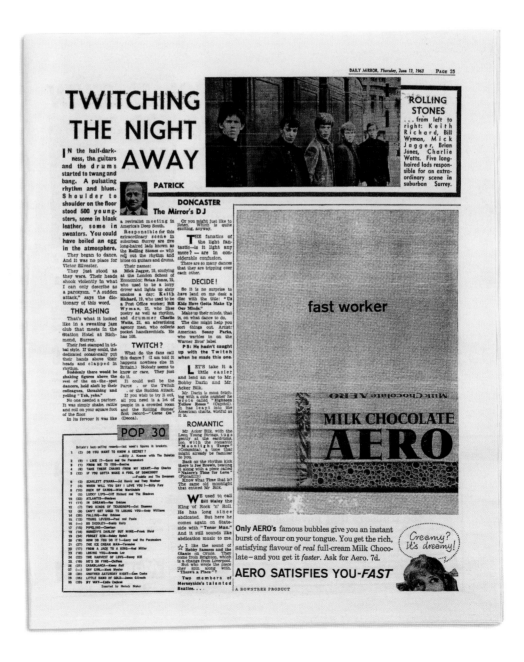

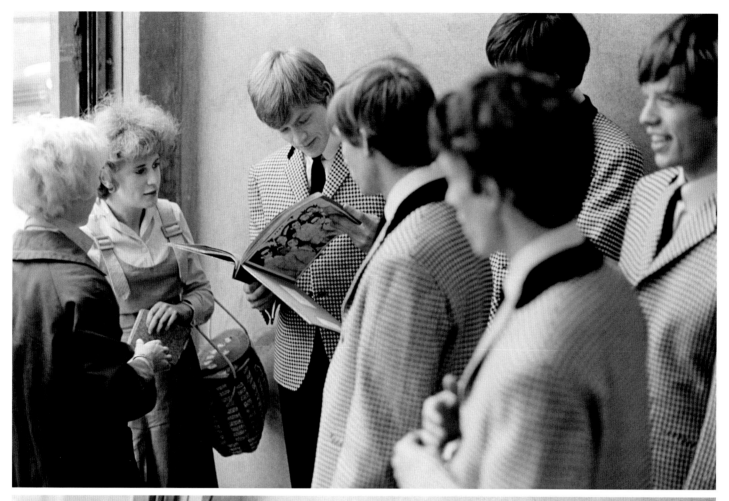

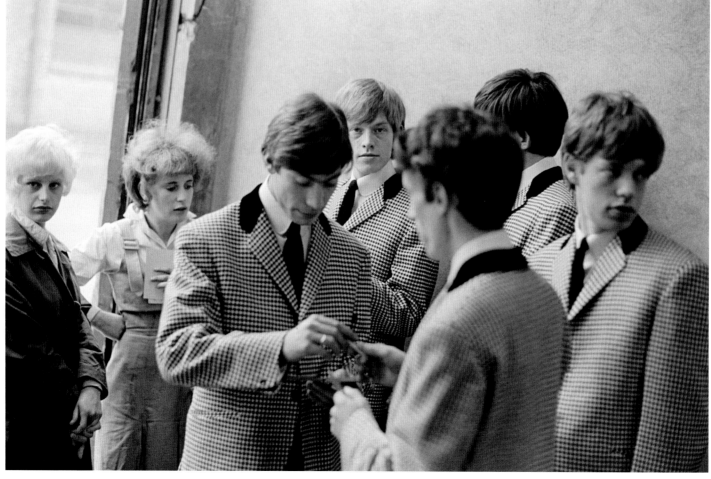

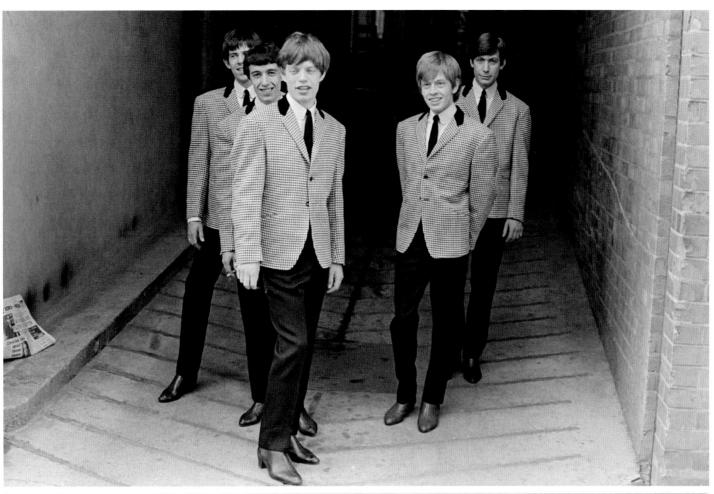

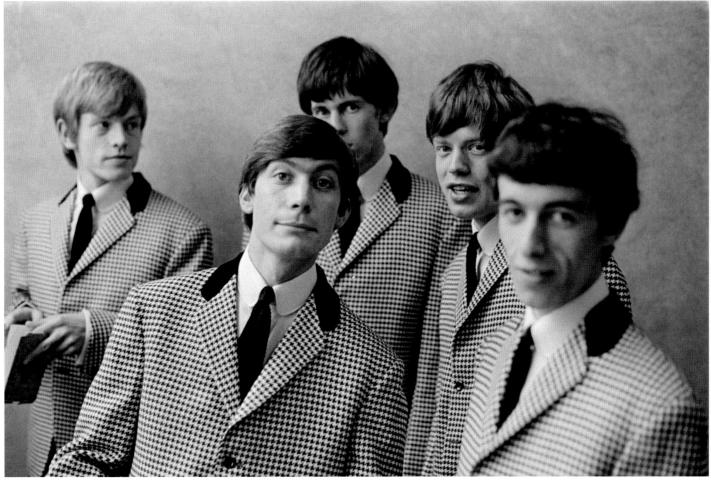

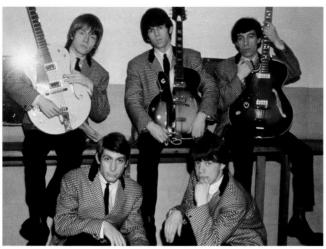

NEW UP and COMING GROUPS
NEW UP and Coming HIT RECORDS

1 "BY THE WAY"
THE BIG THREE F 11689

2 "SOME DO,
SOME DON'T"
LORNE GIBSON F 11684

3 "COME ON"
THE ROLLING
STONES F 11675

4 "FARAWAY PLACES"
THE BACHELORS F 11666

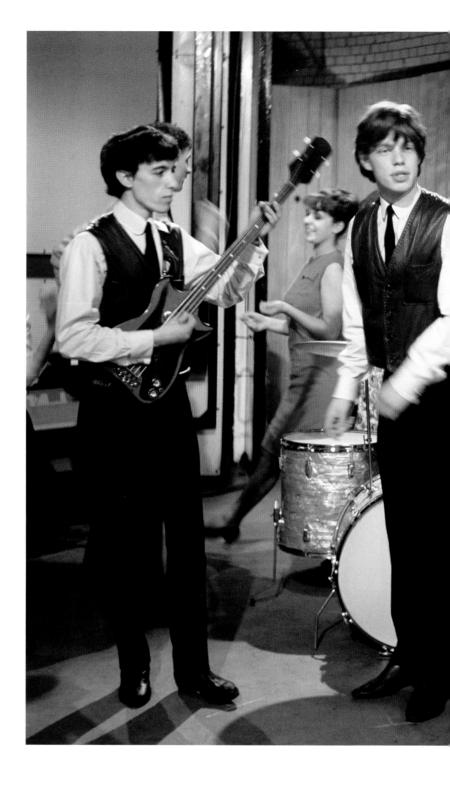

previous pages and above

Thank Your Lucky Stars | **Alpha TV Studios** | **Birmingham, UK** | **7 July 1963**

To appear on *Thank Your Lucky Stars*, we had to dress like a pop group – they'd have thrown us out otherwise – and so Andrew Oldham took us back to Carnaby Street to be measured for these horrendous jackets. We were hip young blues players and we wanted to make a record – no matter what it took – even to the point of wearing those houndstooth jackets. The old DJ who hosted the programme made sarcastic remarks about our scruffy hair but looking at the photos makes me think we'd all had a haircut! KEITH

I remember 'Come On' did pretty well. Then they were on *Thank Your Lucky Stars*. I would race home to see them. They were *the* band, the one I wanted to be in. RONNIE

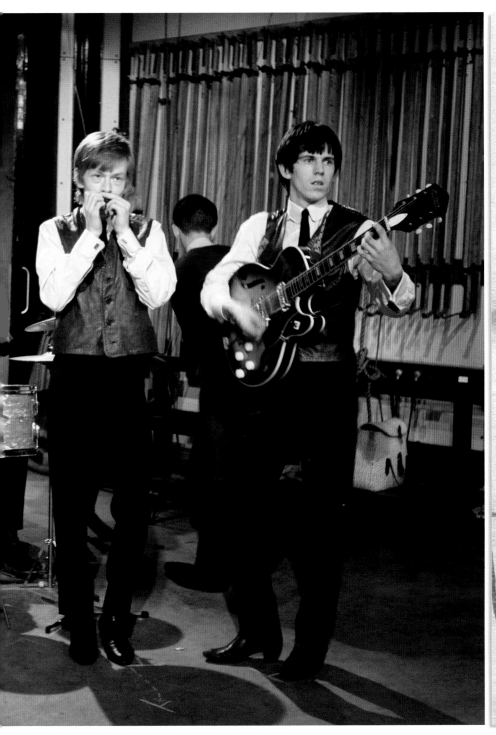

POTTED POPS

JOHNNY KEATING (Piccadilly) sets the groove alight with "Getaway," a red-hot driving-beat number. Just great. Flip is "A Little Waltzin'," a jazz-style three-four number with a big sound.

BOB MOORE and his Orchestra (London) employ that great Mexican trumpet sound for "Kentucky" creating a Latin mood rather than one of the deep South. "The Flowers Of Florence" have a more geographically correct atmosphere but those fascinating trumpets still dominate the disc.

EDDIE CALVERT (Columbia) has recorded the now famous theme of "Emergency Ward 10," but in a most appealing, lush, danceable arrangement. An excellent idea that comes off 100% successfully. "First Love" is a rich and attractive melody helping make this disc top value.

ROLLING STONES (Decca) debut with "Come On," a song and performance aimed straight at the current market for groups. Good chance of selling well. "I Want To Be Loved" is a little unusual, reasonably entertaining.

BILL HALEY and the Comets (Stateside) sound bang up-to-date with "Tenor Man," and "Up Goes My Love." Good for parties and juke boxes.

above

Ready, Steady, Go! | Television House | London, UK | 23 August 1963

The show had only started broadcasting a few weeks earlier and here we are performing 'Come On'. The leather waistcoats were our alternative stage gear to the houndstooth jackets. I much preferred the jackets and hung on to mine after everyone else lost theirs. CHARLIE

above right

'Come On' review from *New Musical Express* | 7 June 1963

I don't think 'Come On' was very good. God knows how it ever got in the charts; it was such a hype. In fact, we disliked it so much that we didn't do it on any of our gigs. MICK

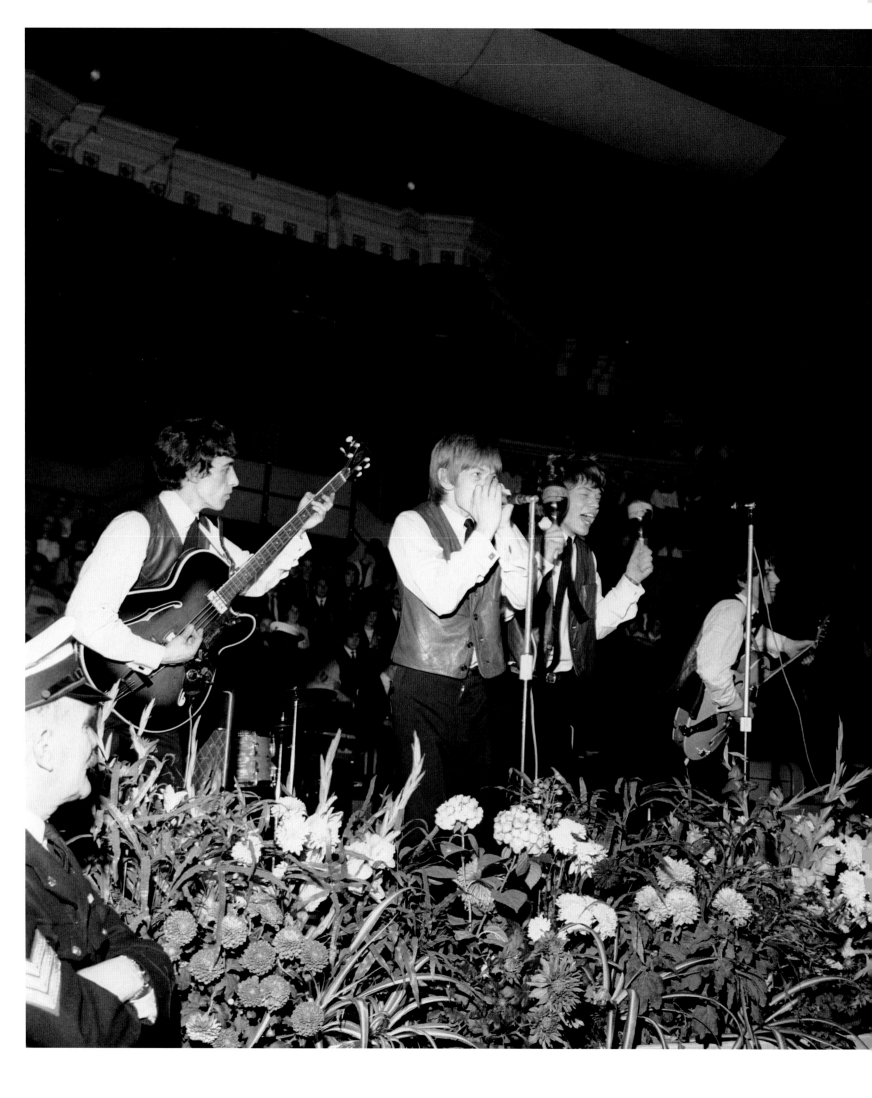

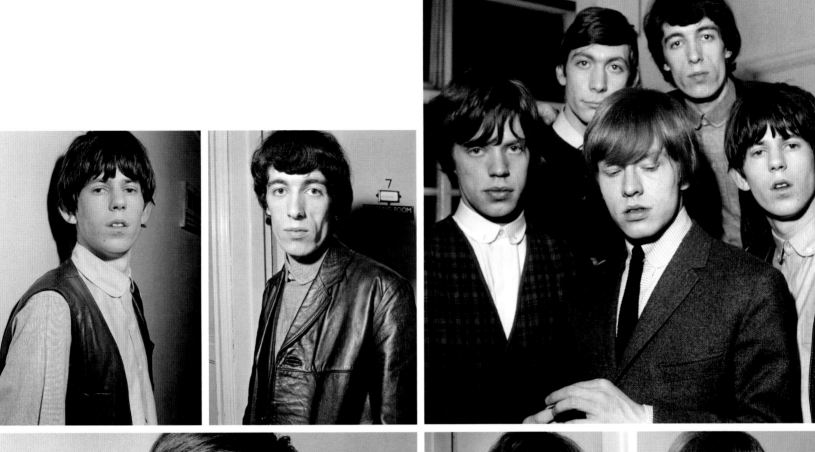

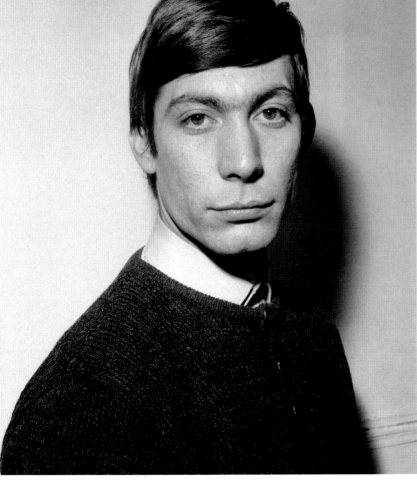

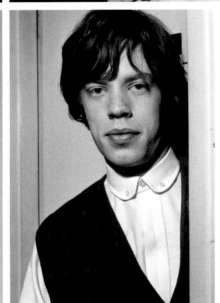

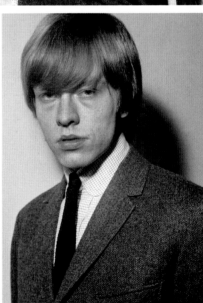

The Great Pop Prom | Royal Albert Hall
London, UK | 15 September 1963

We opened this afternoon performance and were followed by a bunch of typical British pop acts including Shane Fenton and the Fentones. We got an amazing reception. The Beatles closed the show, but we couldn't hang around because we had to head back down the A3 to Richmond to play the Crawdaddy Club that night. KEITH

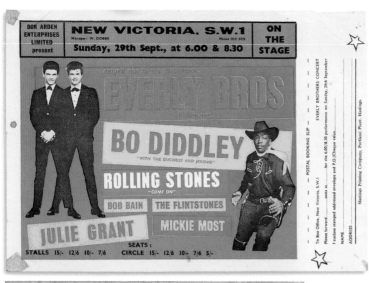

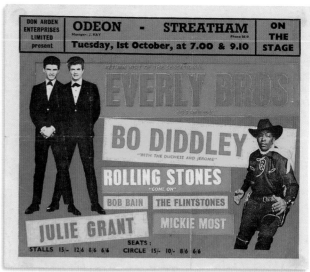

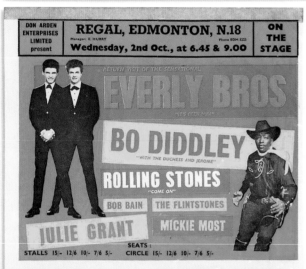

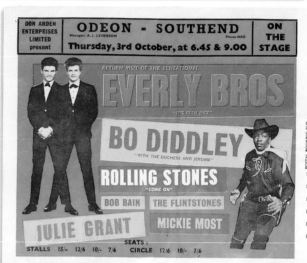

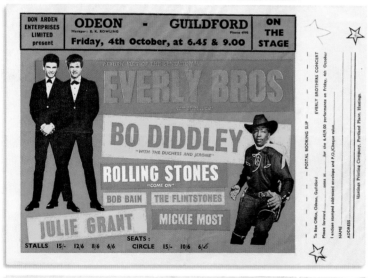

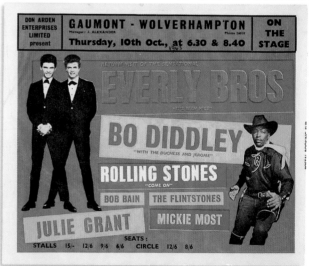

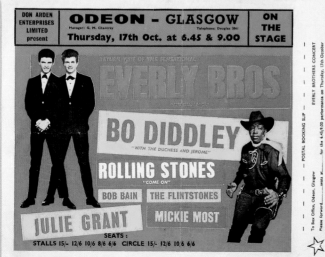

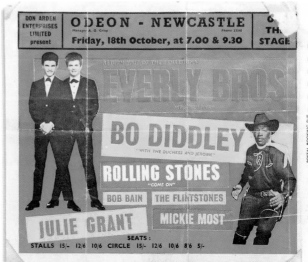

36

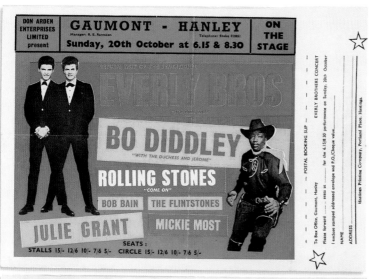

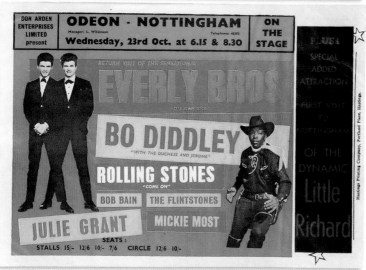

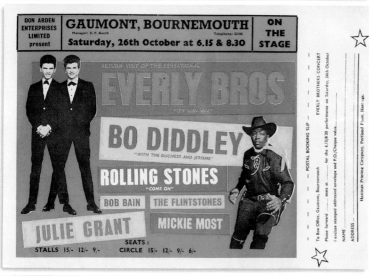

First UK package tour
September – November 1963

It took some time to get used to the screaming,
which was new to us. We used to play clubs,
where they danced or just sat around. KEITH

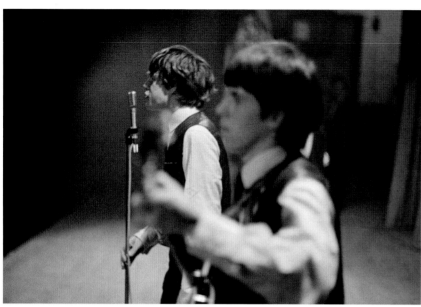

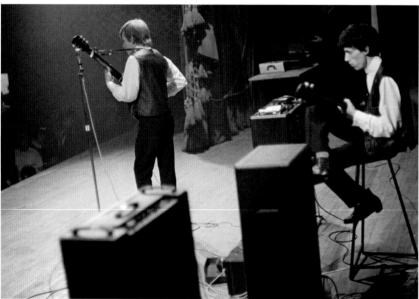

First UK package tour
September – November 1963

We kind of got thrown in at the deep end on
our first UK tour with Little Richard, Bo Diddley
and the Everly Brothers. It didn't take long to
get the hang of their attitude. I'd never been
around that much of England before. And there
were all those birds. There's nothing like 3,000
chicks throwing themselves at you. KEITH

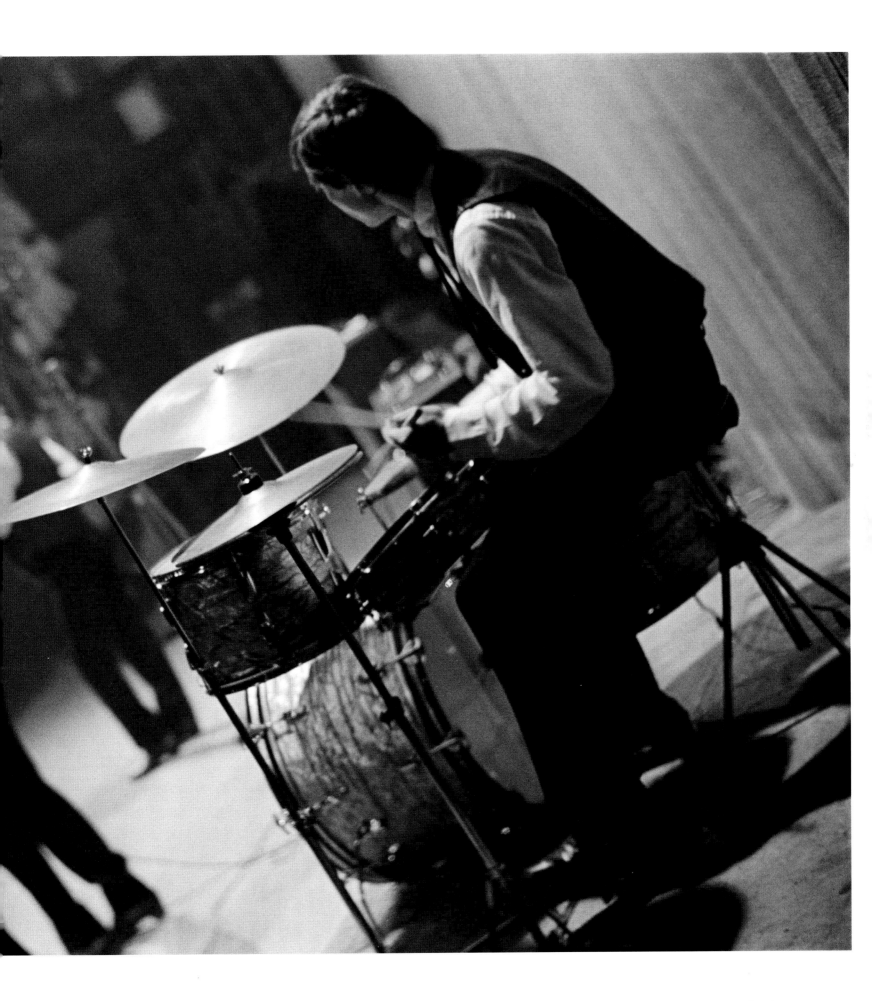

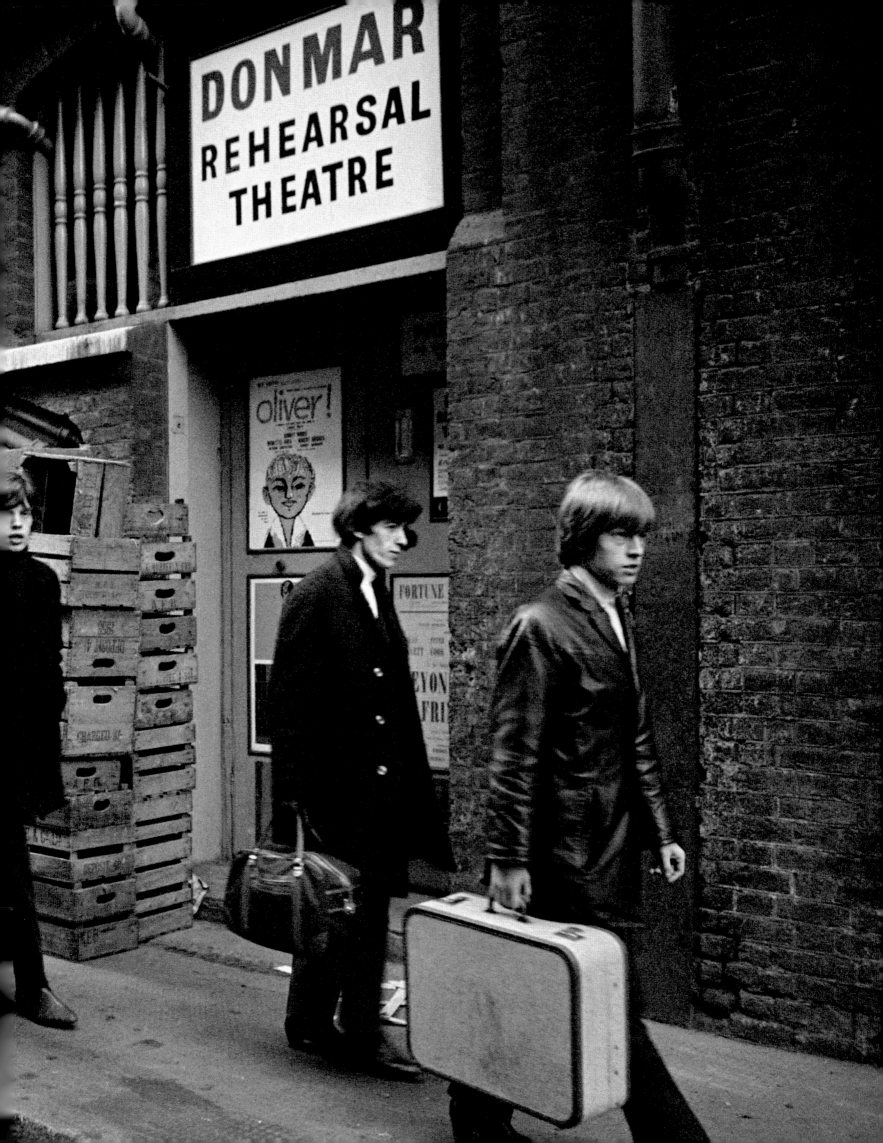

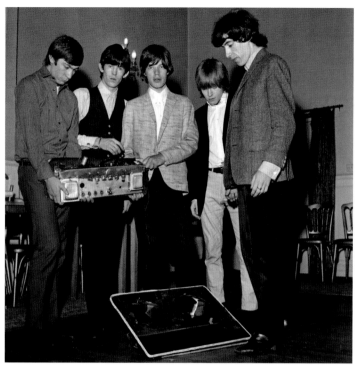

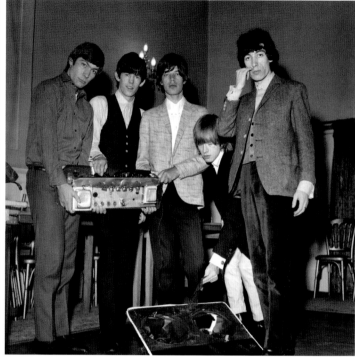

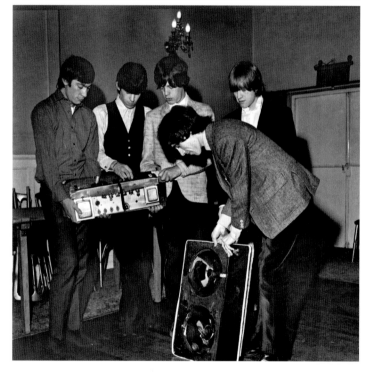

previous pages

London | 1963

In 1963 we spent lots of time playing and recording in this part of London. We've no idea where we were going when this was taken, possibly a photo shoot or maybe a gig.

this page and opposite

Preston Public Hall | Lancashire, UK | 31 January 1964

Immediately after finishing the Everly Brothers package tour we went on another with the Ronettes and then, as soon as that finished, another with John Leyton. After that, it was back to one-nighters, like this one in Preston. The only difference was the crowds were bigger and more enthusiastic than ever.

Looks to me like Bill's equipment had got damaged somehow. CHARLIE

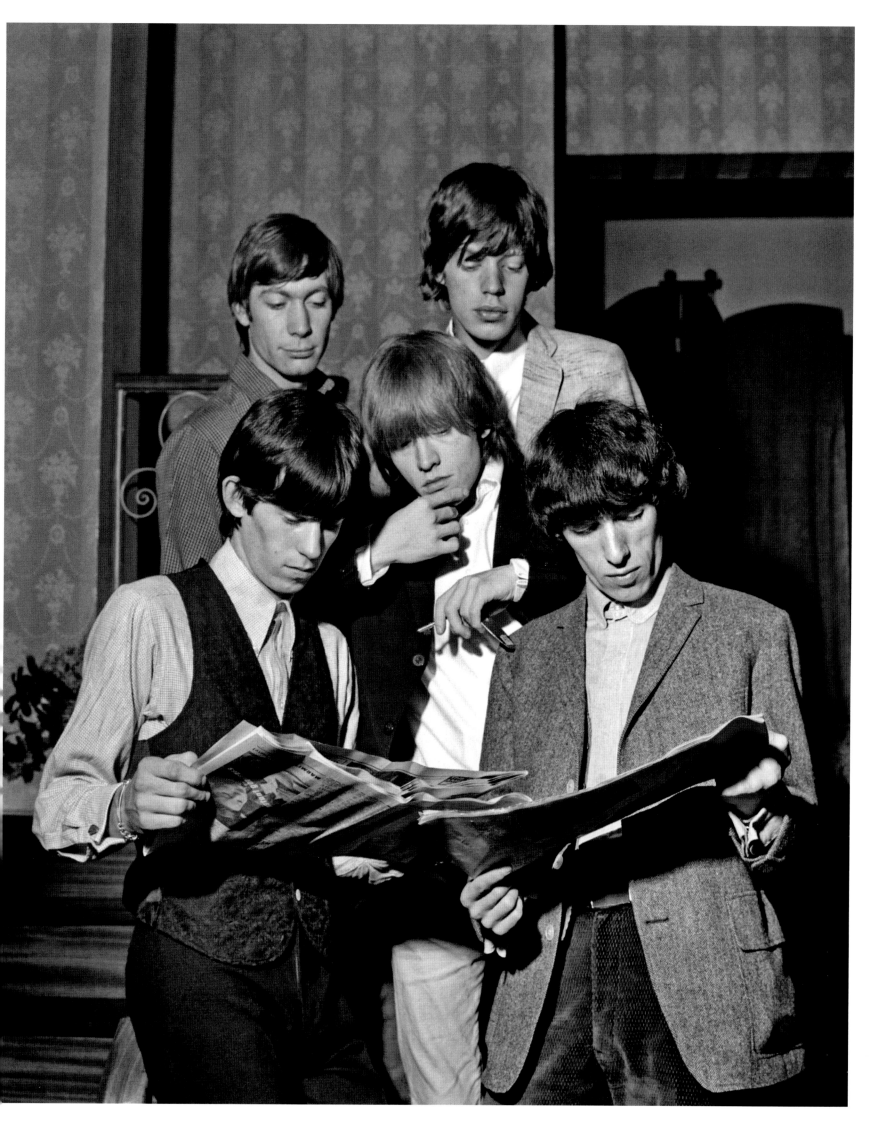

THE TOWN HALL, Crewe :: EDGLEY ENTERTAINMENTS

★ ★ ★ ★

THE SUNDAY STAR

★ ★ CLUB ★

OPENING NIGHT – SUNDAY, NOV. 10th

Hit Parade Stars "Come On" & "Poison Ivy"

THE ROLLING STONES

plus FRANKENSTEIN and THE MONSTERS
and The Fabulous Crestas

Admission Only 5/6 **No age restriction** **7.30—11 p.m.**

— Membership 6d. only —

| Members Only | Join at The Town Hall any Saturday Afternoon 2—4 p.m. or at the Saturday Evening Dance | Visitors Welcome |

THE PHILLIPS COLOUR PRESS LTD., PEMBROKE STREET, ABERDARE

Kidderminster BIG BEAT Sessions
TOWN HALL

'IT'S A CRAZY WORLD' WITH

THURS. MAR 5th
MARTY WILDE
AND THE WILDCATS

ENGLAND'S FIRST AMERICAN CHART TOPPERS

THURS. MAR 12th
THE TORNADOS

PLEASE NOTE FOR ONE WEEK ONLY WE ARE OPEN ON A
Friday, March 20th.
WITH
THE EAGLES

THURS. MAR 26th
The Fabulous ROLLING STONES

Our apologies for the rather high price, but these fabulous Artists command fantastic fees. **Adm 8/6**

7.30-10.45 p.m. **Adm 4/0**
(Except March 26th)

2 GROUPS AT EVERY SESSION

PALACE THEATRE - MANCHESTER
Telephone: CEN 9122 General Manager: TOM H. TILLSTON
SUNDAY, 3rd MAY, 1964
6.00 TWO CONCERTS 8.15

JOHN SMITH presents ALL STAR SHOW

The Fabulous
THE ROLLING STONES
"NOT FADE AWAY"

PETE McCLAIN AND THE FOUR JUST MEN	THE SUNLINERS
THE SWINGING HI-FOUR	
THE OVERLANDERS	THE McKINLEYS

JULIE GRANT

Compere: DAVID HAMILTON

Grand Stalls 10/- ; Orchestra Stalls 7/- ; Grand Circle 10/- ; Circle 8/- ; Upper Circle 2/6 ; Lower Boxes 50/- ; Upper Boxes 36/-.

POSTAL BOOKING FORM
THE ROLLING STONES CONCERT

COLSTON HALL BRISTOL
Sunday, May 10th. 5.30 and 7.45

WESTERN SCENE
presents by arrangement with Malcolm R. Rose

THE ROLLING STONES SHOW

Souvenir Programme 1/-

TUNBRIDGE WELLS BIG BEAT SESSIONS
ASSEMBLY HALL

Tuesday · Mar 17

THE ROLLING STONES !

Adm 7/6 7.30-10.45

SNOD · SHAKE OR STOMP

MIDLAND TOP TEN
PRESENTS

THE ROLLING STONES

| THE MARAUDERS (LUCILLE) | DUKE D'MOND and the BARRON KNIGHTS (PEANUT BUTTER) |

Wayne Fontana and the Mindbenders
(LITTLE DARLIN')

PLUS LOCAL SUPPORTING GROUP
H.M.V. Recording Artistes Denny Laine and the Diplomats

at the
Town Hall, Birmingham
Wednesday, March 25th 1964
6.30 AND 8.45

TICKETS 4/6 ; 6/6 ; 8/6 ; 10/6 available
as from 7th March at the Town Hall Ticket Office and Agents.
Persons wishing to produce this leaflet at the Town Hall Booking Office will be entitled to purchase tickets as from the 22nd February

Midland Top Ten Presents
THE
ROLLING STONES
WEDNESDAY 25th MARCH 1964
SHOW
at the TOWN HALL BIRMINGHAM

THE ROLLING STONES

Wallington BIG BEAT Sessions
STAFFORD ROAD

TUESDAY MARCH 31st
PARAMOUNTS

TUESDAY APRIL 7th
BIG 3
The Touring Giants of the Clubworld

TUESDAY APRIL 14th
MANFRED MANN
Another Top Attraction Next Session

TUESDAY APRIL 21st Britain's No. 1 Group
The Rocking Berries
with
The ROLLING STONES

7.30-10.30 p.m.

SNOD. SHAKE or STOMP

CAPITOL CINEMA (ON STAGE)
Tuesday, 19th May, 1964, at 6.30 & 8.50

Albert A. Berge and Andy Lothian, for more

THE ROLLING STONES · MARK PETERS AND THE SILHOUETTES · FREDDIE AND THE DREAMERS · PETER AND GORDON · MILLY AND THE FIVE EMBERS · TONY MARSH

DAVE BERRY and the CRUISERS

Seats 15/-, 12/6, 10/6, 7/6 & 6/- bookable at the Capitol Cinema. POSTAL BOOKINGS ACCEPTED as from 18th April.

RHYTHM & BLUES EXCITEMENT
AT THE
MARQUEE
EVERY MONDAY AND THURSDAY

THIS THURSDAY, 3rd JANUARY
CYRIL DAVIES R & B ALL STARS
WITH THE ROLLING STONES

FRIDAY · AUGUST 30th
7.30 TO 11.30

NEMS PRESENTATIONS LTD. PRESENT AT
New Brighton Tower

SOUTHERN SOUNDS '63

BRIAN POOLE & The TREMELOES
TWIST AND SHOUT

FOR THE FIRST TIME ON MERSEYSIDE
THE ROLLING STONES

TOMMY BRUCE and the BRUISERS

THE ORIGINAL Checkmates

ALSO
The YOUNG ONES · DINO & THE WILDFIRES · The Roadrunners

TICKETS IN ADVANCE **6/-** AT DOOR ON NIGHT **7/-**

A BOB WOOLER PRODUCTION

DANILO THEATRE - CANNOCK
ON THE STAGE Telephone: Cannock 2169
Wed., 27th May at 6.20 & 8.30

John Smith presents

The ROLLING STONES
"NOT FADE AWAY"

| THE OVERLANDERS | DAVID JOHN and the MOOD |
| The BARRON KNIGHTS featuring DUKE D'MOND | JULIE GRANT TV and Recording Star |

"WORLD WITHOUT LOVE"
PETER & GORDON

| THE CYCLONES | Your Compere TONY MARSH |

Admission: 10/6 8/6 6/6 4/6

— POSTAL BOOKING SLIP —

To
Please forward seats at for the 6.20/8.30 performance on Wednesday 27th May
I enclose stamped addressed envelope and P.O./Cheque value
NAME
ADDRESS

HASTINGS PRINTING COMPANY, PORTLAND PLACE, HASTINGS

COLSTON HALL - BRISTOL
SUNDAY, MAY 10th. 5.30 and 7.45 p.m.

WESTERN SCENE presents by arrangement with Malcolm R. Rose

The Rolling Stones

| JOHNNY CARR & THE CADILLACS | MIKE TOBIN & THE MAGNETTES |
MILLIE & The No Names

The Arun Cities · Christine Marlowe
The Ray Bush R&B Groups · The Echoes
Gene Vincent & The Shouts

Compere - Brian K. Jones

TICKETS 12/6, 10/6, 7/6, 5/6
FOUR COLSTON HALL BOOKING OFFICE - 12 3333

WESTERN SCENE - The Most of England's Original Beat Scene

Winter Gardens Bournemouth
Monday 11th May at 6.15 and 8.40

The
ROLLING STONES

PETER JAY and the JAYWALKERS

JULIE GRANT · CLIFF BENNETT and the Rebel Rousers · KEITH POWELL and the VALETS

Your compere CHRIS CARLSEN

Reserved seats

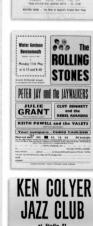

KEN COLYER JAZZ CLUB

at Studio 51
10/11 Great Newport Street,
Leicester Square (Tube)

Open every Wednesday, Thursday,
Friday, Saturday and Sunday
All Night Sessions every Saturday
Rhythm and Blues every Sunday
afternoon with
THE ROLLING STONES
4-6.30

See Classified ads. for band
Pages 16-17

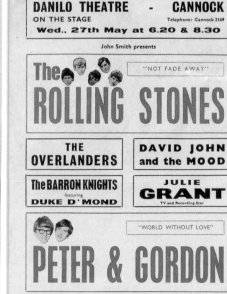

A selection of posters that gives a good idea of what our touring schedule was like and the bands and singers who were on the bill with us.

The Southern Sounds '63 gig was due to be at the Tower Ballroom in New Brighton but it was cancelled. Brian Poole and the Tremeloes was the band that Decca signed, shortly before they signed us, after they turned down the Beatles.

Everything happened quickly. But you had to be quick in those days because there was so much going on and you could get lost in the rush. There were so many bands around – nearly all of them terrible and most of them sort of manufactured. MICK

We'd go and play at the ballrooms and the show would be a Jimmy Reed number, then a Bo Diddley number. The kids had never heard of these things. CHARLIE

CIVIC HALL, GUILDFORD
SUNDAY 15th DECEMBER 8 PM
A CONCERT in RHYTHM N' BLUES
THE
ROLLING STONES
GEORGIE FAME | CARTER LEWIS
and the BLUE FLAMES | and the SOUTHERNERS
GRAHAM BOND QUARTET | THE YARDBIRDS
introduced and compared by
the FLAMINGOS' JOHNNY GUNNEL
TICKETS IN ADVANCE 6|-, 8|-, 10|6 FROM SECRETARY
RICKY TICK CLUBS, MAGPIE COTTAGE, RUNNYMEDE, OLD WINDSOR

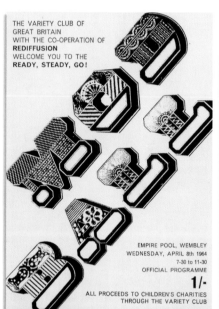

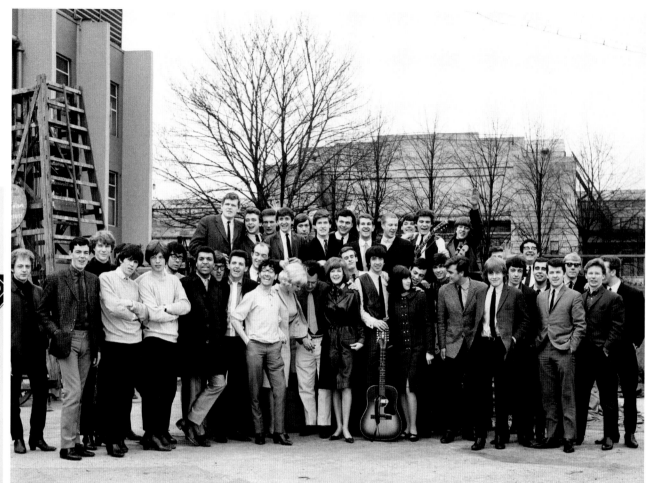

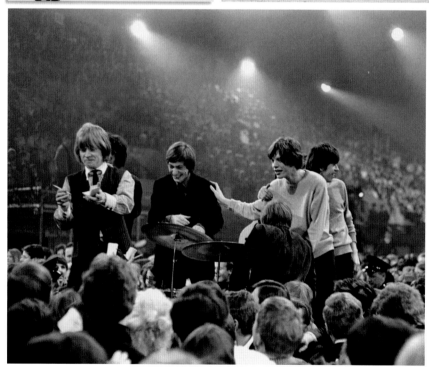

The *Ready, Steady, Go!* Mod Ball | Empire Pool Wembley, London, UK | 8 April 1964

Also on the bill with us were Freddie and the Dreamers, Kathy Kirby, Billy J. Kramer and the Dakotas, the Fourmost, Manfred Mann, the Merseybeats, the Searchers and Cilla Black. According to the Daily Mirror, *'It was the noisiest, screamingest crowd we have ever had at the Empire Pool. The Stones were mobbed as they left the stage. Commissionaires fought to protect them.'*

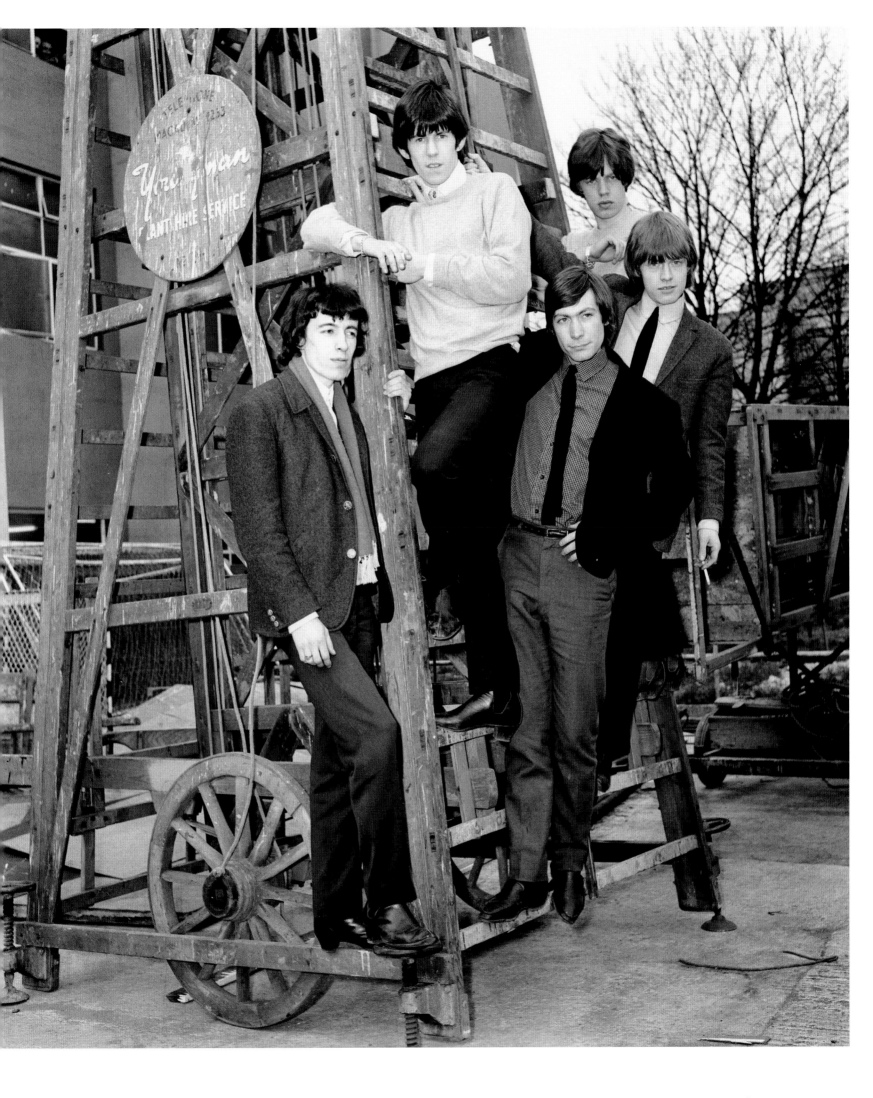

 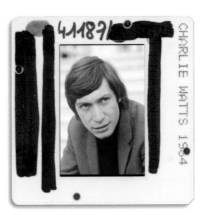 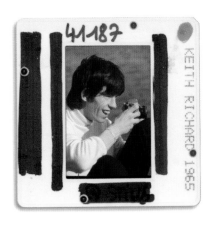

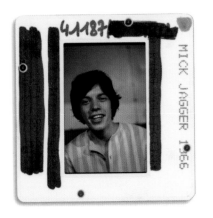 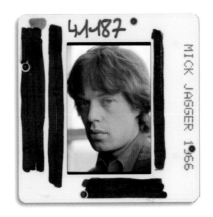 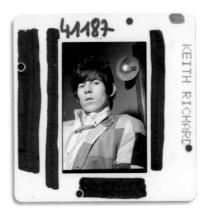 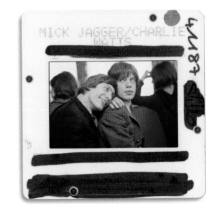

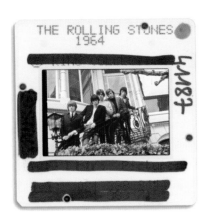 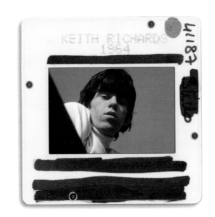 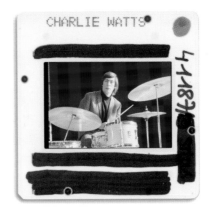 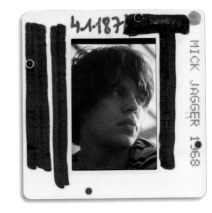

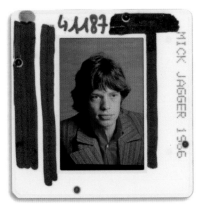 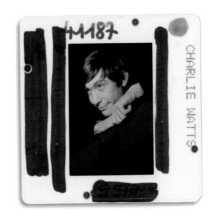 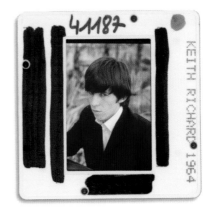 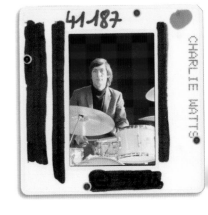

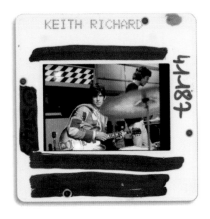 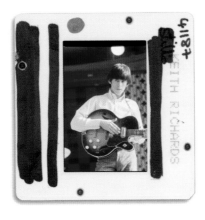

Montreux, Switzerland | 20 April 1964

*We went to Switzerland as part of Britain's entry into a
TV award show. The UK's entry was Ready, Steady, Go!
This was our first trip abroad as a band.*

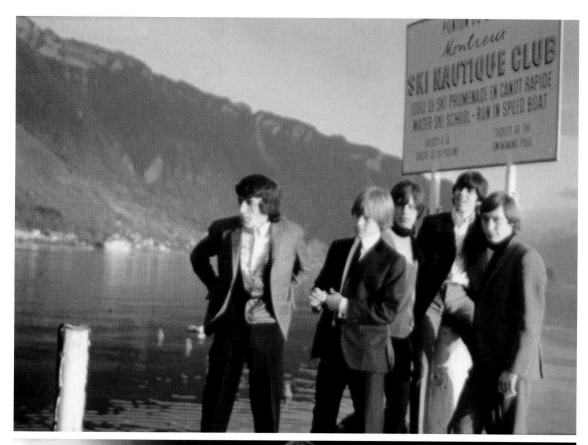

**New Musical Express Poll Winners Concert | Empire Pool
Wembley, London, UK | 26 April 1964**

We were all conscious of the fact that we were beginners. I always
had that feeling that we were trying to rise to the occasion. It was
a massive time of soaking things up. KEITH

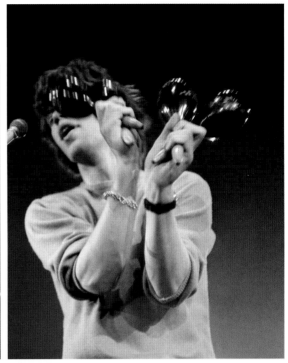

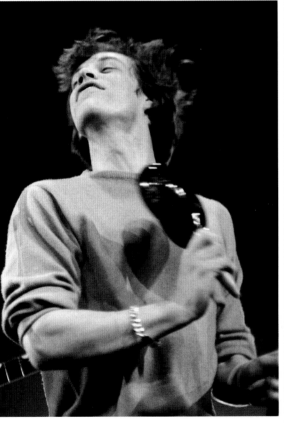

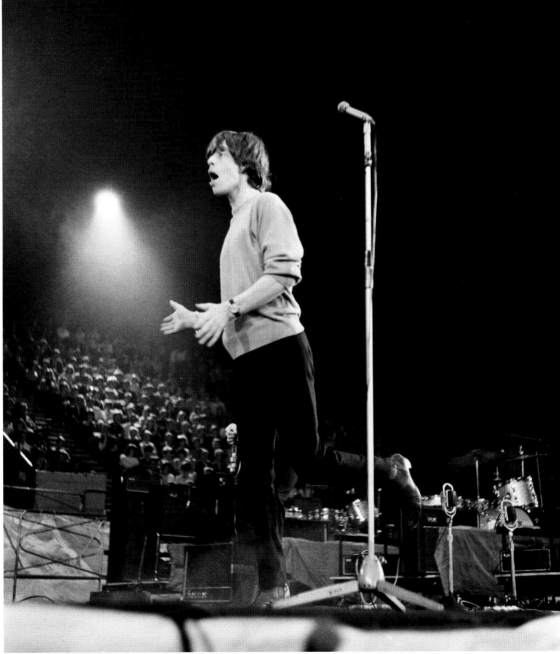

The Palace Theatre | Manchester, UK | 3 May 1964

Here I'm fiddling with my amp and being watched over by Stu. He became the kind of Rolling Stone he wanted to be because he could be totally anonymous, but still be along on all the good shit. KEITH

Although we continued to be (fairly) happy to pose together as a group for a while after this, I think the phase of clutching cuddly toys quickly passed. MICK

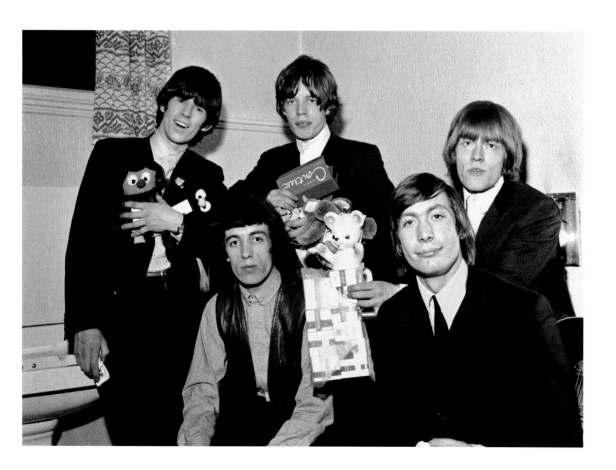

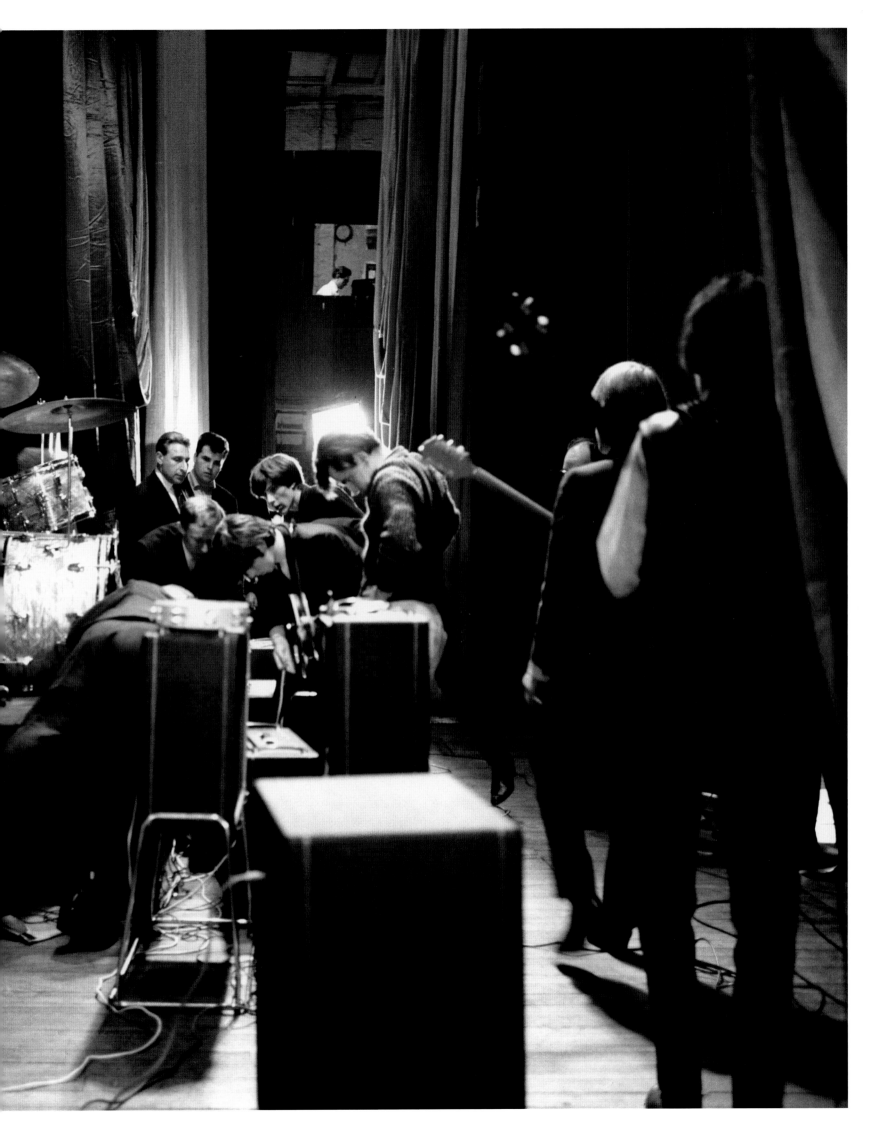

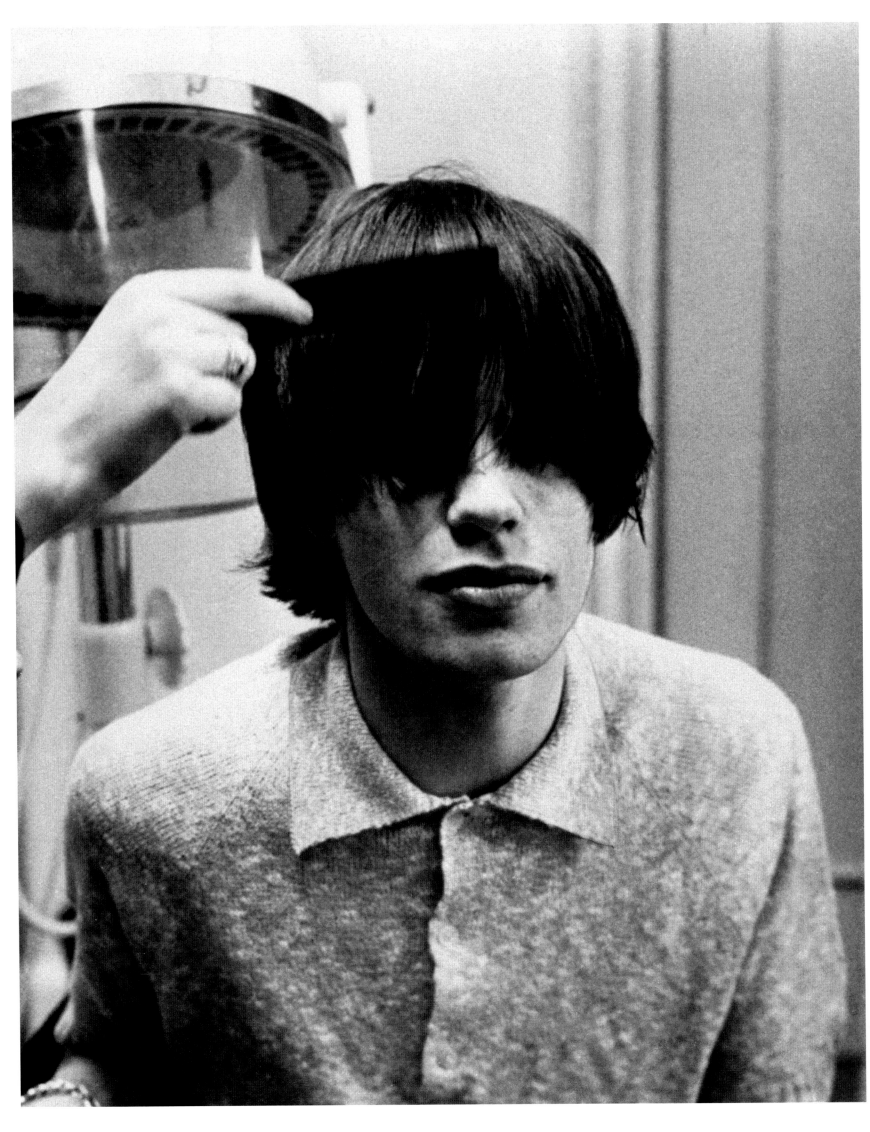

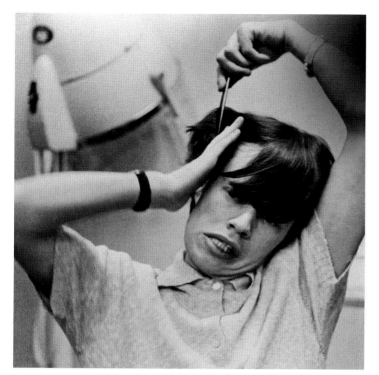

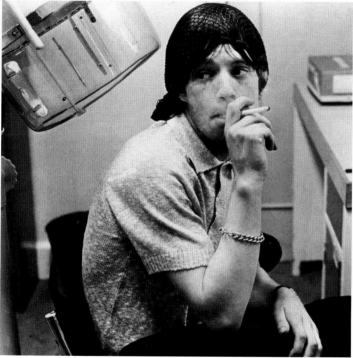

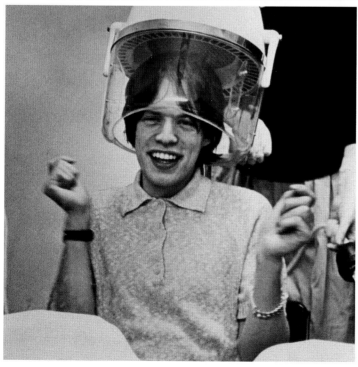

**Backstage before BBC2's *Open House* show
Riverside Studios | Hammersmith, London,
UK | 9 May 1964**

At around the time these photos were taken, I told
the *Daily Mirror*, 'We are completely unmoved
by criticism. We are not worried about obvious
sensationalism on the way we look and dress. I never
did like wearing a suit, but maybe I will when I'm
about twenty-five. We have our hair trimmed about
once every three months.' When these pictures
appeared in the paper, Cliff Richard said, 'I think hair
that long on a boy is disgusting.' MICK

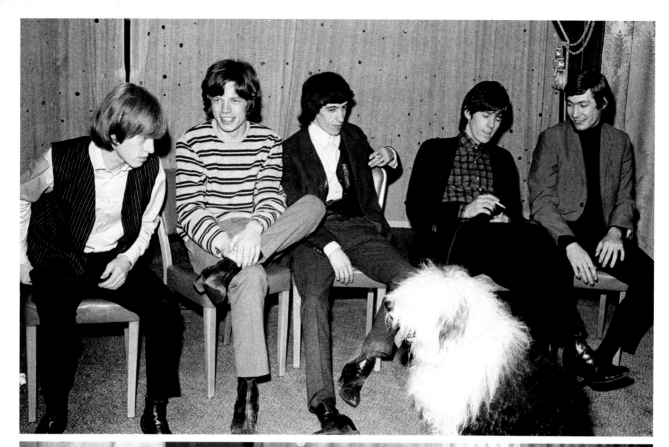

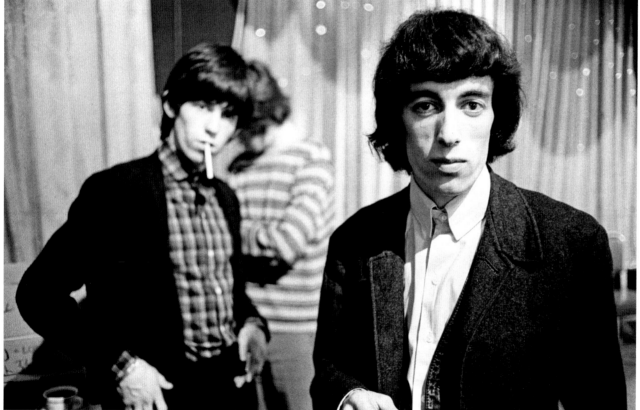

above and opposite

John F. Kennedy International Airport
New York, USA | 1 June 1964

America was a joke when we arrived but, by the time we left, we had an audience. It was all uphill but the audience grew every time we went back. CHARLIE

overleaf

John F. Kennedy International Airport
New York, USA | 1 June 1964

These five shots are the earliest arty shots I've ever seen of us. What's so surprising is that the *Daily Mirror* actually sent a photographer to cover us on our first trip to America. CHARLIE

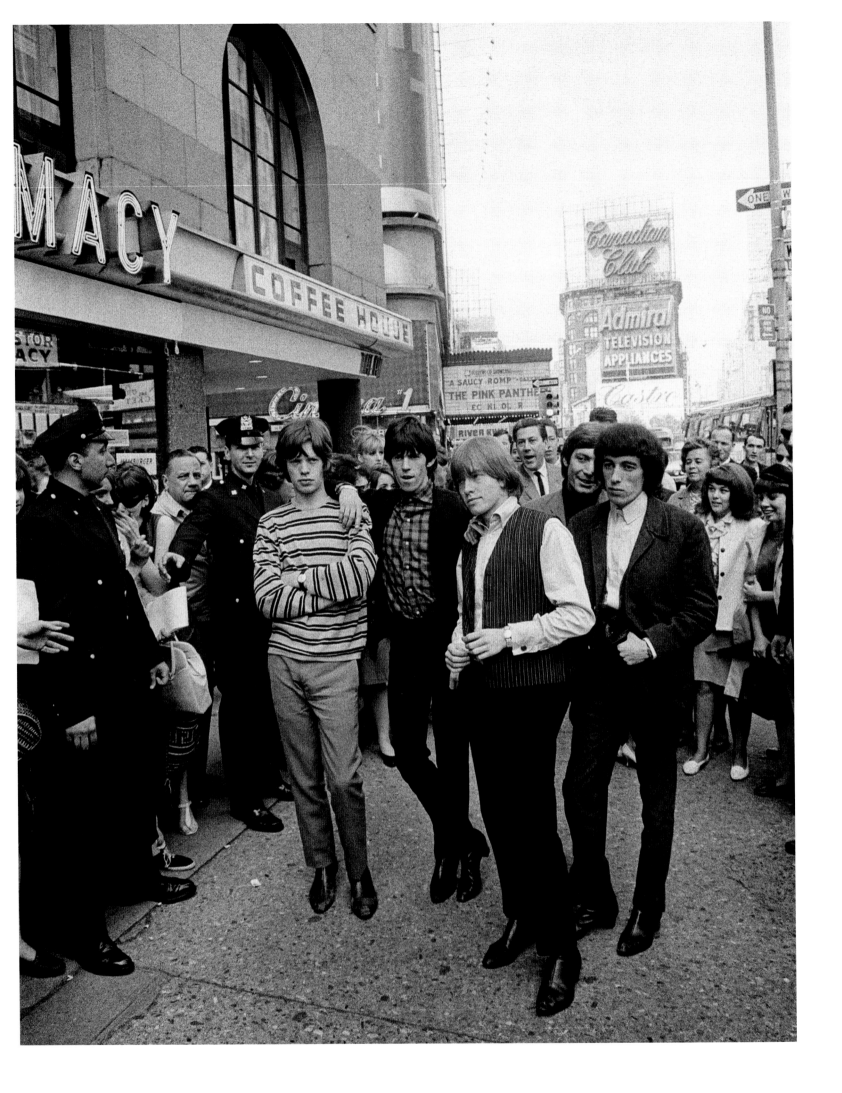

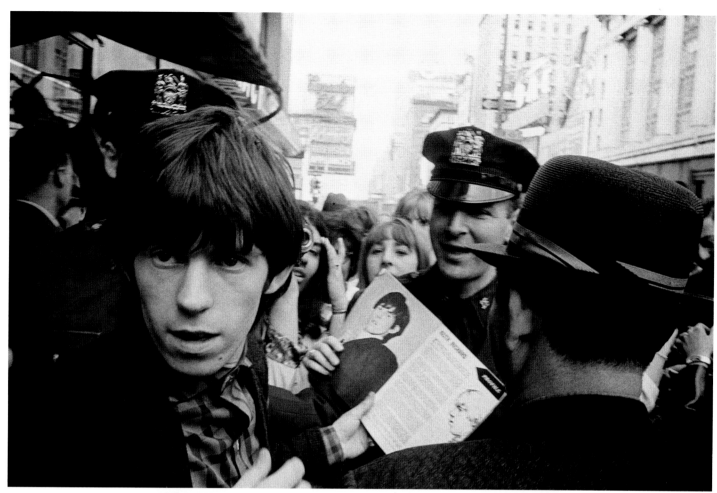

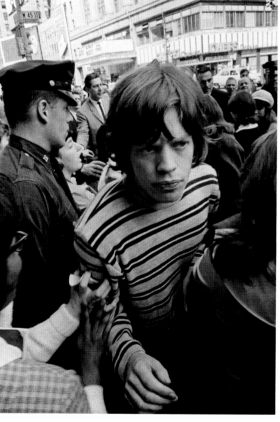

Outside the Hotel Astor | Times Square, New York, USA | 1 June 1964

Arriving from the airport, we were surprised at the size of the crowd waiting for us at the hotel, but they were all pretty well behaved. On that first US tour, everywhere we went we had questions about why we had such long hair and dressed differently and not all in matching suits. We usually answered by saying we dressed differently because we're five different people.

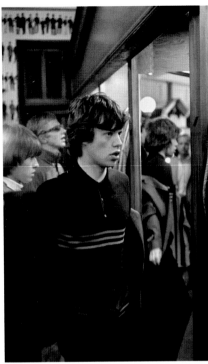 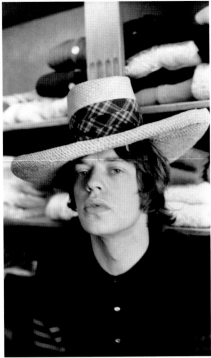

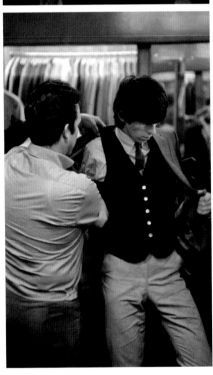 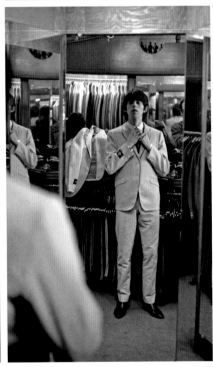 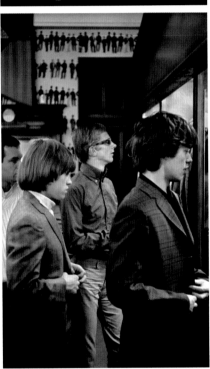

**Beau Gentry menswear store | Hollywood,
California, USA | 4 June 1964**

The day before, we had appeared on Dean Martin's
TV show. He was sarcastic when he introduced us –
'These long-haired wonders from England, the Rolling
Stones…They're backstage picking the fleas off each
other.' Next morning we all went shopping for clothes
with Andrew. KEITH

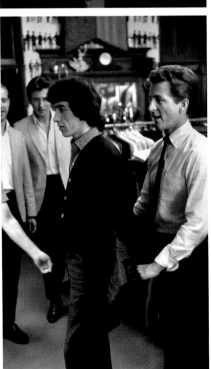

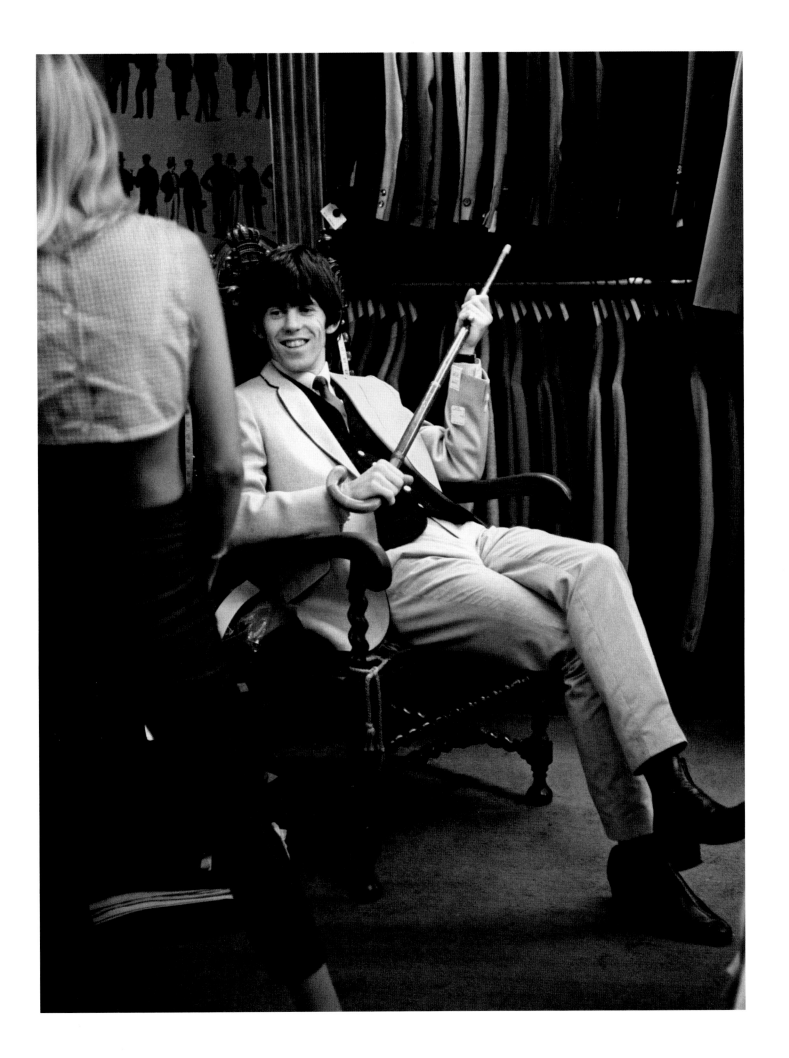

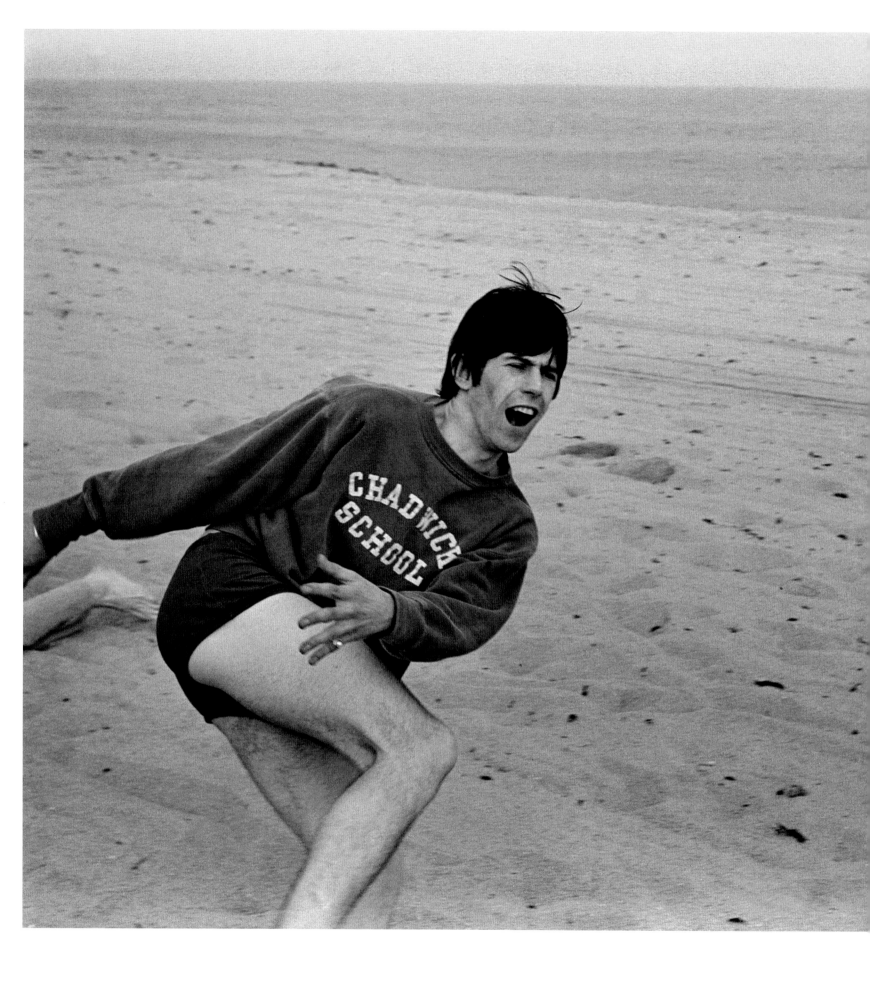

Malibu Beach | Los Angeles, California, USA | 4 June 1964

After we went shopping and had lunch, we all went to the beach for the afternoon.
It was a hot day but, being British, we mostly kept our clothes on.

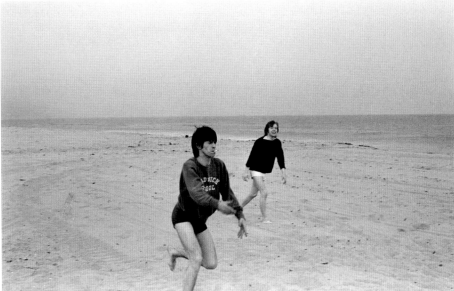
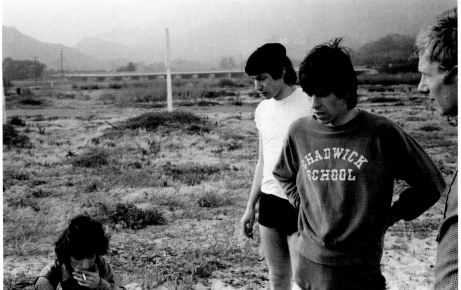
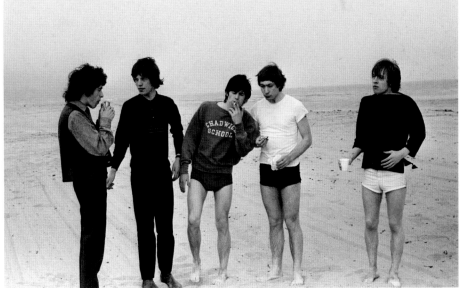

San Bernardino, California
JUNE 5 - 1964
FOR ONE NIGHT ONLY
LIVE - ON STAGE
England's Newest Hit Makers

THE ROLLING
STONES

Teen Fair - San Antonio, Tx. 6th & 7th
Minneapolis, Mn. 12th ★ Omaha, Ne. 13th
Detroit, Mi. 14th ★ Pittsburgh, Pa. 17th
Harrisburgh, Pa. 19th
Carnegie Hall, N.Y. 20th

★ WITH ★
Bobby Vee
The Chiffons
Bobby Goldsboro
Bobby Comstock

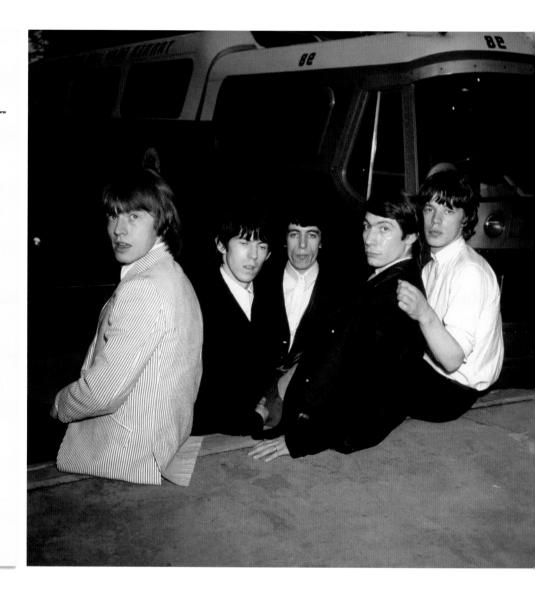

Swing Auditorium | San Bernardino, California, USA | 5 June 1964

The first show we ever did in America. Bobby Goldsboro was on the show – he taught
me a Jimmy Reed lick – and so were the Chiffons. It was a gas. They all knew the words
and were really bopping, especially when we did 'Route 66'. KEITH

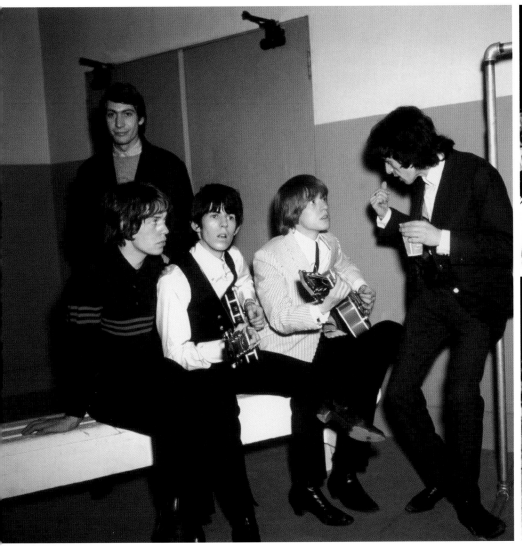

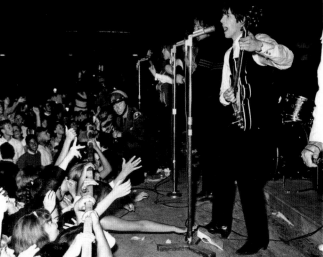

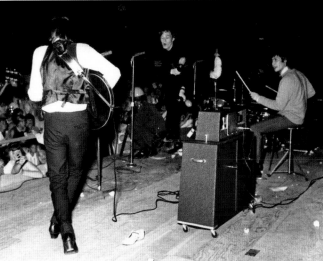

ALEXANDRA PALACE LONDON

FRIDAY, 26TH JUNE 9 P.M.–6.30 A.M.

ROLLING STONES FAN CLUB

ALL NIGHT RAVE

THE ROLLING STONES

Millie & The Five Embers

John Lee Hooker

John Mayalis Blues Breakers

The Barron Knights Featuring Duke D'mond

Jimmy Powell & The Five Dimensions

The Downliners Sect

Tony Colton & The Crawdaddies

Etc. Etc. Etc.

Comperes: Jimmy Saville &

Don Wardell (direct from Luxembourg

Tickets in advance from Rolling Stones Fan Club, 10 Beaufort Road, Reigate, Surrey, or at the door up to 11 p.m. on the night

TICKETS: 25/- EACH

Including Membership of the Rolling Stones Fan Club

Take Piccadilly Tube to Wood Green, Bus No. 233 from Finsbury Park or Wood Green Underground Stations (this Bus passes the door) Buses 43, 102, 134 & 244 (alight at Muswell Hill Broadway) Buses No. 217 & 231 (alight at Victoria Hotel)

LICENSED BAR REFRESHMENTS

HASTINGS PRINTING CO., PORTLAND PLACE, HASTINGS. Phone 2450

Alexandra Palace | London, UK | 26 June 1964

The left hand of the two cymbals that you can see in this photo I still use, although not when I'm playing with the Stones. It's too delicate for that. I use it when I'm playing with my jazz band. CHARLIE

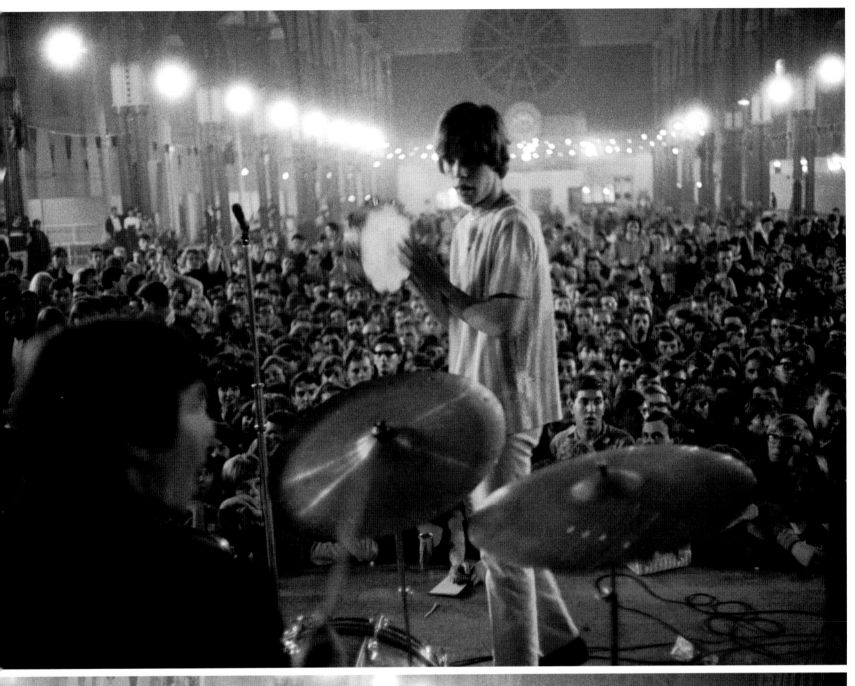
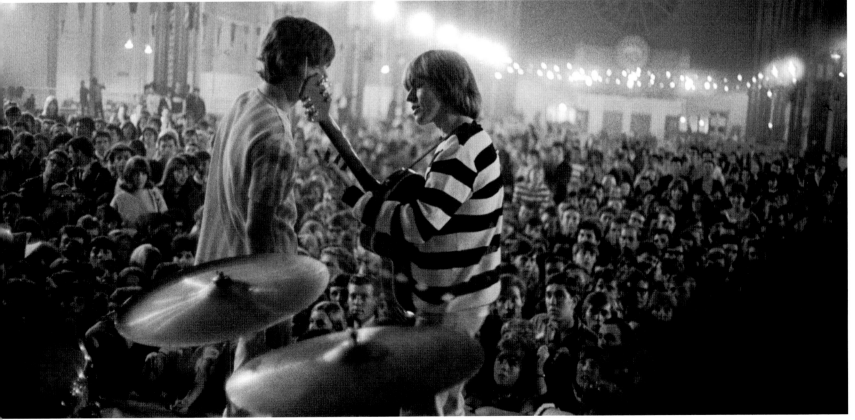

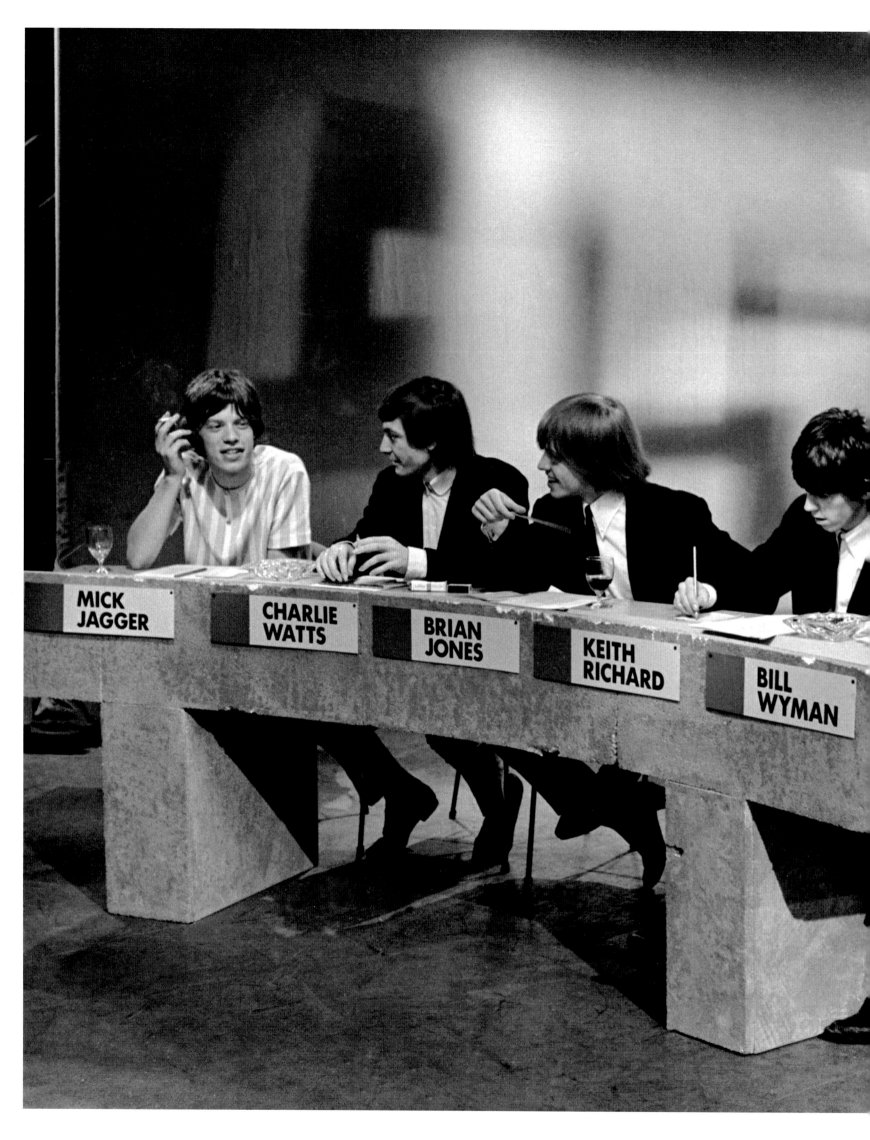

MICK
JAGGER

CHARLIE
WATTS

BRIAN
JONES

KEITH
RICHARD

BILL
WYMAN

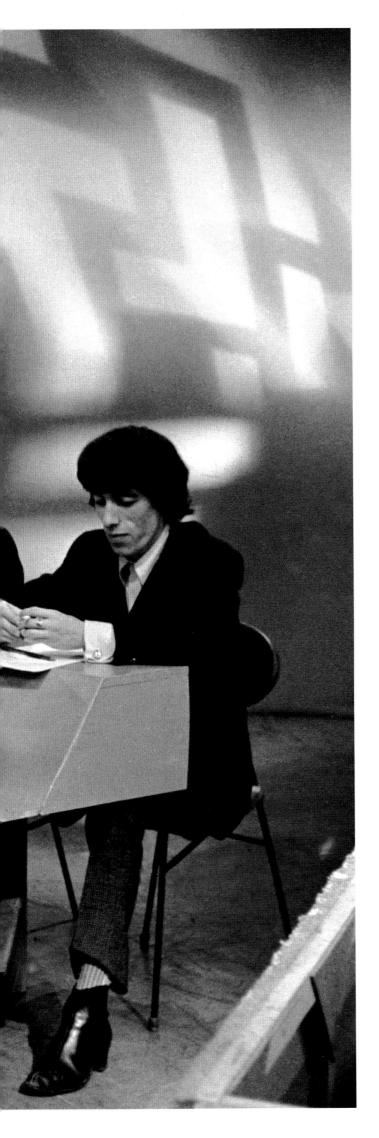

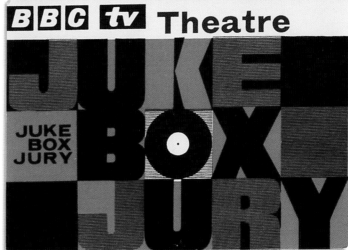

Juke Box Jury | BBC Television Centre | Shepherd's Bush, London, UK | **27 June 1964**

As usual, here we are breaking the mould. *Juke Box Jury* always had four guests giving their opinions on the latest records. Of course, with us, they got five opinions, although on almost every record we agreed with each other. KEITH

I hated doing that show. CHARLIE

IMPERIAL BALLROOM · NELSON
FRIDAY, JULY 24th, 1964 — 9 p.m. to 1 a.m.

BARNOLDSWICK AND GISBURN
CONSERVATIVE BALL
with
KEN REECE AND THE SWINGING SOUNDS
Licensed Bars until 12-20 Late Transport to all parts
TICKETS 5/- AT THE FOYER 5/6
or with DAVID JOHN Tear-off Ticket 4/-

IMPERIAL BALLROOM
NELSON
The Ballroom of the Stars — With Licensed Bars
PRESENTS
SATURDAY, JULY 25TH
1964 — 7-30 p.m. to 11-30 p.m.

THE RETURN OF THE WORLD'S NO. 1 RHYTHM AND BLUES GROUP
THOSE DYNAMIC ROLLING STONES
PLUS THE SENSATIONAL SILHOUETTES AND THE FANTASTIC THUNDERBEATS
Licensed Bars WHAT A FAB NIGHT! Treble Late Transport to all parts
TICKETS: 8/6 AT THE FOYER 9/6

TICKETS at: Burnley — Electron Radio Co, 2, Hall Street, off the Centre; Brierfield — Fell, Newsagent, The Centre. Nelson — Multi Relays; Read's, Butchers, Market Square; The Coffee Pot, Manchester Road; Colne — Rabino's Snack Bar, Skipton Road Top; Barrowford — J. S. Holmes, Newsagent, 108, Gisburn Road and Mr. T. Almond, Nora Street; Earby — Mason's, Greengrocers; Barnoldswick — Holt's Shoe Shop; Accrington — Althams Travel Service; Imperial Ballroom, Nelson 65760.
LATE TRANSPORT ON MAIN ROAD THROUGH BURNLEY TO MEMORIAL GARDENS, PADIHAM and MAIN ROADS THROUGH COLNE TO BARNOLDSWICK

NEXT WEEK: THE SEARCHERS

CENTRAL PRINTING CO. (CHAS. SOWDEN) LTD. BURNLEY, LANCS.

Imperial Ballroom | Nelson, Lancashire, UK | 25 July 1964

This was the time that our ballroom shows were getting increasingly difficult. Screaming girls all too often became fainting girls and just keeping them off the stage was a real challenge for the security staff – who were often ill-equipped and trained to do the challenging job they needed to do. For us, getting in and out of the gigs was also becoming a nightmare. We had a police escort on many occasions.

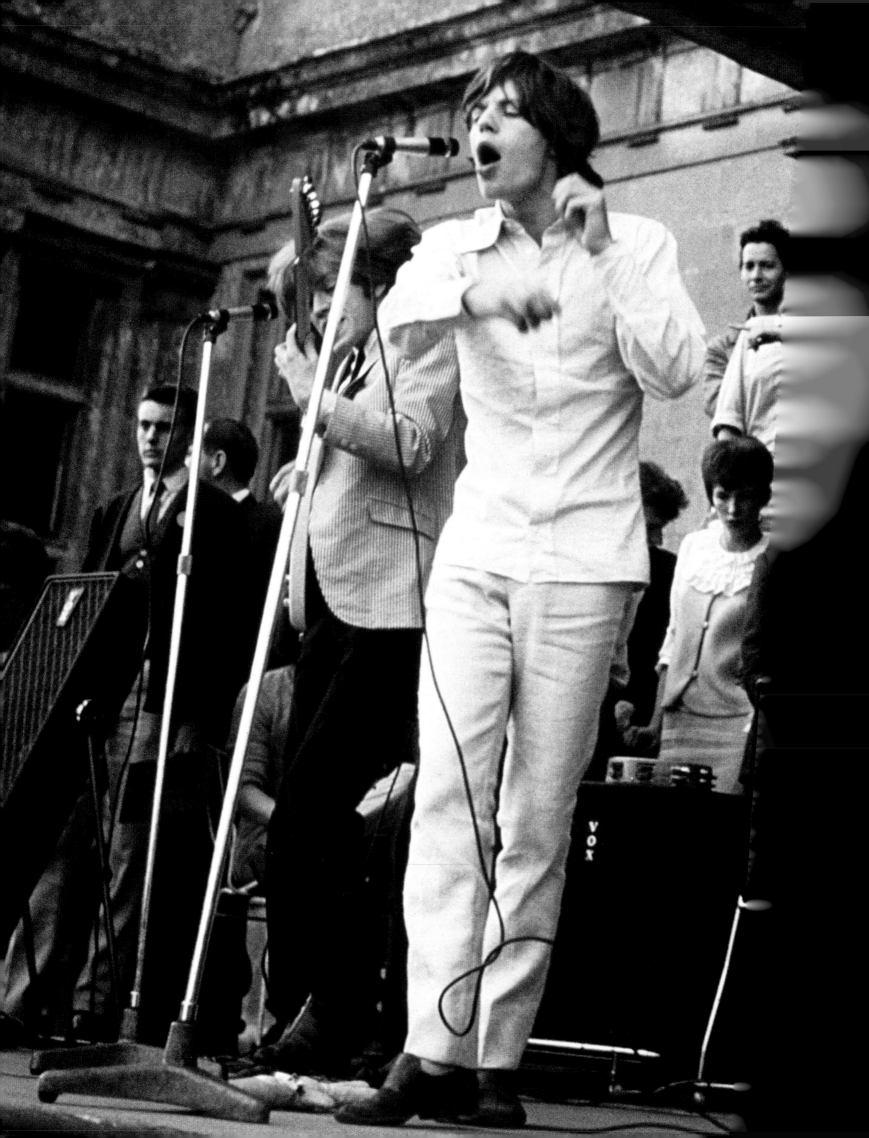

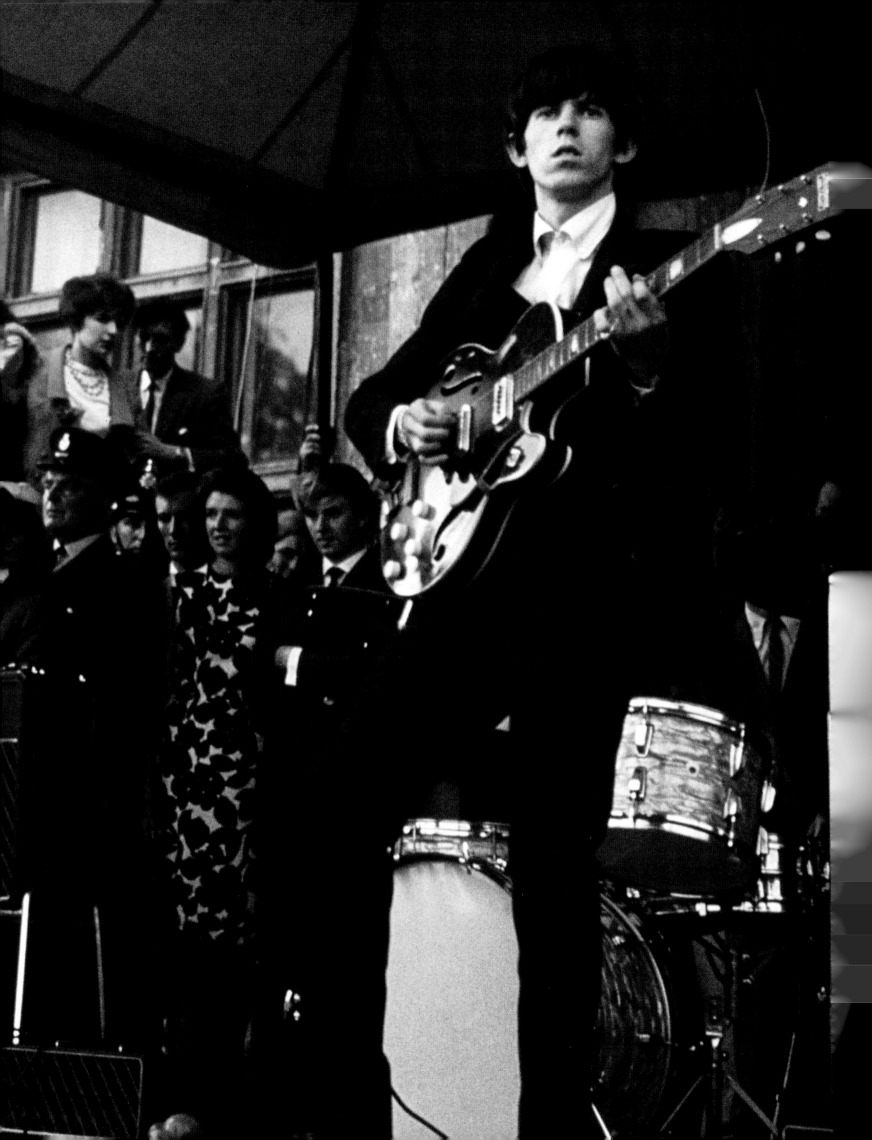

previous pages

Longleat House | Warminster, Wiltshire, UK | 2 August 1964

*We're performing here on the stage outside Longleat House. We had done
a deal with Vox amplification and had taken delivery of the new amps
and speakers a week or so earlier.*

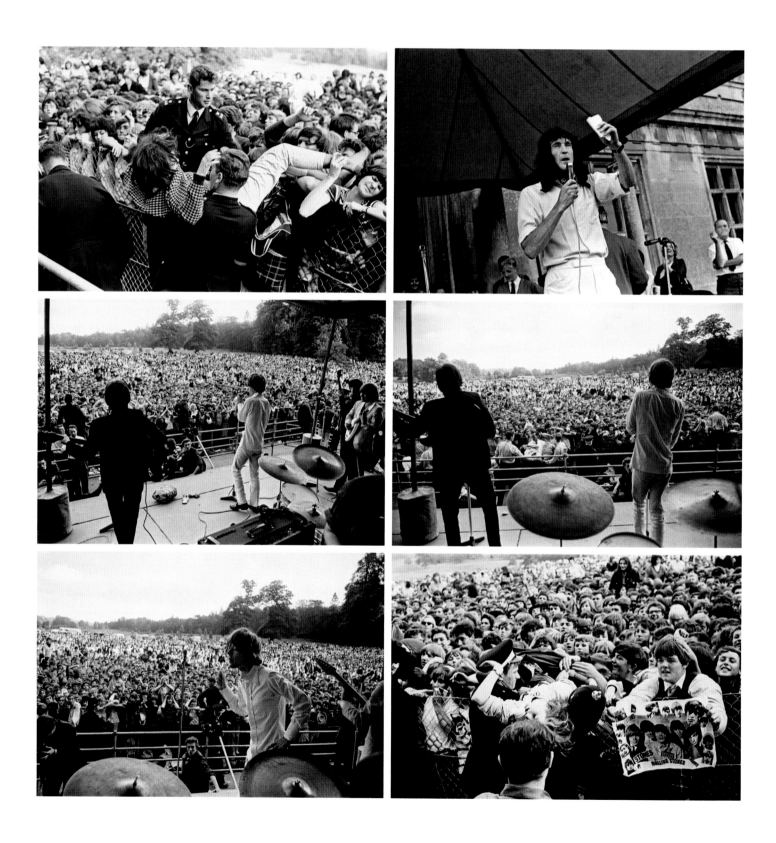

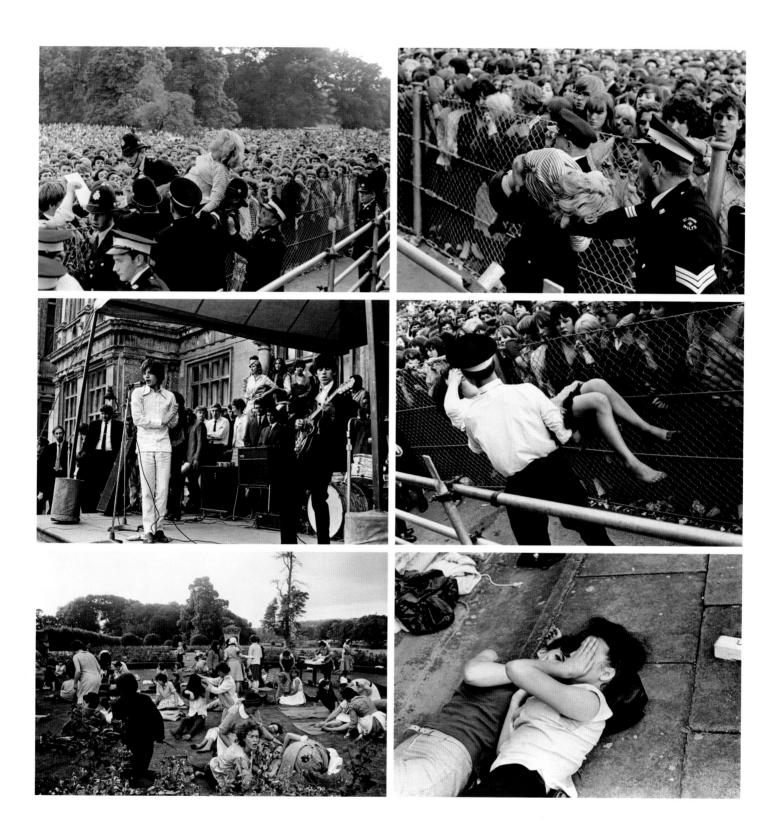

Longleat House | Warminster, Wiltshire, UK | 2 August 1964

We had driven down from London and got there in time to see some
of the house and have drinks in the garden with the Marquess of Bath,
who was a lovely guy. Problems with fainting fans were the same
outside as inside the ballrooms. CHARLIE

*A few weeks later, the Duke was apparently still getting letters from people
complaining about our gig. According to the* Daily Mirror, *his response was,
'They are from either second-rate blackmailers or lunatics.'*

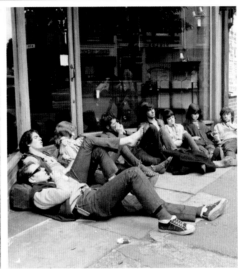
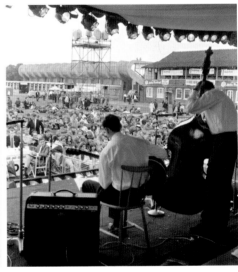

4th National Jazz & Blues Festival | Richmond, Surrey, UK | 7 August 1964

This would have been the first time we had played in Richmond since the heady days of the Crawdaddy Club ended the previous summer. It had been an amazing twelve months for us with hit singles, including 'It's All Over Now' going to No.1 and a No.1 album. We headlined the Friday night and played to a big crowd. Some of them had probably been regulars at the Crawdaddy. MICK

I saw the Stones at the Richmond Jazz Festival playing in a tent. It was rocking. I was the last one out of the tent, looking at everybody packing up the gear, and I fell over a tent peg and smashed my leg. Jagger was at the front of the stage, kissing some bird after the gig. RONNIE

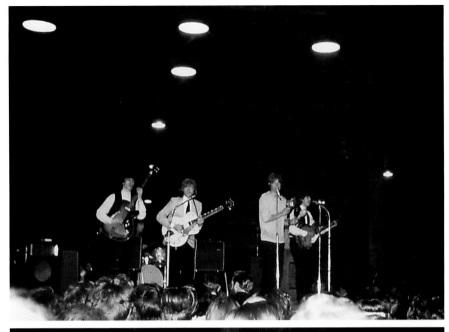

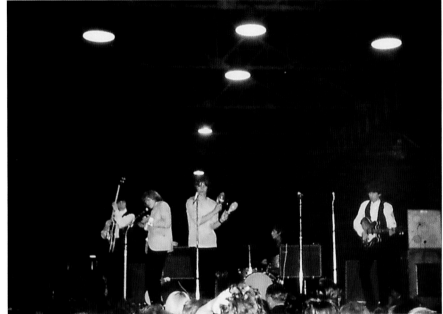

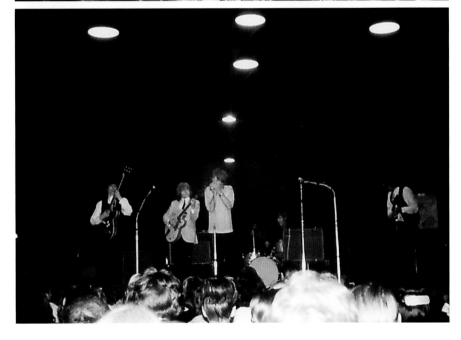

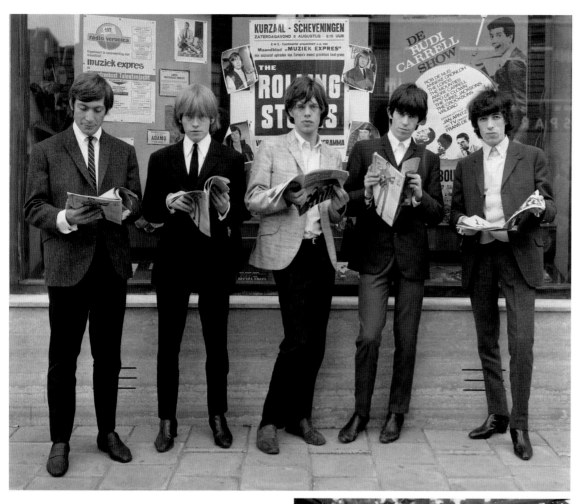

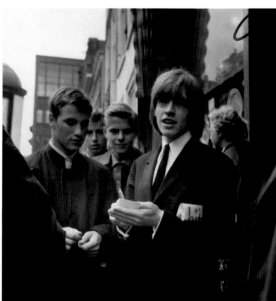

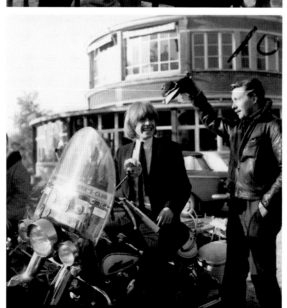

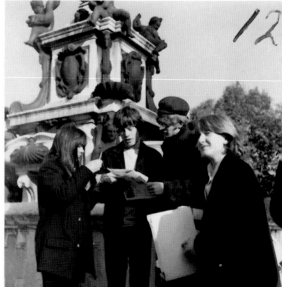

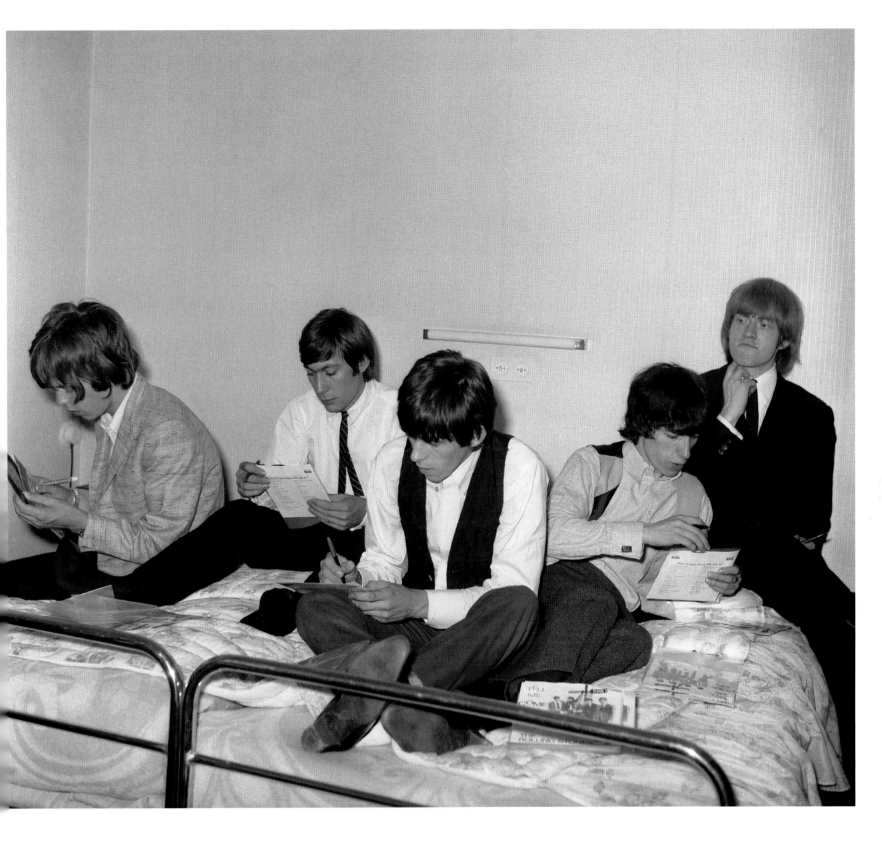

Kurhaus | Scheveningen, The Hague, Netherlands | 8 August 1964

*We flew to Holland to play this old opera house and spent the morning having
a look around the city before we were due to play that evening.*

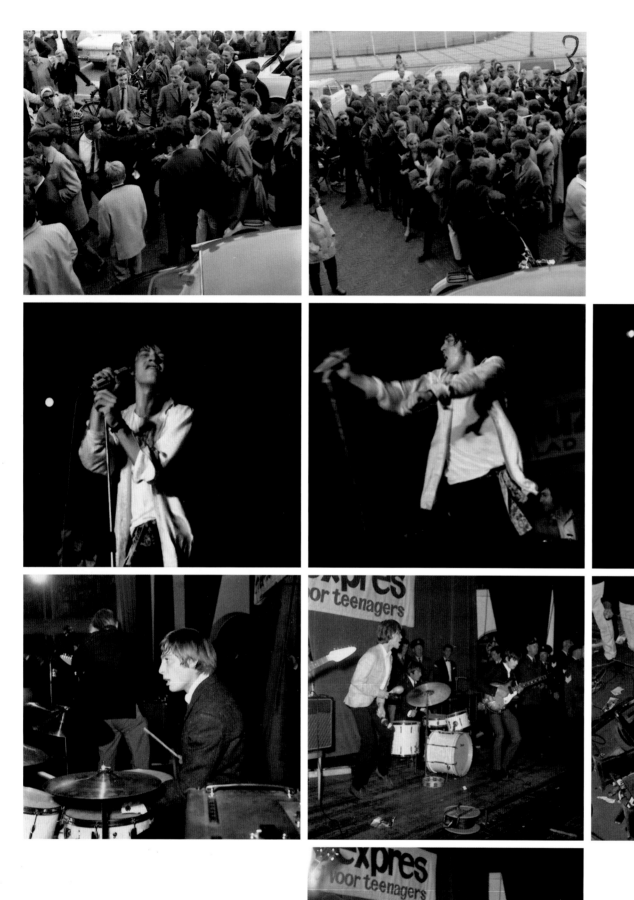

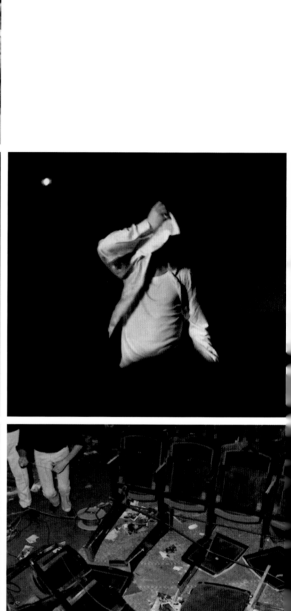

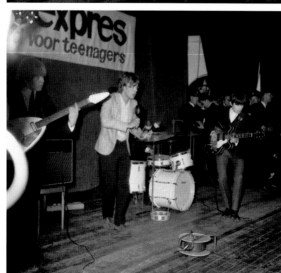

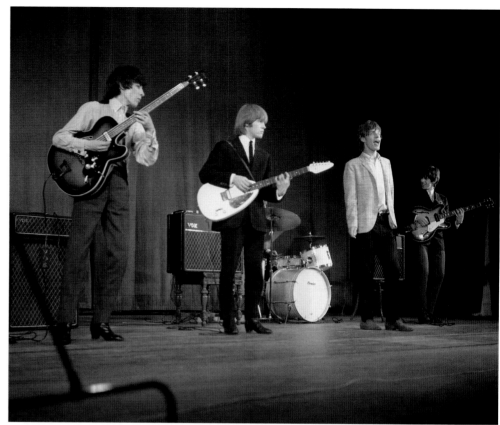

Kurhaus | Scheveningen, The Hague, Netherlands | 8 August 1964

Our first European concert should have been a cause for some celebration but instead it turned into a riot. The crowd, which was mostly guys, went crazy, ripping out cables. Soon there were police all over the stage and a running battle started with the fans. Stu got hit on the head with a bottle and chandeliers were smashed and seats ripped up. Sheer bloody mayhem. KEITH

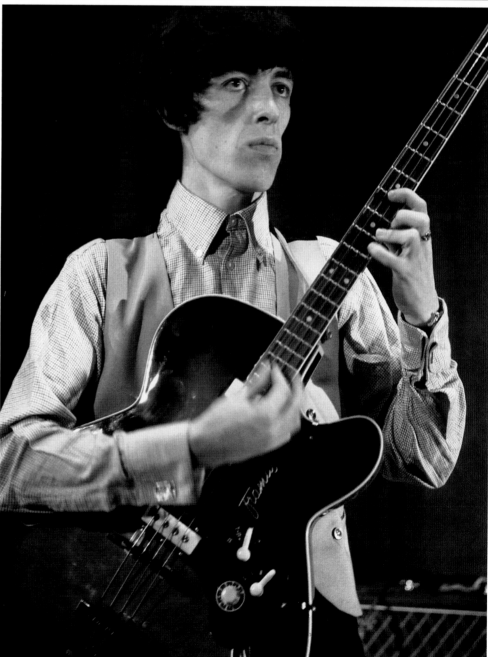

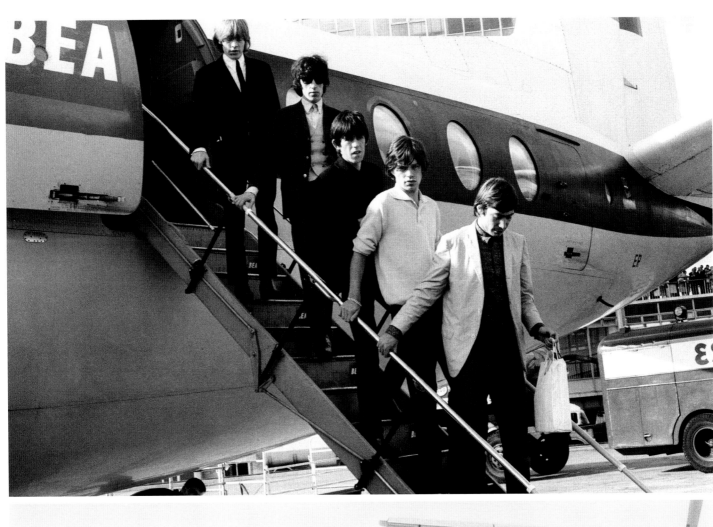

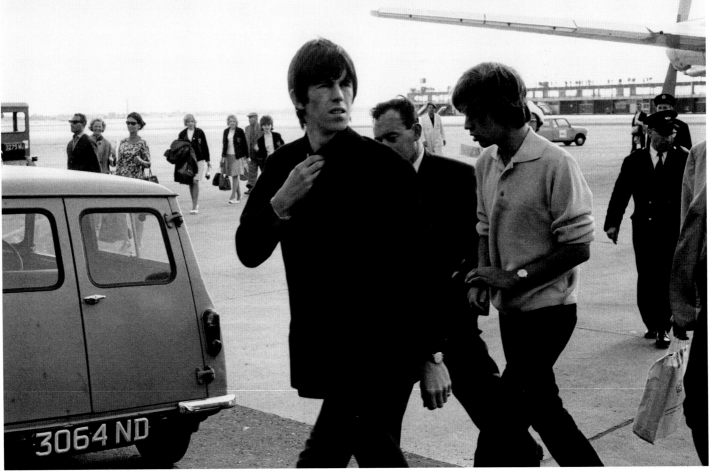

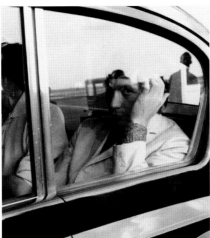
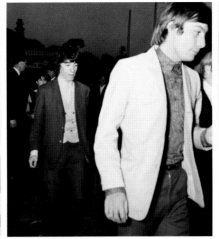

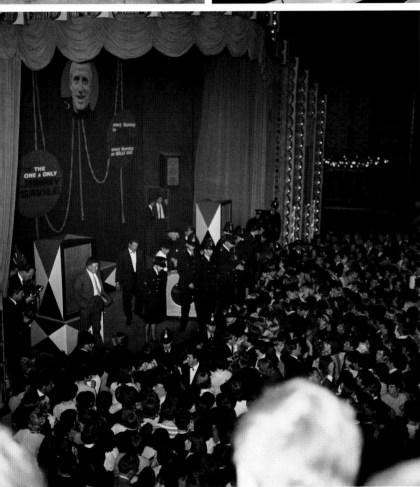
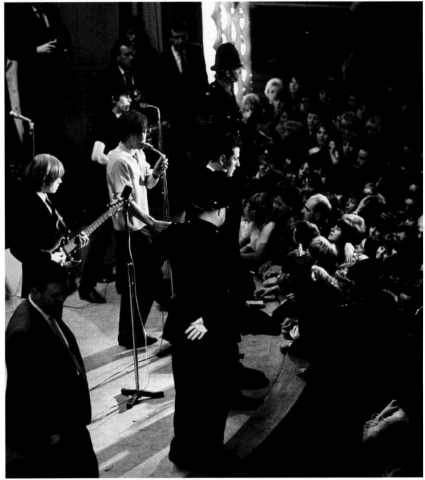

New Elizabethan Ballroom | Belle Vue
Manchester, UK | 9 August 1964

We flew from Holland to London and then to Manchester, while Stu, our friend, pianist and road manager, was left to drive the van. Unfortunately he didn't make it in time for the gig, having got held up in Customs; we had to borrow guitars and drums from the support band. It was another night of craziness after the crowd of over 3,000 got restless waiting for us, waiting for our gear.

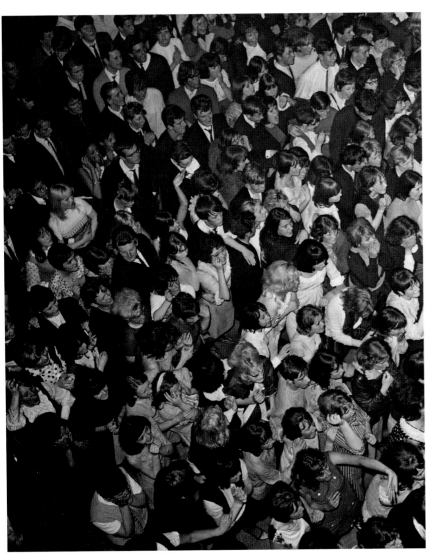
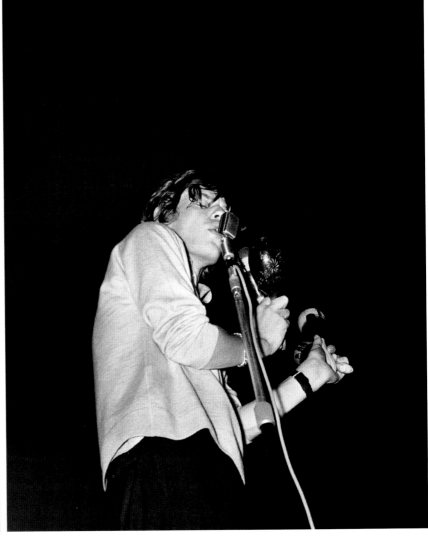

Tower Ballroom | New Brighton, Cheshire, UK | 10 August 1964

According to the Daily Mirror, 'About 200 screaming, yelling, teenage girls fainted as fights broke out at a Rolling Stones show at New Brighton on Monday night. Fifty youths were chucked out from the hall and so was one young Boadicea who brandished a knife at the stewards.'

It was getting to be the same old thing, night after night. There was every chance that someone would get seriously hurt if this kept up. MICK

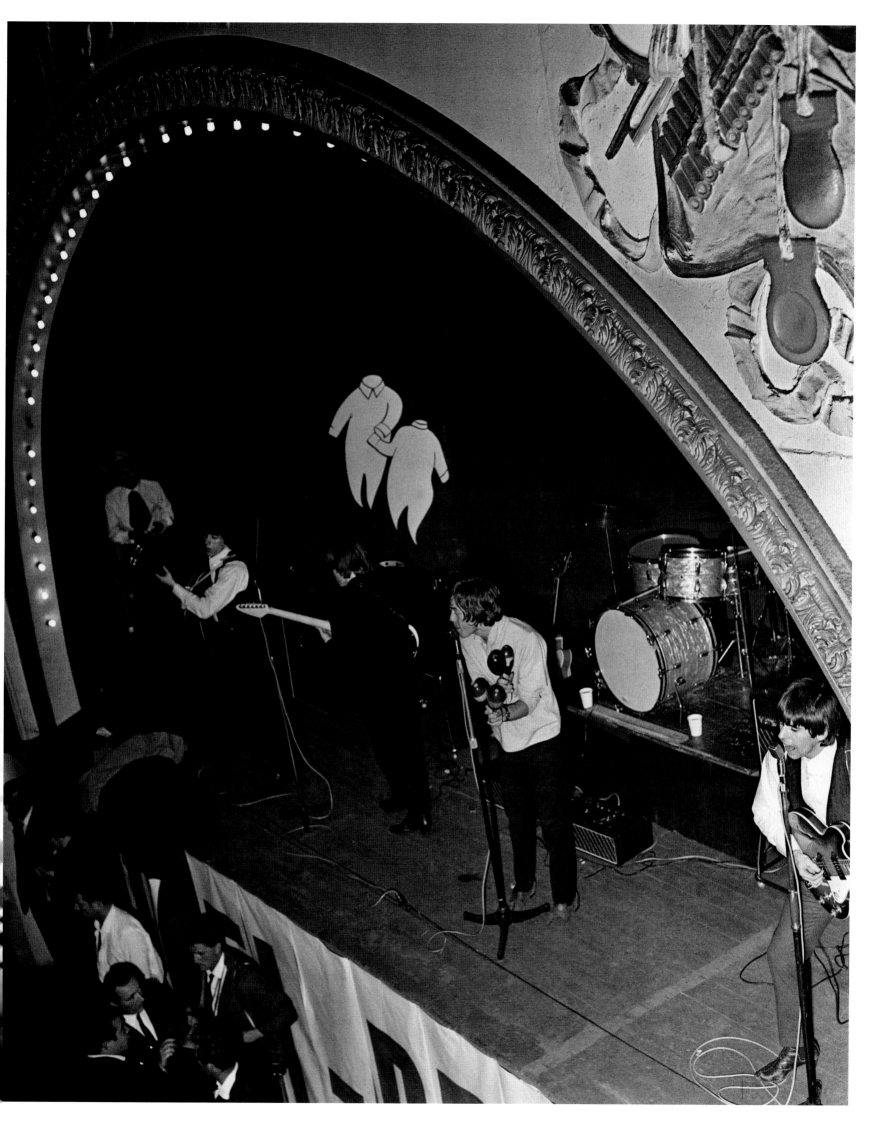

Isle of Man, UK | 13 August 1964

Having tea on the lawn of the hotel was all
very civilized and in marked contrast to the
scenes at our concerts. CHARLIE

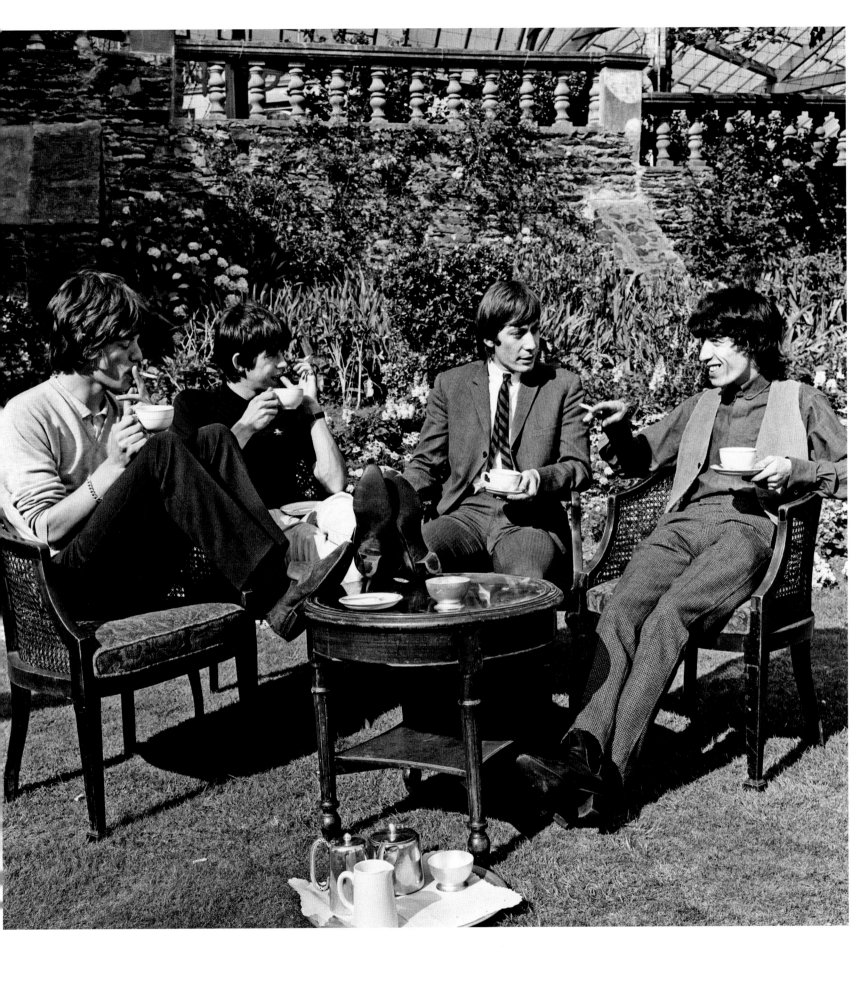

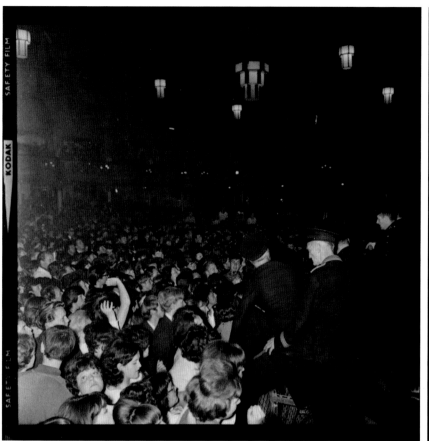

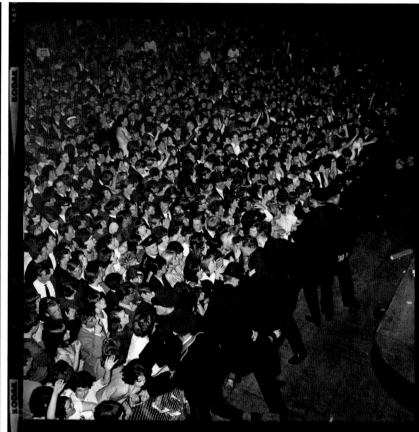

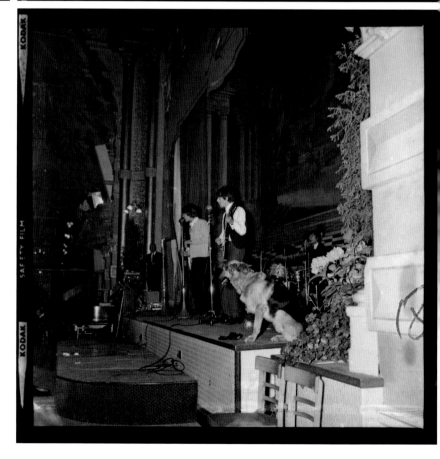

Palace Ballroom | Douglas, Isle of Man, UK
13 August 1964

The evening show was yet another mini-riot. There were 7,000 fans there and the police had trouble containing them. They tried a new tactic and brought a police dog onto the stage to dissuade fans from trying to get at us. It seemed to work, but I'm not sure the dog liked all the noise. MICK

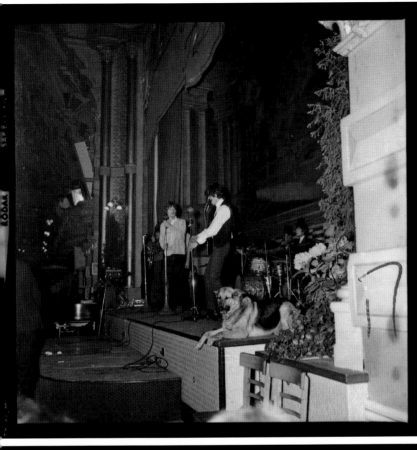

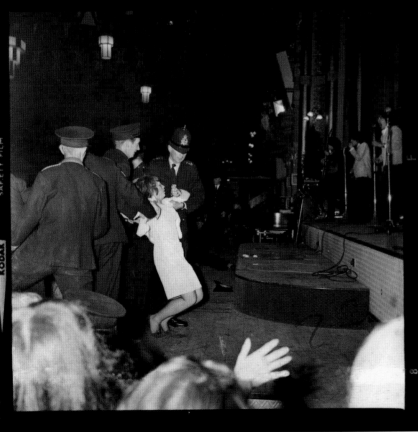

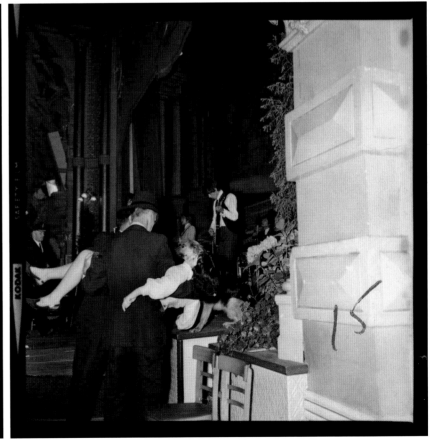

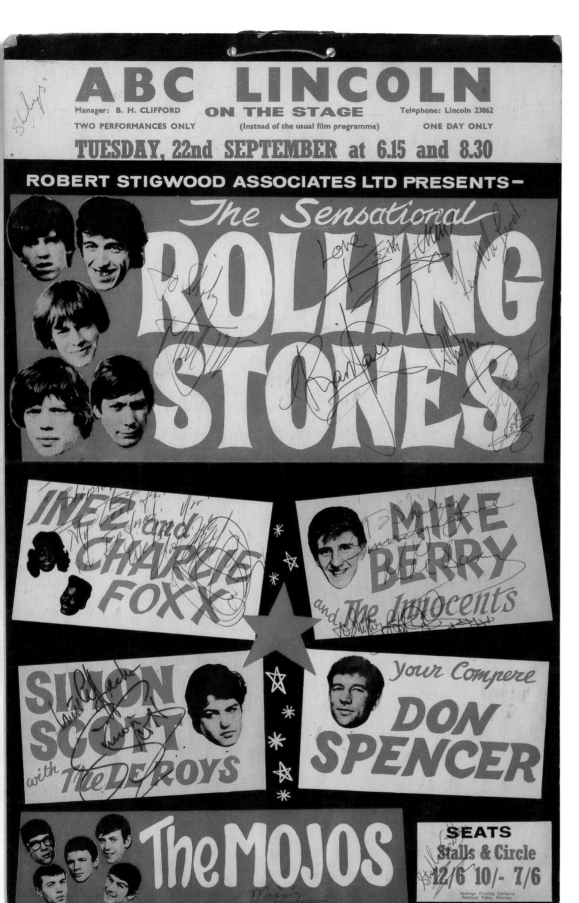

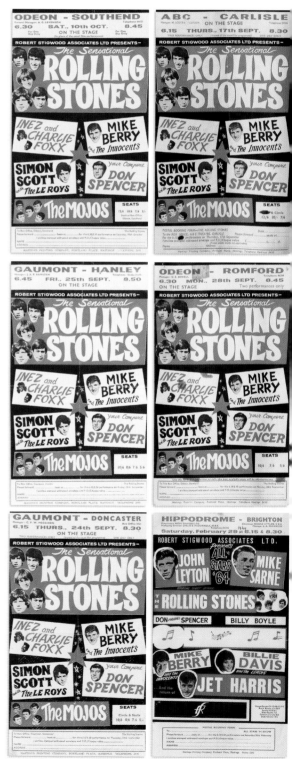

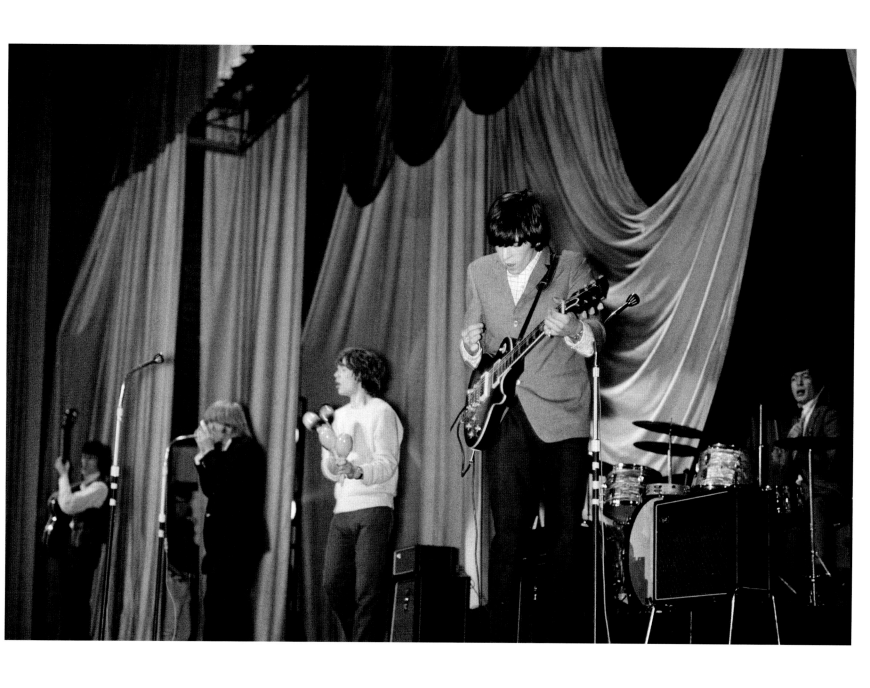

UK package tour | September – October 1964

*Two shows a night at over thirty-two cinemas in thirty-seven days –
spread throughout the length and breadth of Britain – was a gruelling
schedule. Our set was usually eight songs a night that we picked from
around twenty of our songs. Everything from 'Walkin' the Dog' and
'Route 66' to 'Not Fade Away', 'The Last Time' and 'It's All Over Now'.*

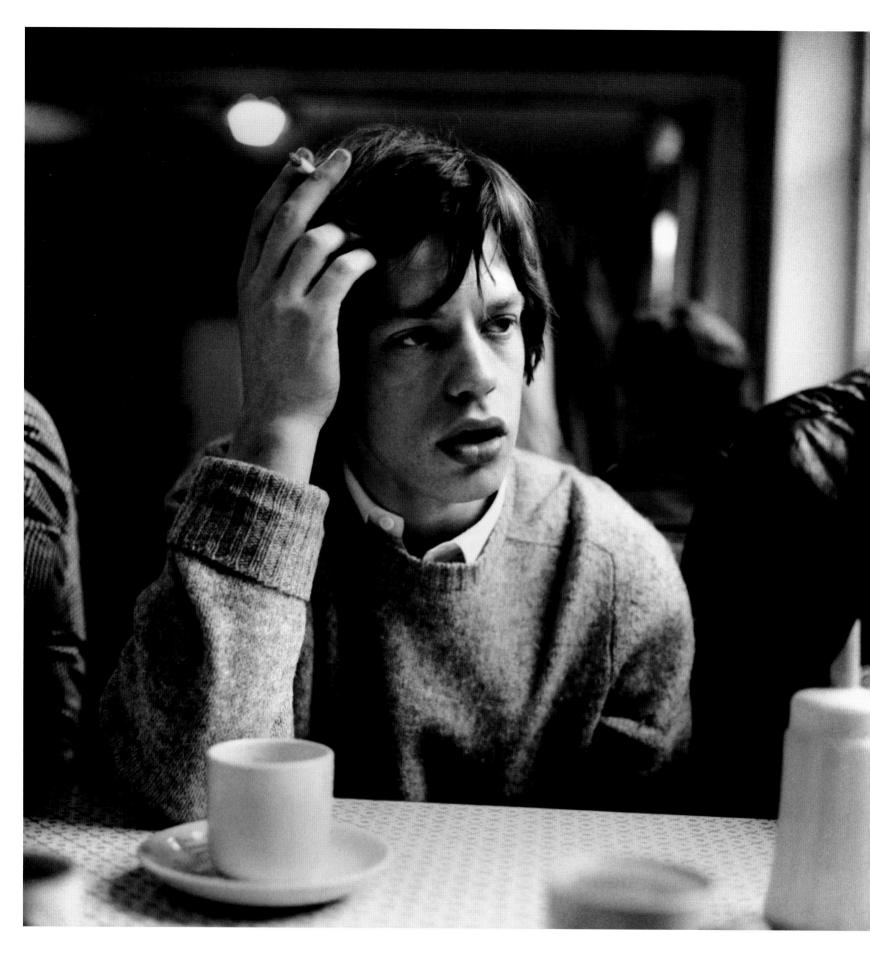

Somewhere in England | September 1964

Pretty much sums up life on the road back then:
a café somewhere, cups of tea and fags. KEITH

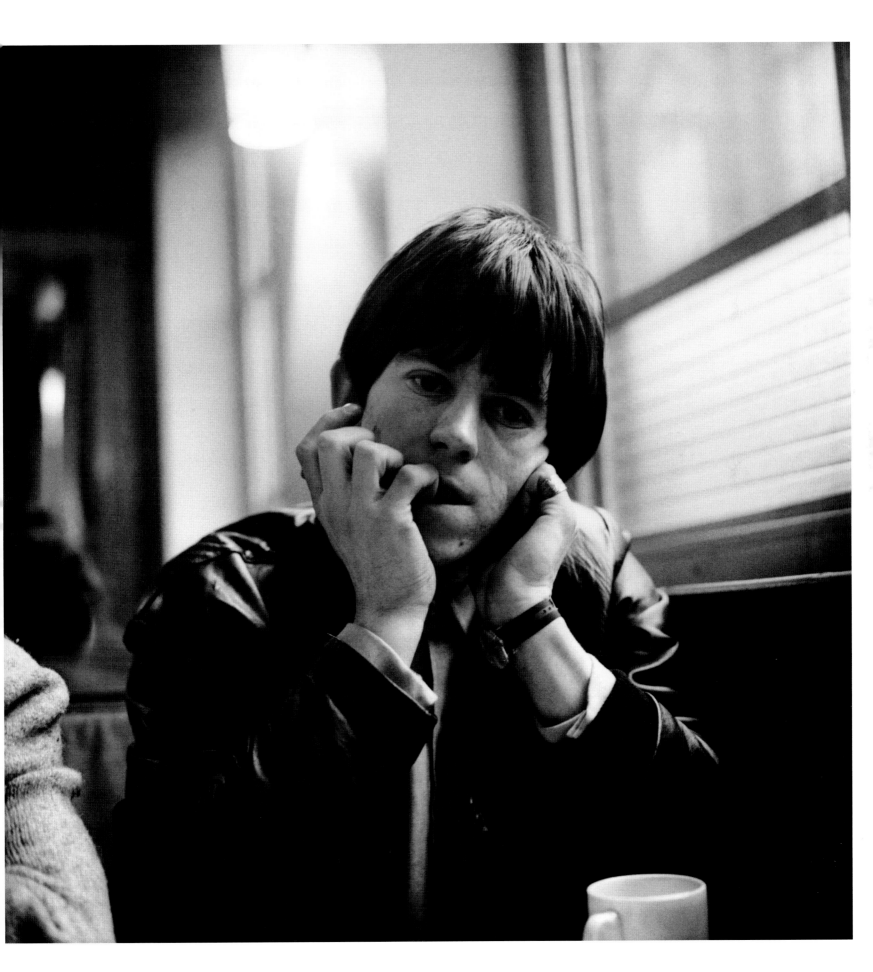

T.A.M.I. Show | Santa Monica Civic Auditorium | California, USA
28 October 1964

We had to follow James Brown, the tightest machine in the world. That did make me a little tight. Thank God the audience was mostly white. However, everybody else was just as nervous. KEITH

There was a huge list of acts. We weren't actually following James Brown because there were hours in between the filming of each section. MICK

The name of the film was changed to Gather No Moss *for release in the UK.*

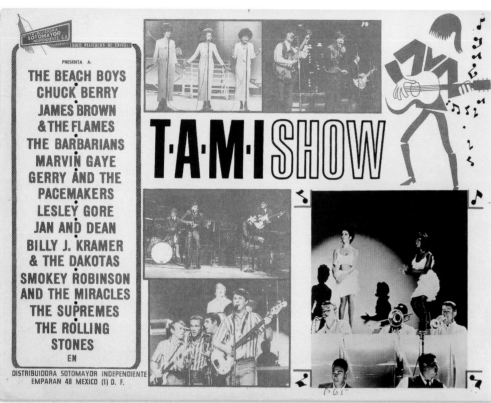

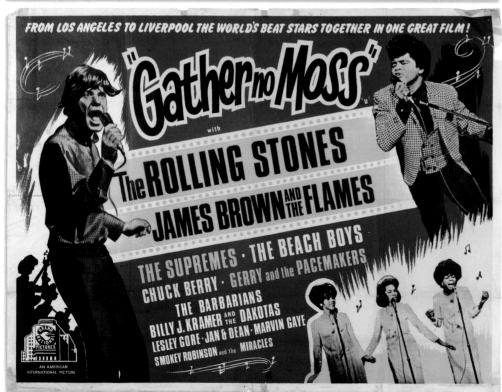

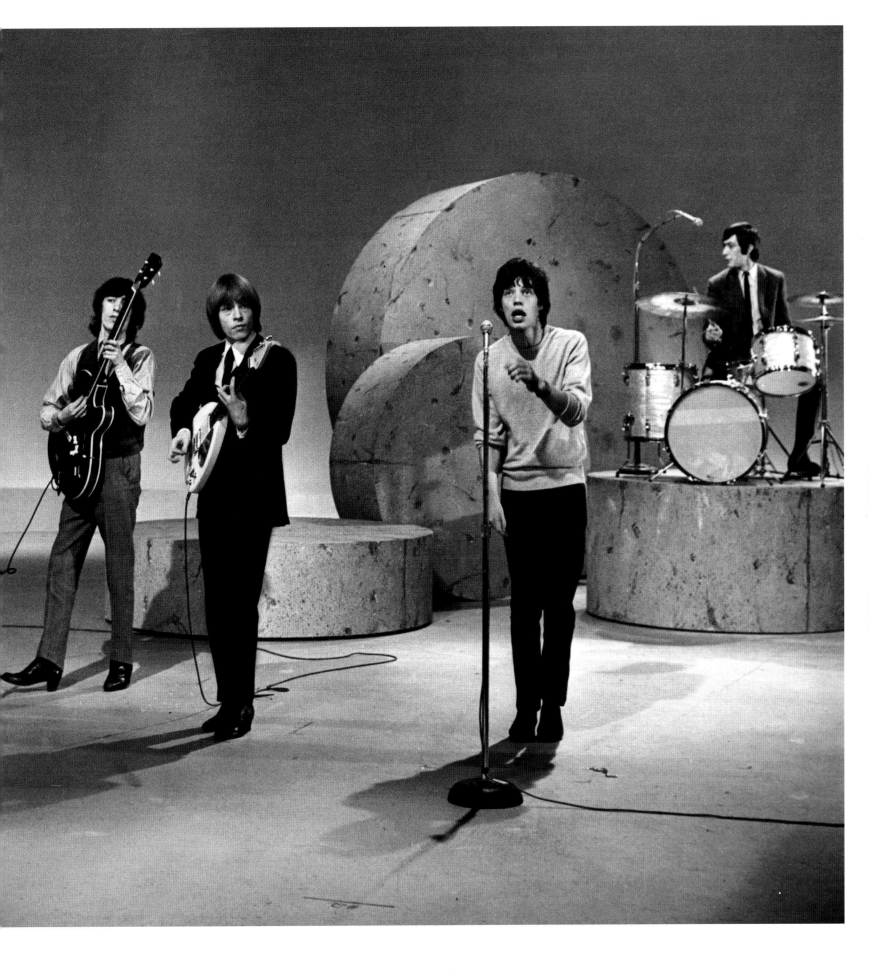

The Ed Sullivan Show | CBS Studio 50 | New York, USA | 25 October 1964

This was our first appearance on The Ed Sullivan Show, a really important step forward for us in America. We played 'Around and Around' in the first half and 'Time is On My Side' in the second.

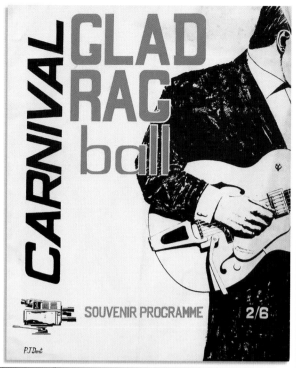

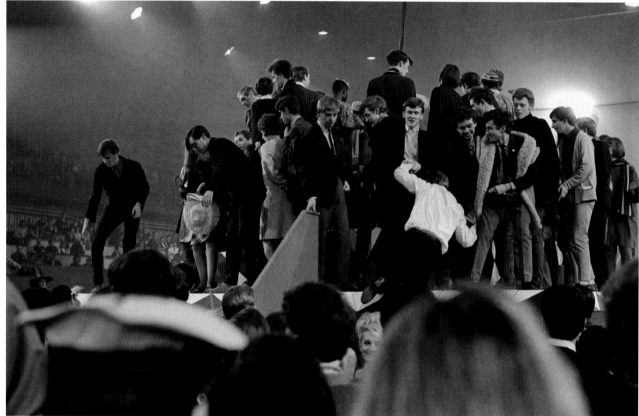

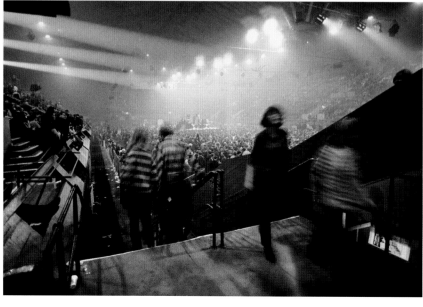

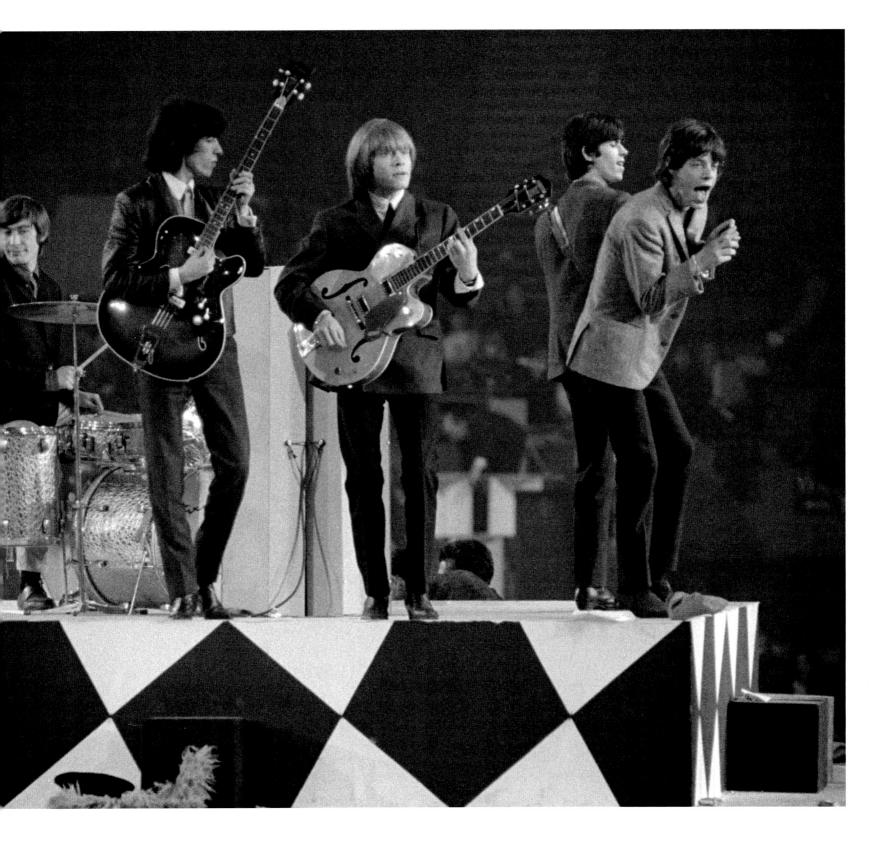

Glad Rag Ball | Empire Pool | Wembley, London, UK | 20 November 1964

I was knackered when we did this show. Having flown back from America three
or four days earlier, I hadn't slept at all. In the afternoon we recorded an appearance
on *Ready, Steady, Go!*, after which I collapsed. But the old trooper in me carried
me through. KEITH

below

Tettenhall Magistrates Court | Wolverhampton, Staffordshire, UK | 26 November 1964

This was not my first brush with the law! I had been fined earlier in the year for some motoring offences. This time, I seem to remember getting fined £16 but, luckily, they didn't endorse my licence – that would have meant I was banned from driving. MICK

opposite

London | 1964

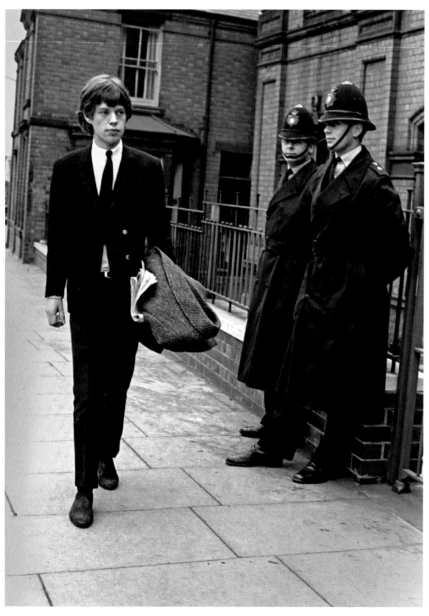

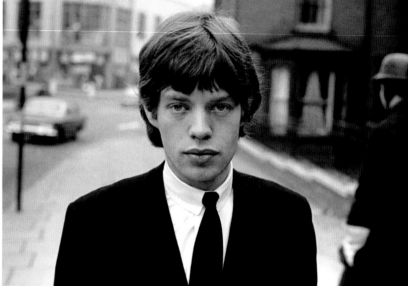

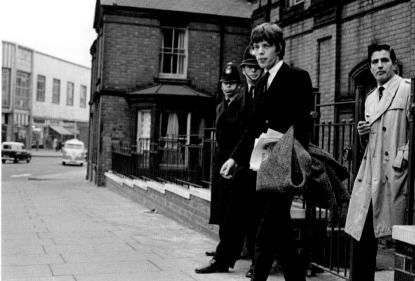

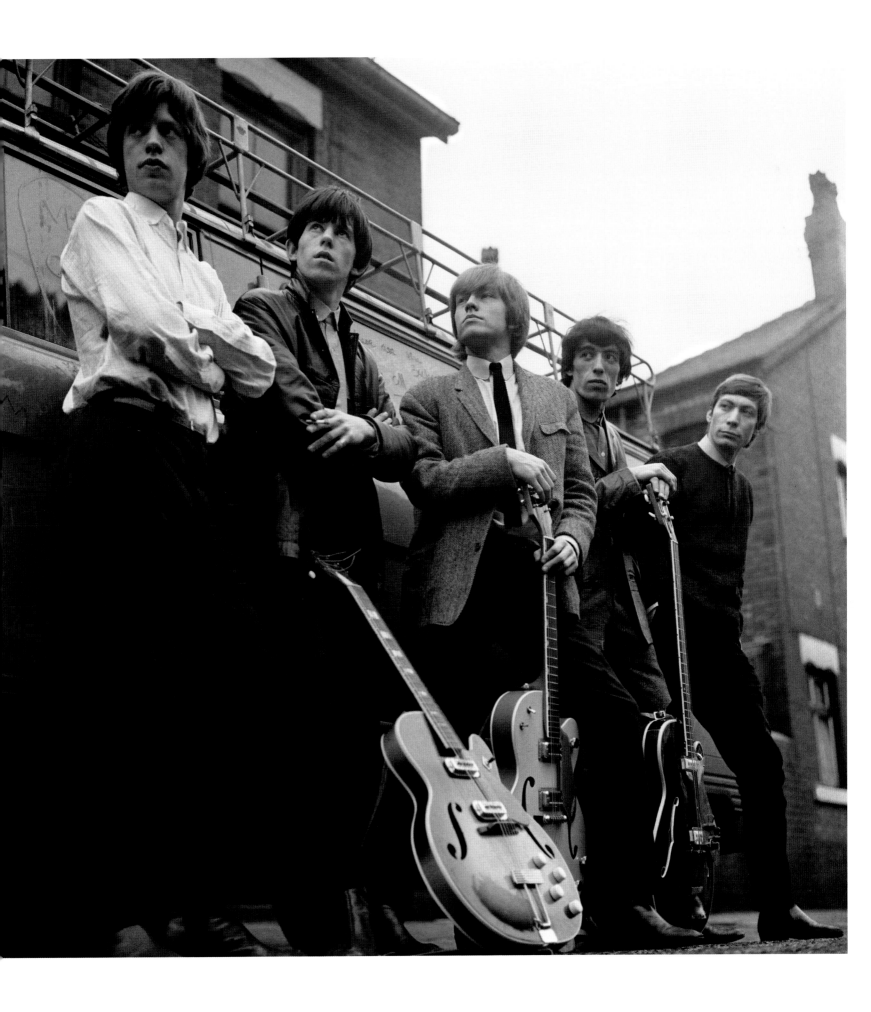

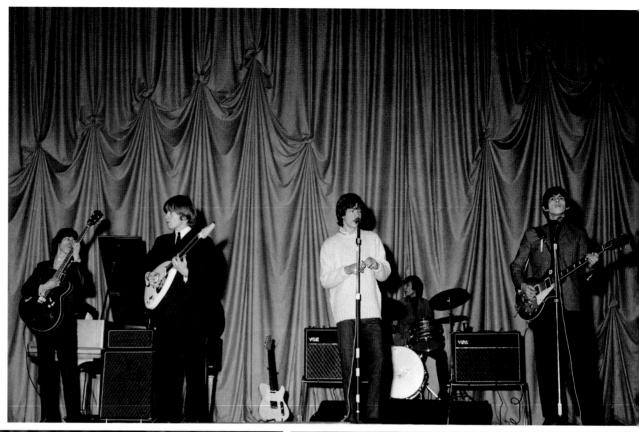

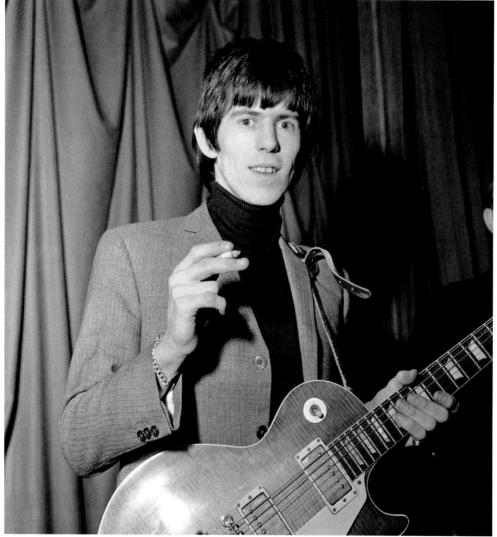

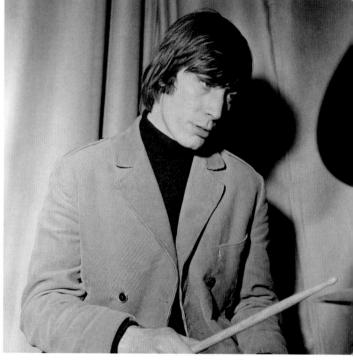

The ABC Theatre | Belfast, Northern Ireland, UK | 6 January 1965

This was on our second visit to Ireland. After Belfast, we played in Dublin and Cork. We would have been playing 'Little Red Rooster' at these gigs as it had topped the UK chart at the end of November 1964.

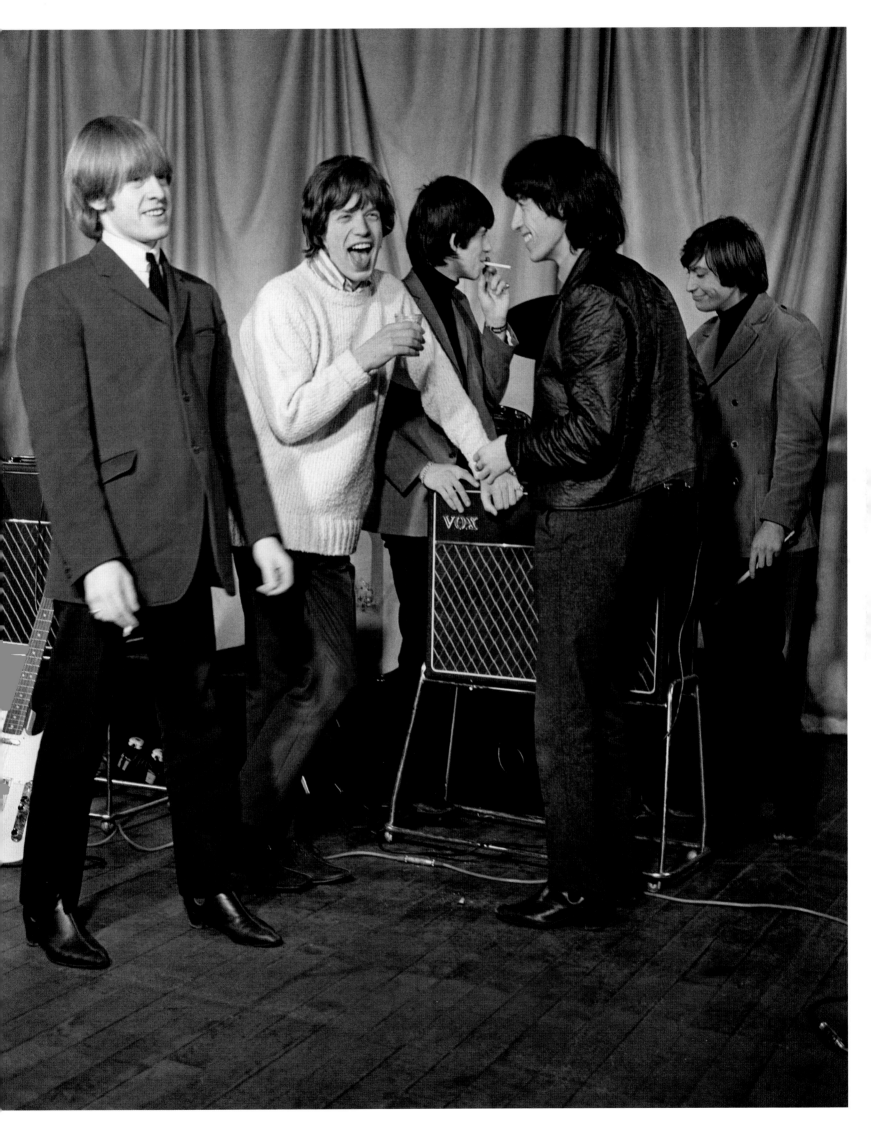

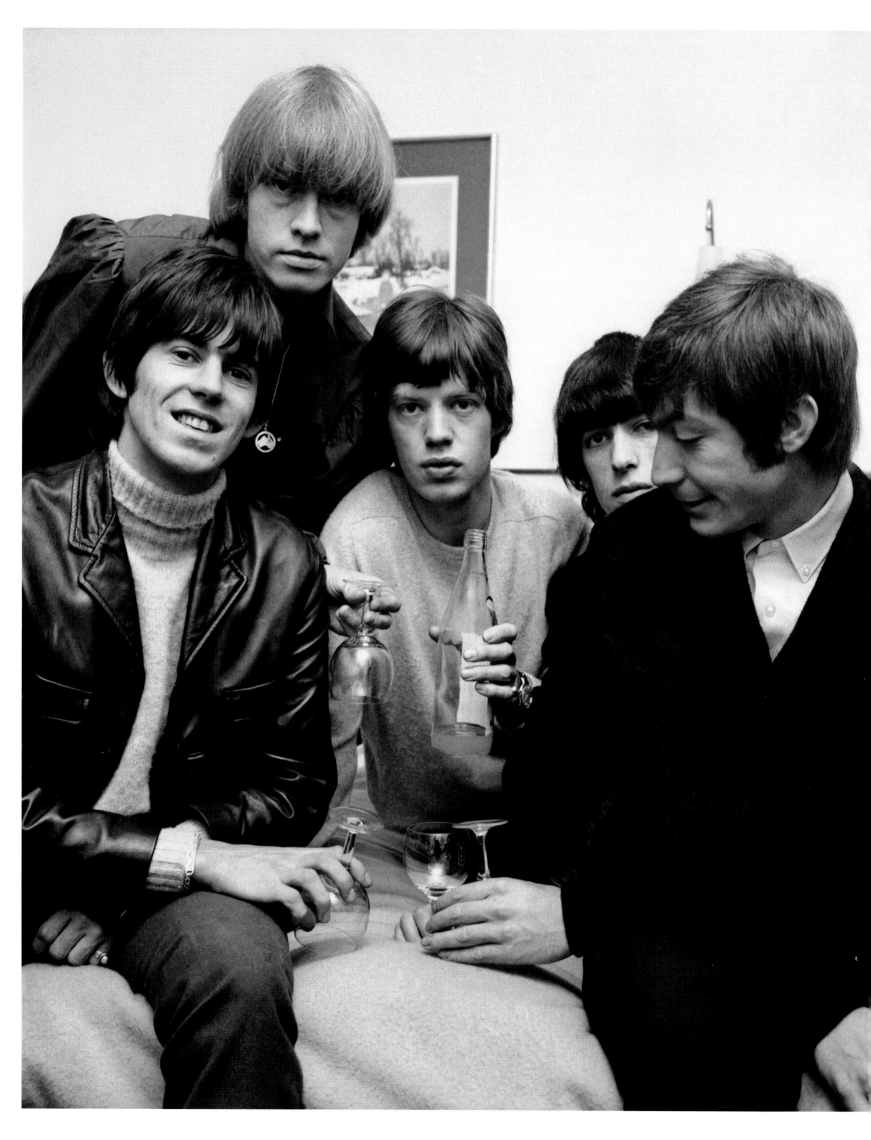

Scene at 6.30 | **Granada Studios** | **Manchester, UK** | **11 March 1965**

Besides Top of the Pops *and* Ready, Steady, Go!, *there were several other British TV programmes that we appeared on regularly, including this one filmed in Manchester. We were celebrating as we had just heard that 'The Last Time' was going to No.1 on the UK singles chart.*

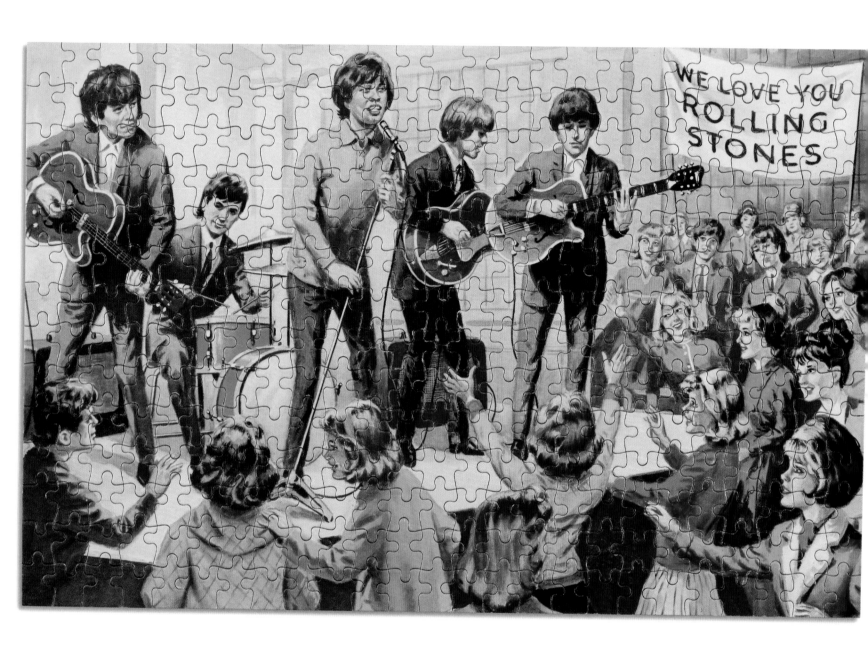

We knew that we were entering a different phase in our career
when merchandise started appearing. Much of it was sold
from adverts in the music papers and magazines like *Rave* and
Valentine. I've never seen these jigsaw puzzles before. CHARLIE

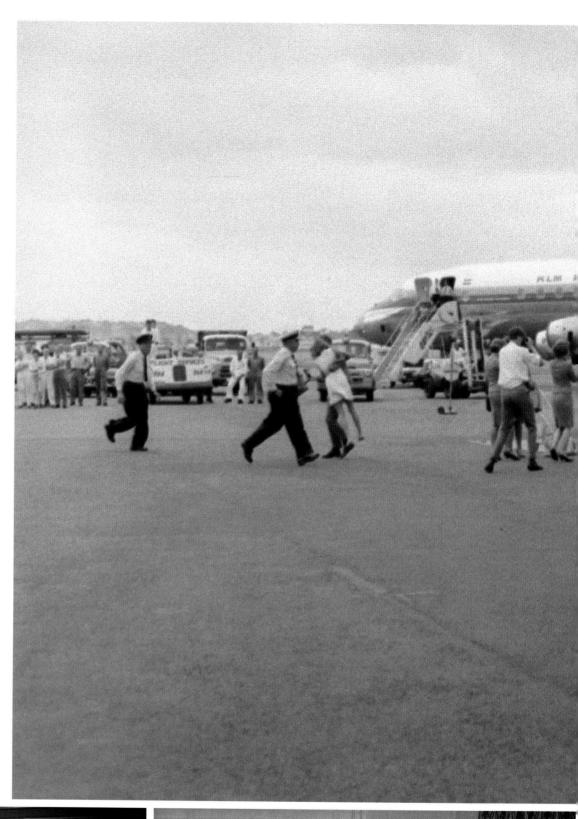

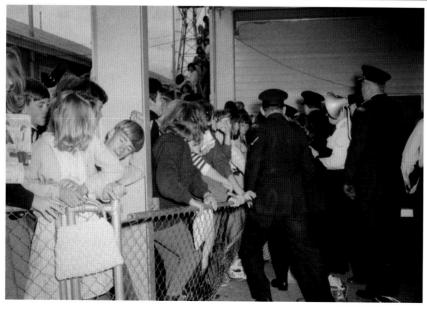

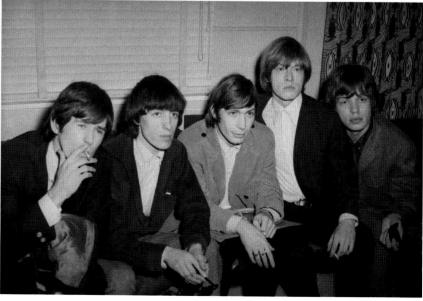

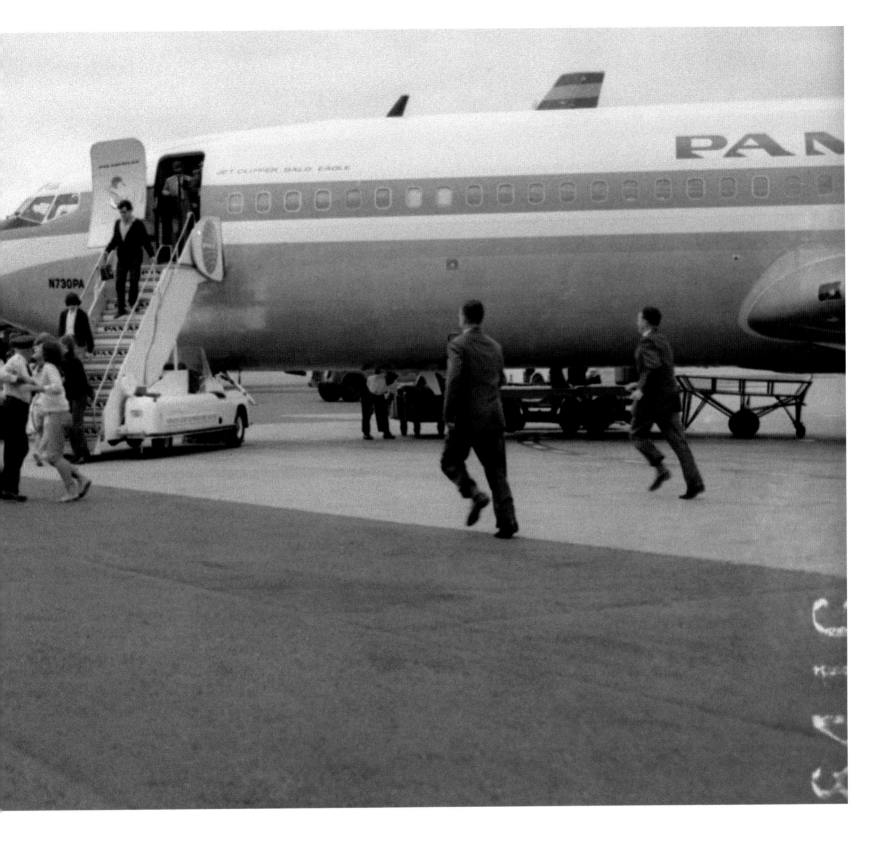

Sydney Airport | Mascot, Sydney, Australia | 21 January 1965

Our first visit to Australia and New Zealand was an amazing success. Our singles had been doing great on the charts in Australia and we played to over 100,000 fans in ten cities across the two countries.

I remember staying somewhere in New Zealand where there were just two bathrooms in the hotel that we had to share with the other guests. Everything seemed to close by 7pm. MICK

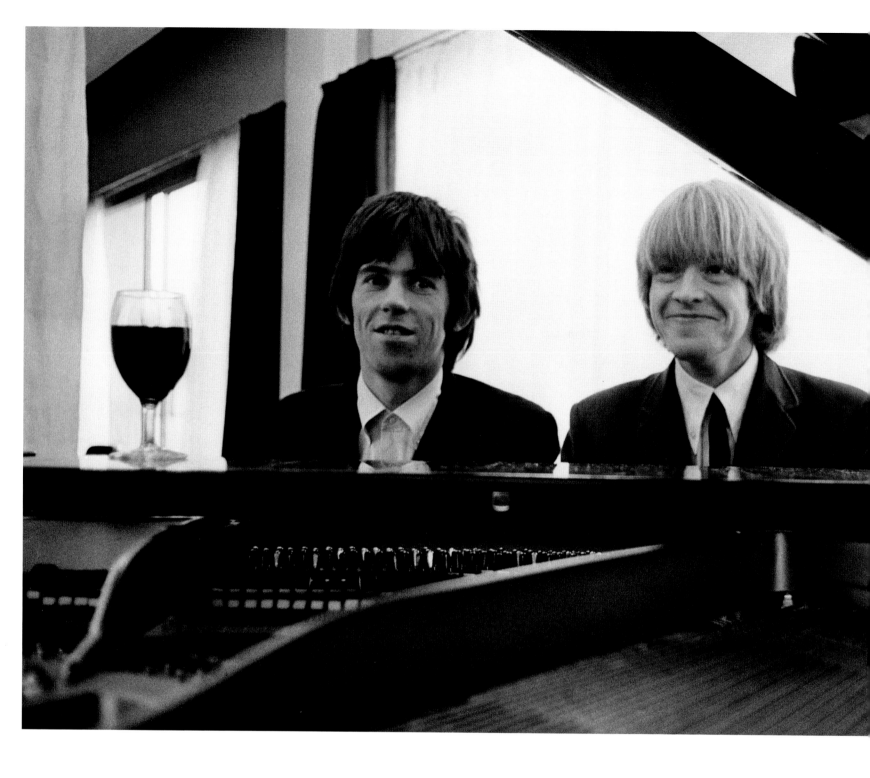

The Royal Hotel | Copenhagen, Denmark | 25 March 1965

This was our first visit to Scandinavia and we did a short tour of six dates in Denmark and Sweden. We stayed at the Royal Hotel which was the perfect place to stay. In June we went back to both Sweden and Denmark for more shows as well as visiting Norway and Finland.

Bill and I went to the Tivoli Gardens and saw Erroll Garner, The Oscar Peterson Trio and Ella Fitzgerald in the evening. It was great to see these jazz legends in concert. CHARLIE

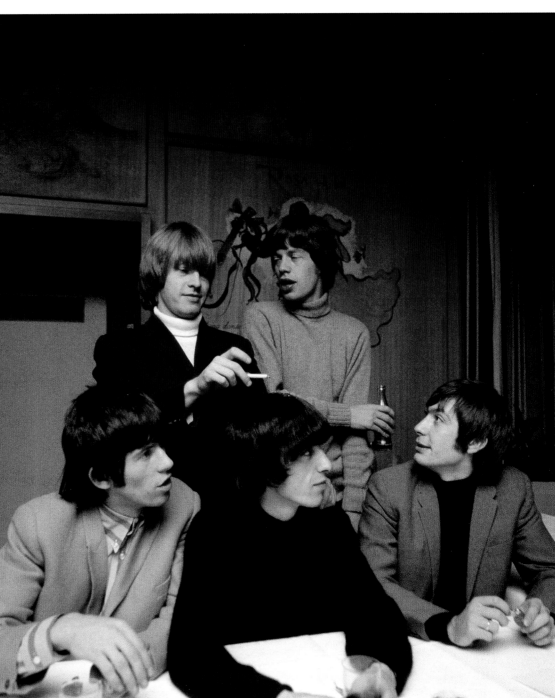

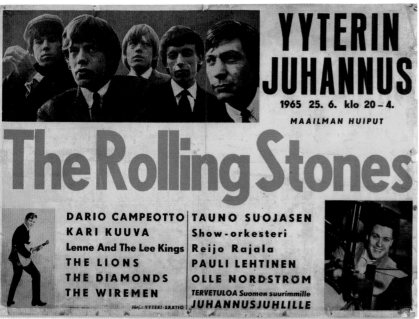

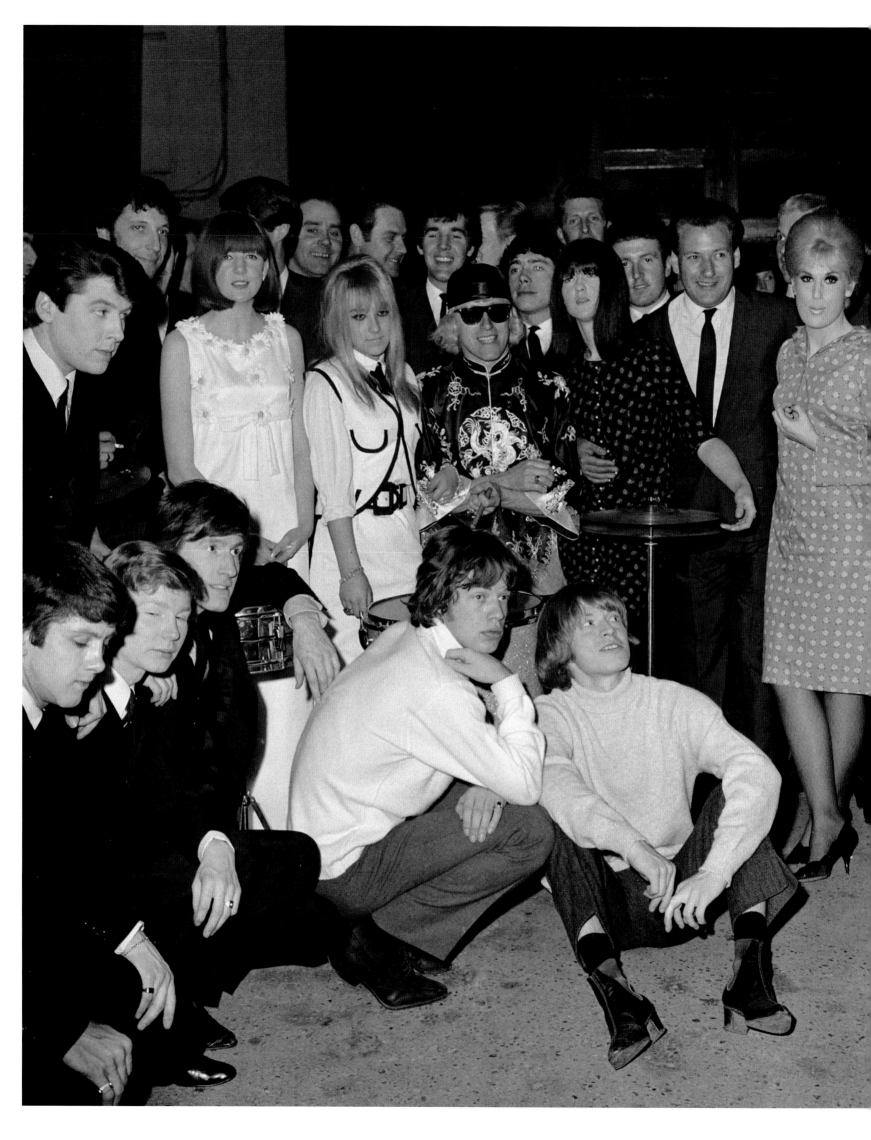

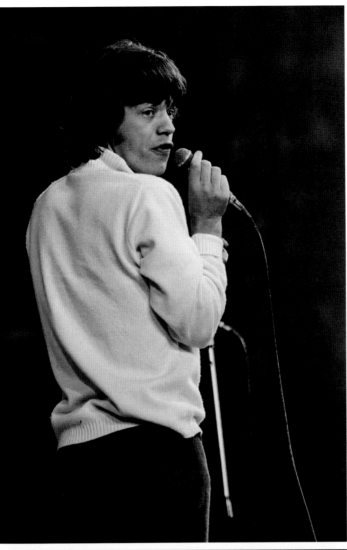

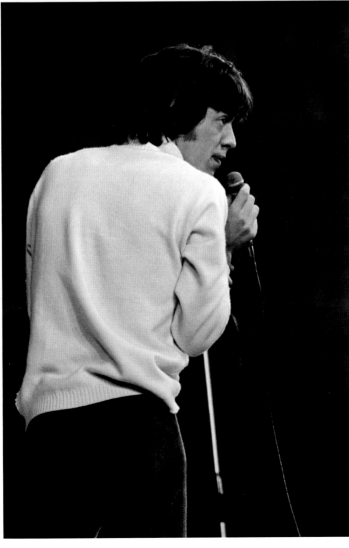

New Musical Express Poll Winners
Concert | Empire Pool | Wembley,
London, UK | 11 April 1965

*Brian and Mick got volunteered to attend
the photocall along with all the artists
that appeared on the show. We topped
the bill and were introduced by DJ Jimmy
Savile – who, for some reason, was dressed
as a Chinaman. We did 'Everybody Needs
Somebody to Love' and 'Pain in My Heart'
as a medley, followed by 'Around and
Around' and 'The Last Time'.*

For me, the best performer in this
photo is Dusty Springfield. She was
great. CHARLIE

overleaf

**Olympia Theatre | Paris, France
April 1965**

*On our second trip to Paris to play at
L'Olympia, we were photographed by
the renowned French photographer
Jean-Marie Périer. He was going
out with the French singer Françoise
Hardy, who came to the shows.*

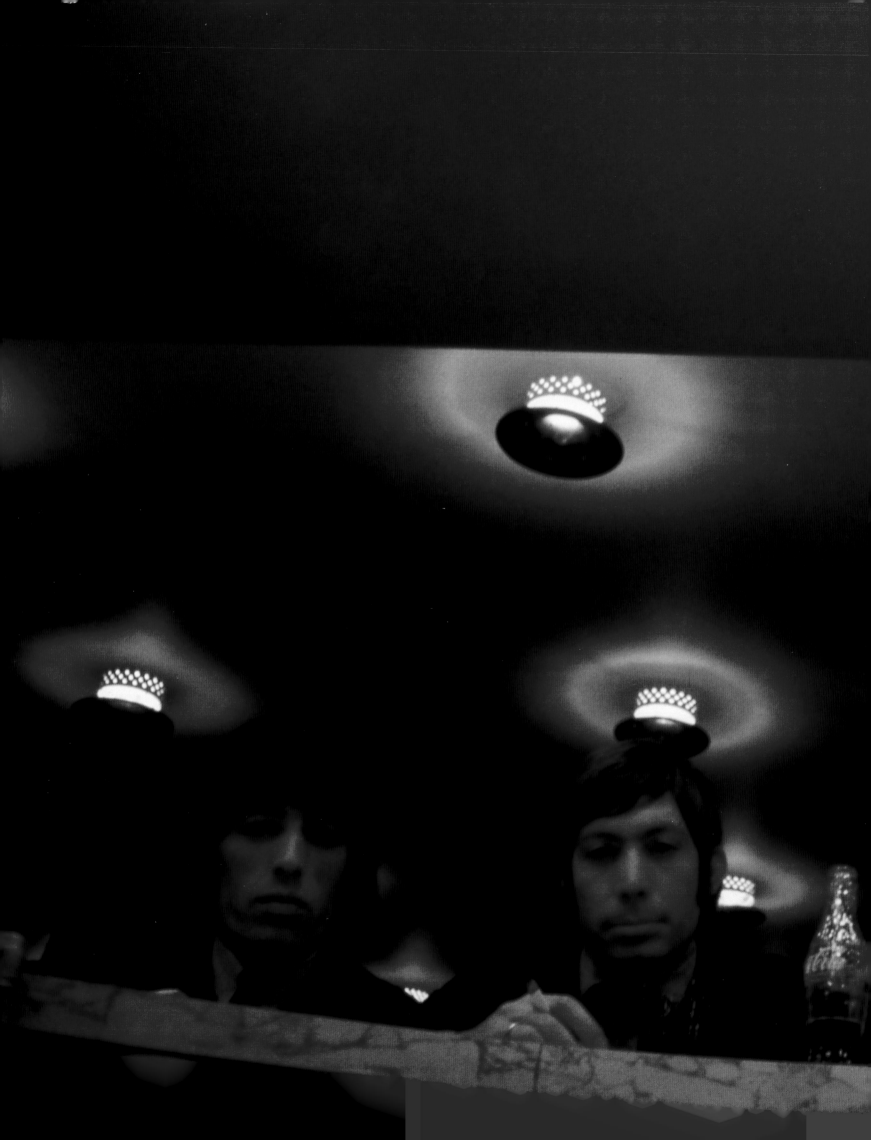

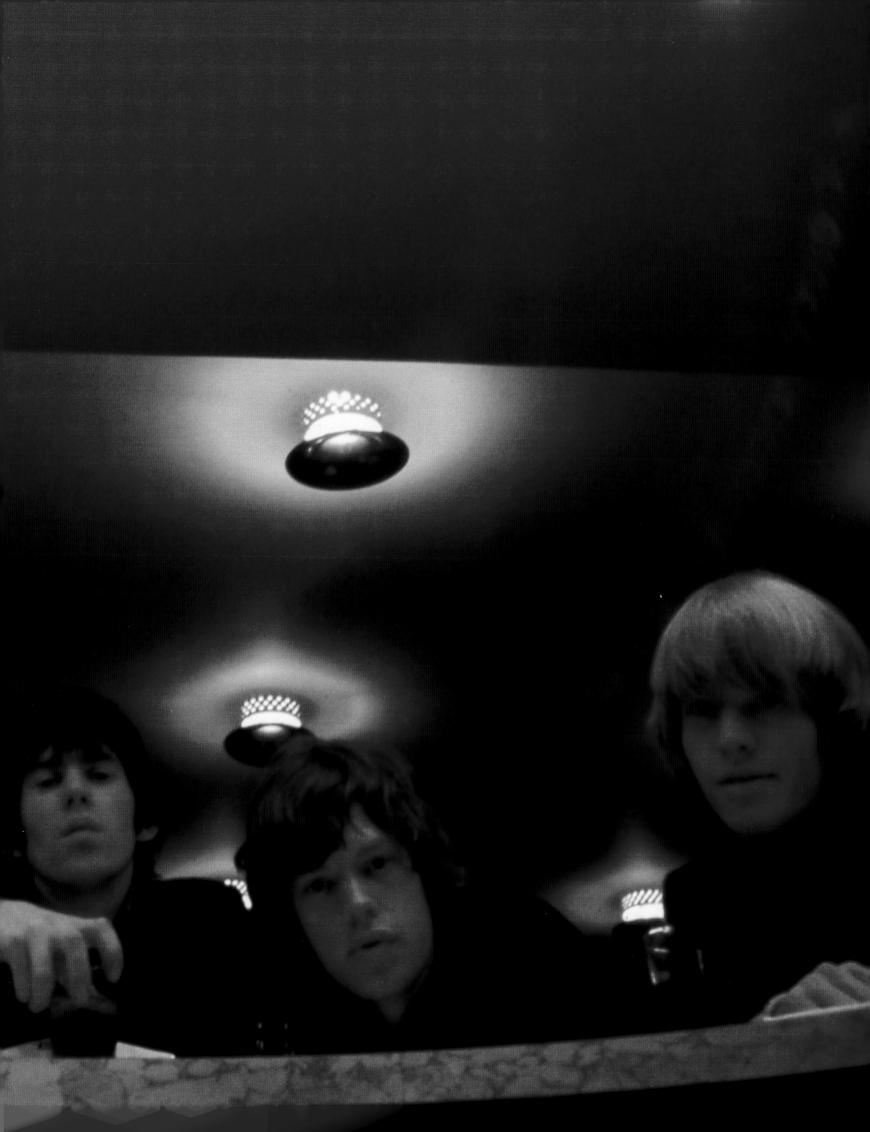

 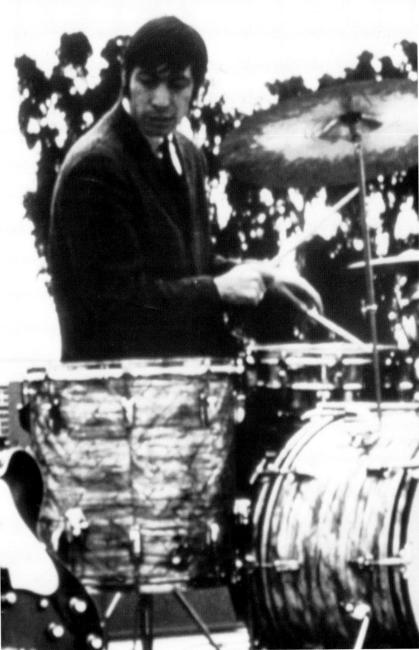

Ratcliffe Stadium | Fresno, California, USA | 22 May 1965

This set of slides was shot at Fresno, a matinee show on our third North American tour. It was the longest trip away from home that we had done up until that point and was hectic.

Issued in 1965, the pictures for these bubblegum cards were probably all taken in Montreux, Switzerland, in April 1964.

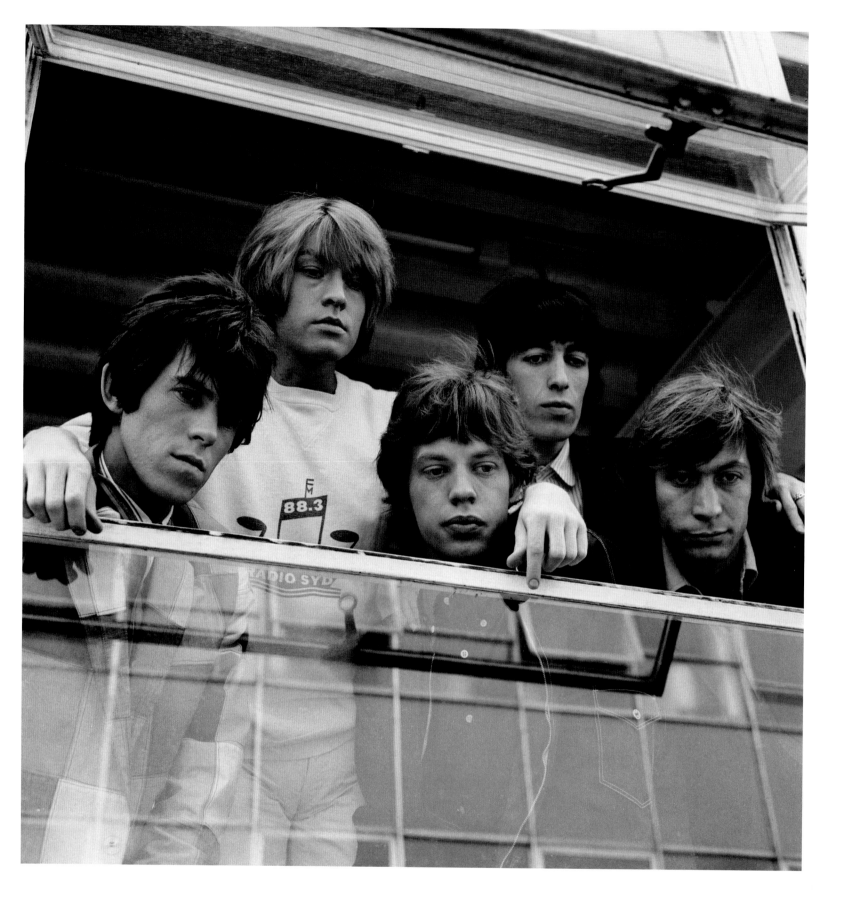

Scene at 6.30 | Granada Studios | Manchester, UK | 23 August 1965

Another trip to Manchester to appear on television. Before we arrived, the fans waiting at the gates had somehow got the idea we were being smuggled into Granada's studio in a furniture van. They forced their way through the gate and tried to get into the studio buildings. A fireman turned his hose on them.

overleaf

Original printer's proofs of posters for three of our shows in 1965. The first, with the Hollies as our special guests, was a fourteen-dates-in-fourteen-days package tour, on which we played two shows every night. The poster from Great Yarmouth was a mini-tour and the Belfast show was one of a couple of Irish dates, during which Peter Whitehead filmed the Charlie is My Darling *documentary.*

I'm told that it was in Ireland that we first performed 'Satisfaction' in concert. I can't remember, but I do remember Don Wardell as a very funny guy. CHARLIE

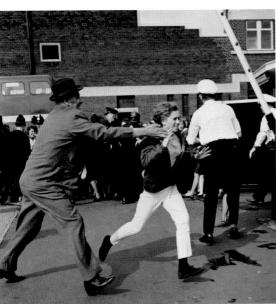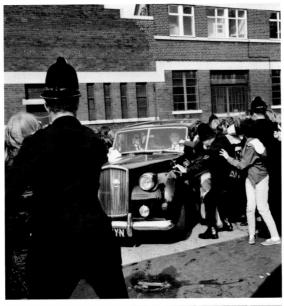
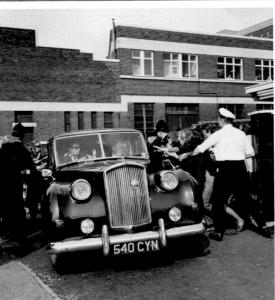

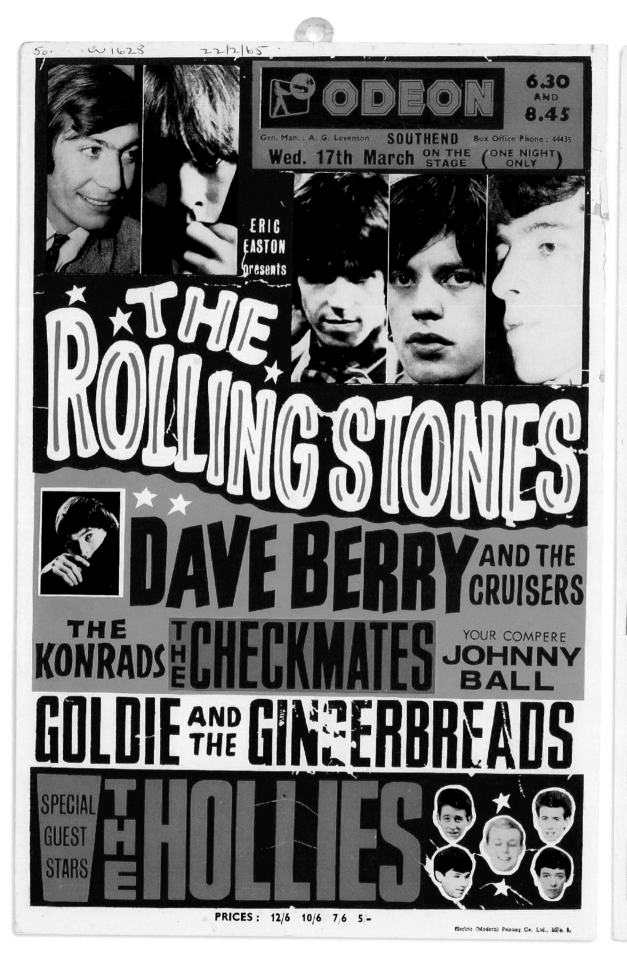

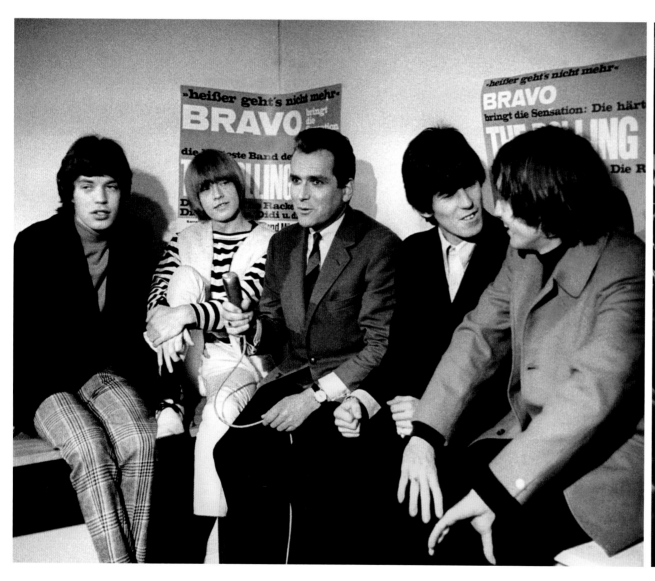

West German tour | 11–15 September 1965

Our first concerts in Germany were promoted by Bravo, the music magazine. The two shows on 11 September were in Münster; the shows on the 15th were in West Berlin. We played Essen on 12 September, two shows at Hamburg's Ernst Merck Halle (below, left) on 13 September and two shows at Circus-Krone-Bau in Munich (below) on 14 September. After West Berlin, we went to Vienna, where we played on 17 September.

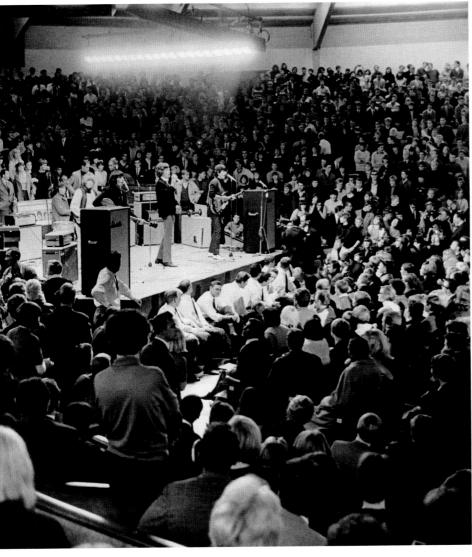

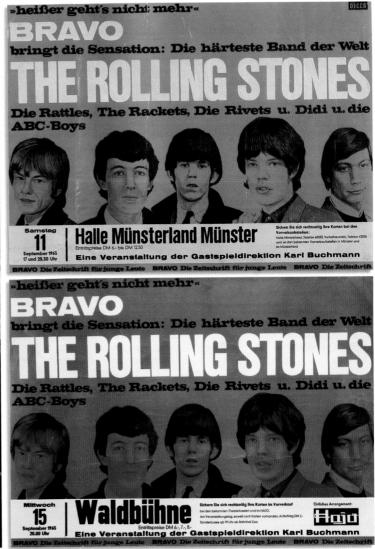

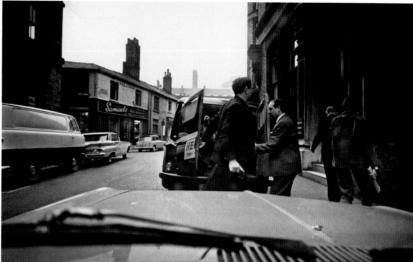

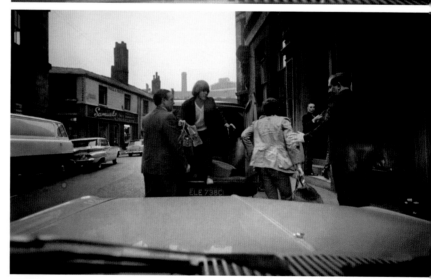

Odeon Cinema | Manchester, UK
3 October 1965

Getting in and out of the venues was increasingly difficult. Everything had to be planned and nothing left to chance. Using an anonymous-looking van was good, but it made even the shortest of journeys from hotels to cinemas pretty cramped. At the time I was quoted as saying, 'Who thought of this – Montgomery?' That was about right. It was like a military operation. MICK

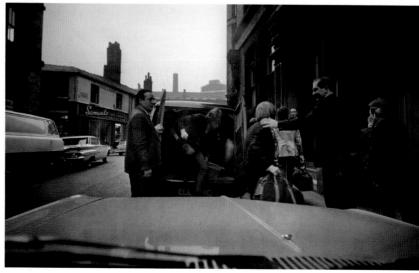

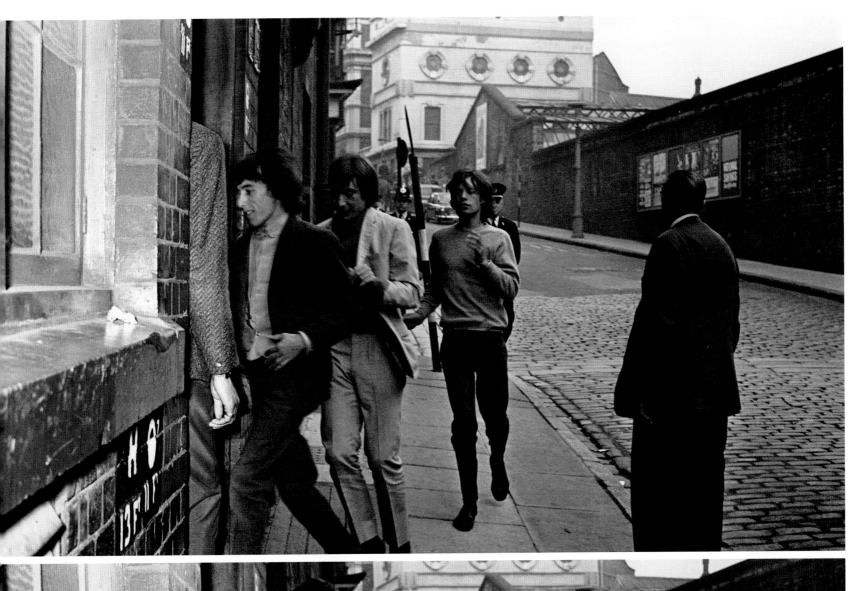

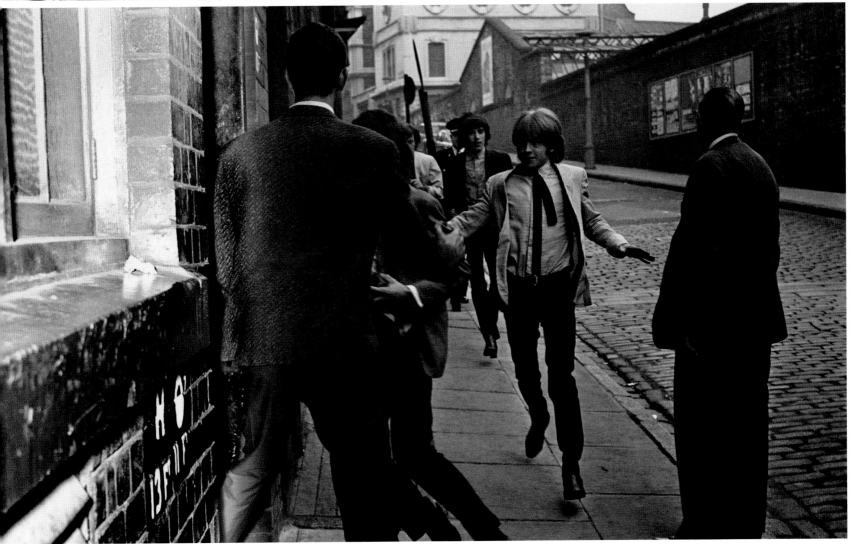

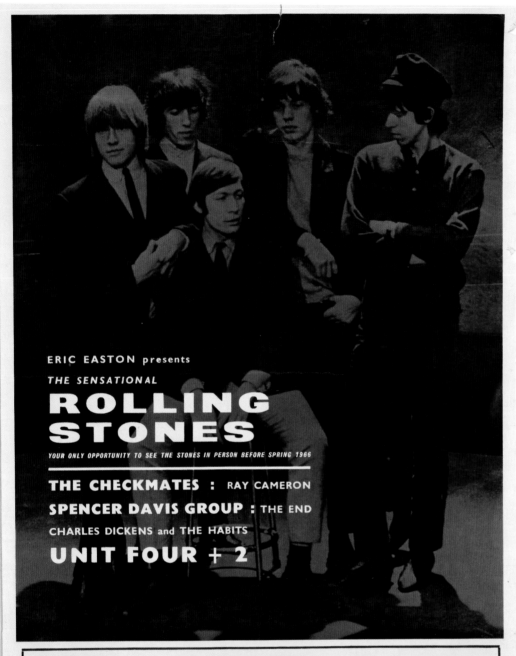

ERIC EASTON presents

THE SENSATIONAL

ROLLING STONES

YOUR ONLY OPPORTUNITY TO SEE THE STONES IN PERSON BEFORE SPRING 1966

THE CHECKMATES : RAY CAMERON

SPENCER DAVIS GROUP : THE END

CHARLES DICKENS and THE HABITS

UNIT FOUR + 2

AN ABC THEATRE

ABC - NORTHAMPTON

Manager: L. G. WEBSTER

ON THE STAGE

Telephone 35839

ONE NIGHT ONLY INSTEAD OF THE USUAL FILM PROGRAMME

Saturday, 16th October at 6.30 and 8.45 p.m.

Stalls & Circle 12/6 10/- 7/6 ALL SEATS MAY BE BOOKED IN ADVANCE

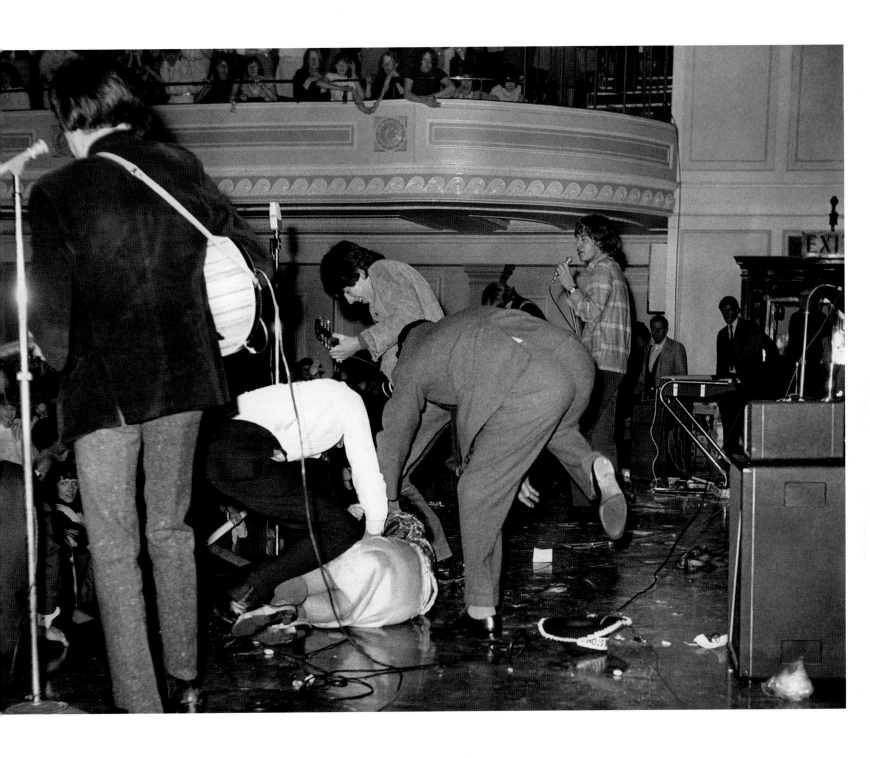

City Hall | Newcastle upon Tyne, UK | 7 October 1965

*Twenty-four cities in twenty-four days was about as intense as touring can get.
We usually stayed well away from the venues to avoid over-eager fans – but, once
we were on playing, there was very little stopping them from charging the stage
in desperate attempts to get to us.*

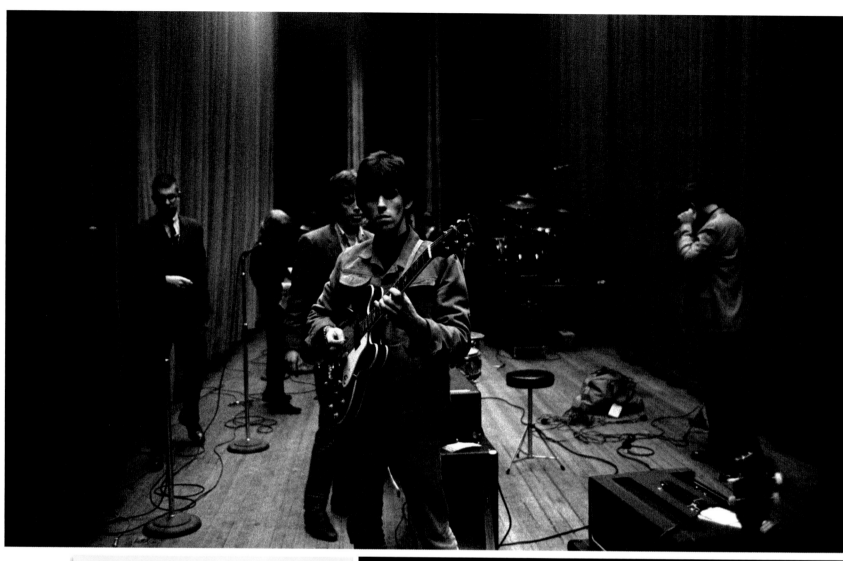

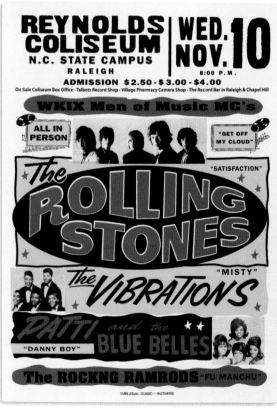

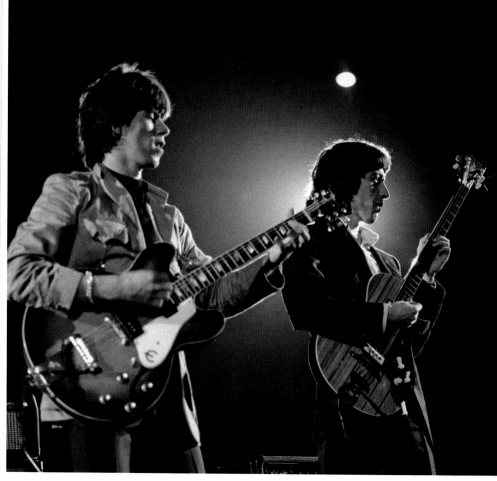

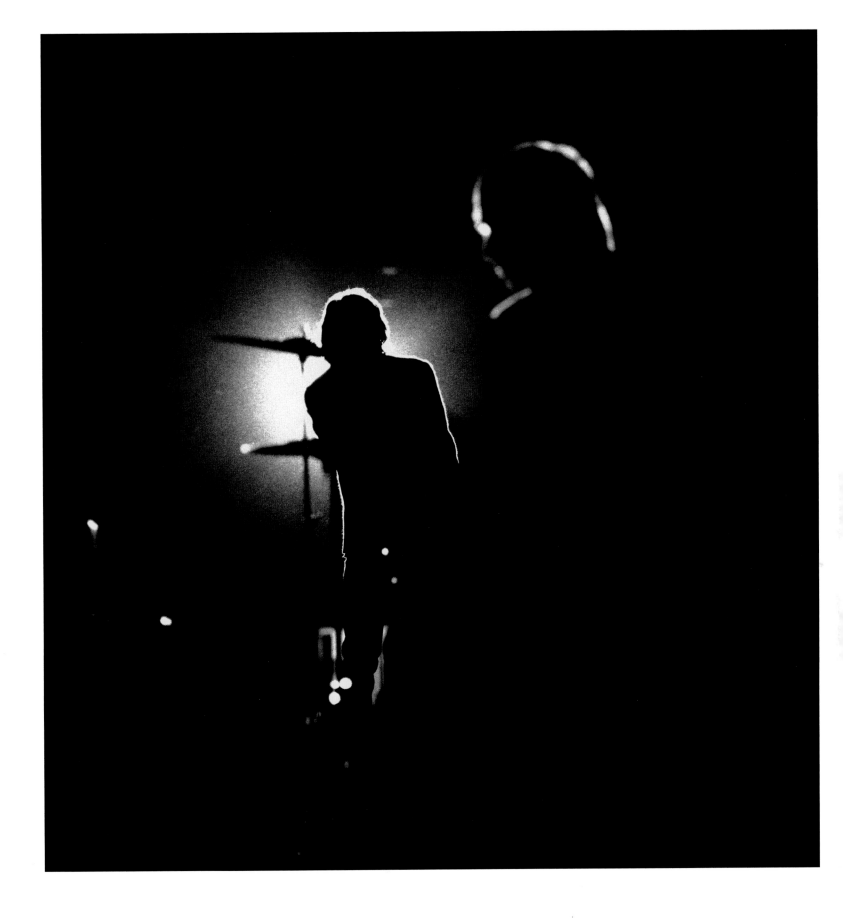

North American tour | 29 October – 5 December 1965

We played 'Satisfaction' every night. It had been No.1 in the US for a month in the summer of 1965. Mick and I were sitting back in a hotel room in San Diego when there was a knock at the door and the phone started ringing and people wanted the next hit. If we had been allowed total artistic freedom, we probably wouldn't have written half of those songs. KEITH

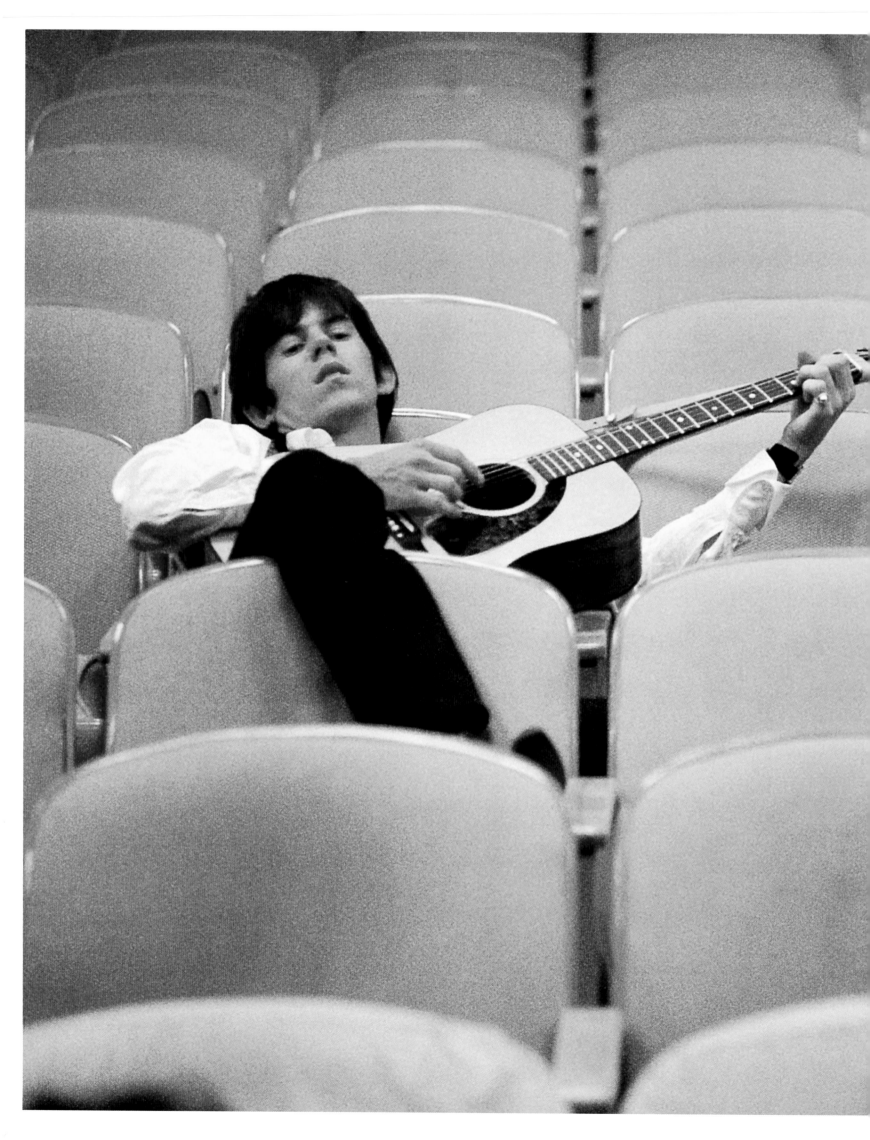

**Arizona Veterans Memorial
Coliseum | Phoenix, Arizona, USA
30 November 1965**

We did well over thirty cities in just
over five weeks. No wonder I was taking
it easy. We played to something like
a quarter of a million people. KEITH

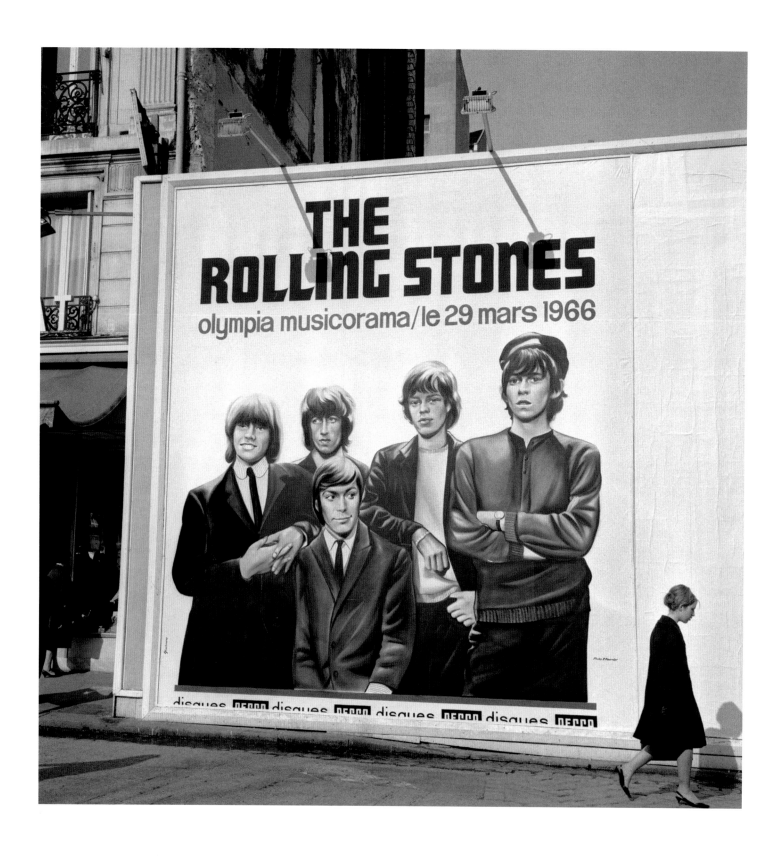

European dates | 29 March – 5 April 1966

A short tour taking in Holland, Belgium, Sweden and Denmark,
as well as shows in Paris, Marseille and Lyon in France. In all,
around 22,000 people saw us – a fraction of the number that would
soon be watching us at a single show in a stadium. The two photos
opposite are from our show at the Olympia in Paris on 29 March 1966.

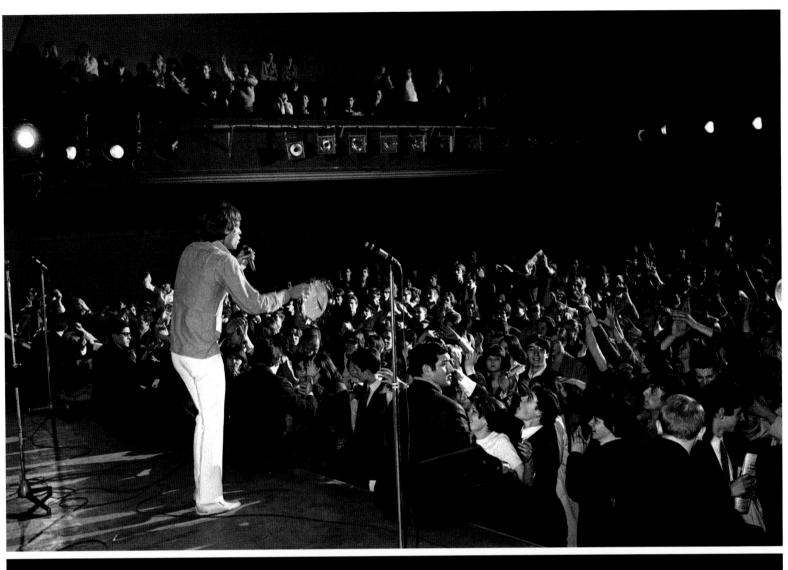

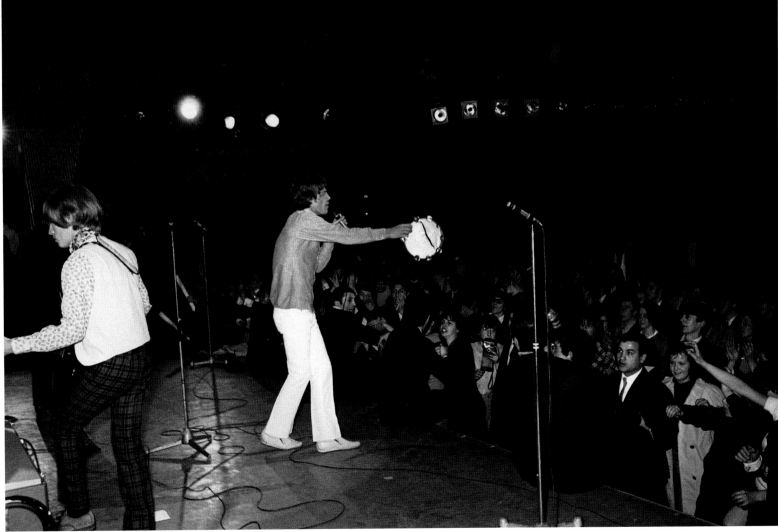

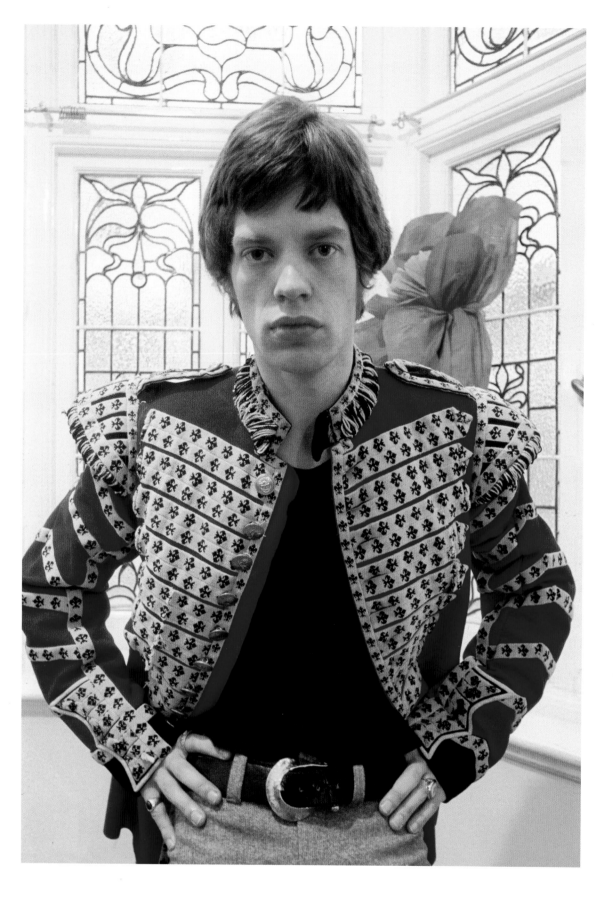

Ready, Steady, Go! | **Wembley Studios** | **London, UK** | **27 May 1966**

We were regulars on *Ready, Steady, Go!* throughout 1966 until the show finished for good at Christmas that year. I appeared on the show in May wearing this jacket. I was also on the last ever show and was sad to see it end. It was the best music show on British TV in the sixties. MICK

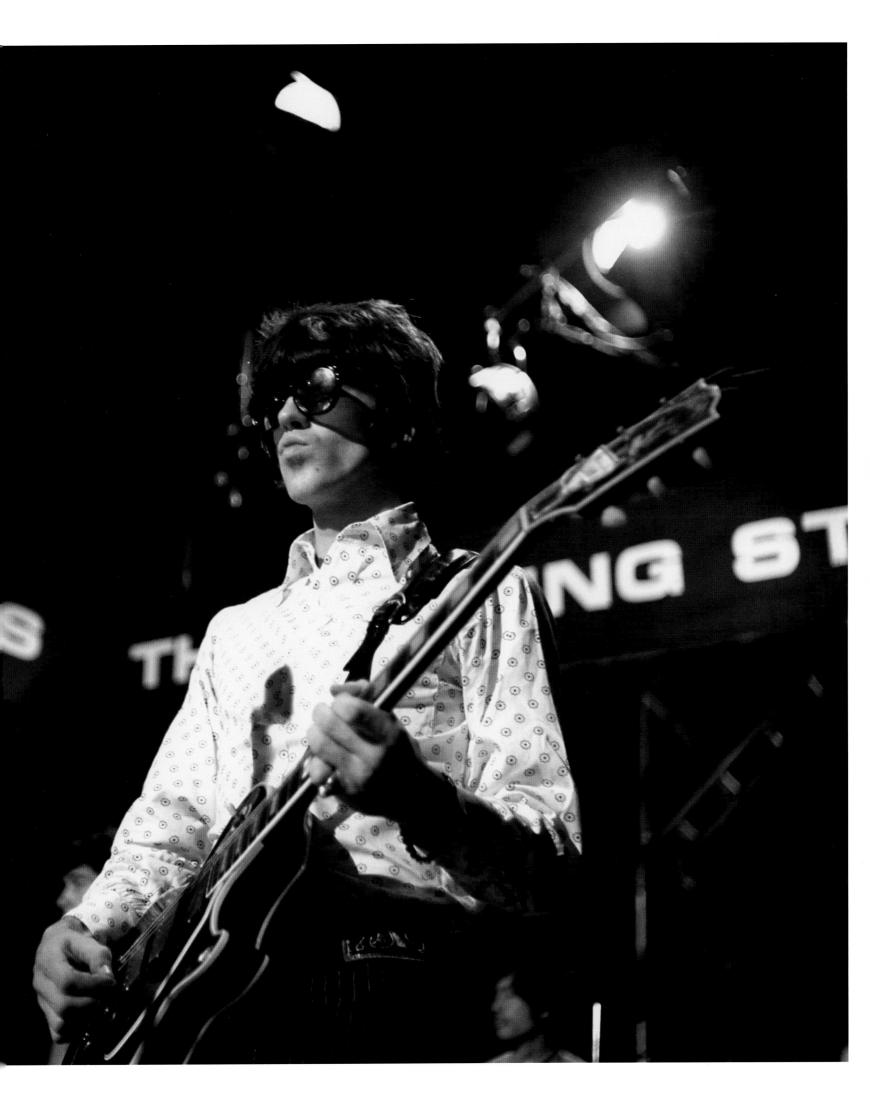

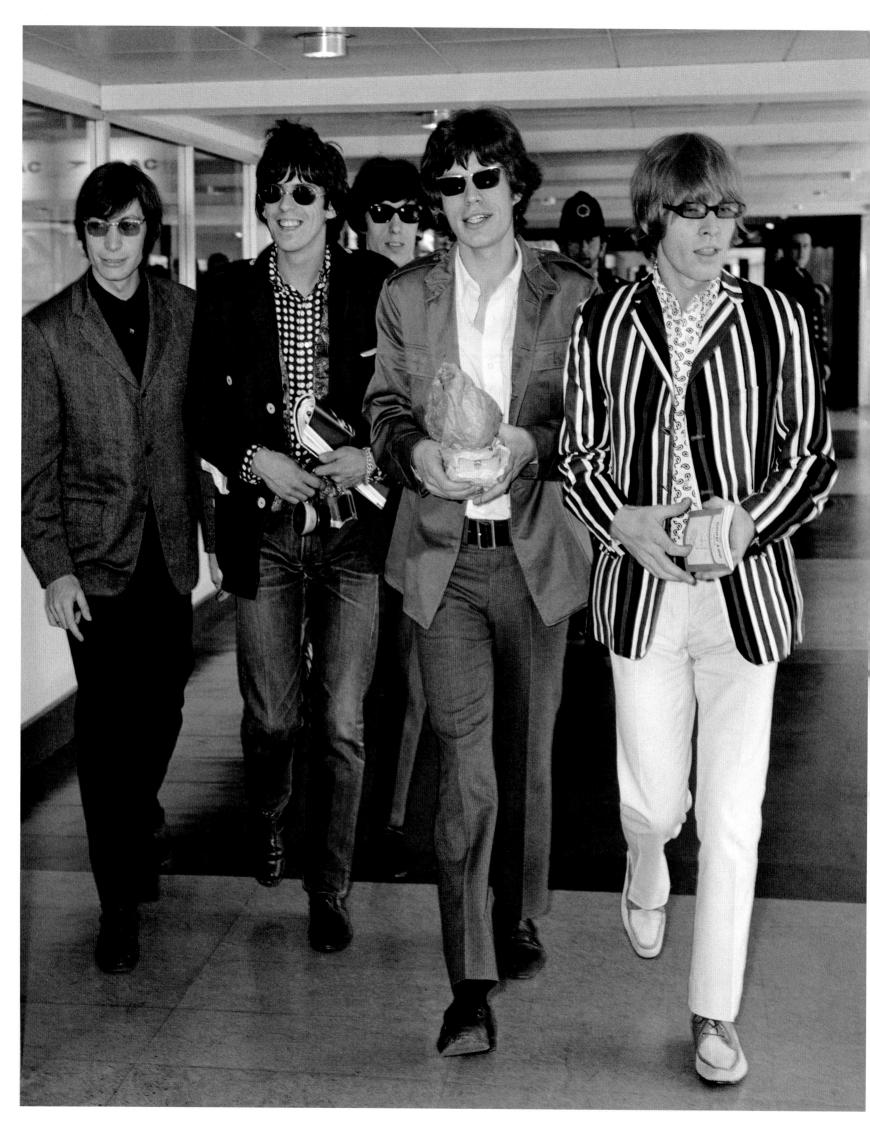

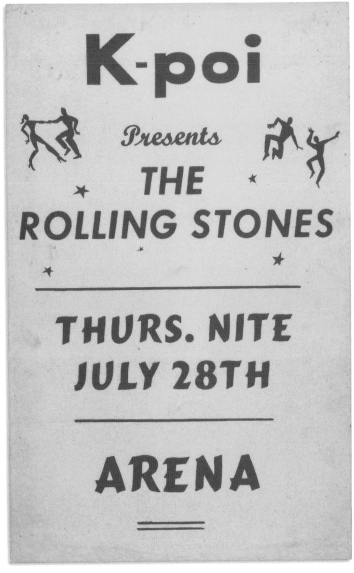

opposite

Heathrow Airport | London, UK | 23 June 1966

Leaving home to begin a twenty-state tour of America with the first show the following day at the Manning Bowl in Lynn, Massachusetts. The penultimate date of the tour was at the Cow Palace in California and the last in Honolulu on 28 July.

overleaf

**Forest Hills Tennis Stadium | New York, USA
2 July 1966**

This has been my view of the band – and the audience beyond – for the last fifty years. CHARLIE

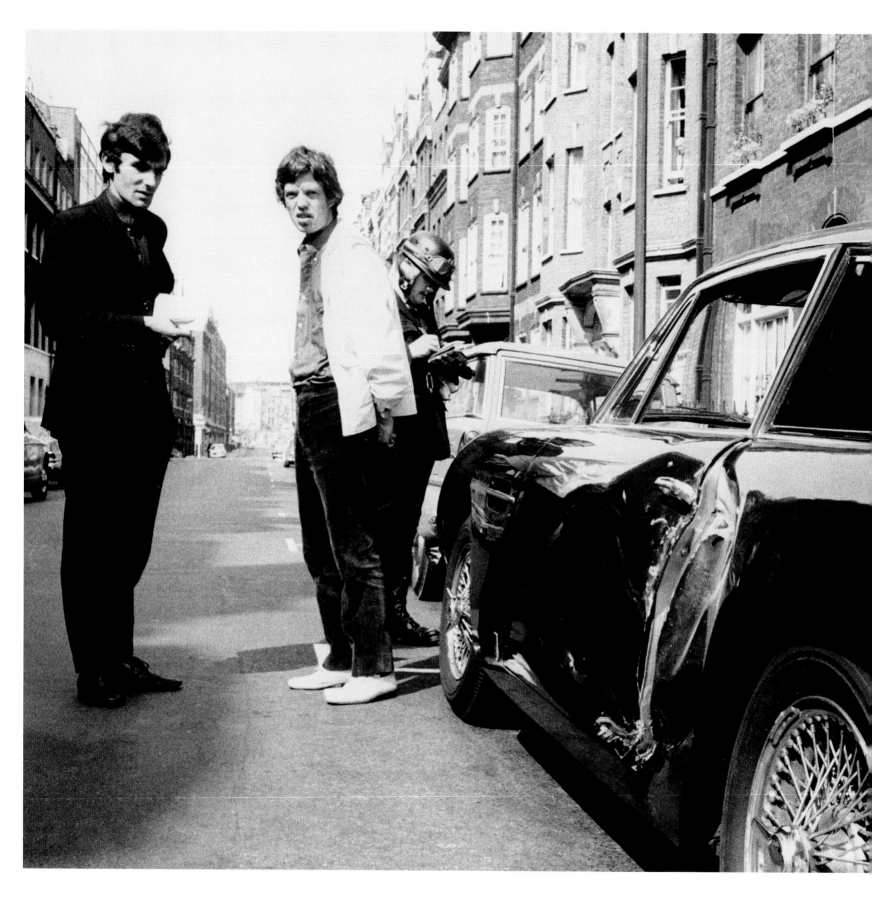

Great Titchfield Street | London, UK | 28 August 1966

This was my midnight blue Aston Martin DB6 after I'd had a run-in
with another car close to my flat in Harley House, Marylebone.
I'd only had it for three weeks when this happened. It cost me £200
to have it fixed. You can see Chrissie Shrimpton in the car. MICK

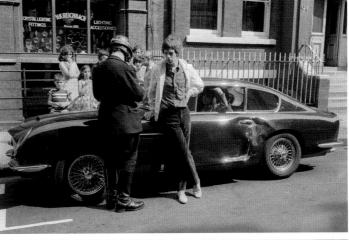

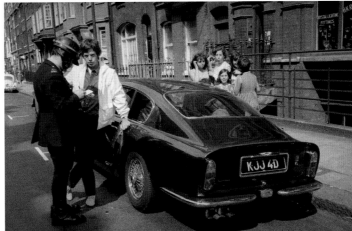

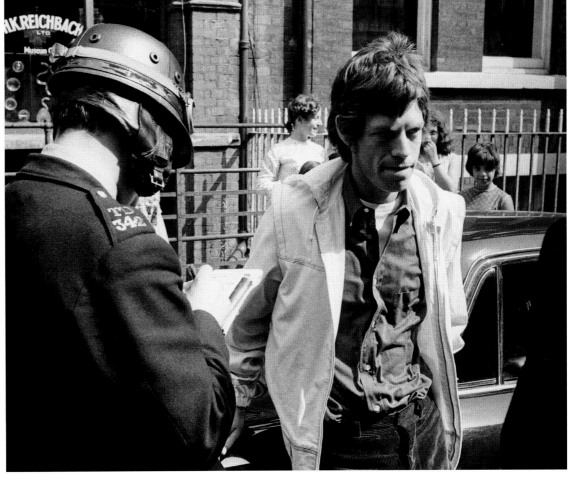

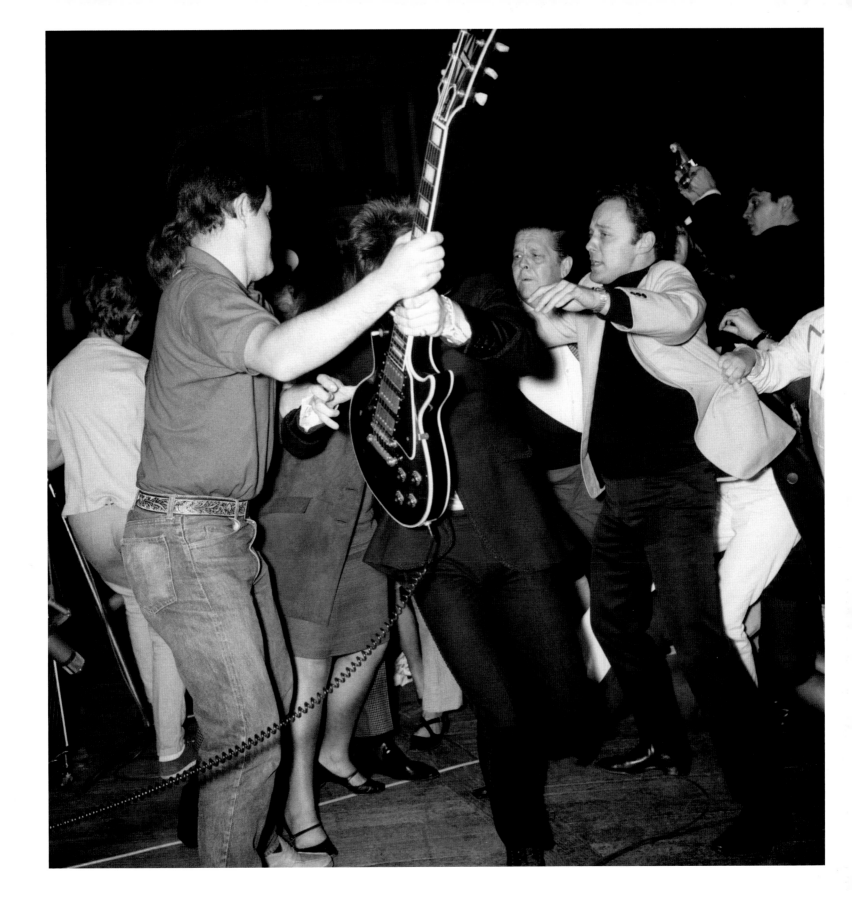

Royal Albert Hall | London, UK | 23 September 1966

This was the first night of a twelve-city UK tour with Ike and Tina Turner, and the Yardbirds with Jeff Beck and Jimmy Page. We hadn't toured the UK in a year and I recall us thinking at the time that things may have been a little different, but the fans were just as fervent as ever. MICK

That's Stu grabbing Keith's guitar as he rushes off stage. CHARLIE

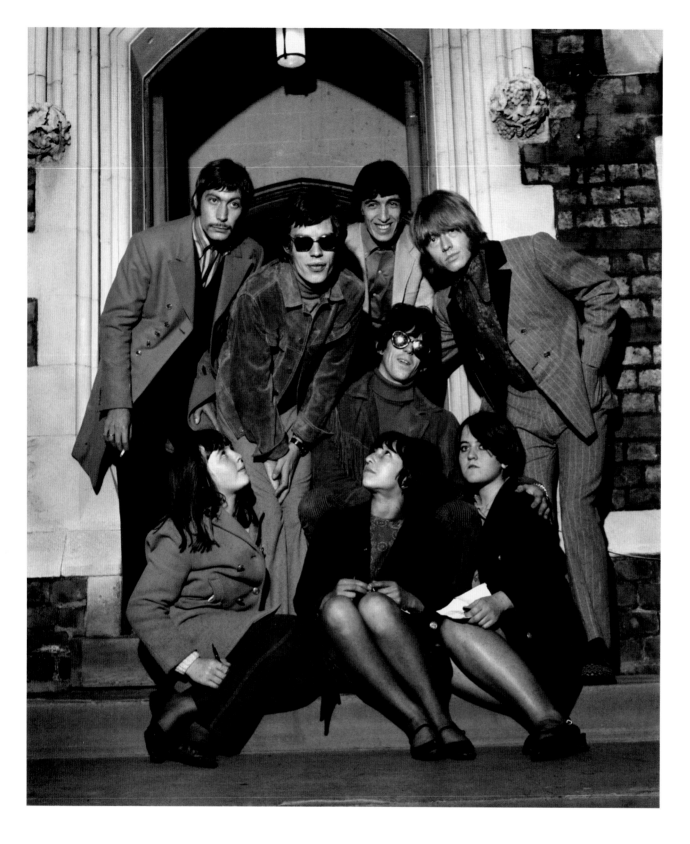

above

Manchester, UK | 28 September 1966

Outside our hotel in Manchester with fans.

opposite

***Daily Mirror* | 15 September 1966**

*Just before the UK tour started, we released a new single, 'Have You Seen Your Mother,
Baby, Standing in the Shadow!' – and this was a PR stunt that was dreamed up to
promote it. The photograph was taken in New York City on 10 September.*

Brian looked great as the Jean Harlow lookalike with the cigarette. CHARLIE

Oh! Brian, Keith, Mick, Charlie and Bill.. HOW YOU'VE CHANGED

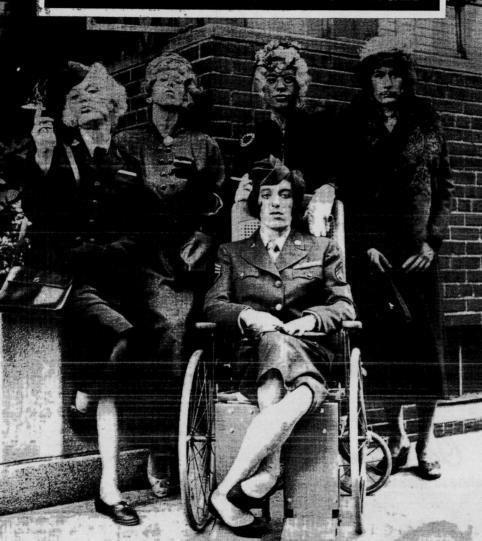

THIS extraordinary picture was taken last Saturday afternoon in a back street off New York's Third-avenue, and Mr. Andrew Loog Oldham confessed that he was a little worried about it at first.

He manages the Rolling Stones—and the picture is of his charges. The Jean Harlow type on the left is Brian Jones.

In line with him from the left are Keith Richard, Mick Jagger (he is made up to look coloured) and Charlie Watts. Bill Wyman sits this one out—in uniform.

They got all togged up like this in wigs and furs and skirts to illustrate the theme of their new record, which is entitled

by PATRICK DONCASTER

"Have You Seen Your Mother, Baby, Standing In The Shadow?"

"It is about the attitude that exists between parents and their children," explained Mr. Oldham.

The Shadow is the uncertainty of the future. The uncertainty is whether we slide into a vast depression or universal war.

And the Stones, in this picture, set out to give their idea of what some of the mothers of today's generation might have

looked like in the Shadow of the warring Forties. "They are parodying the theme," said Mr. Oldham. "New York is quiet on Saturdays. And only three fans were about when the picture was taken."

It will be used as a record sleeve in the United States. And it is likely to cause a storm there when it is issued next month. Because Americans don't take kindly to such parodies of Motherhood.

The song will be issued in Britain next week. Musically, it's a jolly romp that will have the fans dancing rather than worrying about war or want. Or that picture.

Doncaster's Discs—Page 20.

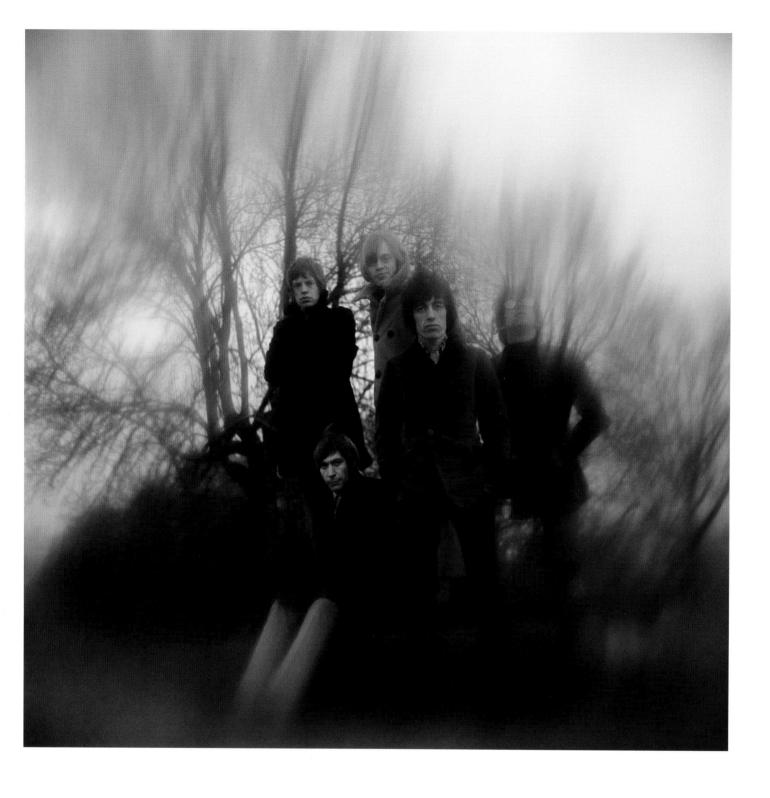

Primrose Hill, London, UK | 15 November 1966

We had been recording all night at Olympic Studios
and went from there in Andrew Oldham's Rolls Royce
to Primrose Hill at around dawn for a photo session with
Gered Mankowitz. These are outtakes from what eventually
became the cover shot of *Between the Buttons*. CHARLIE

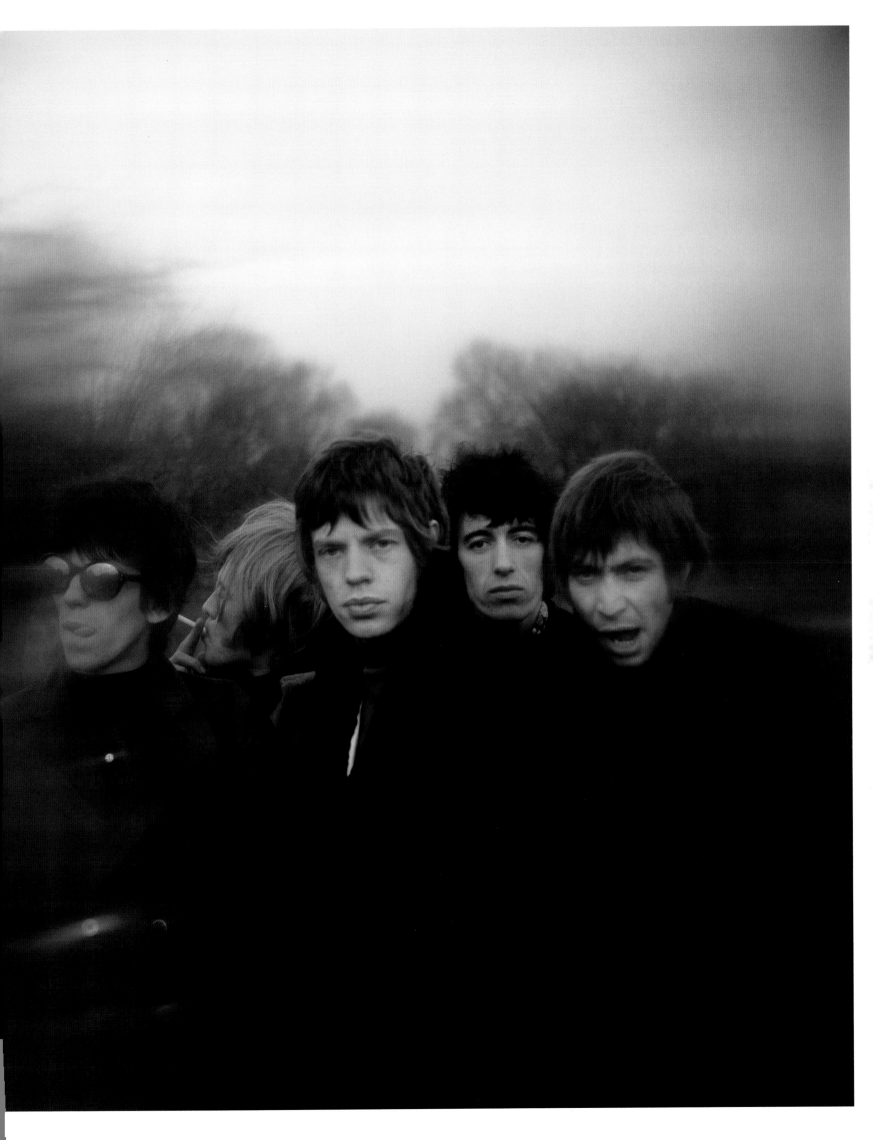

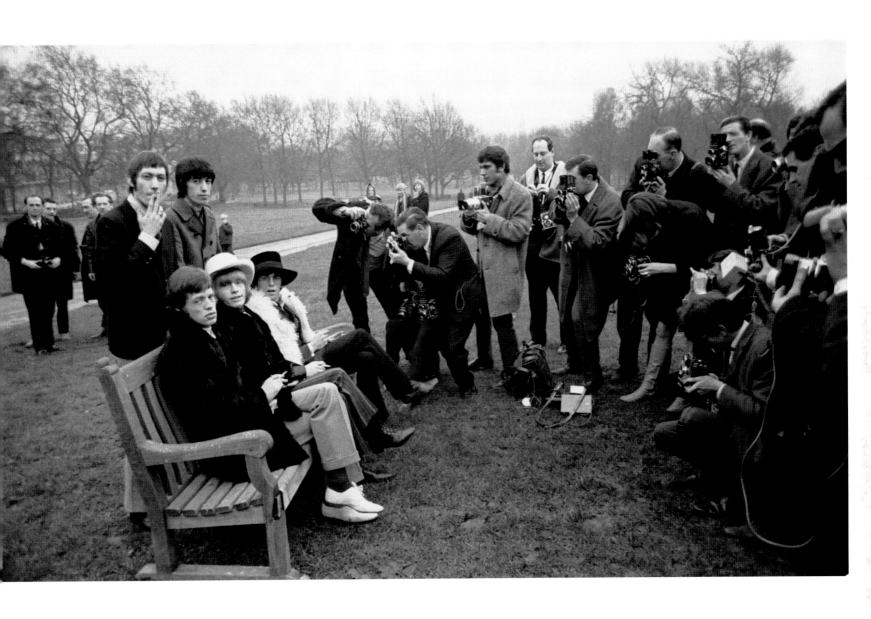

Green Park, London, UK | 11 January 1967

Everyone must have seen the photos of us taken in Green Park the day before we left to go to America but it's interesting to see all the photographers gathered around us trying to get their shots. It's something that's not changed over the years. The only thing that's different is that for the last twenty years or so we haven't done it so often. CHARLIE

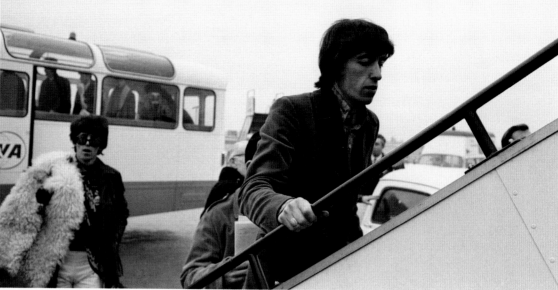

THE ROLLING STONES 50 | 1967

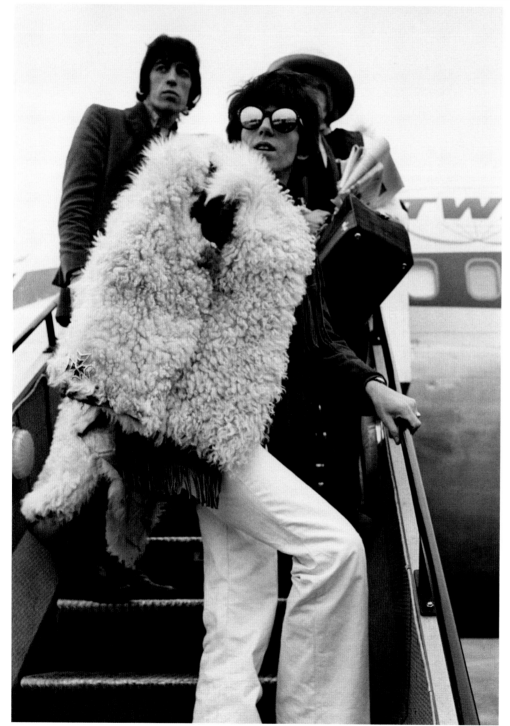

this page

**Heathrow Airport | London, UK
12 January 1967**

*The day after the Green Park photocall,
we – apart from Mick – flew to New York.
We were going to appear on Ed Sullivan
to promote our new single – 'Let's Spend
the Night Together' backed with 'Ruby
Tuesday' – that came out the next day.*

opposite

**Heathrow Airport | London, UK
13 January 1967**

It was Friday the thirteenth and I
remember people asking me whether
or not I was superstitious about flying
that day. It certainly didn't worry me,
but the others all decided to go a day
early. Of course nothing happened –
although when we got to New York our
luck ran out: Ed Sullivan insisted we
change the lyrics to 'Let's Spend the
Night Together'. I had to sing 'time'
instead of 'night' to get us on air.
We also did 'Ruby Tuesday', which is a
wonderful song. It's a nice melody and
a lovely lyric – neither of which I wrote.
But I always enjoy singing it. MICK

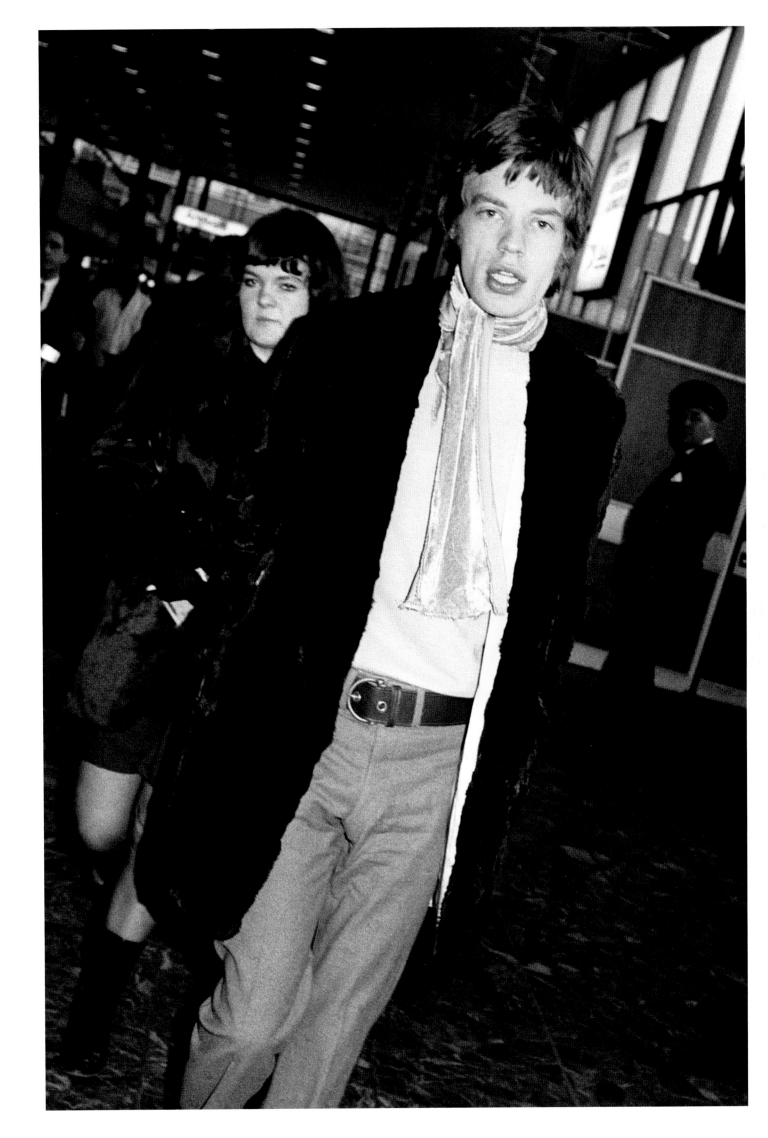

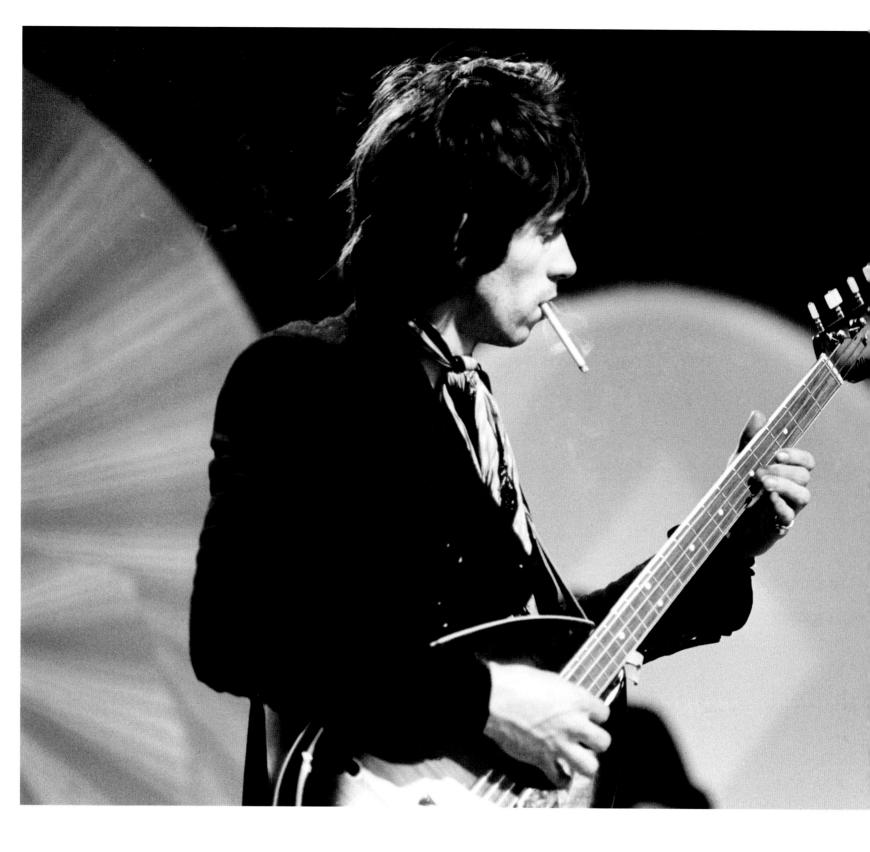

Sunday Night at the London Palladium | London, UK | **22 January 1967**

All these photos are from the afternoon rehearsal and soundcheck for the
London Palladium show that led to a load of ridiculous controversy for weeks
after. We refused to appear on the roundabout at the end of the show; it was
one of the conditions on which we did the show. Andrew Oldham didn't want
a scene; that's him arguing the toss with Mick, being watched by Glyn Johns,
our engineer. He wanted us on the roundabout and we rebelled. And yes, I
know it's Bill's bass; I was just messing around on it during the rehearsal. KEITH

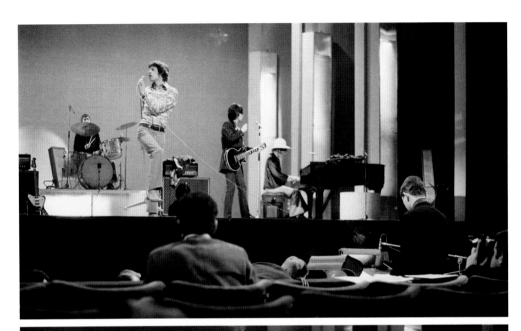

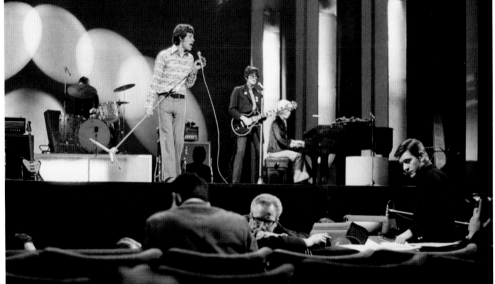

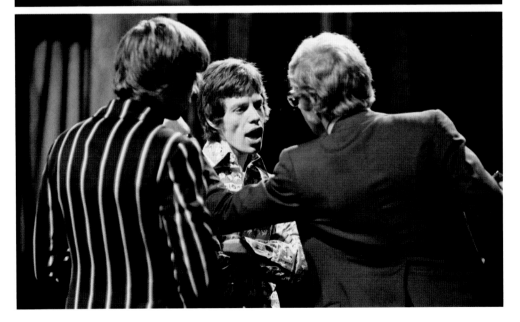

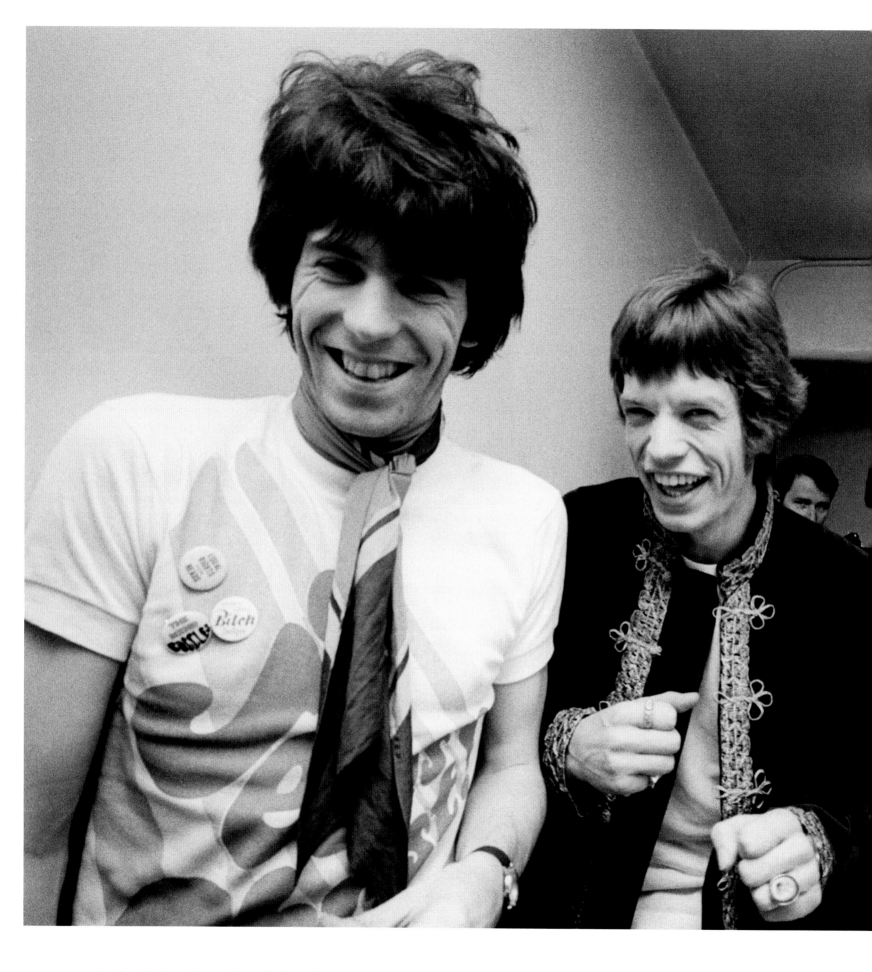

Sunday Night at the London Palladium | London, UK | **22 January 1967**

Making good our escape after refusing to appear on the roundabout. This is
a lovely photo of Mick and Keith and shows what a great laugh we all thought
it was. CHARLIE

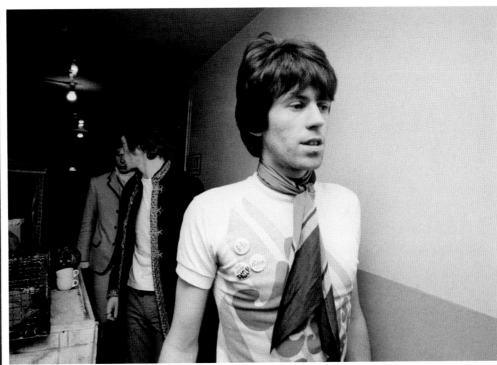
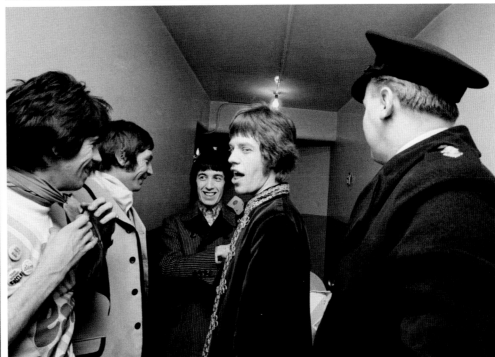
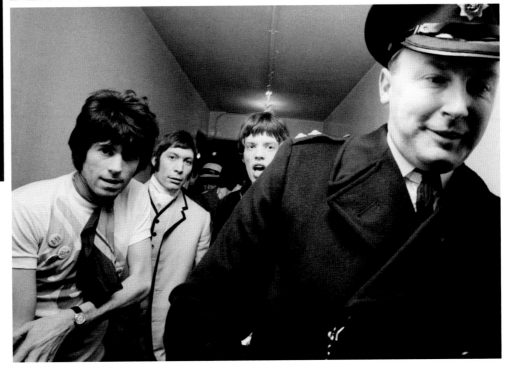

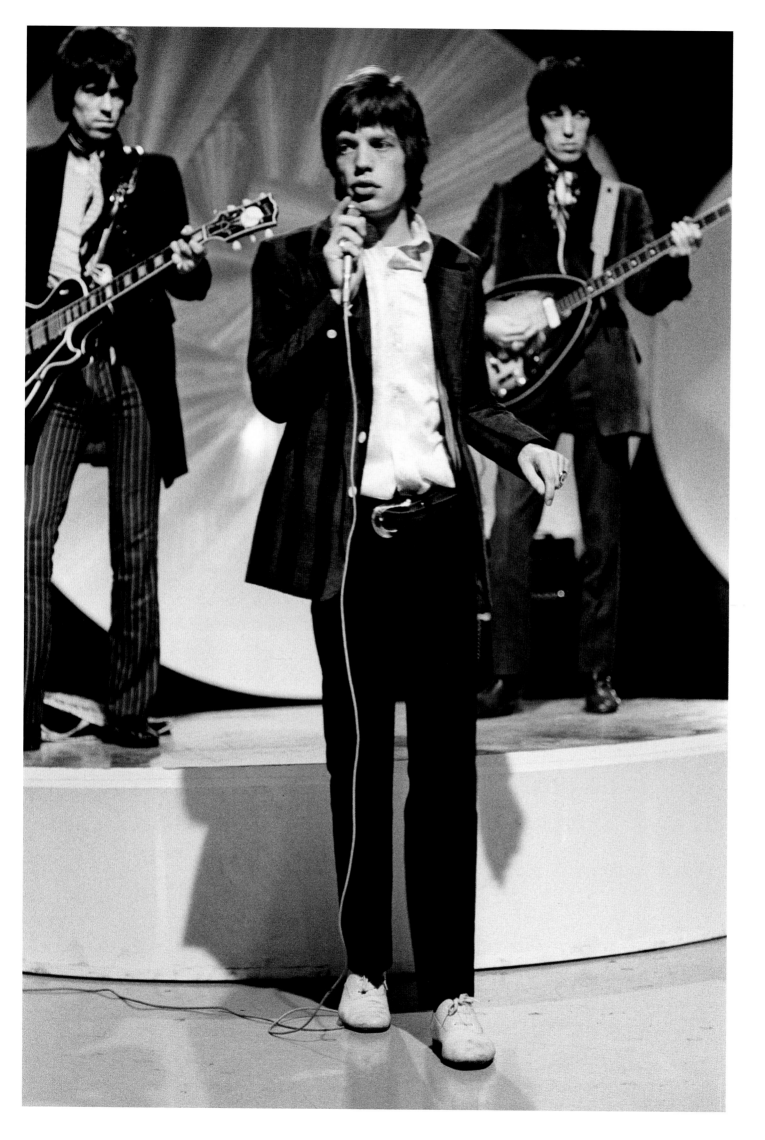

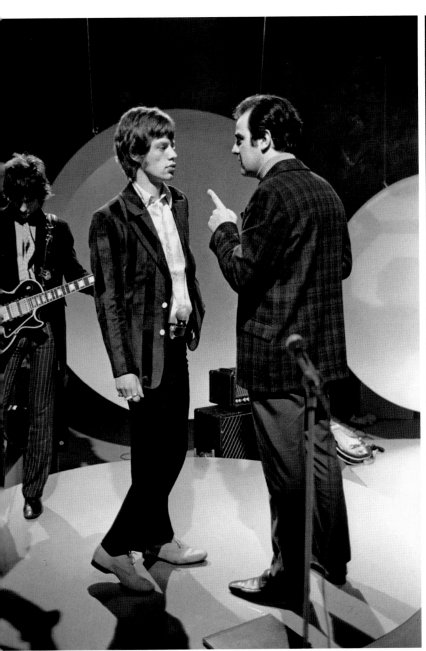

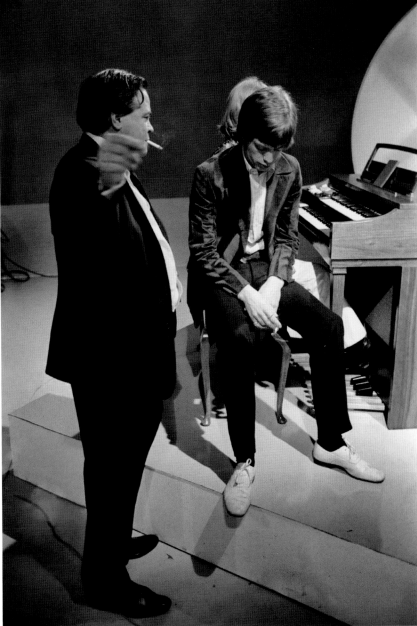

The Eamonn Andrews Show | UK | 5 February 1967

Here we are rehearsing for Eamonn Andrews's TV show, prior
to it going out live that evening. It should have been a run-of-the-
mill appearance for us: we were going to mime to 'Let's Spend
the Night Together', but the Musicians Union insisted we perform
the song live. The whole thing blew up into a major row and at
one point we even suggested they play the track and we would just
sit around or something while they filmed us. In the end, we had
to perform live and so we did 'She Smiled Sweetly' from *Between
the Buttons*. I suspect that was what we were discussing in the
middle picture. MICK

In the right-hand photo, that's Les Perrin – our PR man – looking
like he's telling Mick off! Mick, like all of us, was just annoyed by
the MU's attitude. CHARLIE

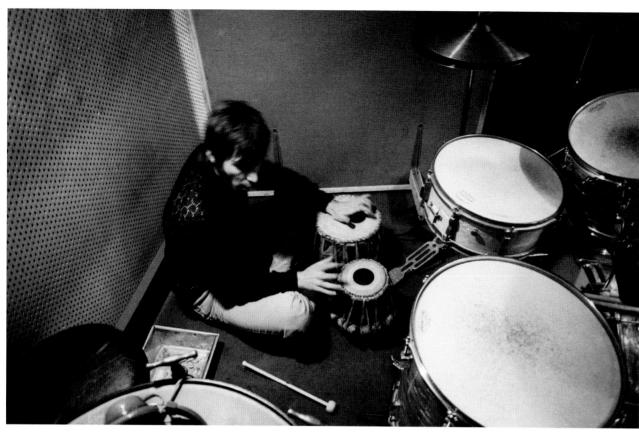

Olympic Studios | Barnes, London, UK | February 1967

These photos are most likely from a series of sessions we did in February 1967, working on new material that would eventually find its way onto Their Satanic Majesties Request.

It's Olympic, I know, but I've no idea what song I was using those little hand drums on. CHARLIE

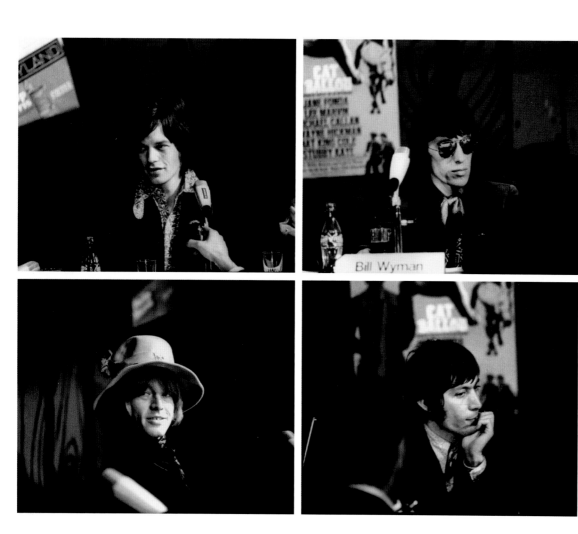

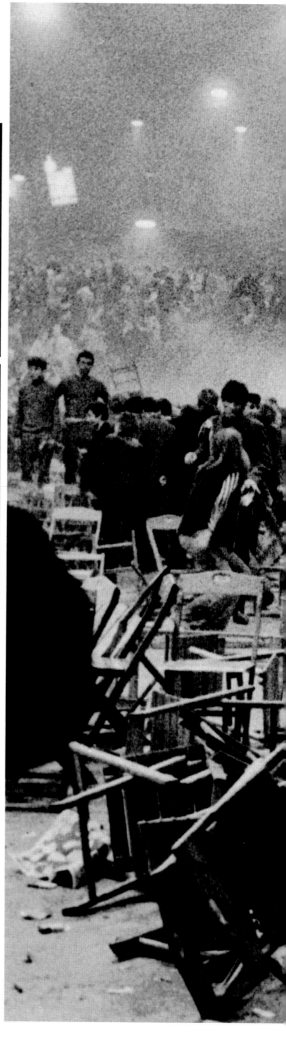

Hallenstadion | Zurich, Switzerland | 14 April 1967

The four smaller photos were taken at a press conference. The main photo is the scene inside the venue after we had finished playing later that evening.

I was jumped on while I was singing by one of the 12,000 fans that were there. For a moment, everyone stopped playing. Then, as one of our crew dragged him off me, I got up from the floor and we just carried on. We were bundled out as soon as we finished playing. A full-scale riot then took place. MICK

The day before our Zurich show, we played at the Palace of Culture in Warsaw, Poland, where there had also been a riot. The Communist Party officials had given tickets for our performance to the party faithful, rather than letting real fans have a chance to buy them. There were running battles in the street. CHARLIE

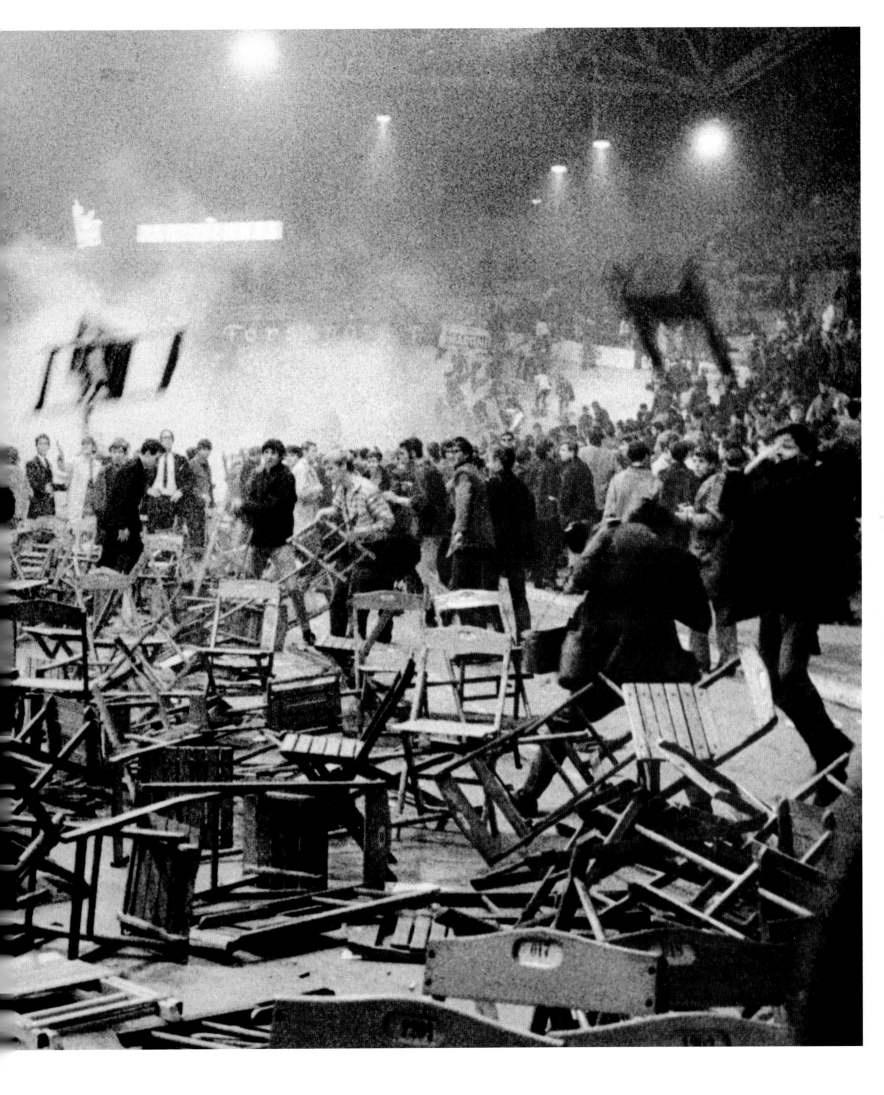

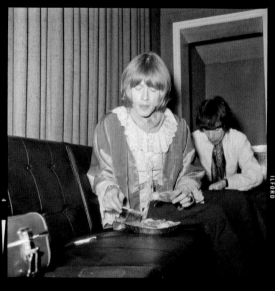
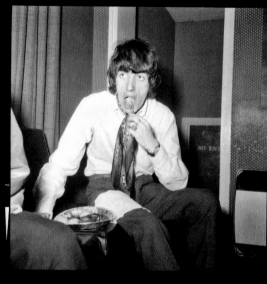
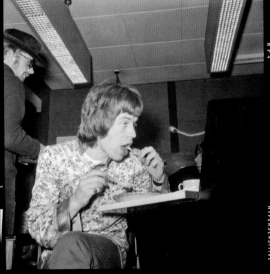
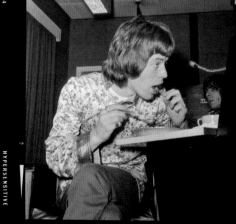

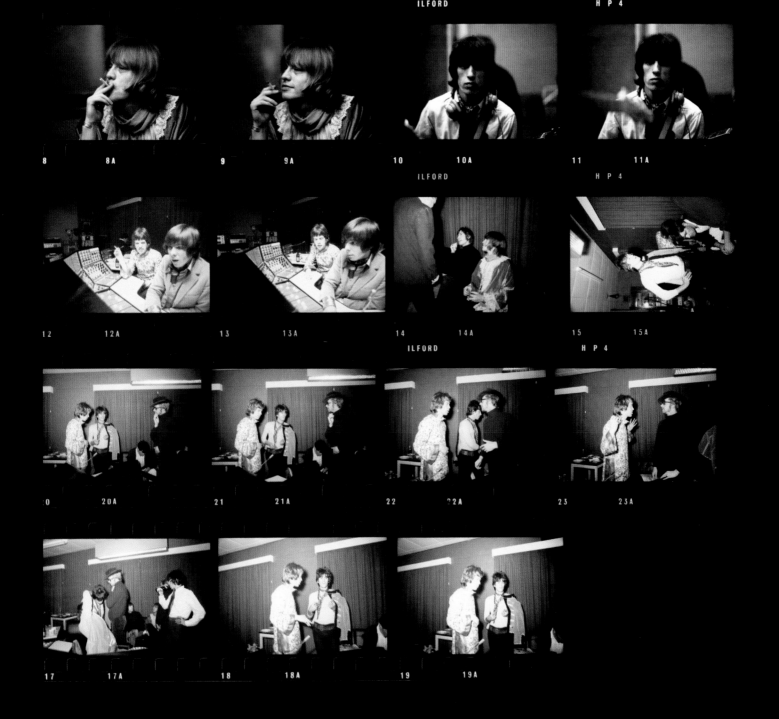

Olympic Studios | Barnes, London, UK | 19 May 1967

Another session for *Their Satanic Majesties Request*. Andrew Oldham was there – he's the one in the hat. Stu was there too. Apart from the changing fashions, it could have been any session during the previous four years. That was how we worked: get in the studio and see what happened. KEITH

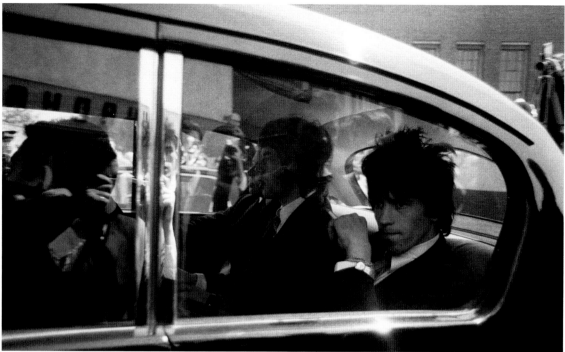

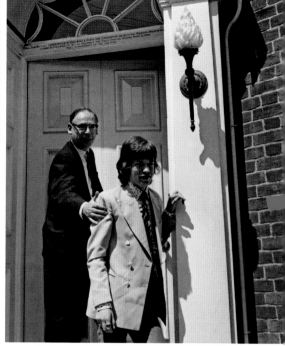

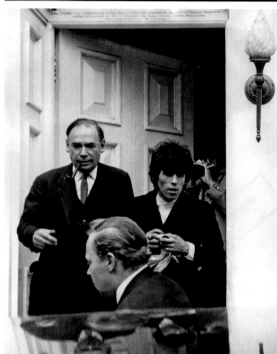

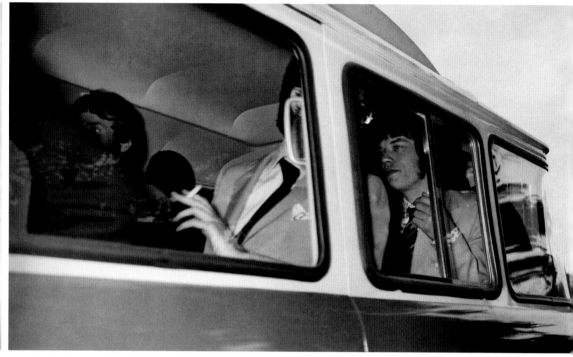

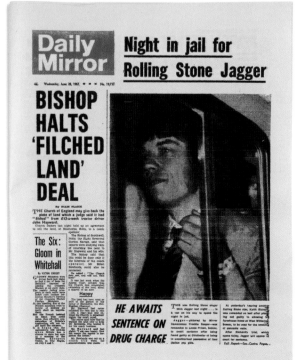

Chichester, West Sussex, UK | May – June 1967

Mick and Keith's appearance in court over a drugs bust at Keith's home, Redlands in Sussex, in February. They elected to be tried by jury the following month.

Mick was found guilty and remanded in custody so that he could be sentenced after Keith's case was tried. He was taken to Lewes Prison where he stayed overnight. Keith remained free and was tried the following day when he was also found guilty. Mick was sent to Brixton Prison and Keith to Wormwood Scrubs Prison.

left

Front page of the *Daily Mirror* | 28 June 1967

London, UK | 30 June 1967

Mick leaving Brixton Prison in the late afternoon on his way to pick up Keith from Wormwood Scrubs Prison, after both had been released on bail. They drove to the chambers of their QC, Michael Havers (who later became Lord Chancellor under Margaret Thatcher), and waited outside before going in for a meeting. Later, they went to The Feathers pub on Fleet Street. At the end of July, Keith won his appeal and Mick was given a conditional discharge.

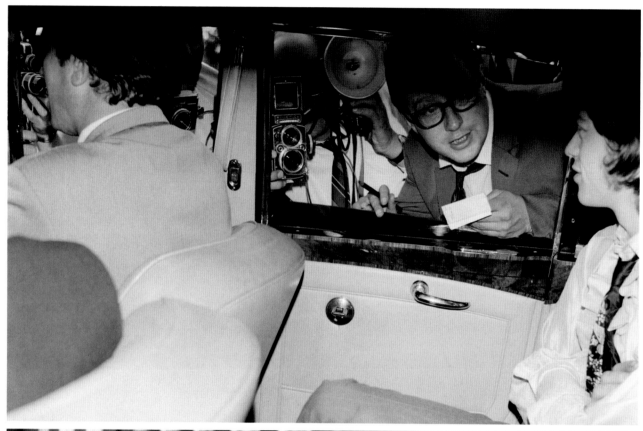

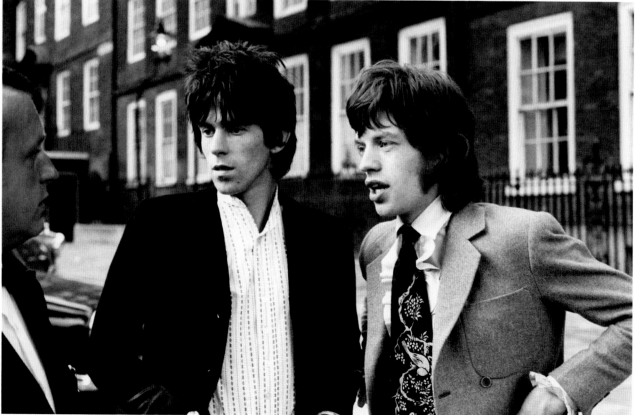

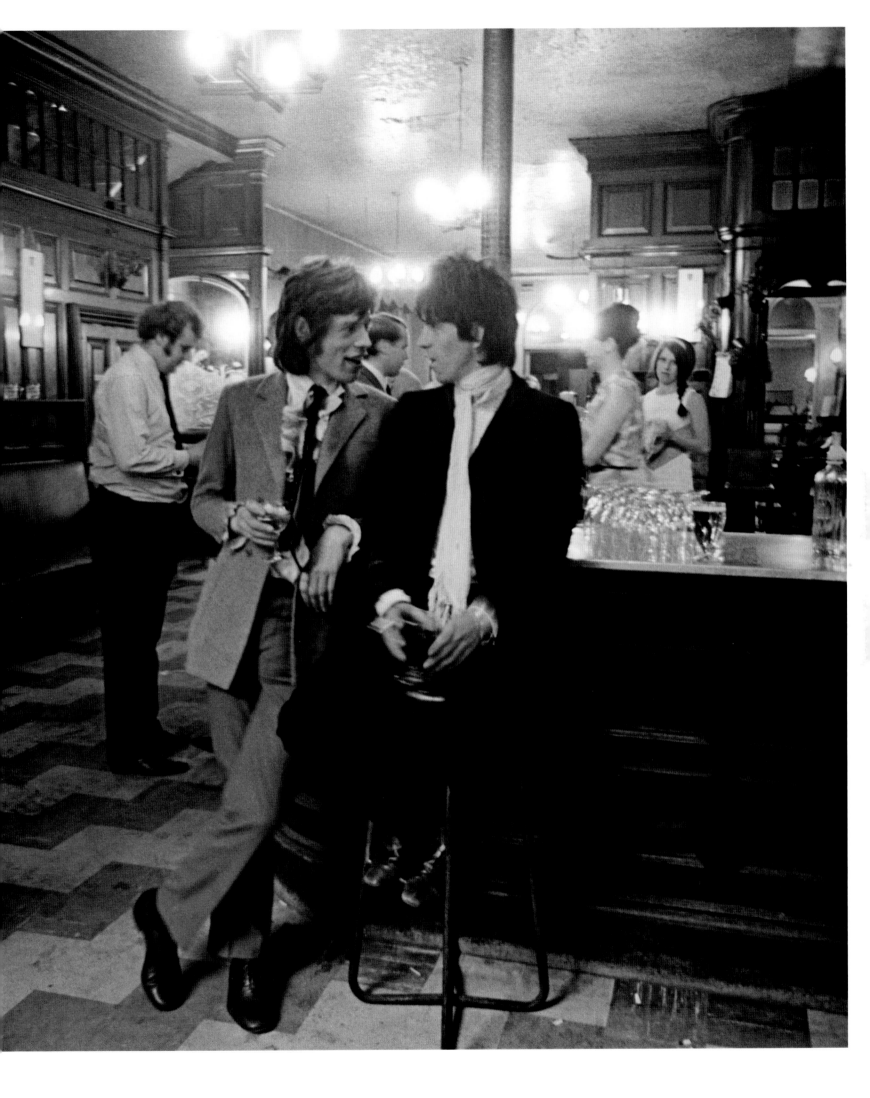

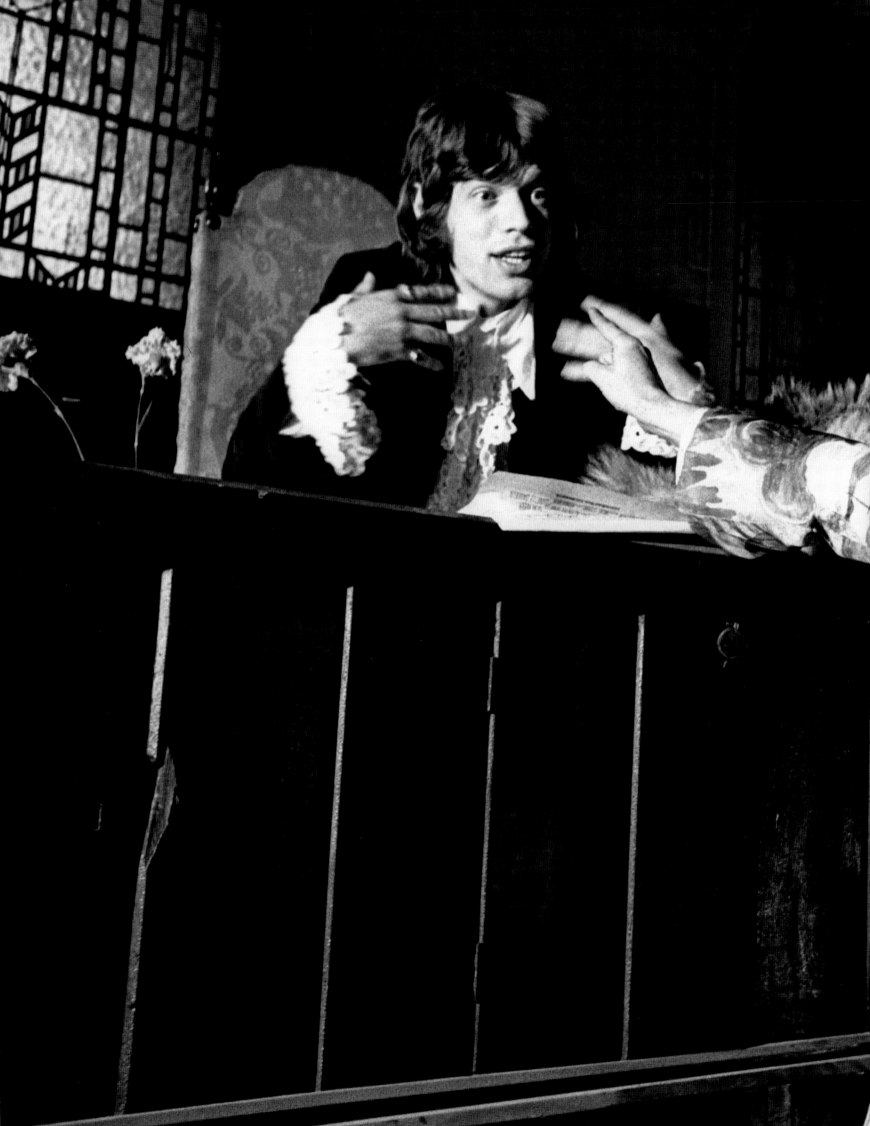

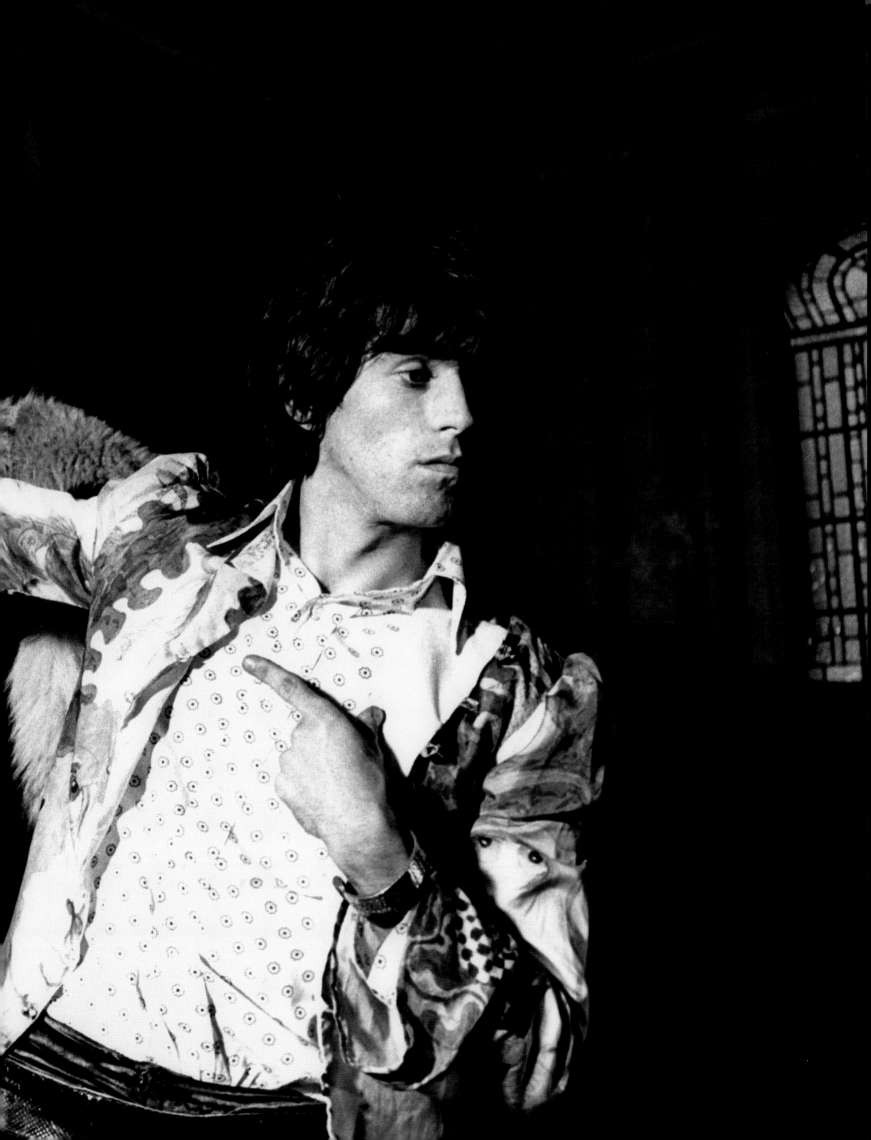

previous pages

Essex, UK | 30 July 1967

Keith, Marianne and me went to a church hall to film a spoof of *The Trials of Oscar Wilde* with director Peter Whitehead. It was to promote our single 'We Love You'. The scenes we shot in the hall were intercut with footage of the whole band recording at Olympic and us at the Royal Albert Hall in September 1966. MICK

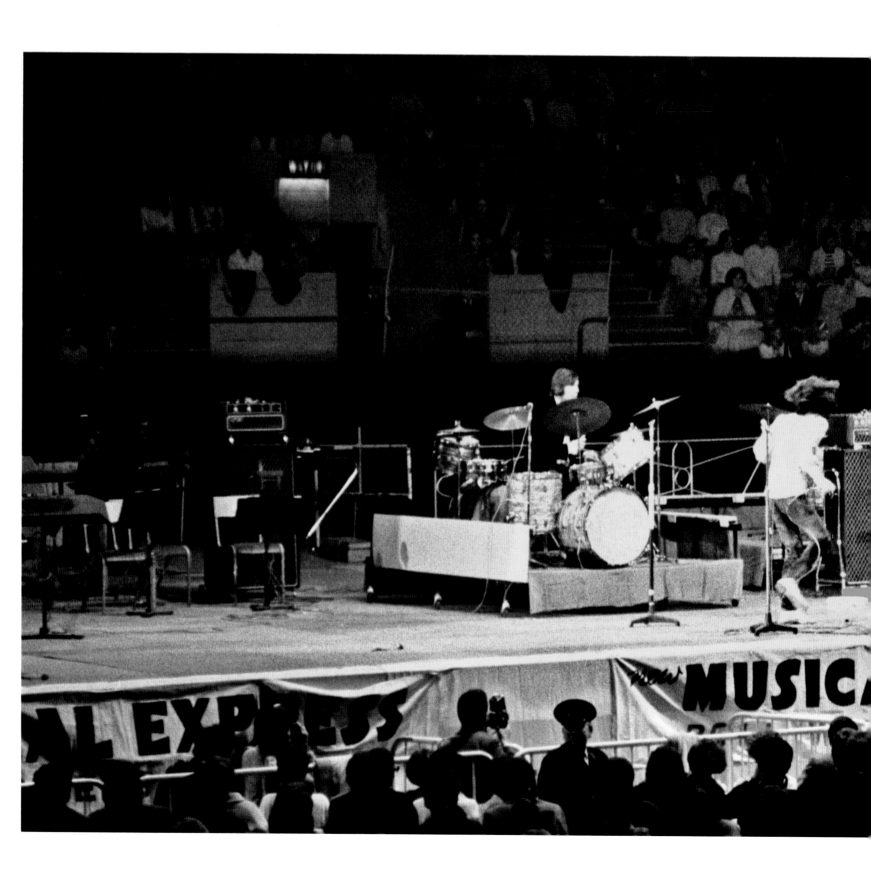

below

New Musical Express Poll Winners Concert
Empire Pool | Wembley, London, UK | 12 May 1968

This was our last concert appearance with Brian. We had once again won the Best
British R&B Group and come second to the Beatles as Best British Vocal Group.
We played 'Jumpin' Jack Flash', which was our next single, and 'Satisfaction'.

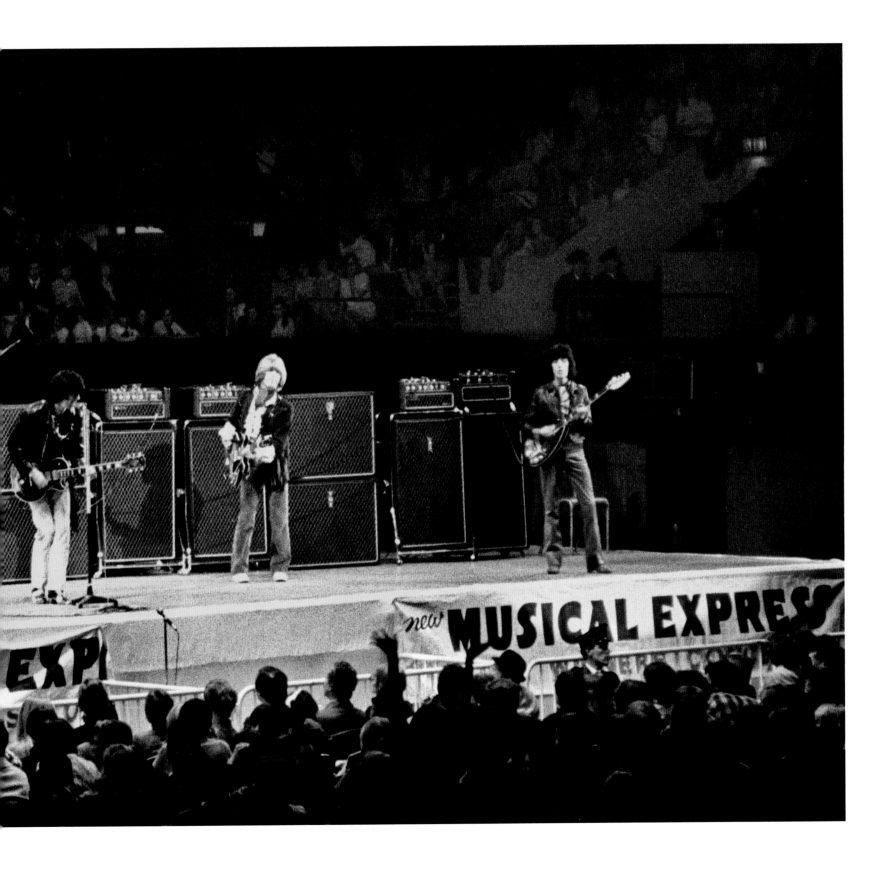

ACADEMY CINEMA TWO
OXFORD STREET · GER 5129

SHIRLEY KNIGHT · AL FREEMAN Jnr.

in LEROI JONES'S dramatic masterpiece

DUTCHMAN (X)

Directed by ANTHONY HARVEY

AND

PETER WHITEHEAD'S

definitive statement on the swinging city

TONITE LET'S ALL MAKE LOVE IN LONDON

IN COLOUR (A)

with

JULIE CHRISTIE · VANESSA REDGRAVE
MICK JAGGER · ERIC BURDON · GENEVIEVE
MICHAEL CAINE · LEE MARVIN · VASHTI
THE ROLLING STONES · THE ANIMALS · PINK FLOYD
EDNA O'BRIEN · ALAN ALDRIDGE · DAVID HOCKNEY

Printed by WARD & FOXLOW, Hanover Street, W.1, from an Original Lino Cut by Peter Straubdel

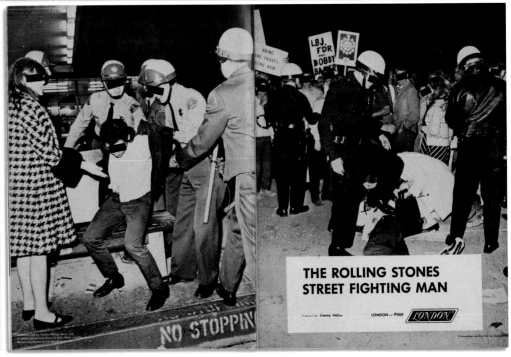

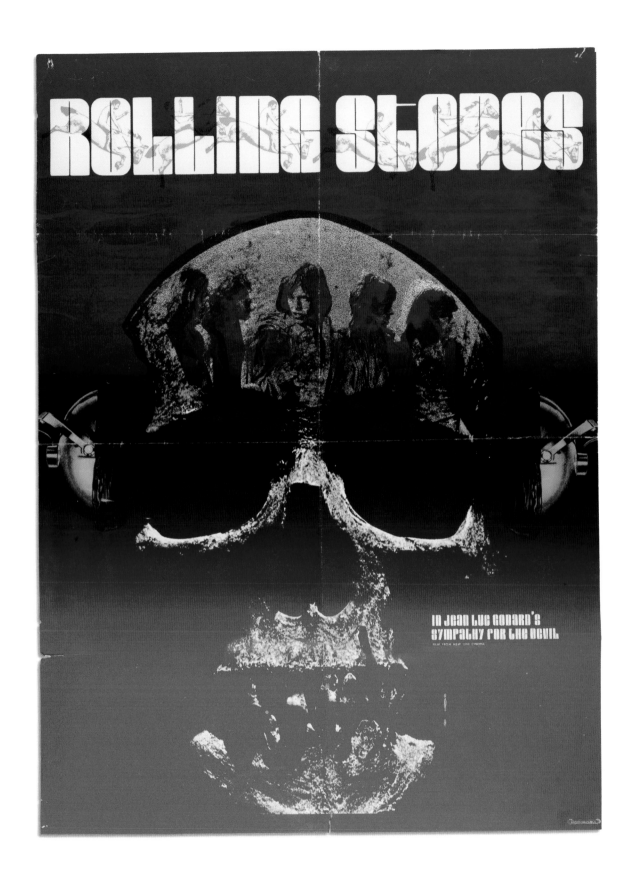

A selection of posters from the late 1960s, including an advert for our
US single, 'Street Fighting Man'. This advert only appeared once in
the press, as the single met with a lot of opposition from radio stations
across America. Many stations banned it and it failed to even make
the Top 50 because so few people knew it was out.

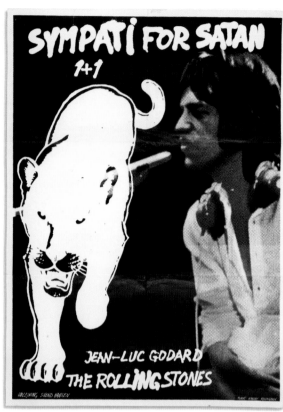

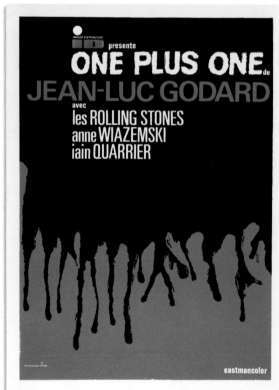

Olympic Studios | Barnes, London, UK | 4–10 June 1968

The great French cinematic innovator Jean-Luc Godard filmed us in the studios at Olympic several times for his movie *One Plus One*. It was a load of crap and, while filming, he managed to set the studio on fire. KEITH

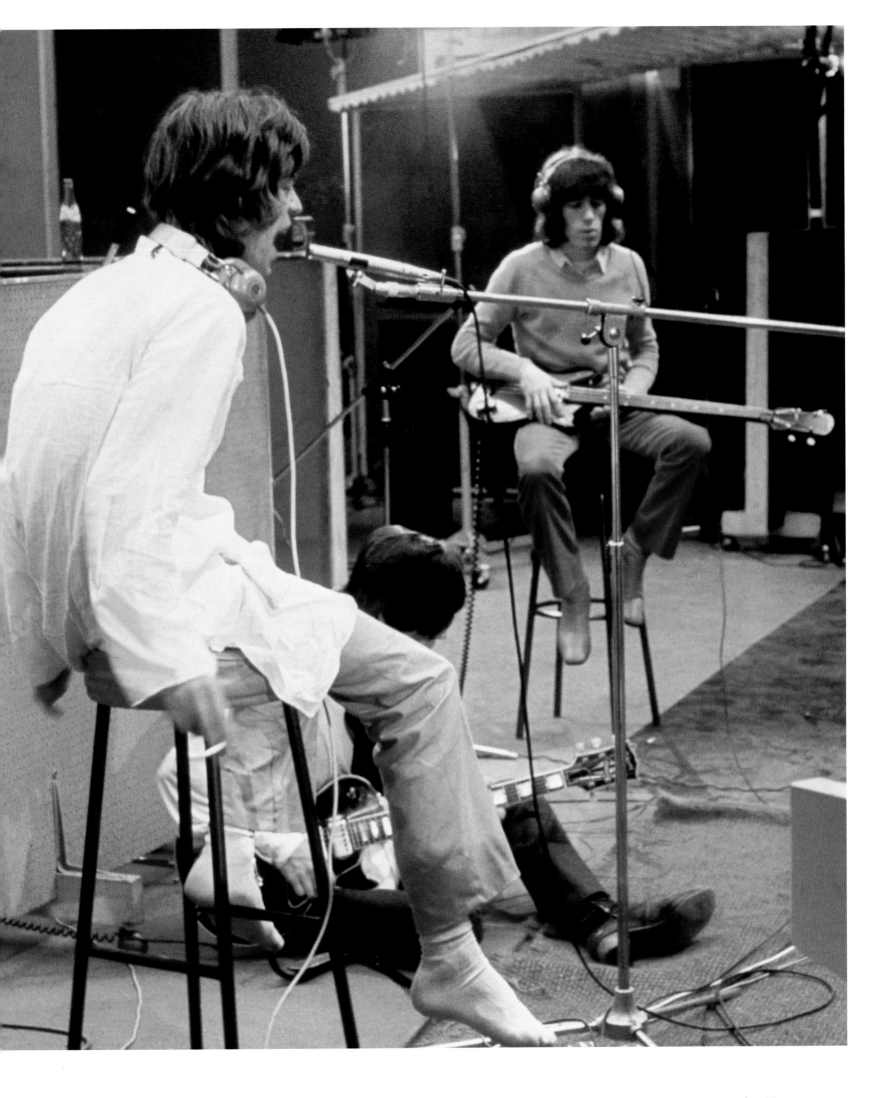

Frost on Saturday | **ABC Television Studios** | **Teddington, London, UK** | **29 November 1968**

David Frost's Saturday night show got a big TV audience and was perfect for us to promote our new album, *Beggars Banquet*. I sang 'Sympathy for the Devil' live to a backing track. This was our final TV appearance with Brian. MICK

On the version of 'Sympathy for the Devil' that appeared on the album, I play bass, Bill plays maracas and Charlie actually sings in the woo-woo chorus. KEITH

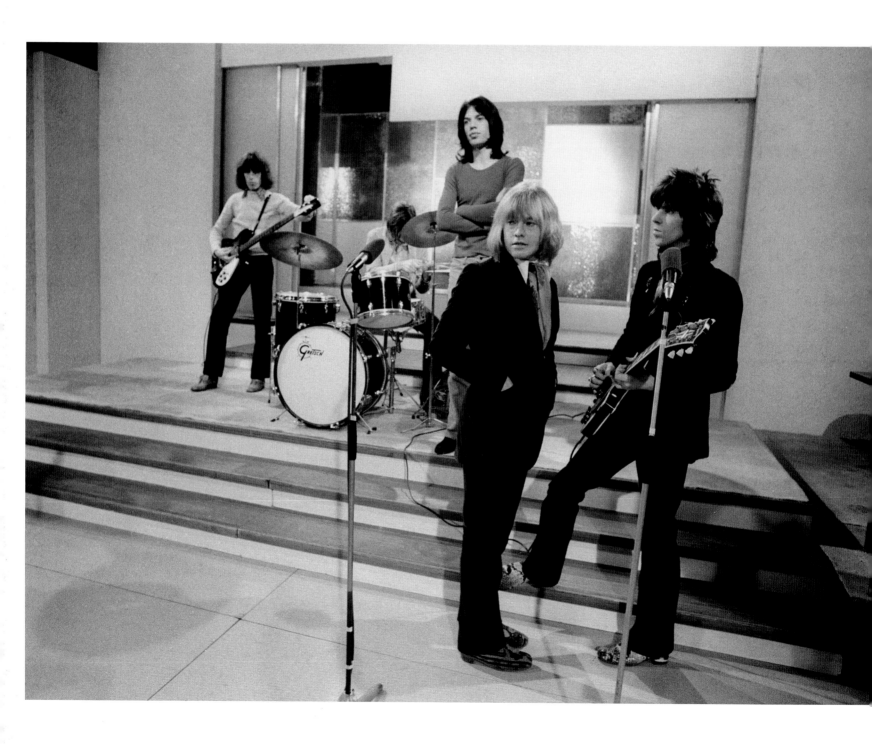

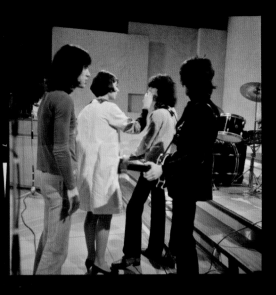
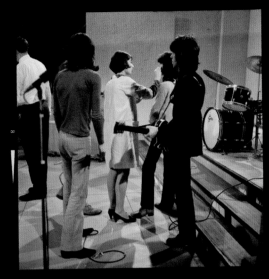
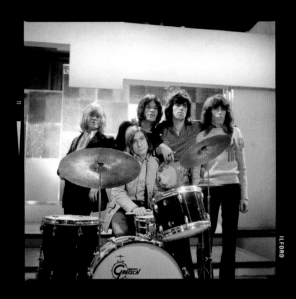
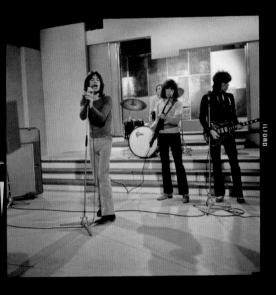
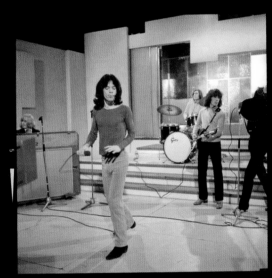
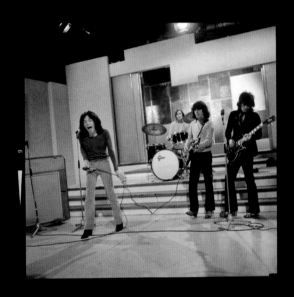
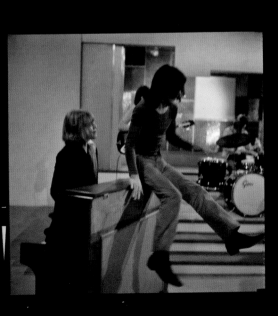
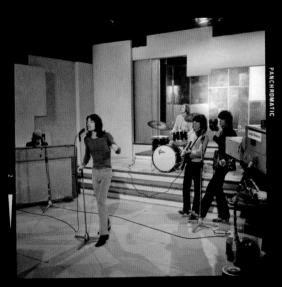
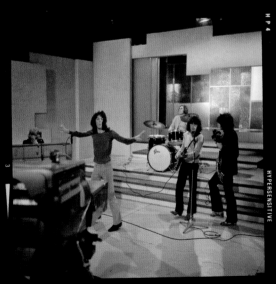

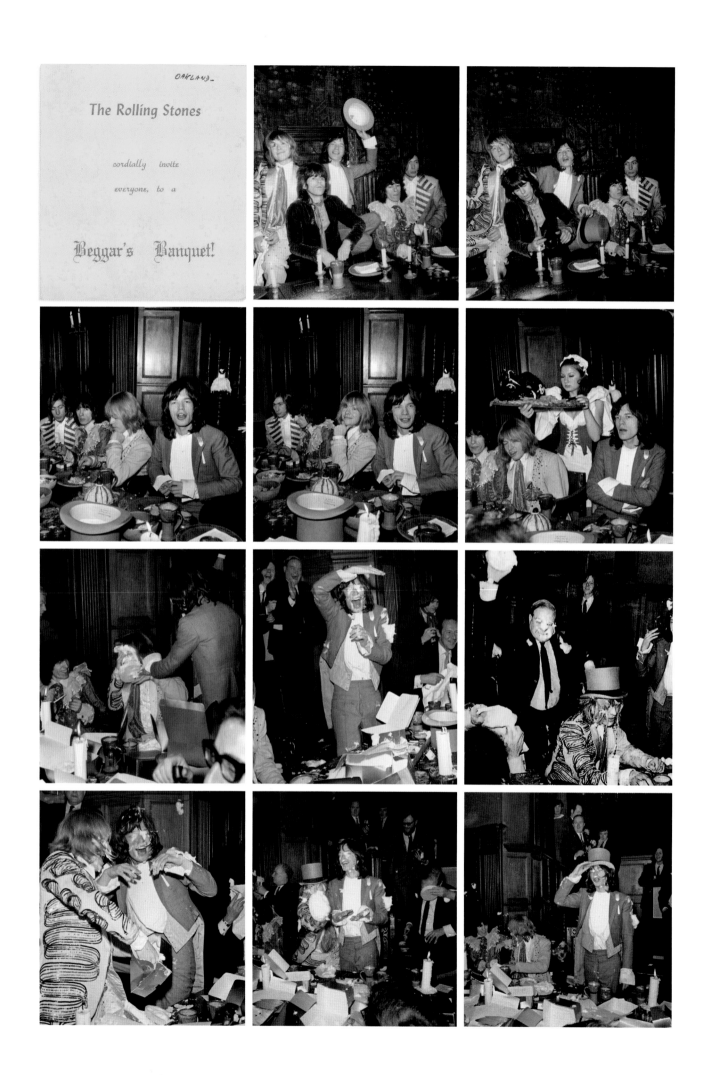

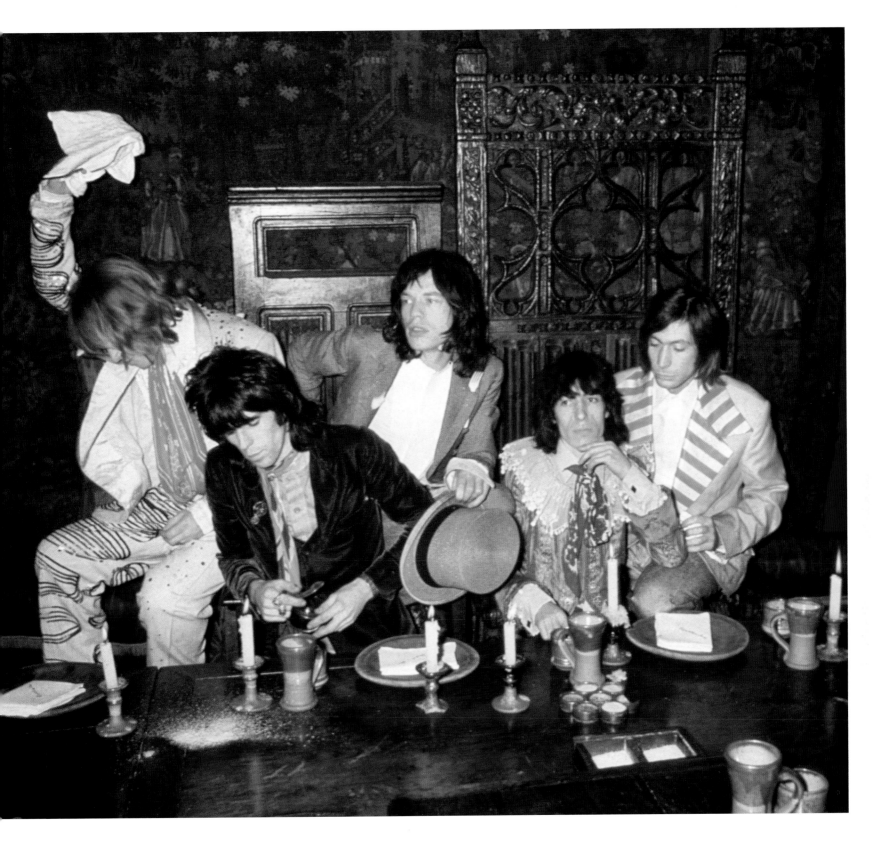

Gore Hotel | London, UK | 5 December 1968

It was the launch for *Beggars Banquet* and we wanted to do something
a little different. After we had eaten, I thanked everyone for coming,
then picked up a custard pie and rubbed it all over Brian's face. After
that it all got a bit out of hand. MICK

The man in the suit and tie with cream over his face is our PR man Les
Perrin. Also there was Lord Harlech, the president of the British Board of
Film Classification. They, along with all the journalists we'd invited, joined
in with a great deal of enthusiasm. I hated all that pie throwing. CHARLIE

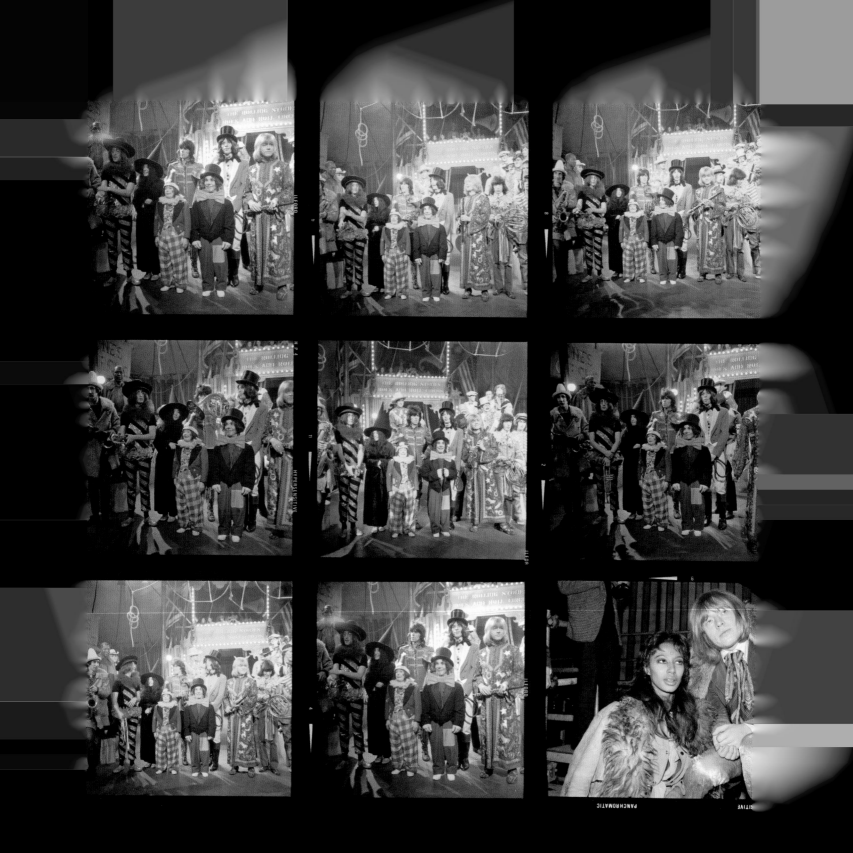

ve and overleaf

e Rolling Stones Rock and Roll Circus | Intertel Studios | Wembley,
ndon, UK | 10–11 December 1968

*worked with director Michael Lindsay-Hogg on this project that included
n Lennon, Yoko Ono, The Who and Eric Clapton.*

e of my lasting memories from Rock and Roll Circus *was Yoko crawling out of
lack bag that she'd been writhing around in on stage, only to start screaming
d wailing on a song of hers, backed by John on guitar and a French classical
inist. It kind of summed up the shambles that it all was.* CHARLIE

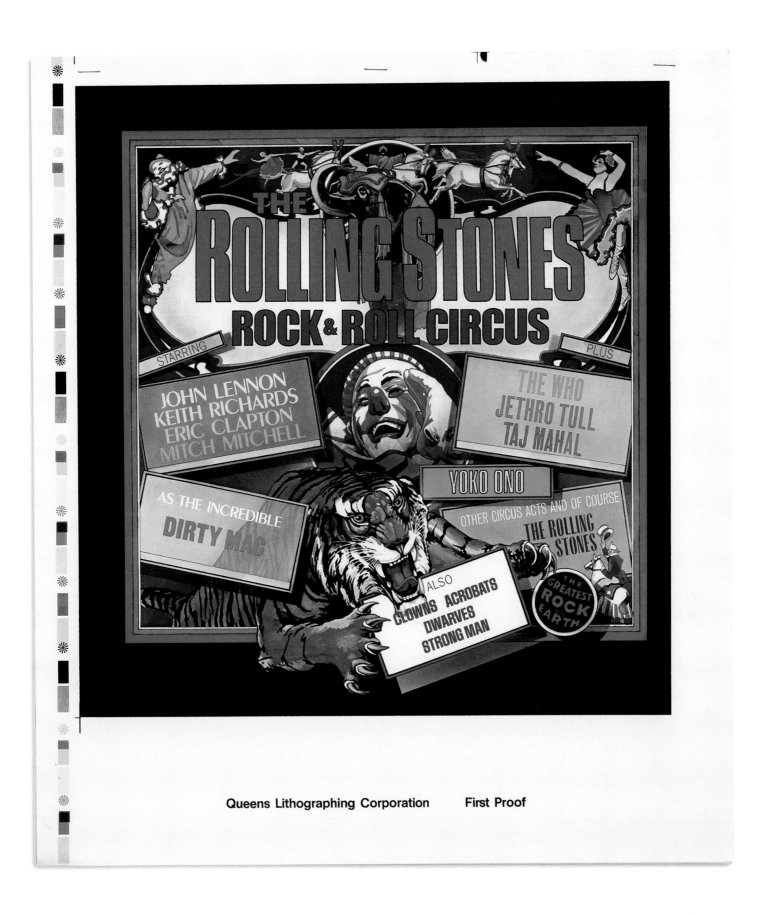

Queens Lithographing Corporation First Proof

*This printer's proof is a rejected cover
design for the planned album.*

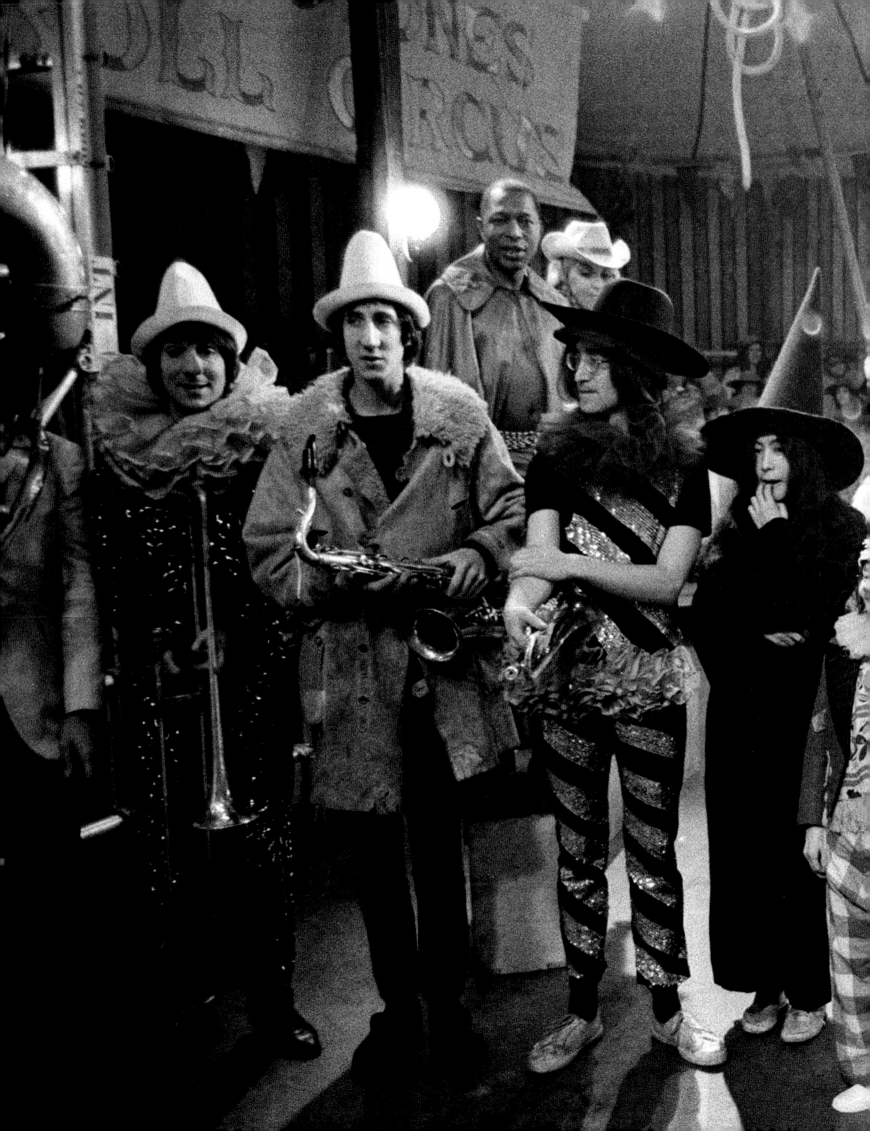

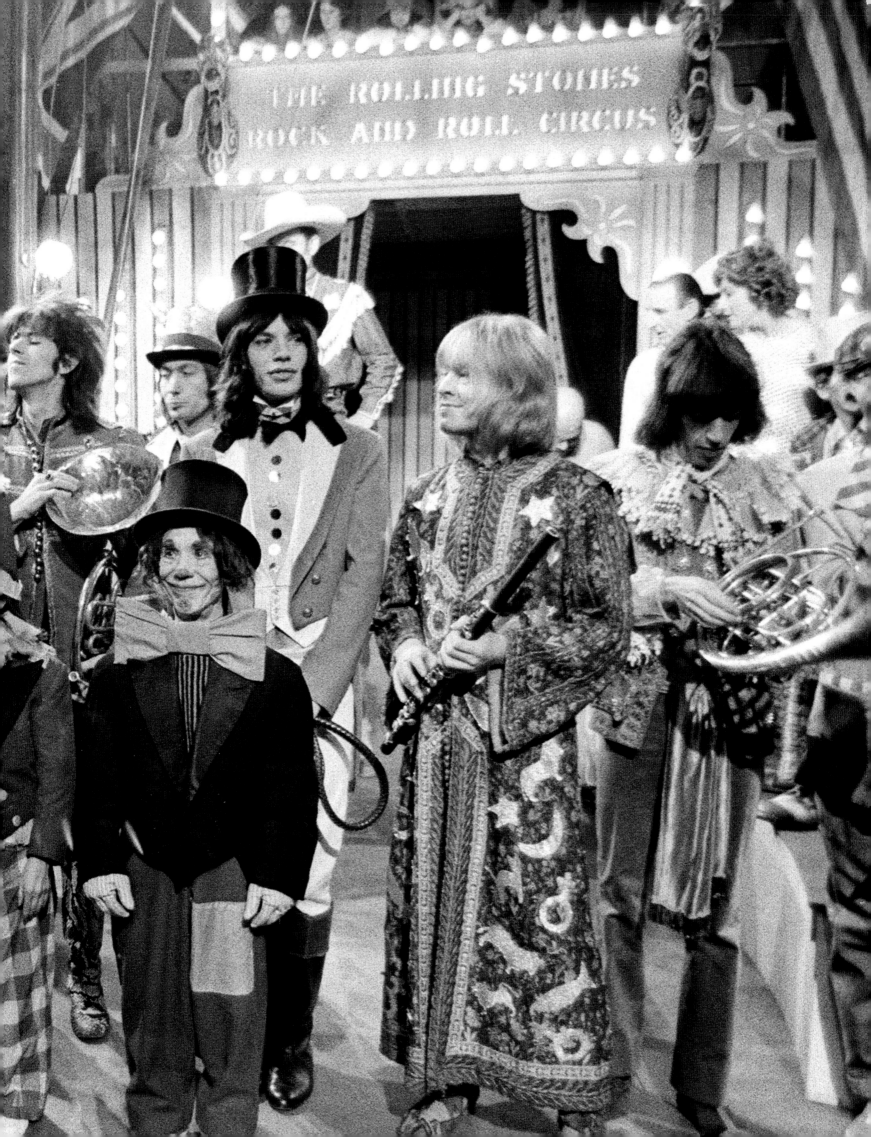

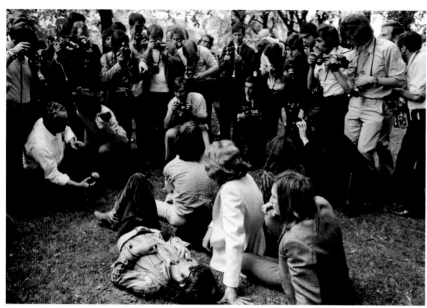

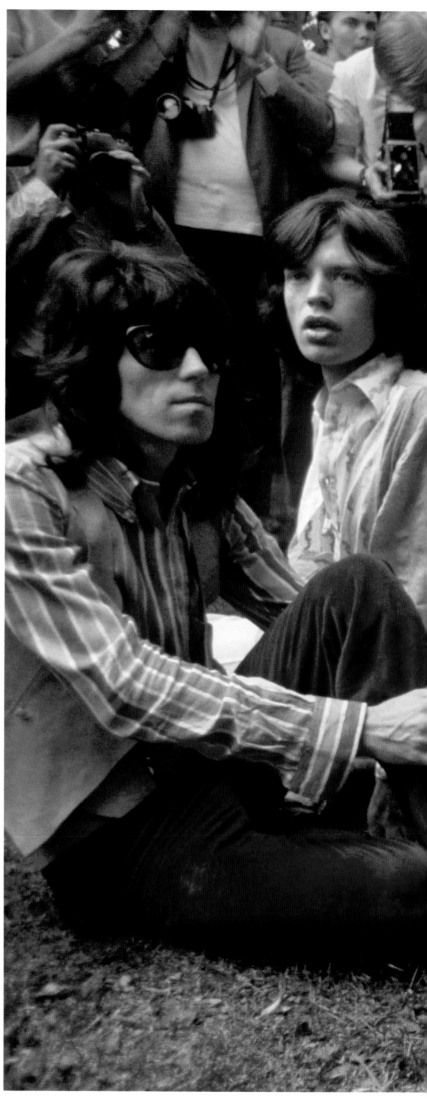

Hyde Park, London, UK | 13 June 1969

*We did a press conference at the bandstand
in Hyde Park to introduce Mick Taylor, Brian's
replacement, and to announce that we would
be giving a free concert in the park on 5 July.*

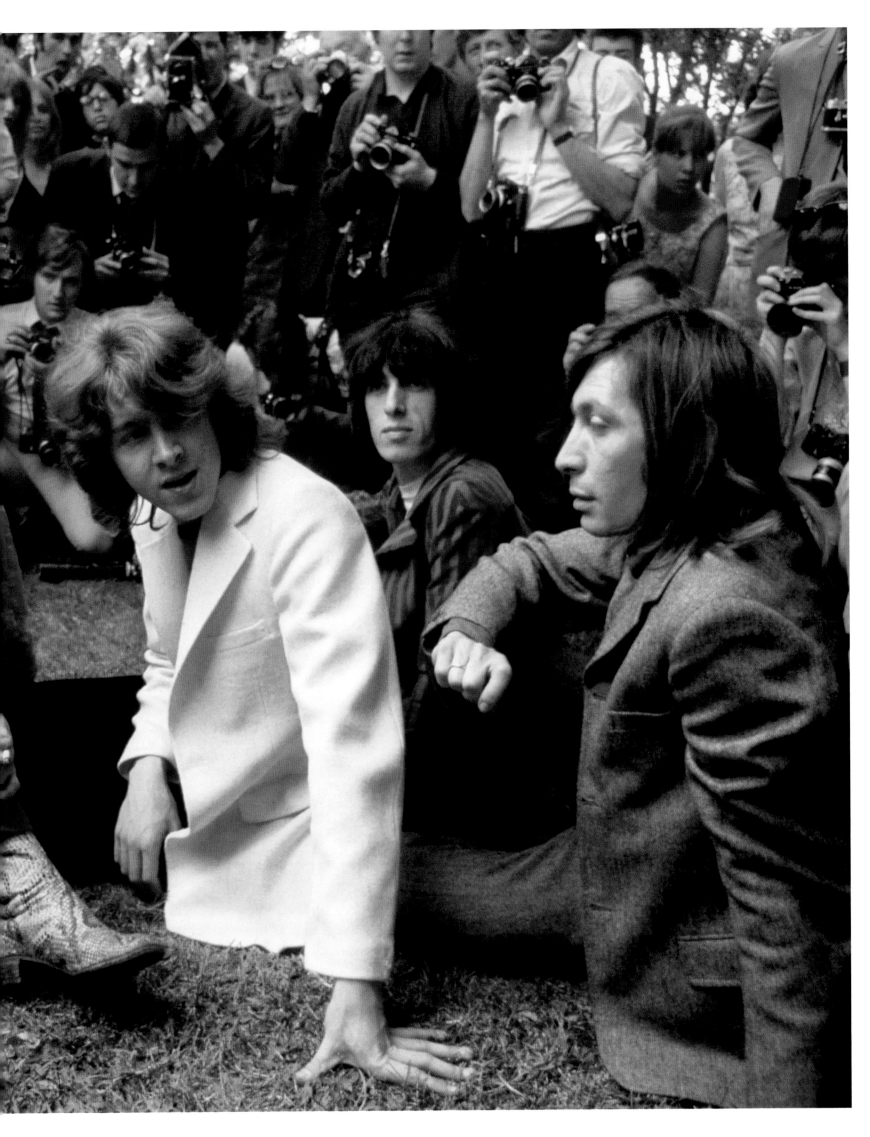

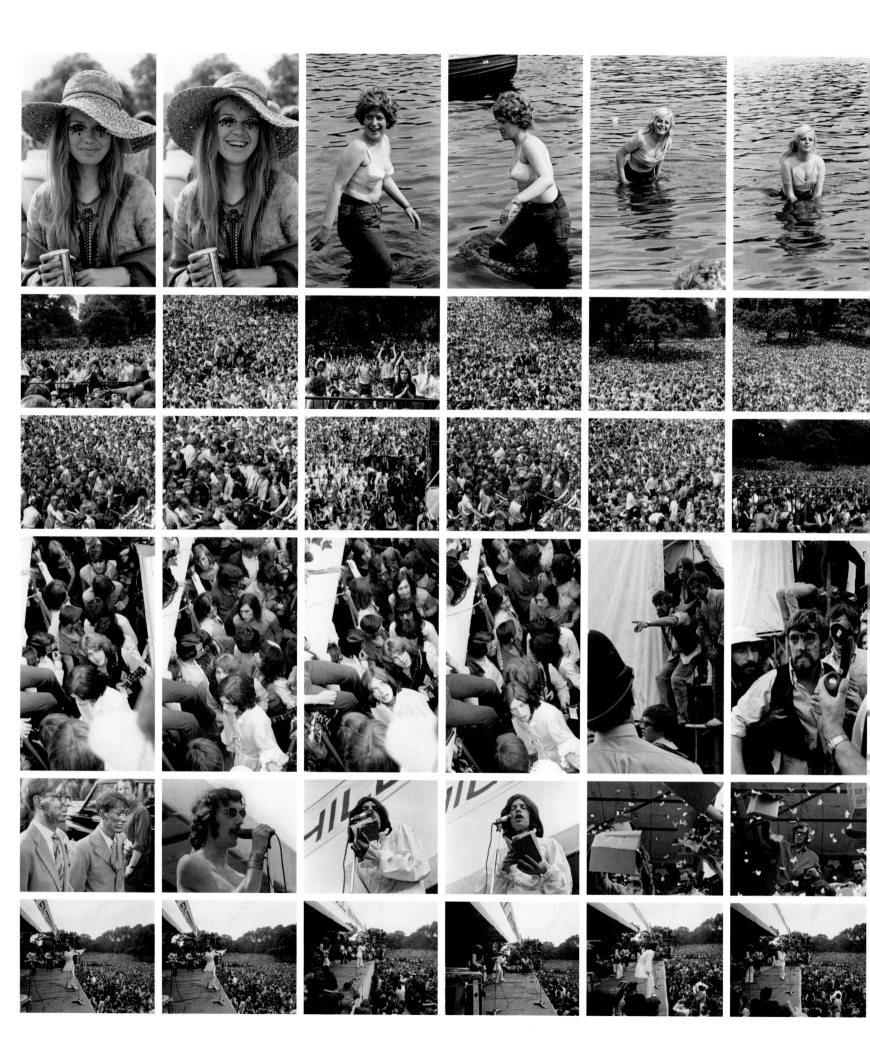

Hyde Park, London, UK | 5 July 1969

'The greatest rock and roll band in the world. They're incredible. Let's hear it for the Stones!' is how Sam Cutler introduced us when we went on stage to play to anything from 250,000 to 500,000 people.

Hyde Park was important, not because of the musical content but because it was one of the largest gatherings ever held in London. It was also one of the most abysmal-sounding shows we've ever done. KEITH

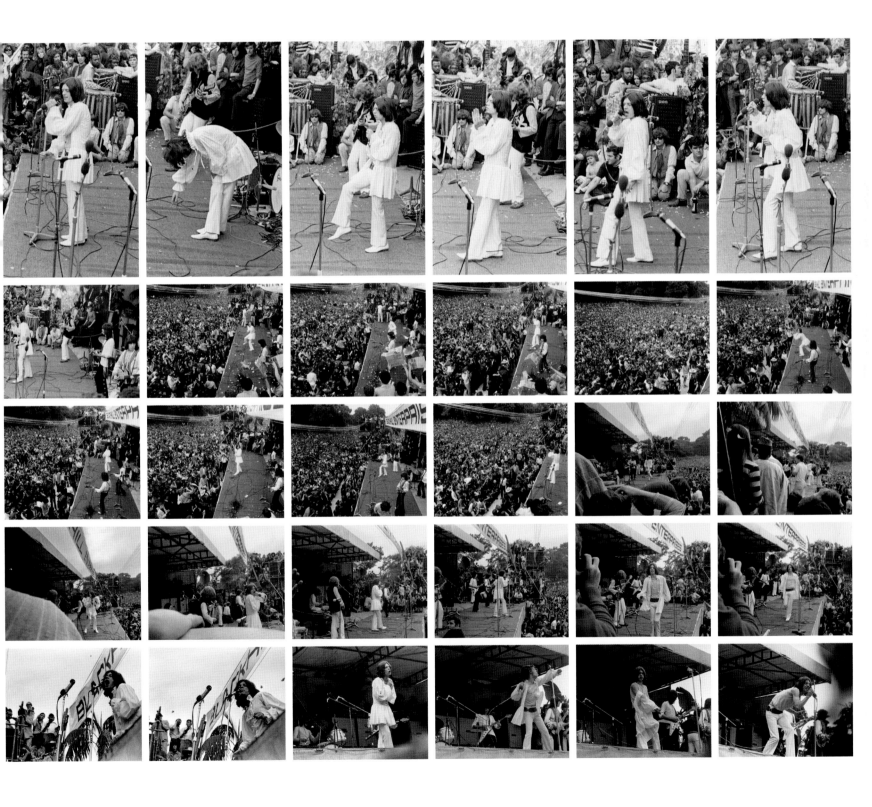

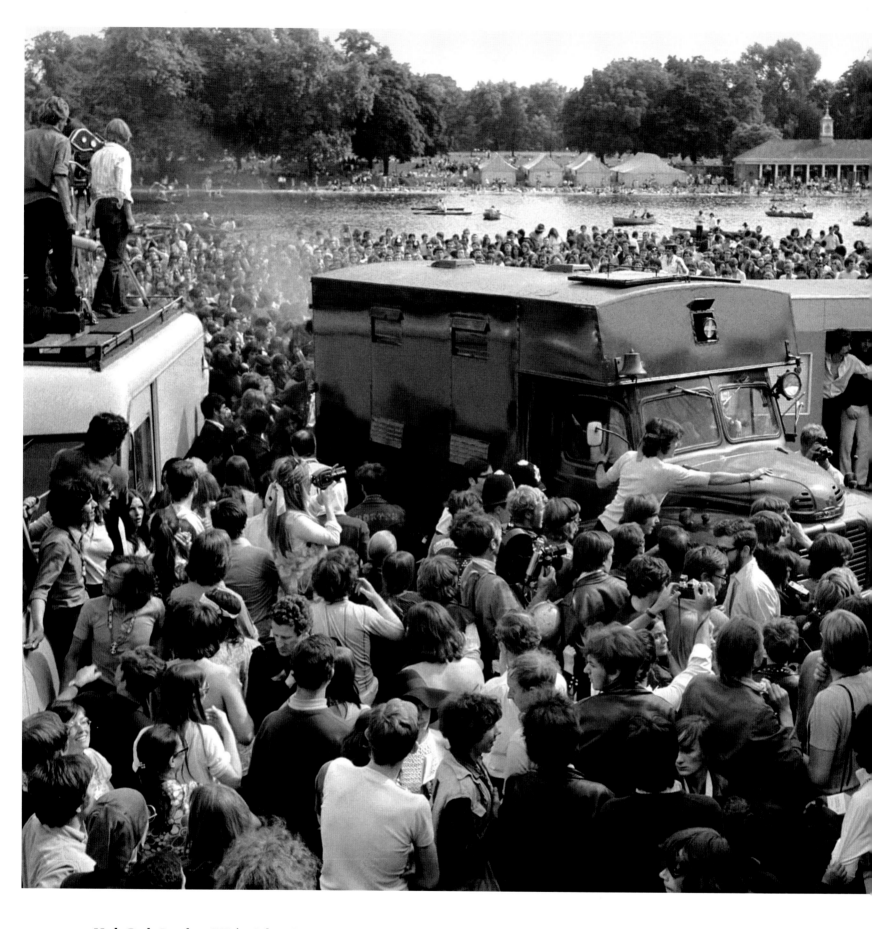

Hyde Park, London, UK | 5 July 1969

The van in the main picture is the old military ambulance that was used to get us into the backstage area at Hyde Park. The caravan behind it was our dressing room.

There was a sea of people in Hyde Park and I was walking around the outside wondering how I could get into this band. RONNIE

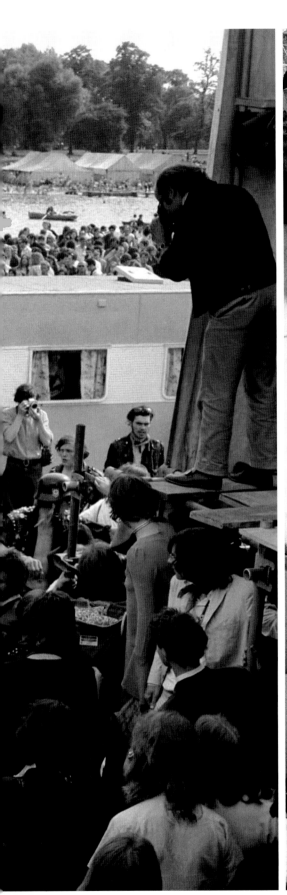

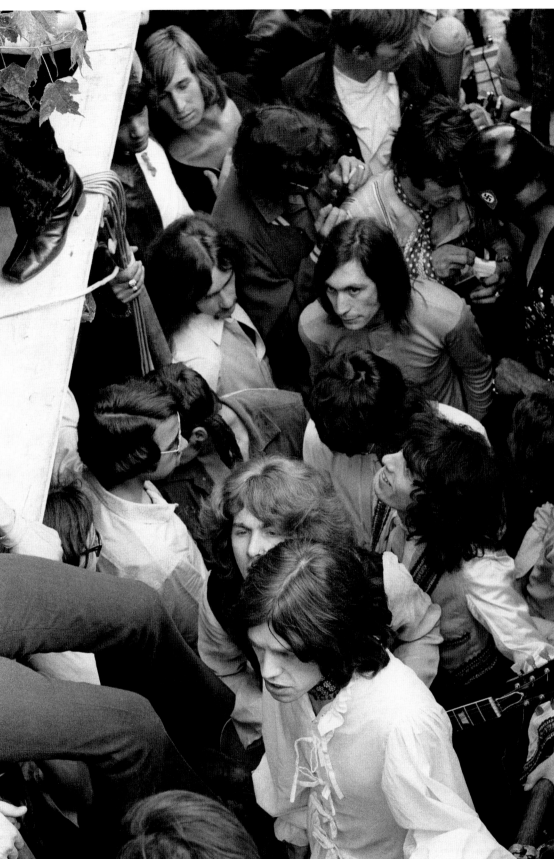

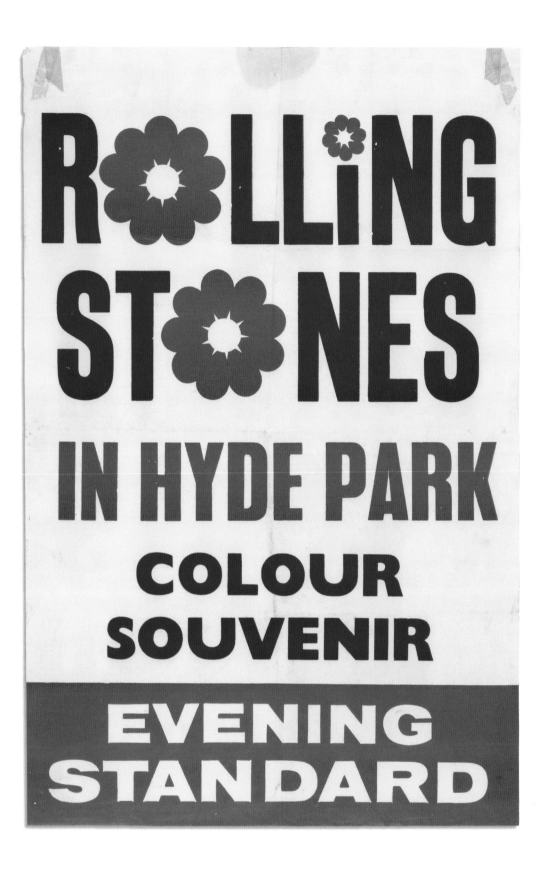

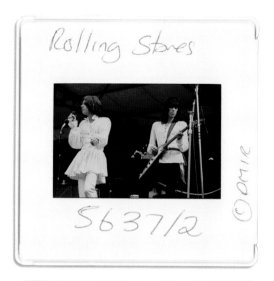

Rolling Stones

5637/2 ©DMro

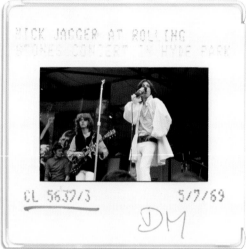

MICK JAGGER AT ROLLING
STONES CONCERT IN HYDE PARK

CL 5637/3 5/7/69

DM

CL5637/15

5/7/69

©Daily Mirror

Hyde Park, London, UK | 5 July 1969

It was a challenge to go out and play for all those people. I think
we were pleased to get out and play with somebody else, because
we'd been like a horse with three legs. The bad part was that Brian
wasn't there any more, which was really sad. MICK

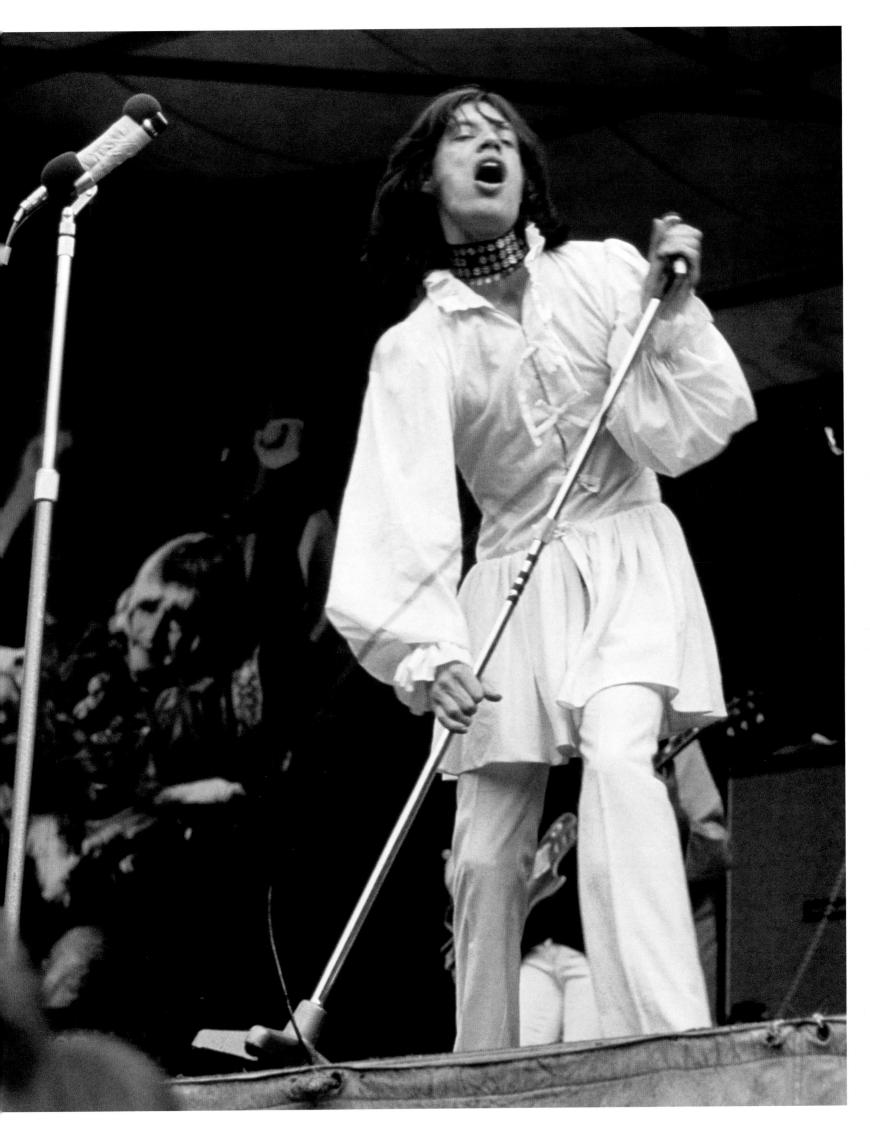

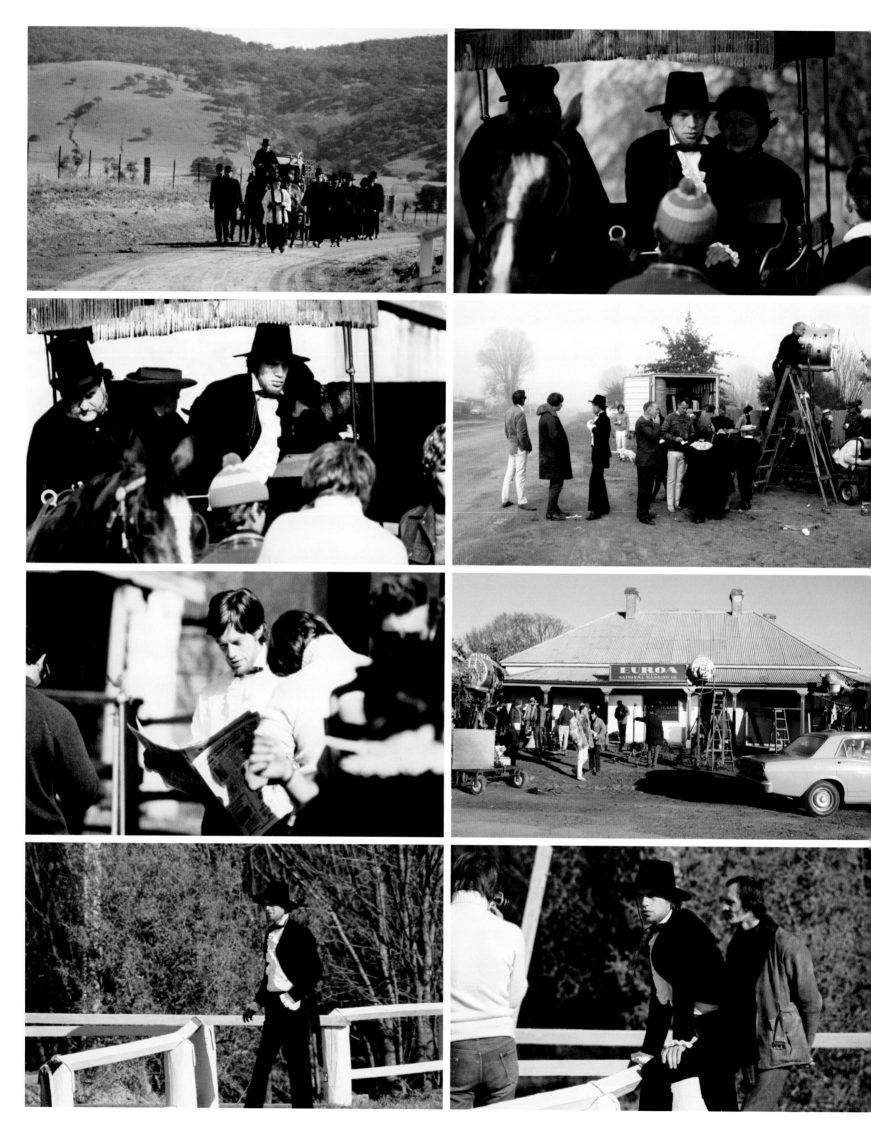

Filming *Ned Kelly* | Braidwood, New South Wales, Australia | August 1969

I wrote 'Brown Sugar' in Australia in the middle of a field. They were really odd circumstances.
I was doing this movie, *Ned Kelly*, and my hand had got really damaged in this action sequence.
So stupid. I was trying to rehabilitate my hand and I had this new kind of electric guitar, and
I was playing in the middle of the outback and wrote this tune. MICK

North American tour | 7–30 November 1969

We were like a phoenix and the 1969 tour was our first resurrection. We played twenty-three shows in sixteen cities on our first North American tour since 1966. We really had to tighten up and get our stage chops together, but at least we were a working unit again. KEITH

The tour was filmed and the movie, Gimme Shelter, *premiered at the end of 1970.*

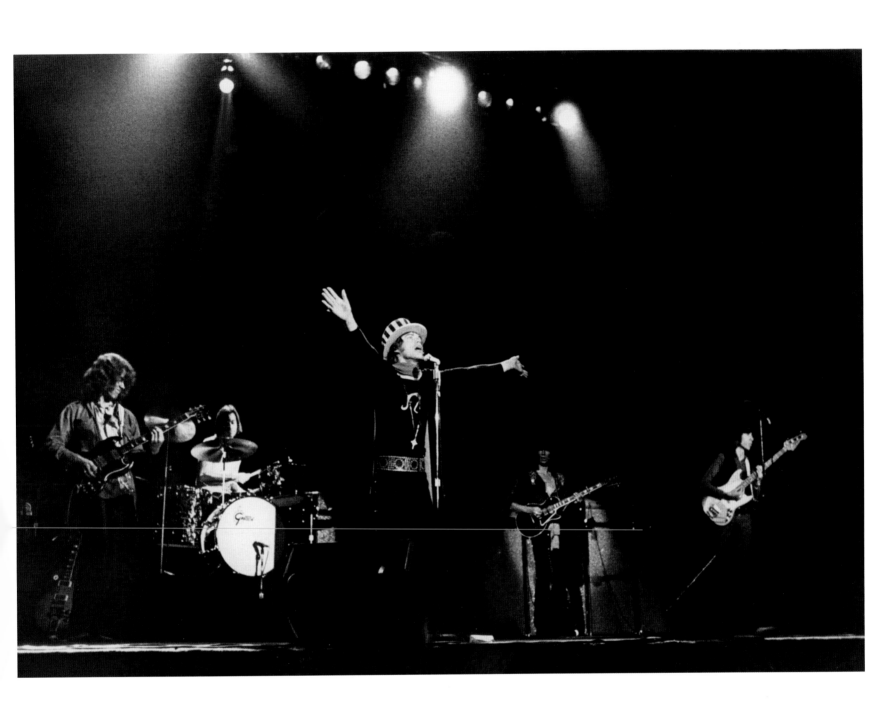

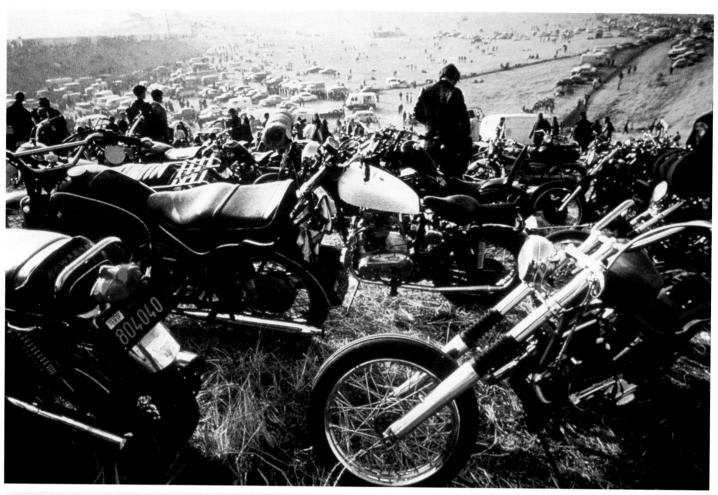

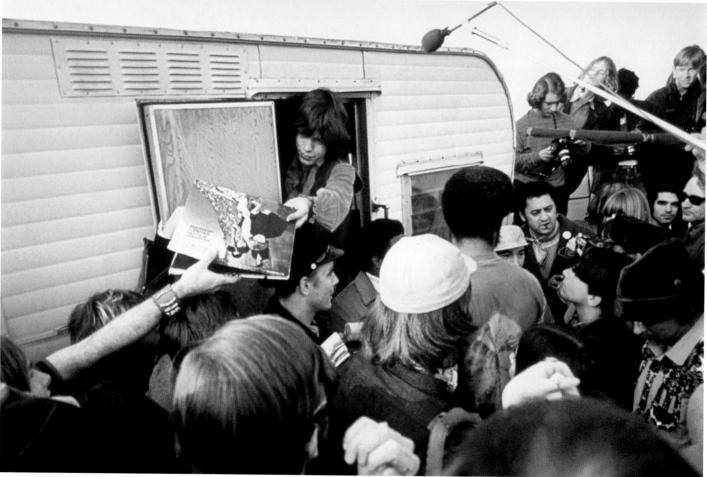

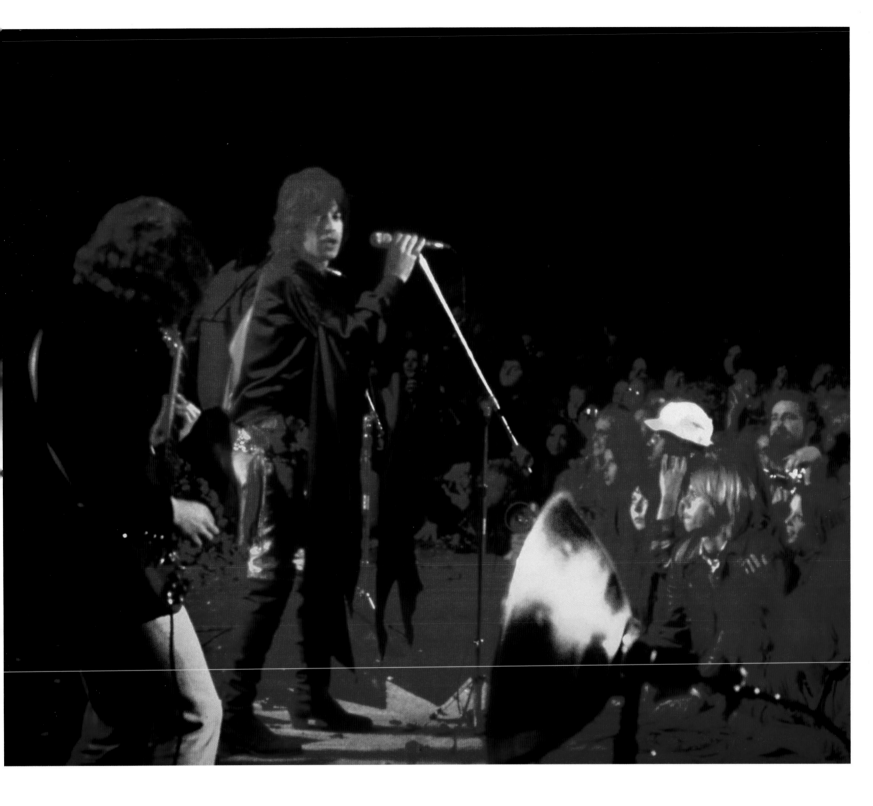

opposite, above and previous pages

Altamont Speedway | Livermore, California, USA | 6 December 1969

Altamont came right at the end of the tour. We came into Altamont by helicopter, got out and saw oceans of people completely out of it. If Woodstock started it, we ended it. I didn't see the stabbing and wasn't aware of it until later on when we saw the footage for *Gimme Shelter*. What happened at Altamont was not what we played music for. We had, yet again, got into another fine mess. CHARLIE

Thank God we got out of there, because it was hairy – though we were used to hairy escapes. This one was just on a bigger scale in a place we didn't know. KEITH

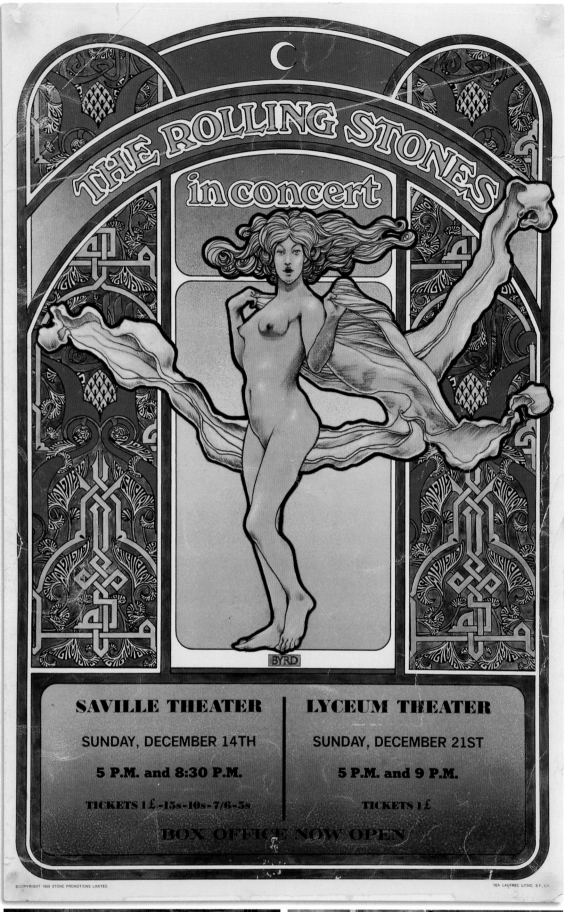

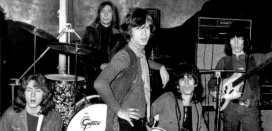

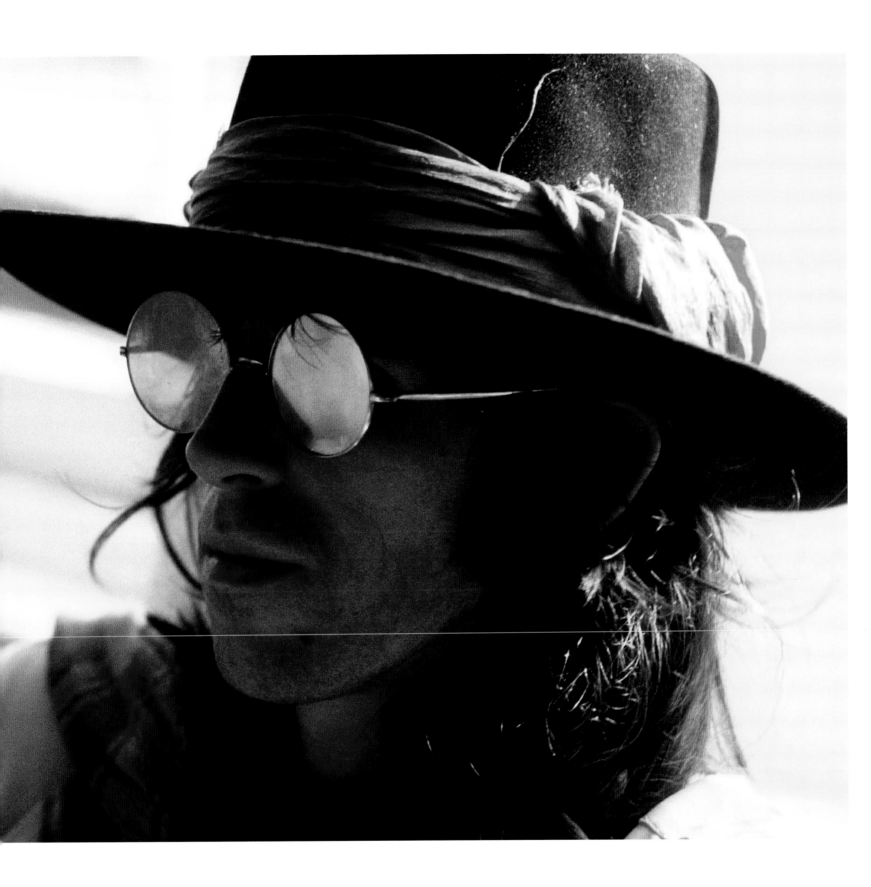

Saville Theatre | London, UK | 14 December 1969

Back from America, we played two shows in London to reconnect with our British fans. At the time it didn't really feel like the end of an era. The Sixties only became The Sixties *as time went on.*

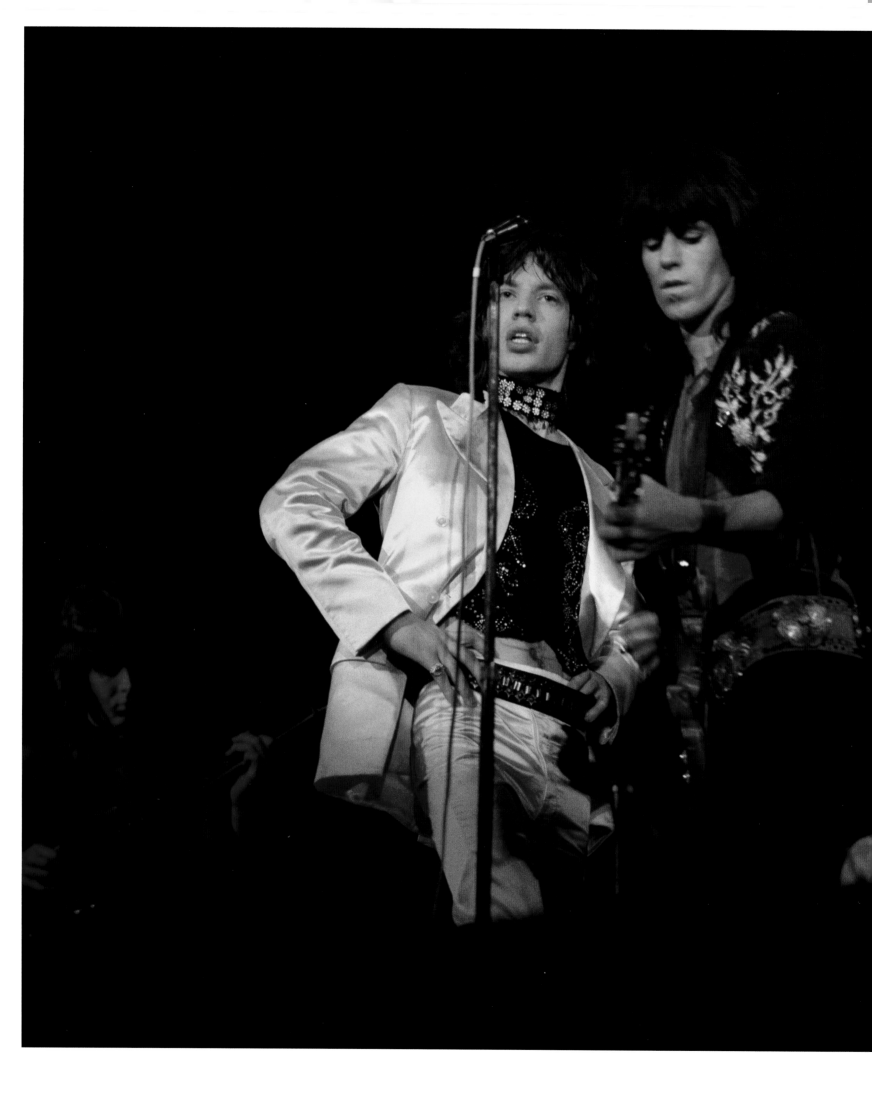

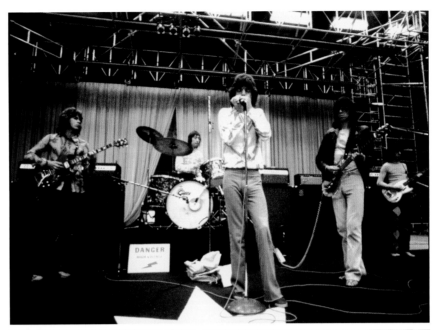

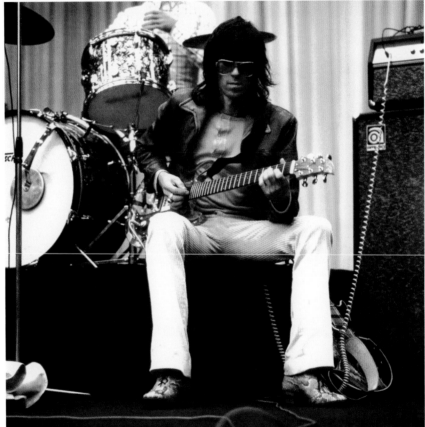

European Tour | 30 August – 9 October 1970

*This was our profitless tour – despite playing for over 200,000 fans at twenty dates.
The costs were enormous and we had more people than ever on the road with us.
We didn't play enough large venues to make the thing work and we had too many
days off compared with the way we used to do things. However, back then, touring
was all about selling records and we certainly did that. The photo on the left is at
Vejlby-Risskov Hallen, Aarhus, Denmark, on 9 September and the two above are
at Baltiska Hallen, Malmö, Sweden, on 30 August.*

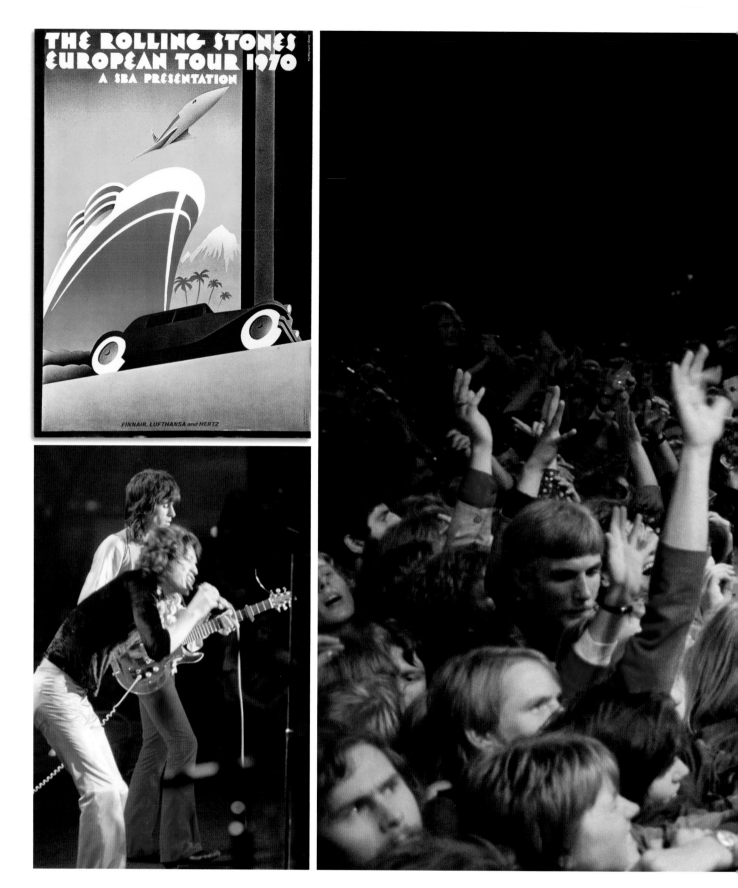

above

Rai Halle | Amsterdam, Netherlands | 9 October 1970

This was the last night of our tour.

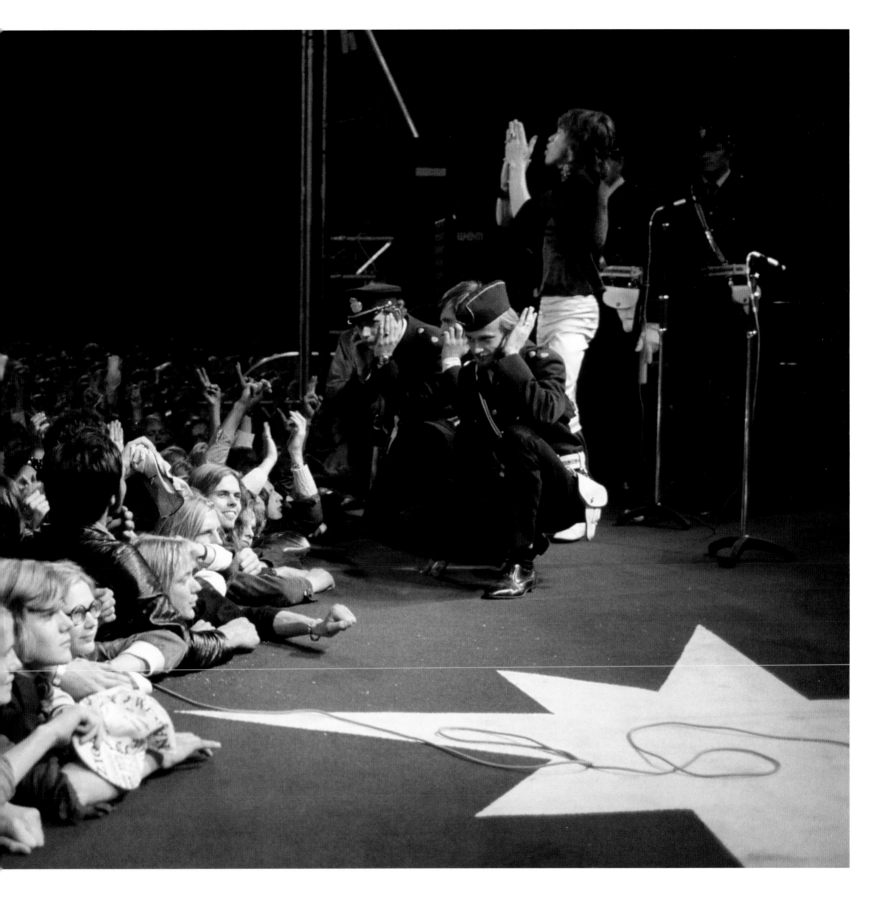

Somewhere in Scandinavia | August – September 1970

It was during this tour that Jimi Hendrix died and, before it ended, Janis Joplin had also passed away. It seemed like every interview focused on our age and how long we'd keep going. On several occasions I told an interviewer that I'd pack it in by the time I was thirty. It was like everyone thought you had to be young to play rock 'n' roll. I think we've successfully disproved that point. MICK

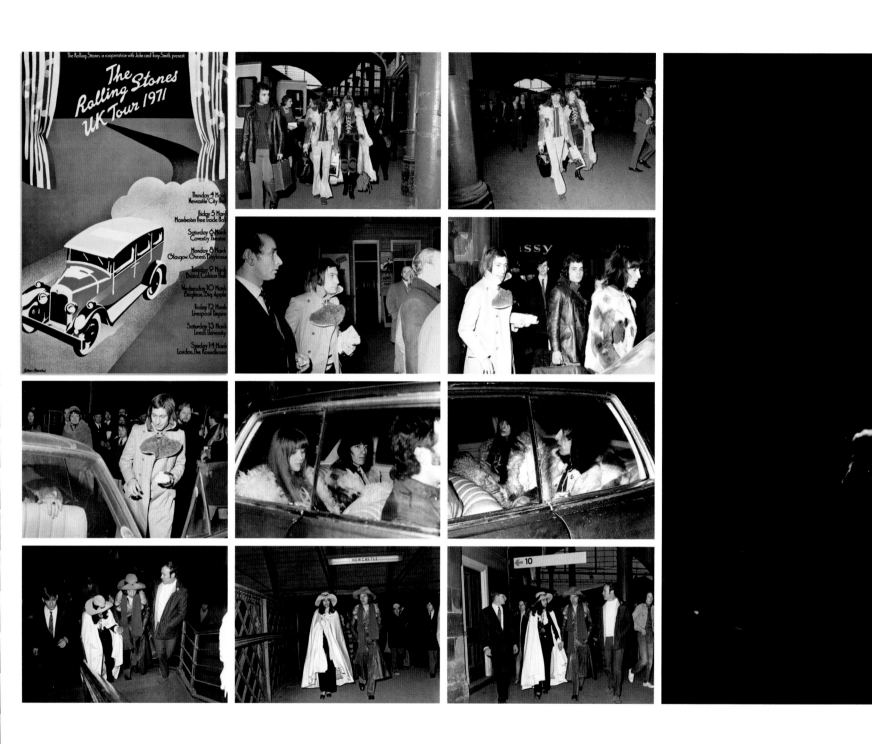

City Hall | Newcastle upon Tyne, UK | 4 March 1971

This was our first tour of the UK since the autumn of 1966. It was also our farewell tour as we had, for tax reasons, decided to move to France. We did sixteen shows in nine cities and this was our first show of the tour. We all took the train to Newcastle and, in the pictures on the left, that's us arriving at Newcastle station. The photographs on the right are of us leaving the hotel the next morning to head to Manchester, where we played the Free Trade Hall.

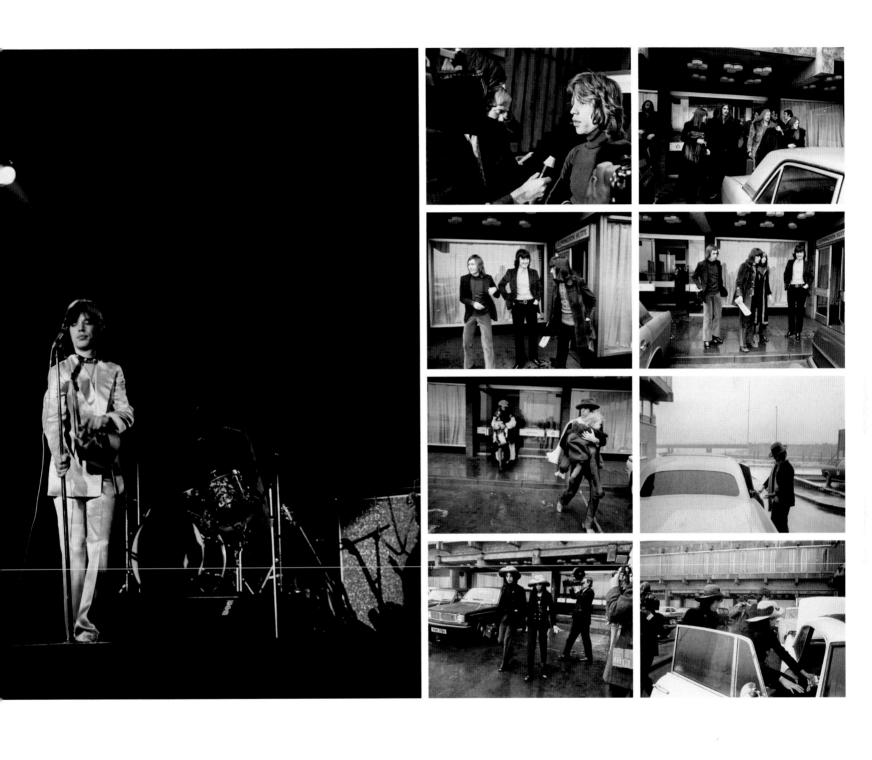

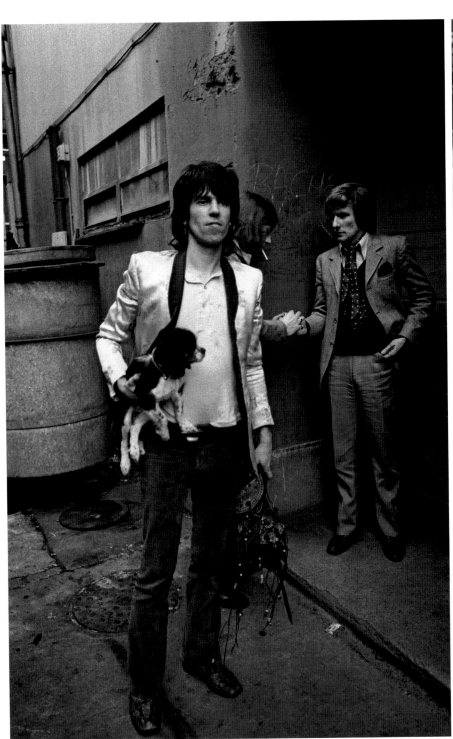
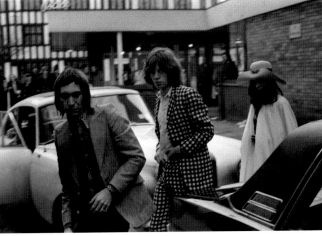
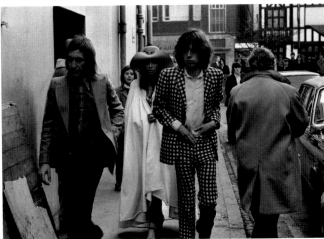
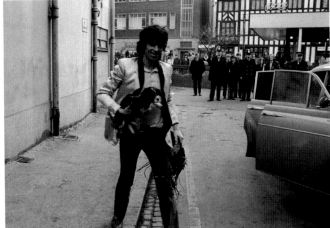

Coventry Theatre | Coventry, West Midlands, UK | 6 March 1971

I had a real problem with my dog, Boogie, after the Glasgow show when
we went to Bristol. I'd missed the train that everyone else had taken and
so had to take a flight. The airline wouldn't let me take the dog in the cabin
so, after much arguing, he had to go in the hold. I wasn't happy. KEITH

The Roundhouse | London, UK | 14 March 1971

We were forced onto our back foot by the whole tax thing. So the only thing to do was to go away, reconstruct everything and say, 'We're all going to do this boys: we're going to move out. Let's be a family.' KEITH

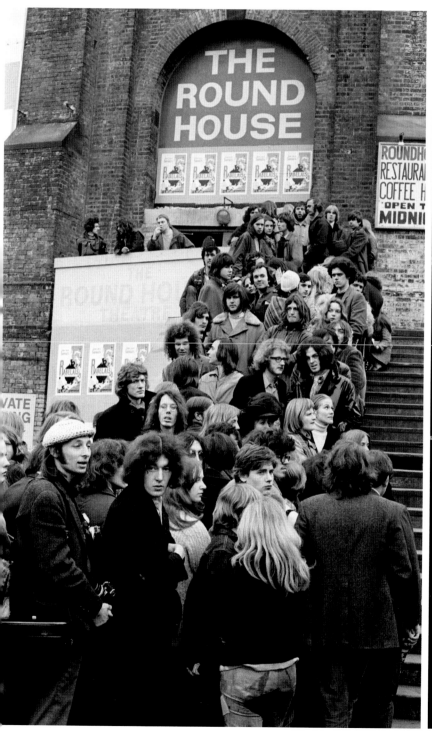

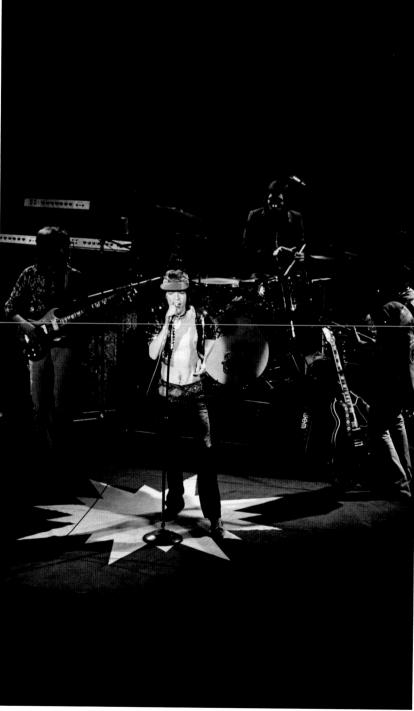

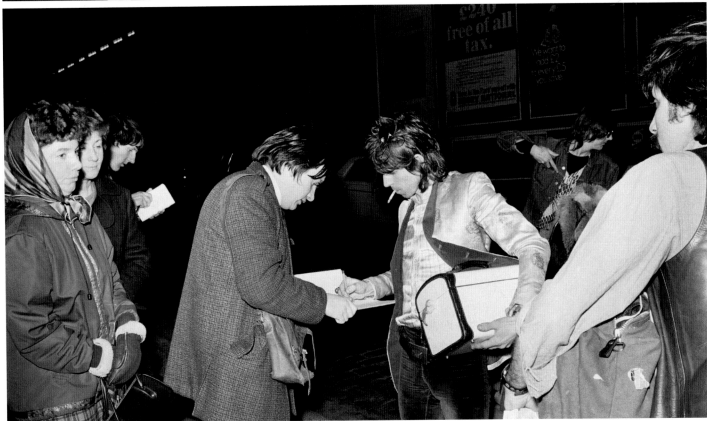

Empire Theatre | Liverpool, UK | 12 March 1971

We're not sure if the poster in the background of the photos above was there especially for our benefit… Tickets sold out very quickly and we heard that fans stood in line for anything up to sixteen hours – a long time to be standing out in the cold in the middle of winter. Our set included 'Jumpin' Jack Flash', 'Dead Flowers', 'Prodigal Son', 'Wild Horses' and 'Little Queenie', with 'Sympathy for the Devil' and 'Let It Rock' for an encore most nights.

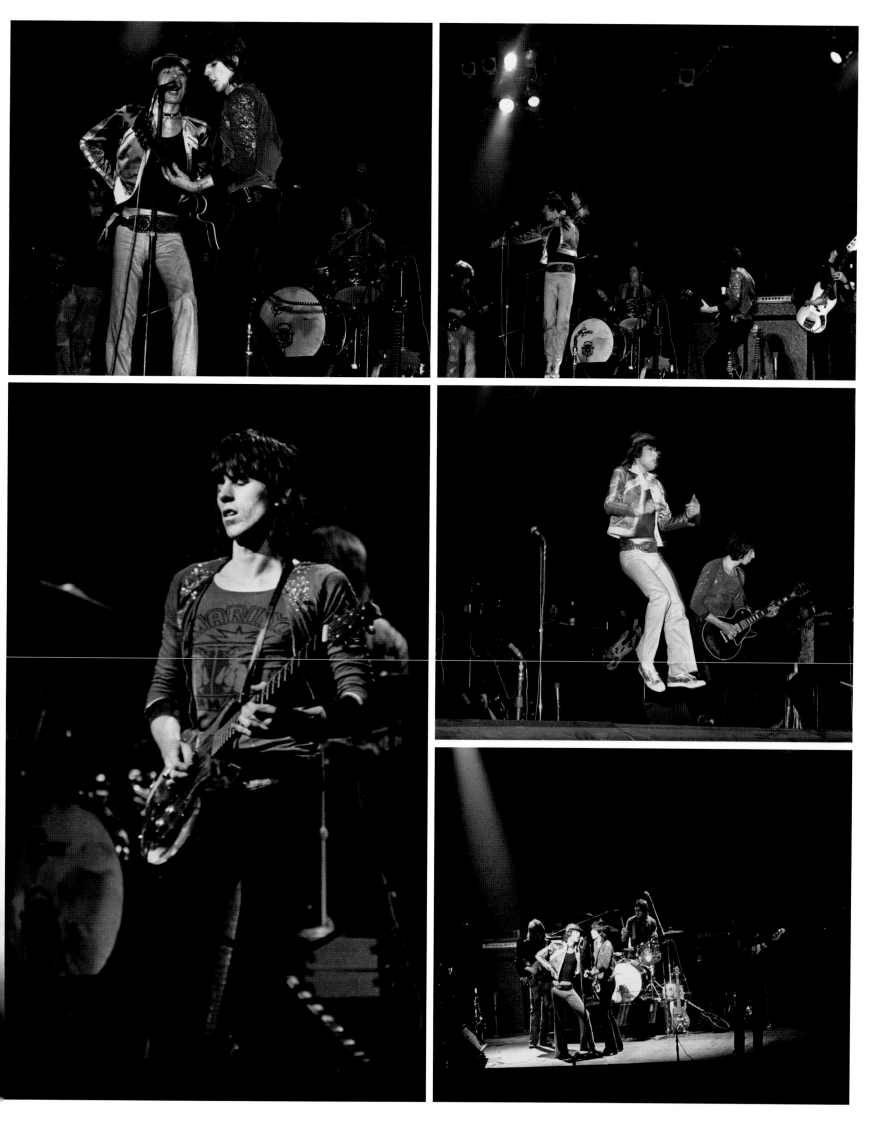

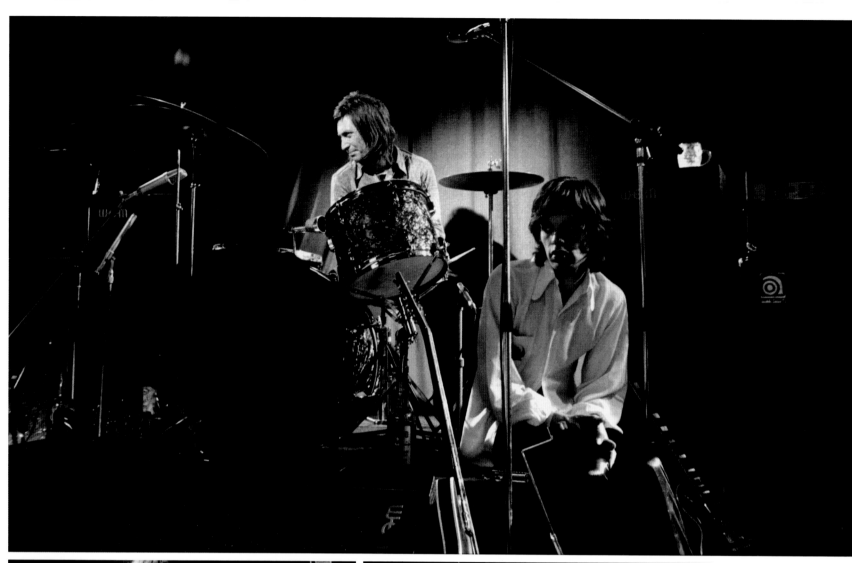

these pages and overleaf

The Marquee Club | London, UK | 26 March 1971

We filmed a TV special at the Marquee and did 'Live With Me', 'Dead Flowers',
'I Got The Blues', 'Let It Rock', 'Midnight Rambler', 'Satisfaction', 'Bitch' and
'Brown Sugar'. Bobby Keys was on sax and Jim Price on trumpet. The late,
great Nicky Hopkins played piano. In the photo above, the boy with Bill is his
son, Stephen. The pictures on this page were all taken at rehearsal. The one
overleaf is during the performance that was filmed.

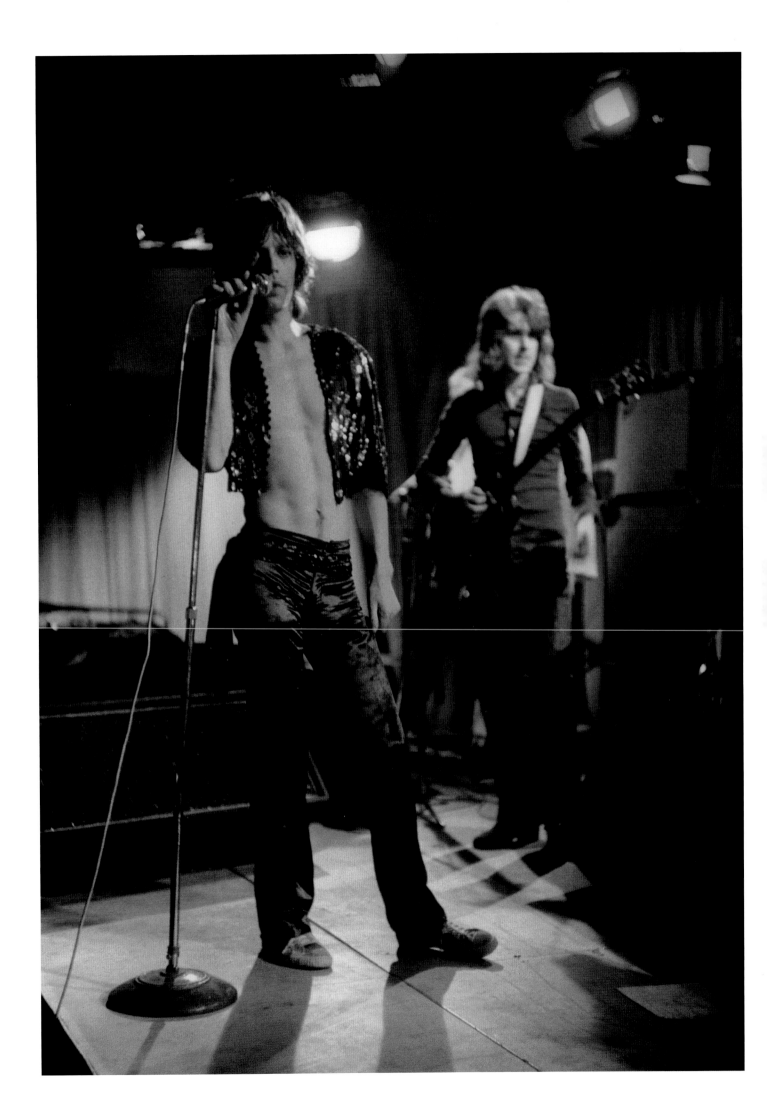

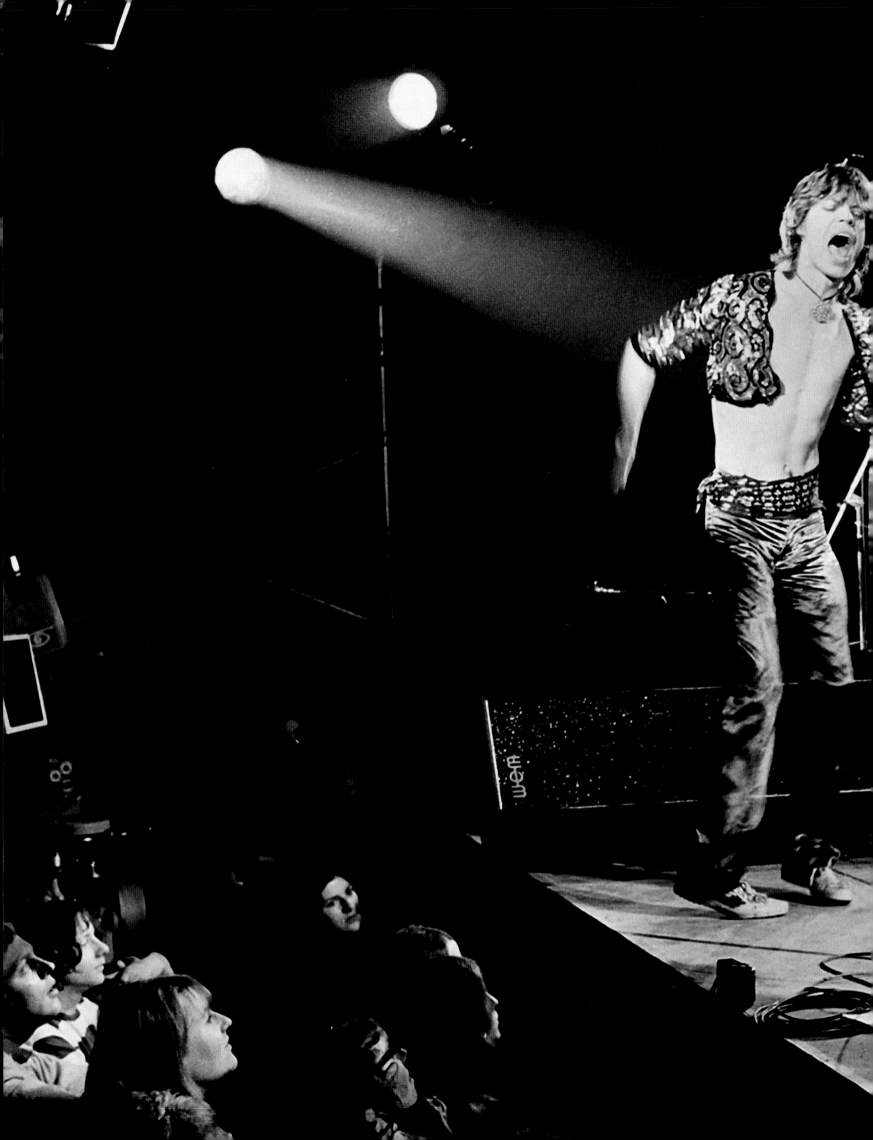

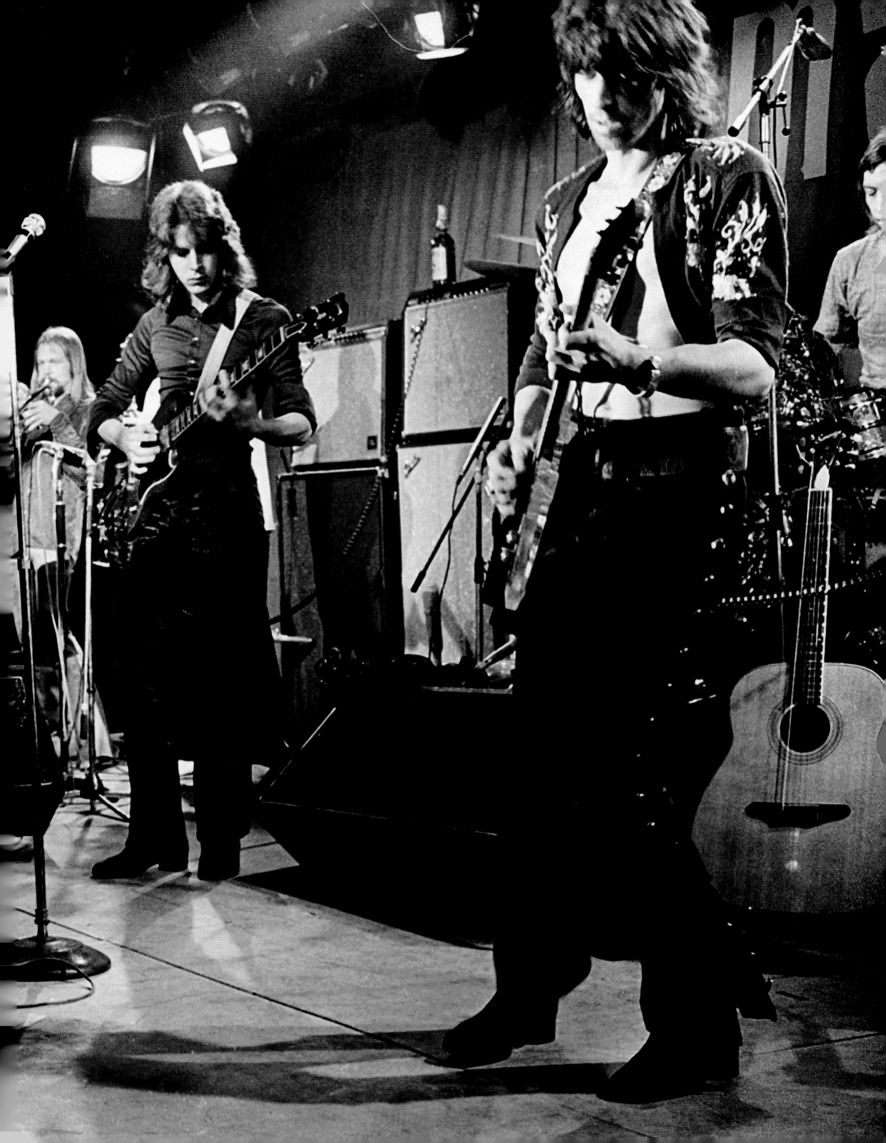

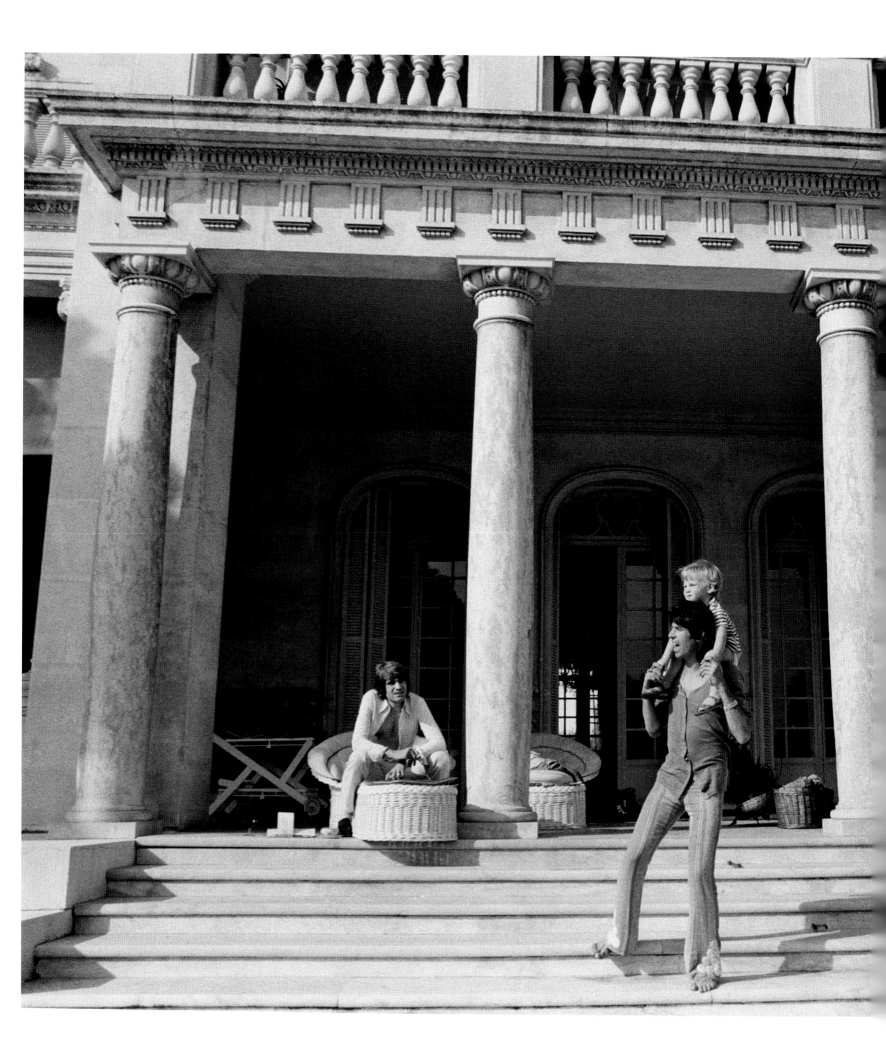

THE ROLLING STONES 50 | 1971

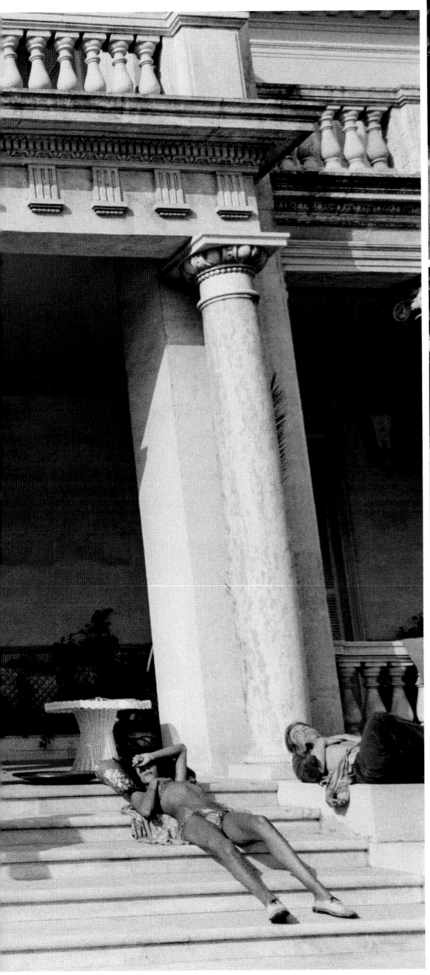

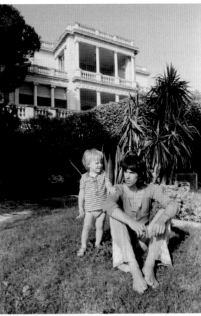
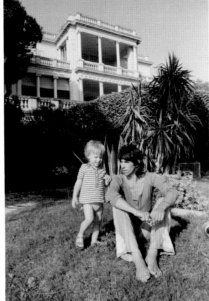
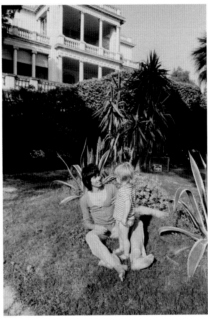
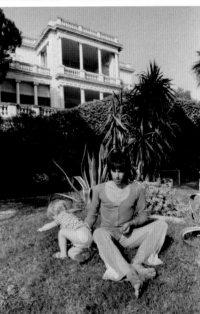

Nellcôte | Villefranche-sur-Mer, France | April 1971

Keith with his son Marlon, at Nellcôte in the Côte d'Azur.

Nellcôte was a great house, and it wasn't too showy. It was
in the bay at Villefranche and had been built in the 1890s.
We hadn't intended to record at my house but, having looked
around for a studio, we couldn't find anything suitable. KEITH

Everybody had a great time, but it was very stressful, because
the people who weren't in the band could go to London every
now and again, and we weren't able to do that. CHARLIE

Nellcôte | Villefranche-sur-Mer, France | April 1971

It was difficult. A couple of us would be in a room here, and
somebody would be through that door, and the piano would
be in another room again, and everything [was] coordinated
through our mobile recording truck. KEITH

Stu had the piano in one room, I'd be down in the cellar
and they'd move the guitars around. CHARLIE

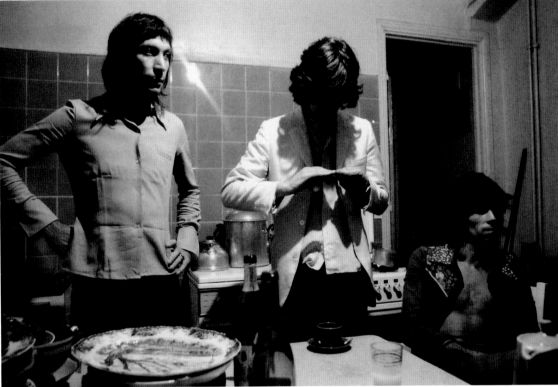

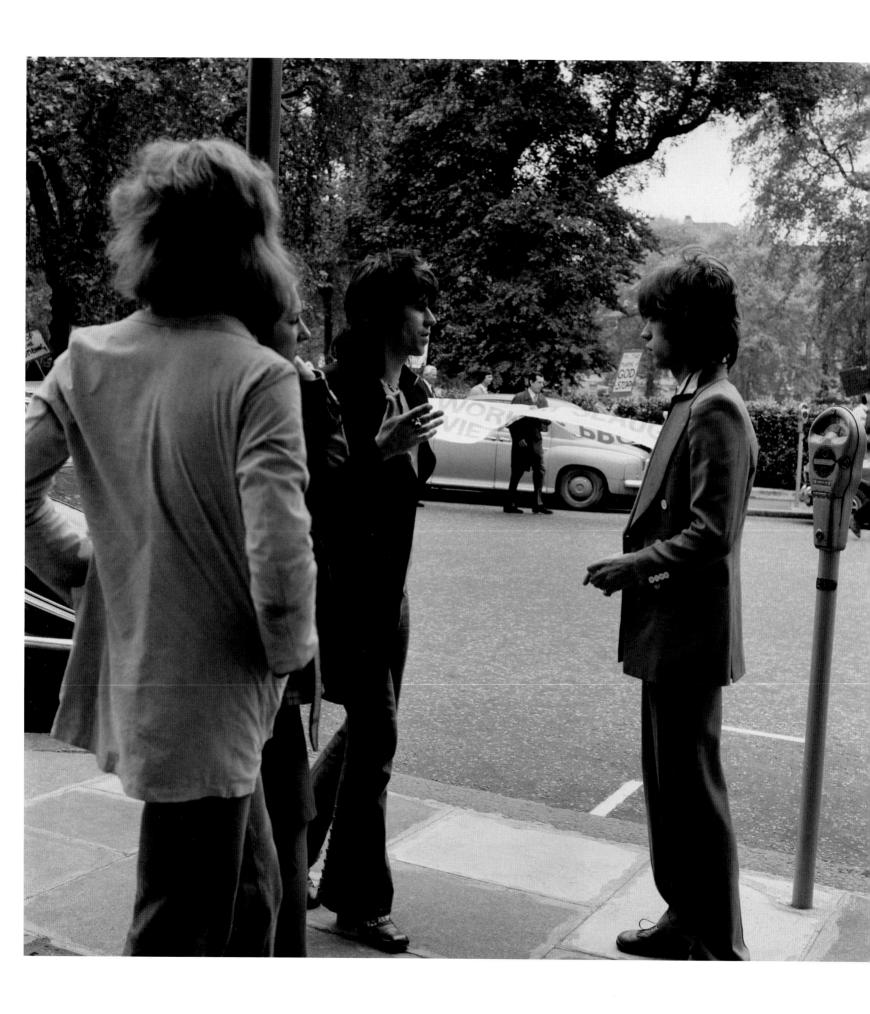

London, UK | 24 May 1972

We were back in London to do interviews as
Exile on Main Street had just been released.
'Tumbling Dice', the first single from the
album, had come out a month earlier.

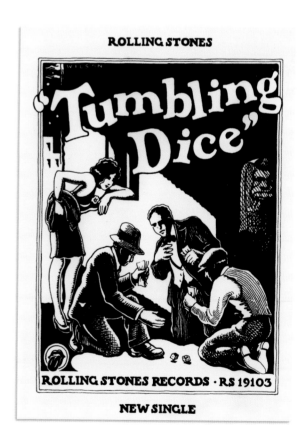

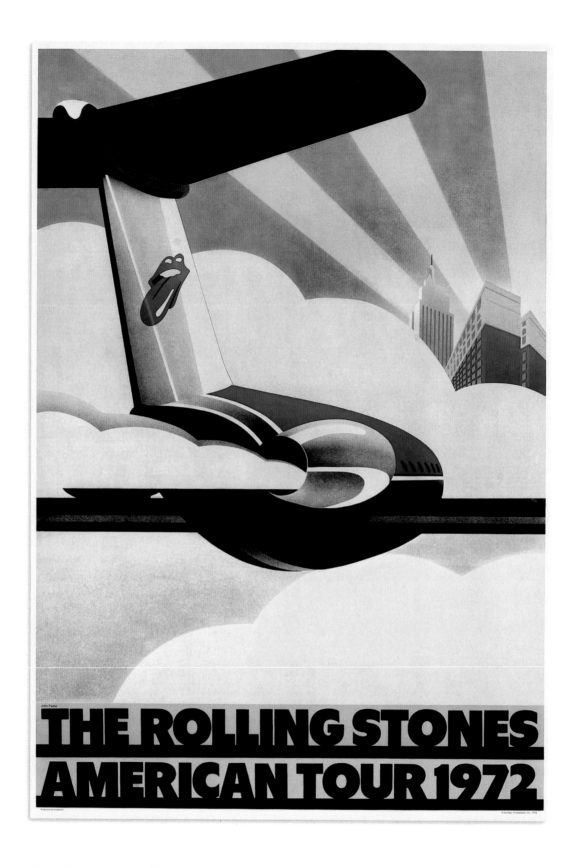

North American Tour | 3 June – 26 July 1972

Our seventh tour of North America began in Vancouver and ended in New York City nearly two months later. We played to almost three quarters of a million people, although it could have been several million, such was the demand for tickets. At fifty shows in over thirty cities, we grossed what was the largest amount of money for a rock tour at that point in history.

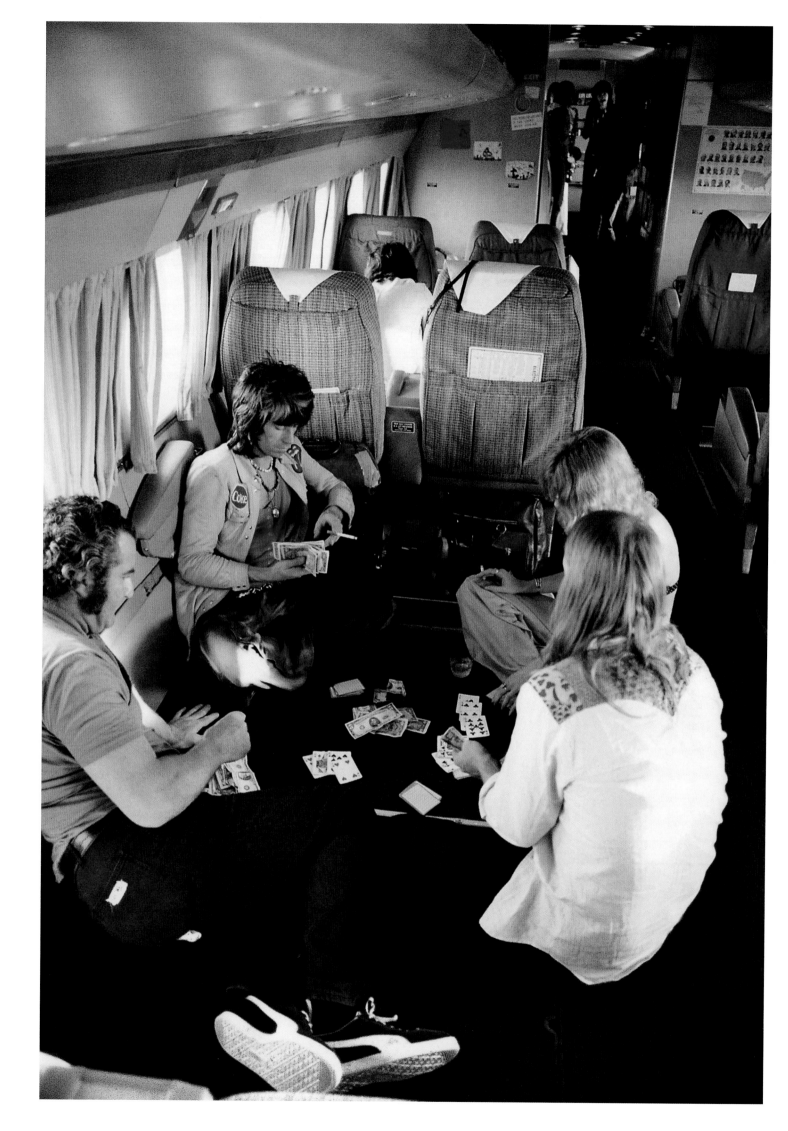

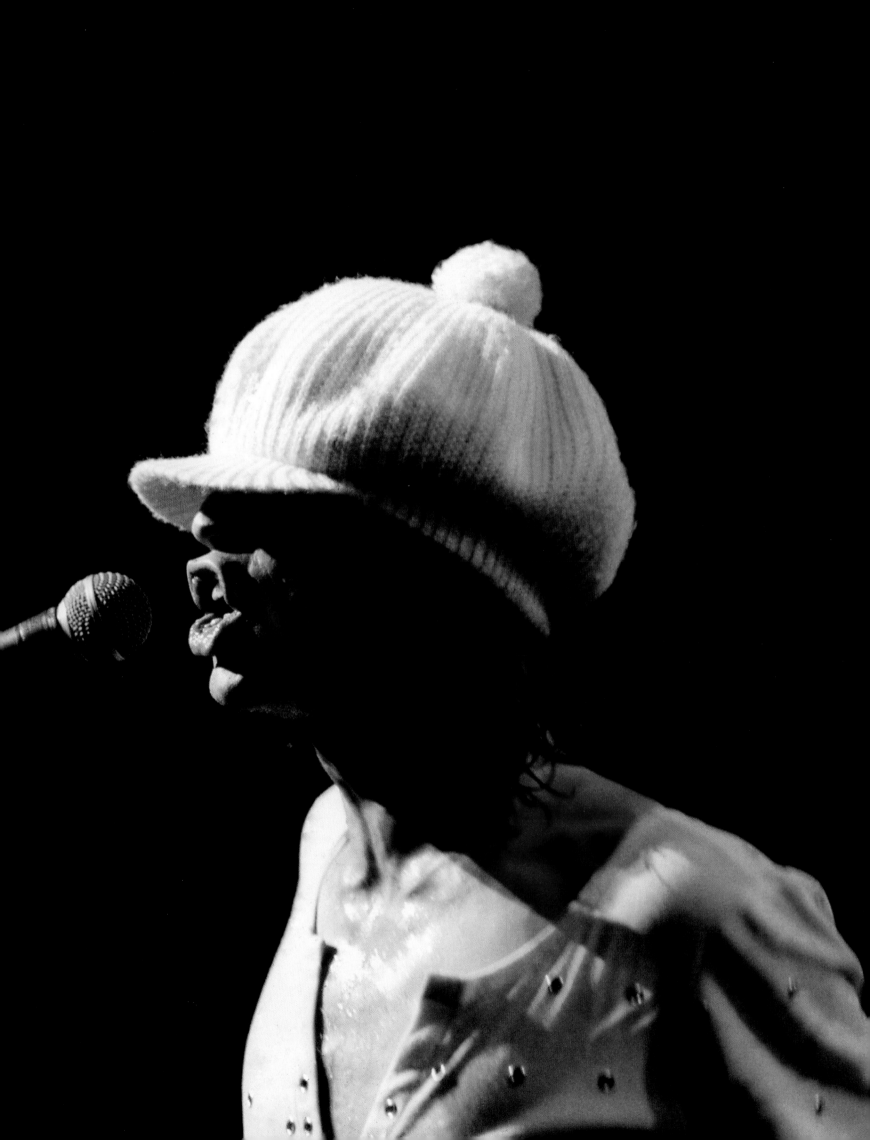

previous pages

Civic Arena | Pittsburgh, Pennsylvania, USA | 22 July 1972

The penultimate stop on our North American Tour, on which we were supported by the great Stevie Wonder.

The Forum | Los Angeles, California, USA | 18 January 1973

*We played a benefit for the victims of a Nicaraguan earthquake that had killed
and injured tens of thousands and left a quarter of a million people homeless.
It was another milestone: at that point, the highest-grossing rock concert ever.*

The Forum | Los Angeles, California, USA | 18 January 1973

We were supported by Cheech and Chong, and Santana, and played a set
that lasted over an hour and a half. It included songs from our last four
albums and a pair from the old days: 'Route 66' and 'It's All Over Now'.
The encore was 'Midnight Rambler'.

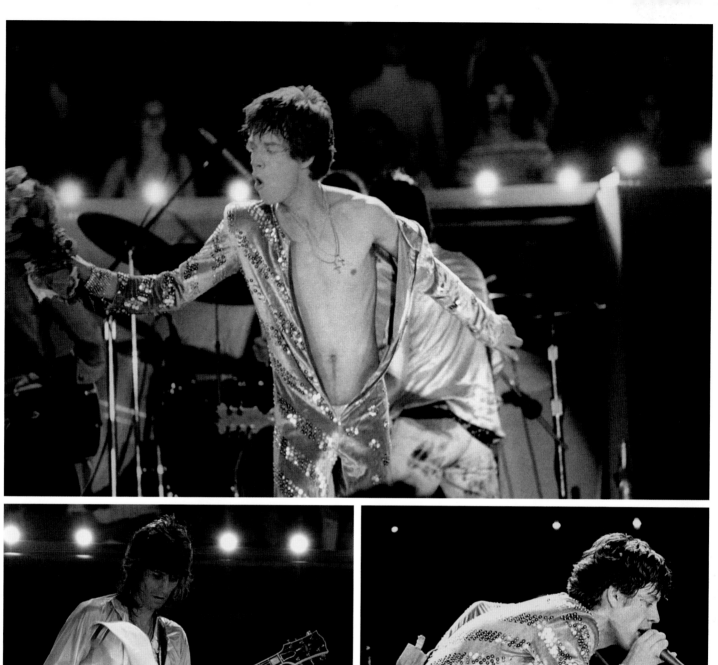

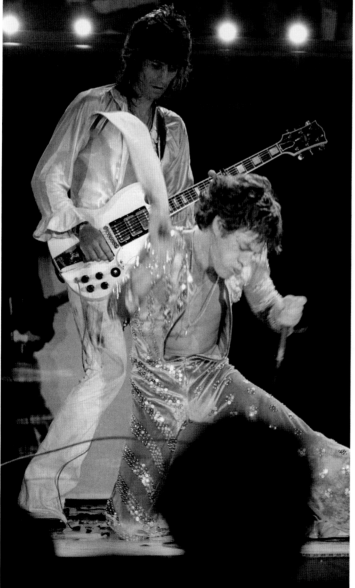

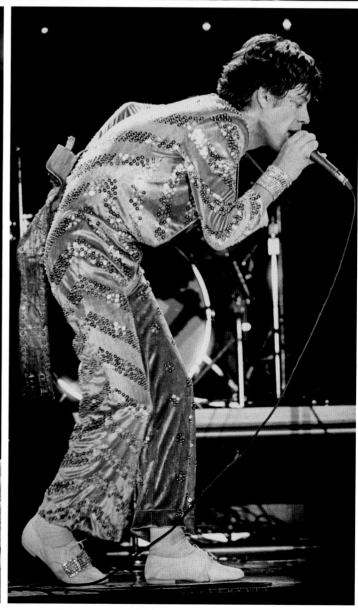

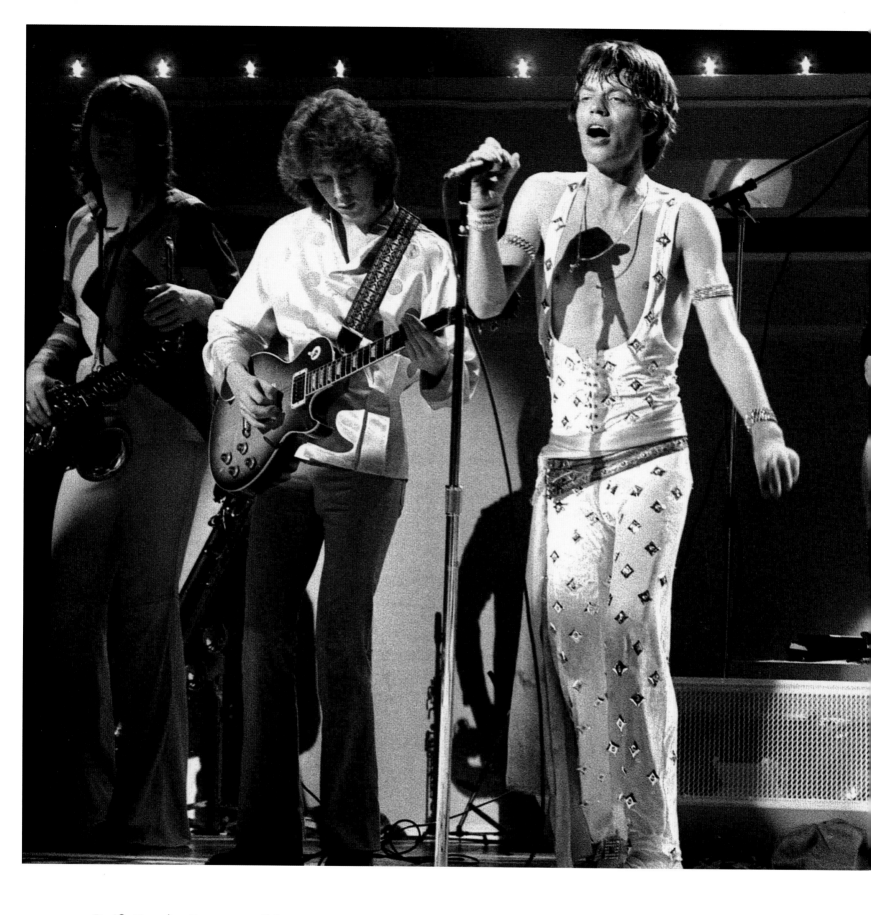

Pacific Tour | 21 January – 27 February 1973

We played Honolulu's International Center on 21 and 22 January (above), after which we had planned on flying to Japan for our first ever tour there. Unfortunately, the Japanese government decided to refuse Mick an entry visa because of the drug case back in 1967. There had been record-breaking ticket sales – our five gigs in Tokyo sold out in four hours – so we had to let down a lot of fans. The poster (opposite above) had already been used to promote our visit.

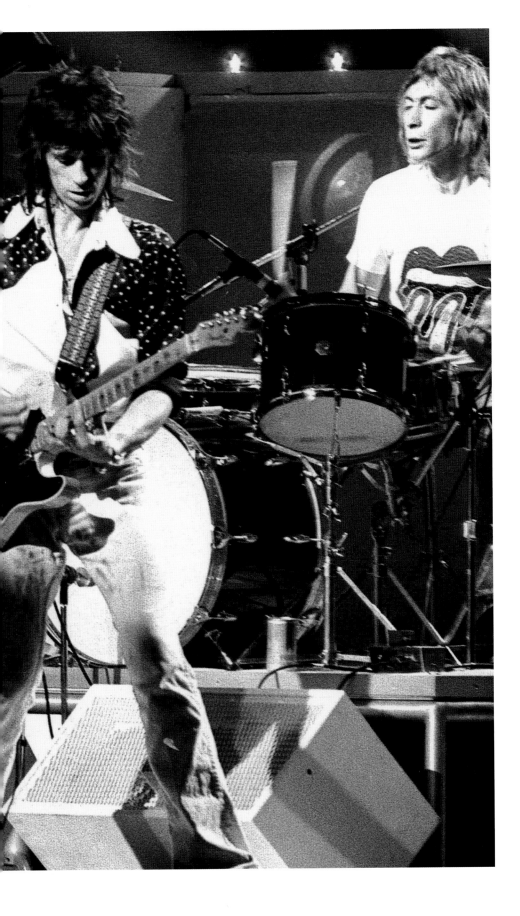

Australian Tour | 14 February – 27 February 1973

After a show in Auckland, New Zealand, we flew to Brisbane,
then to Melbourne, Adelaide, Perth and Sydney.

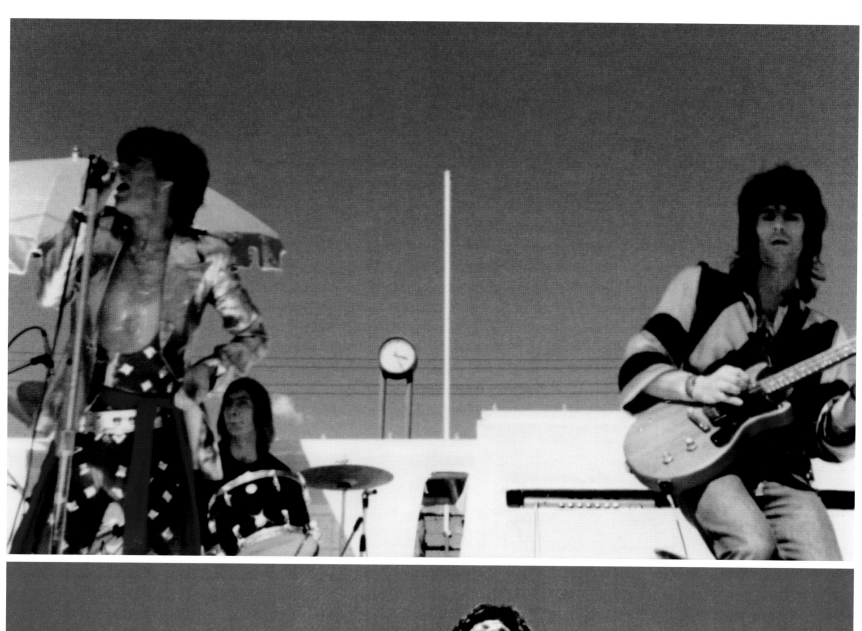
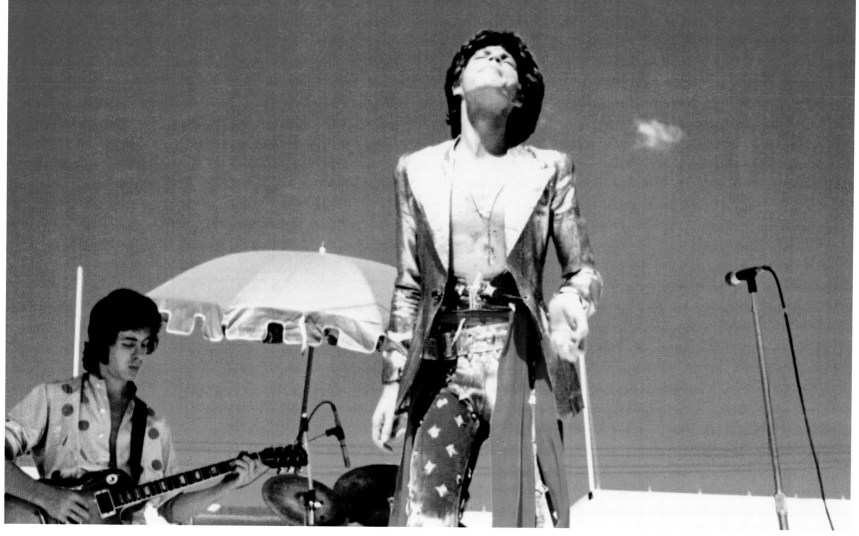

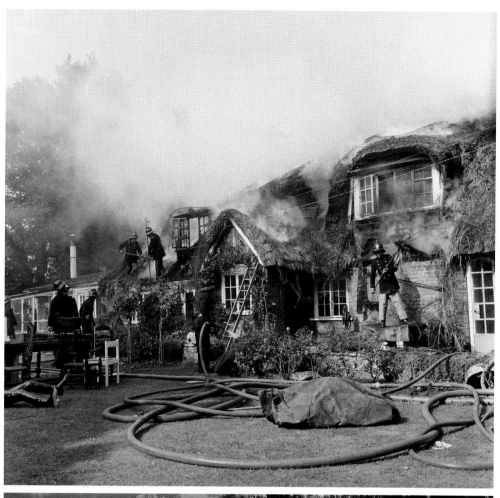

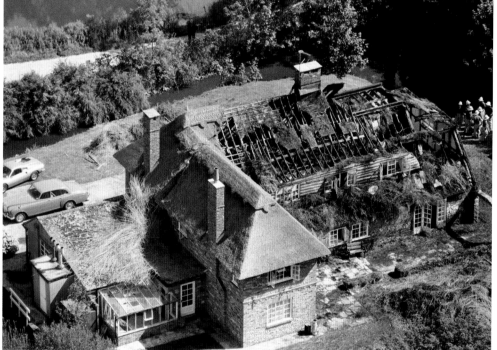

Redlands | West Sussex | 31 July 1973

I've had two or three houses burn down. Redlands burned down
once – the roof went with the whole top floor. It was a terrible
thing to happen to such a beautiful place. Parts of it date back
to the 12th century. KEITH

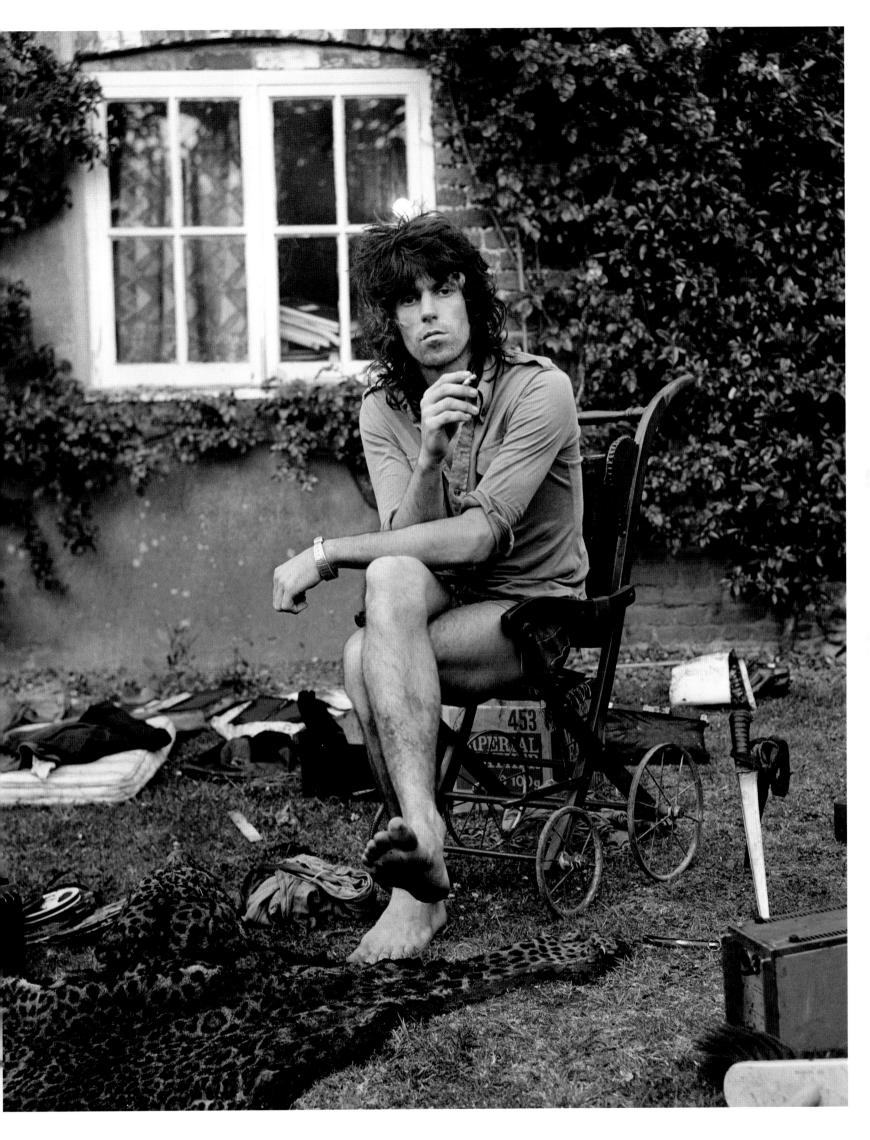

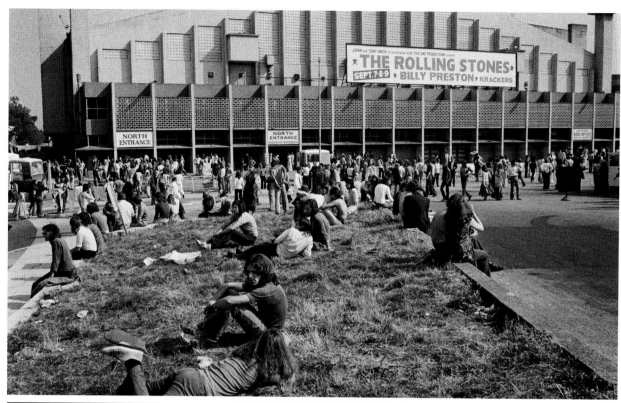

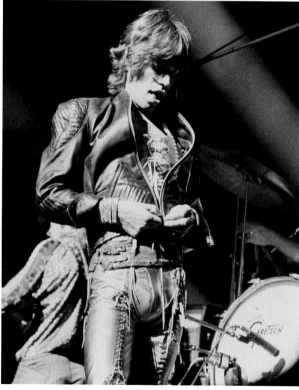

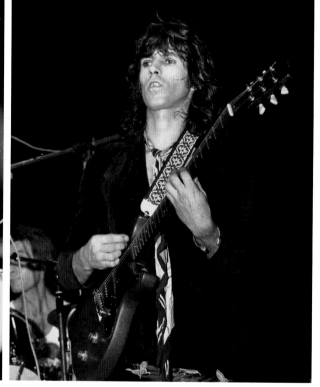

Empire Pool | Wembley, London, UK | 8 September 1973

*'Brown Sugar', 'Gimme Shelter', 'Happy', 'Tumbling Dice', 'Star Star', 'Angie',
'You Can't Always Get What You Want', 'Dancing With Mr. D.', 'Doo Doo Doo
Doo Doo (Heartbreaker)', 'Midnight Rambler', 'Honky Tonk Women', 'All
Down The Line', 'Rip This Joint', 'Jumpin' Jack Flash' and 'Street Fighting
Man' formed our set for the Wembley shows. The demand for tickets was so
great that we added a fourth show and did two on this day.*

European Tour | 1 September – 19 October 1973

John Pasche, the man who designed the tongue logo, also designed our poster for this tour.

This was the longest European tour of our career to this point: twenty-one cities in eight countries. *Goats Head Soup* was the album of the moment. 'Angie' from the album did well all over Europe and went to No.1 in the US. We recorded a show in Belgium, released as *The Brussels Affair* in 2011, that really highlights how strong and tight we were with Mick Taylor playing brilliant guitar as a foil for Keith. We also had Billy Preston and his horn section, augmented by Bobby Keys's saxophone. Great sound. MICK

I was there when Mick Taylor handed in his cards. It was at a party thrown by Robert Stigwood. I was sitting next to Mick Taylor and Mick Jagger, and Mick Taylor was saying, 'Mick, I'm leaving the band.' Jagger said, 'What?' 'I really am leaving the band right now.' And he got up and left. RONNIE

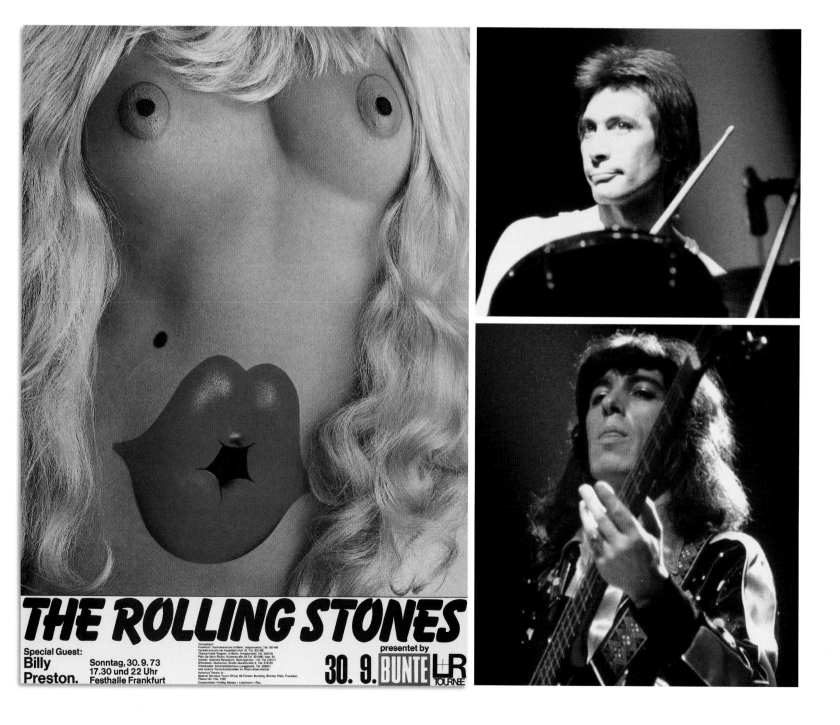

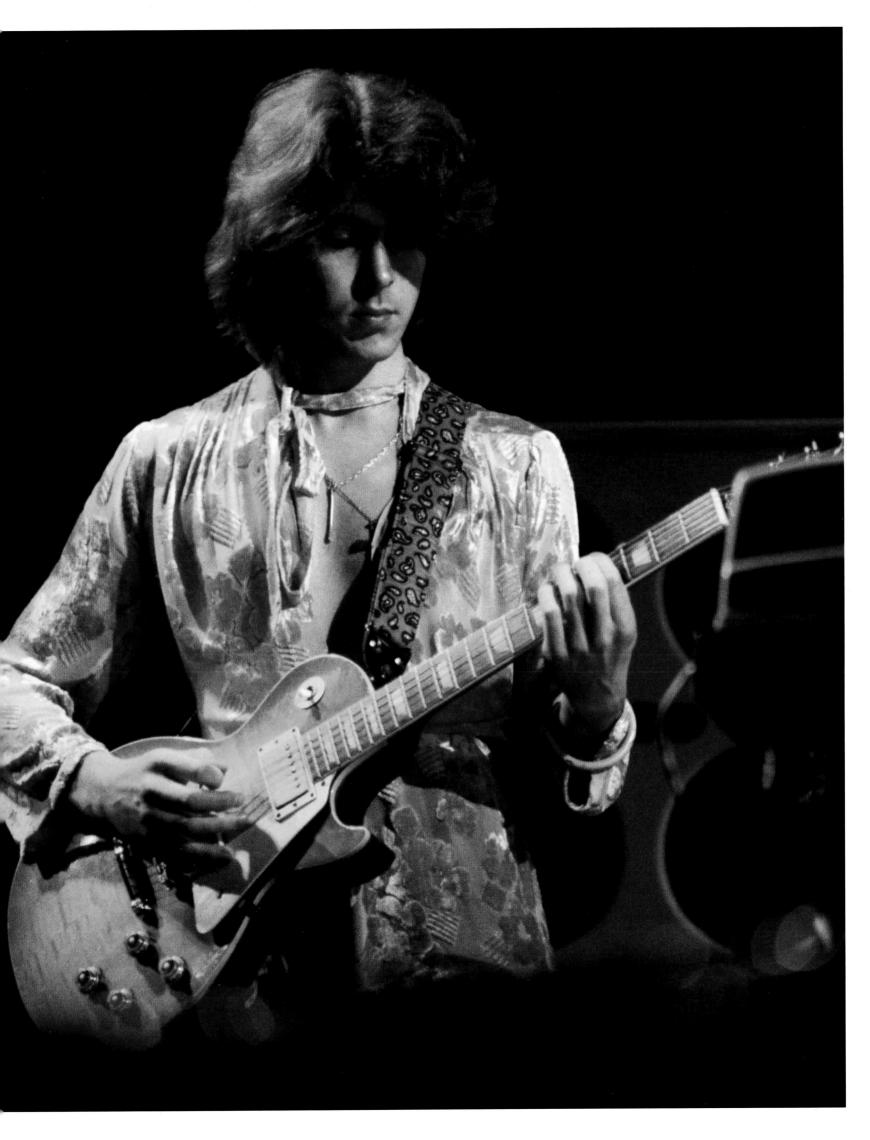

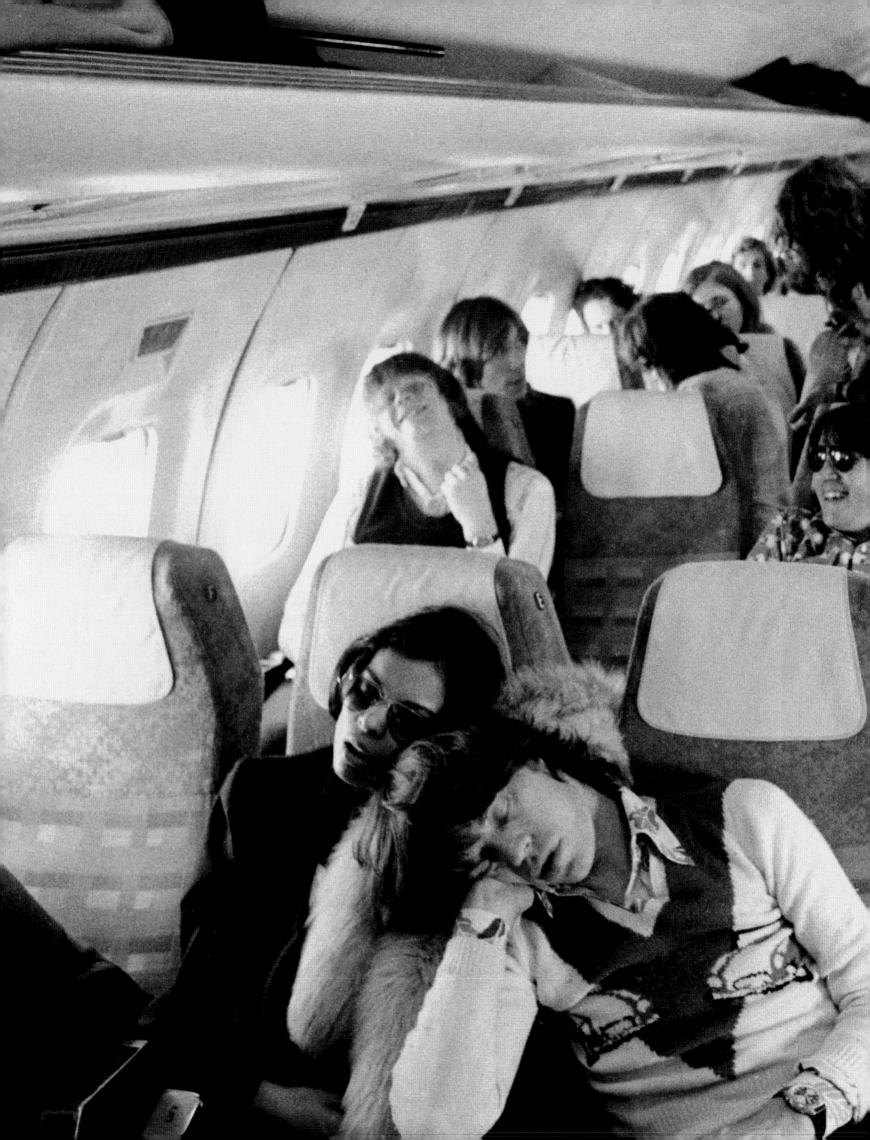

previous pages

Somewhere over Europe | European Tour 1973

On our way from one gig to another – a reminder of life on the road and in the air, back in the day.

right

London | August 1974

Ronnie Wood brings the right kind of chemistry. More right than Brian. Mick Taylor is basically a cold fish. I like him – he's a great guitar player – but basically he's the type of guitar player that should be in a band with only one guitar player. Woody's made for two guitars but he just hasn't had the chance to do it till now. Woody's strength, as is mine, is to play with another guitar player. None of that virtuoso claptrap. KEITH

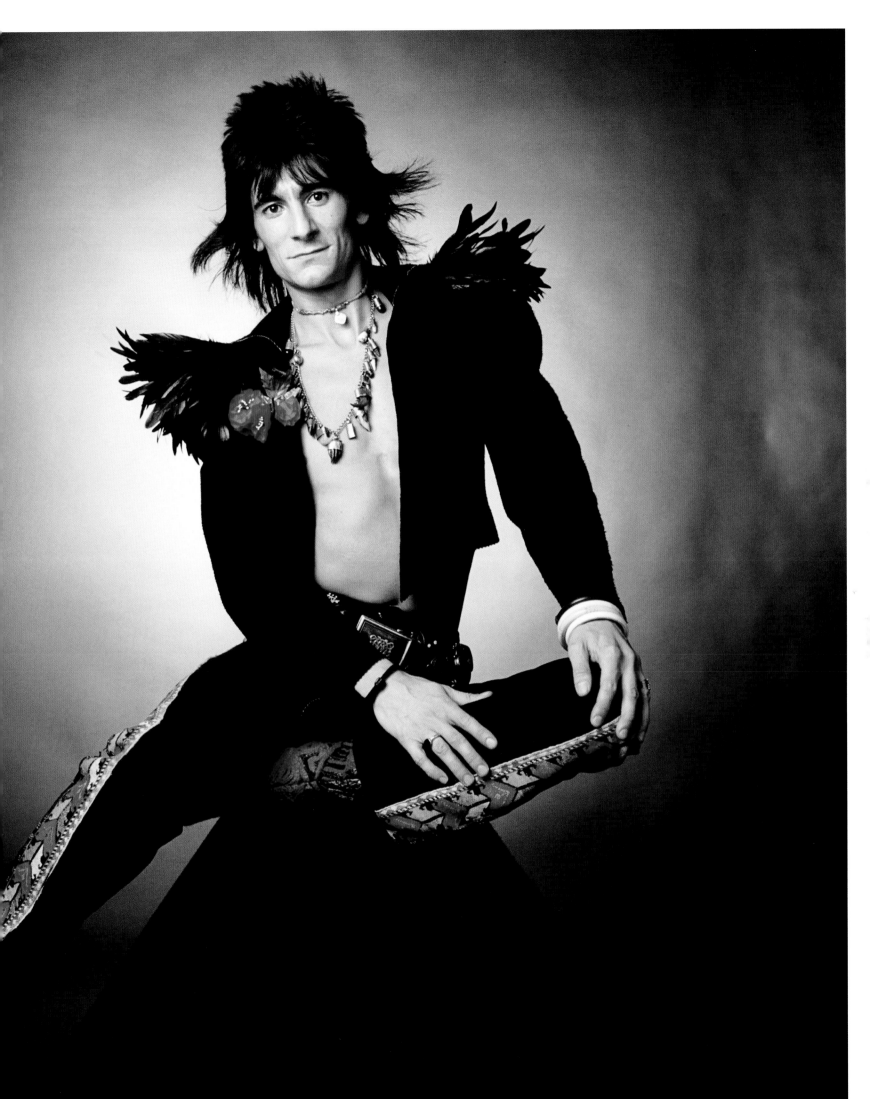

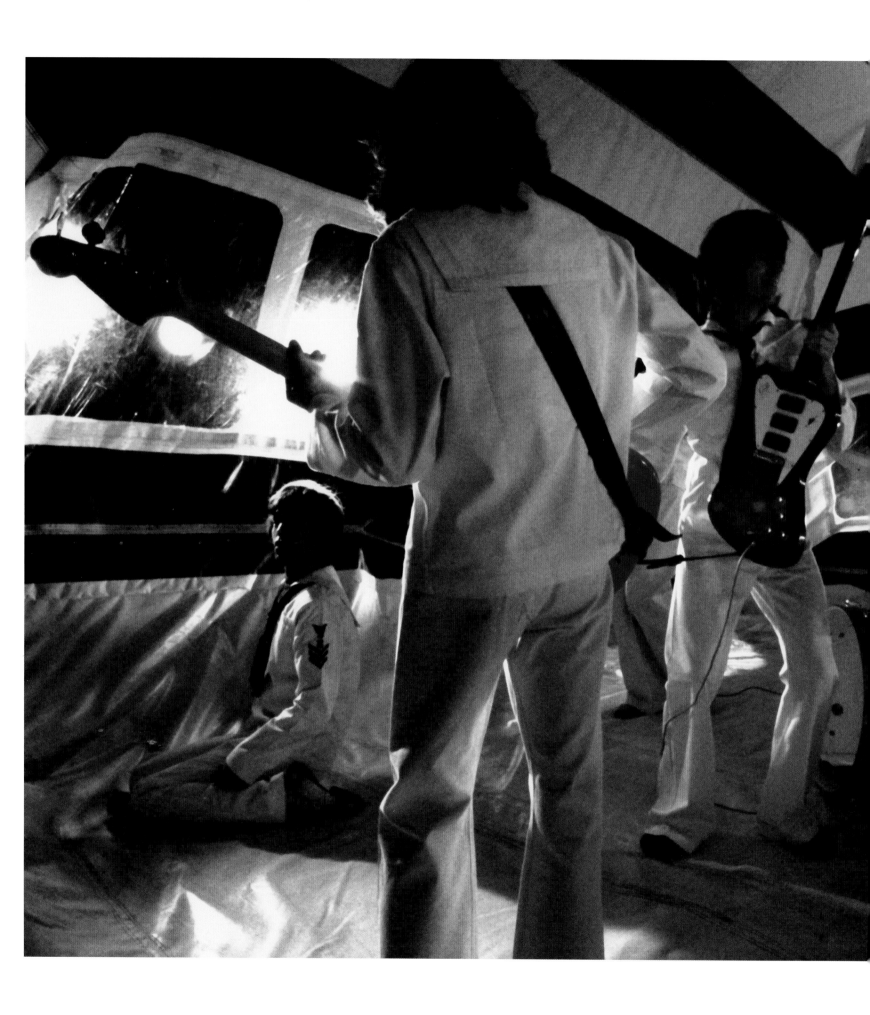

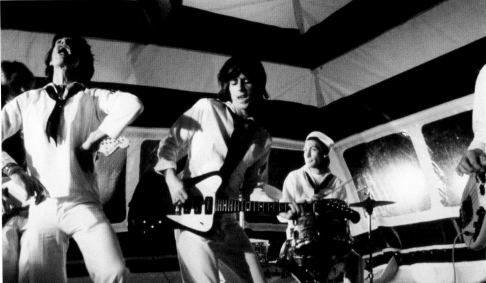

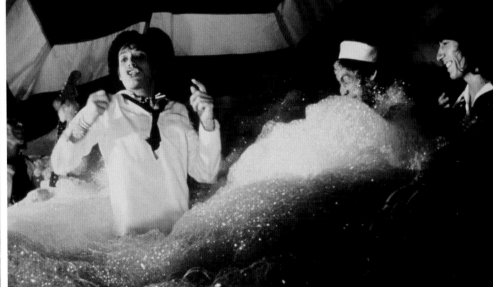

'It's Only Rock 'n Roll' video shoot | London Weekend Television Studios, UK | 1 June 1974

'It's Only Rock 'n Roll' is actually David Bowie and Mick Jagger doing the song, since Mick had gone over to Ronnie's and dubbed it with Bowie. We tried to re-cut it but, in the end, we said, 'Keep the original and we'll over-dub, because it's got the feel.' KEITH

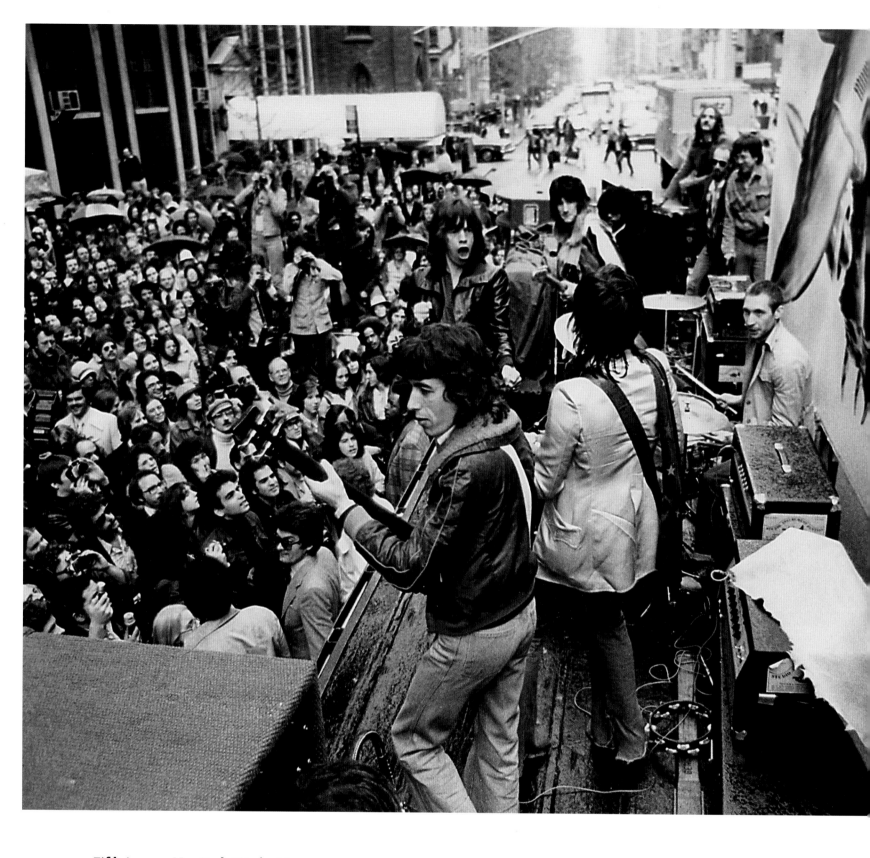

Fifth Avenue, New York City | 1 May 1975

This was my favourite sort of gag. We went down Fifth Avenue on a flatbed truck and played
'Brown Sugar' to promote our North American tour. People looked as we passed but, being
New York, they didn't really care that much, and sort of gave it a quick glance. The journalists
that we hoped to cover the story of us playing outdoors weren't told about this, having been
put into a bar. I don't know whose idea this was, but Stanley Unwin – the unconventional
English comedian who spoke in his own made-up funny language – was put into this bar to
entertain the journalists. As we came near, they were told to go outside and to see us playing.
I don't know how bemused the mostly American journalists were by Stanley Unwin, who was
unconventional even by British standards. MICK

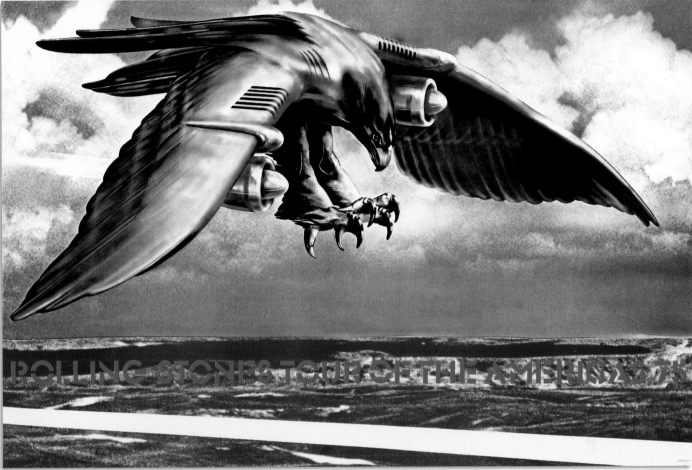

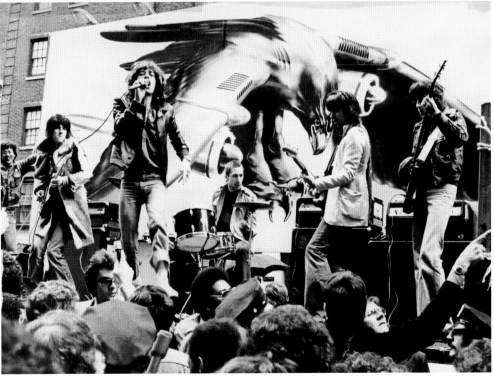

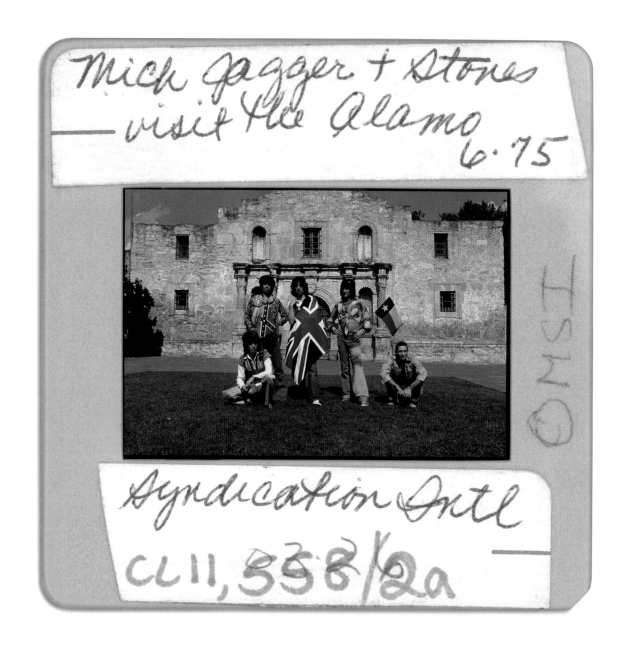

Mick Jagger + Stones
visit the Alamo
6·75

OMSI

Syndication Intl
CL11,558/2a

CL 11,558/34

6/75

The Alamo | San Antonio, Texas, US | 4 June 1975

*We did this photo shoot with the Daily Mirror at the famous Alamo in
the afternoon before the second show of our eighth North American tour.*

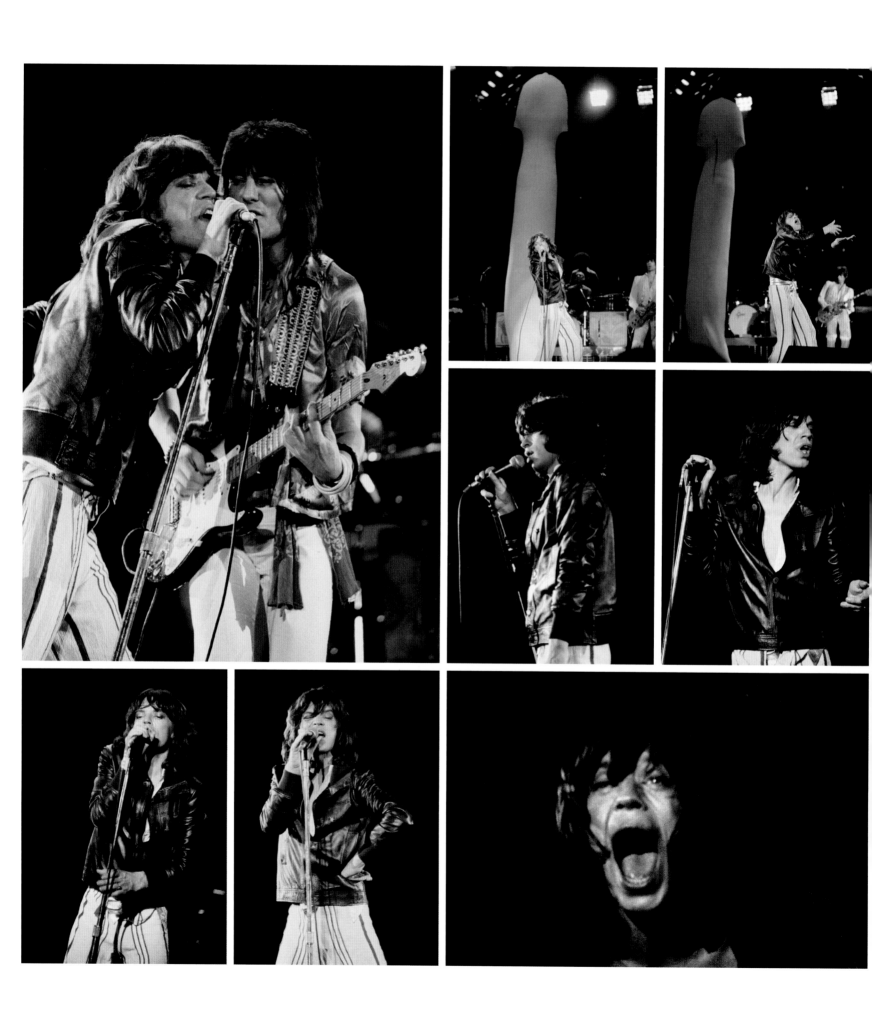

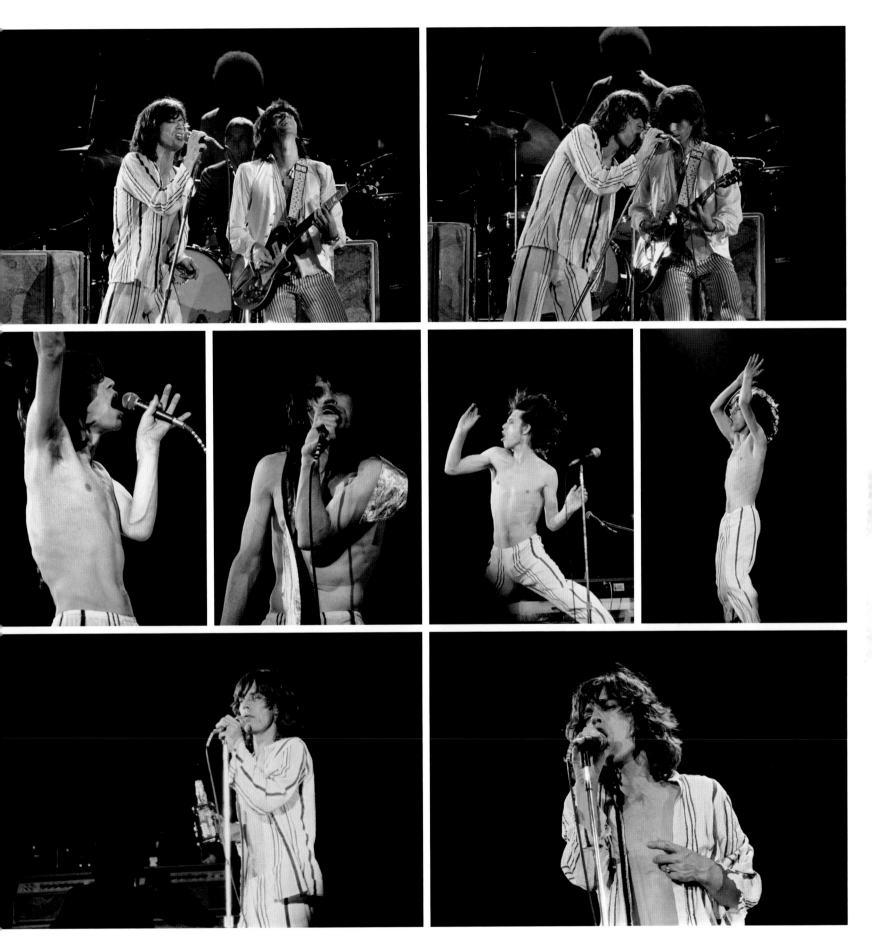

The HemisFair Plaza Arena | San Antonio, Texas, US | 3 June 1975

After the show, the police threatened us with prosecution if we ever used
the inflatable penis again. It didn't seem worth spending a night in jail for it,
so the following day we did the show without inflating it. MICK

The HemisFair Plaza Arena | San Antonio, Texas, US | 3 June 1975

This was a very different kind of tour from the ones we'd done before. It was a
watershed because it was when we started hanging the sound and the lights.
It was during this time that the whole arena show started as an industry. MICK

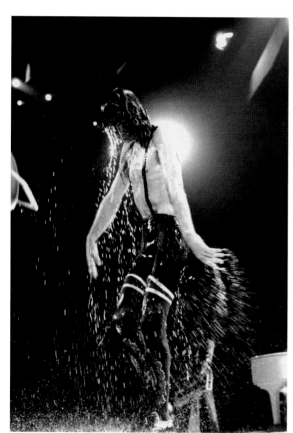 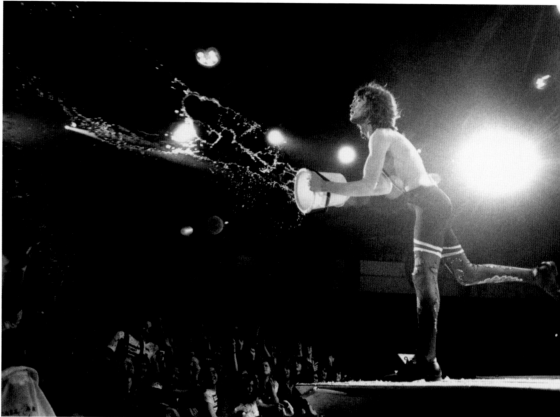

The Tour of The Americas | 1 June – 8 August 1975

We played to over one million people on forty-six shows in twenty-seven cities, with 300 lights over a stage that was like a giant lotus flower. We had planned to go on to play gigs in South America but these got blown out. It would be another two decades before we toured South America.

In 1975 I did two tours with the Faces, with the Stones tour of the States in the middle. Keith said, 'We'll never formally announce you as being in the band. We'll just keep 'em guessing.' RONNIE

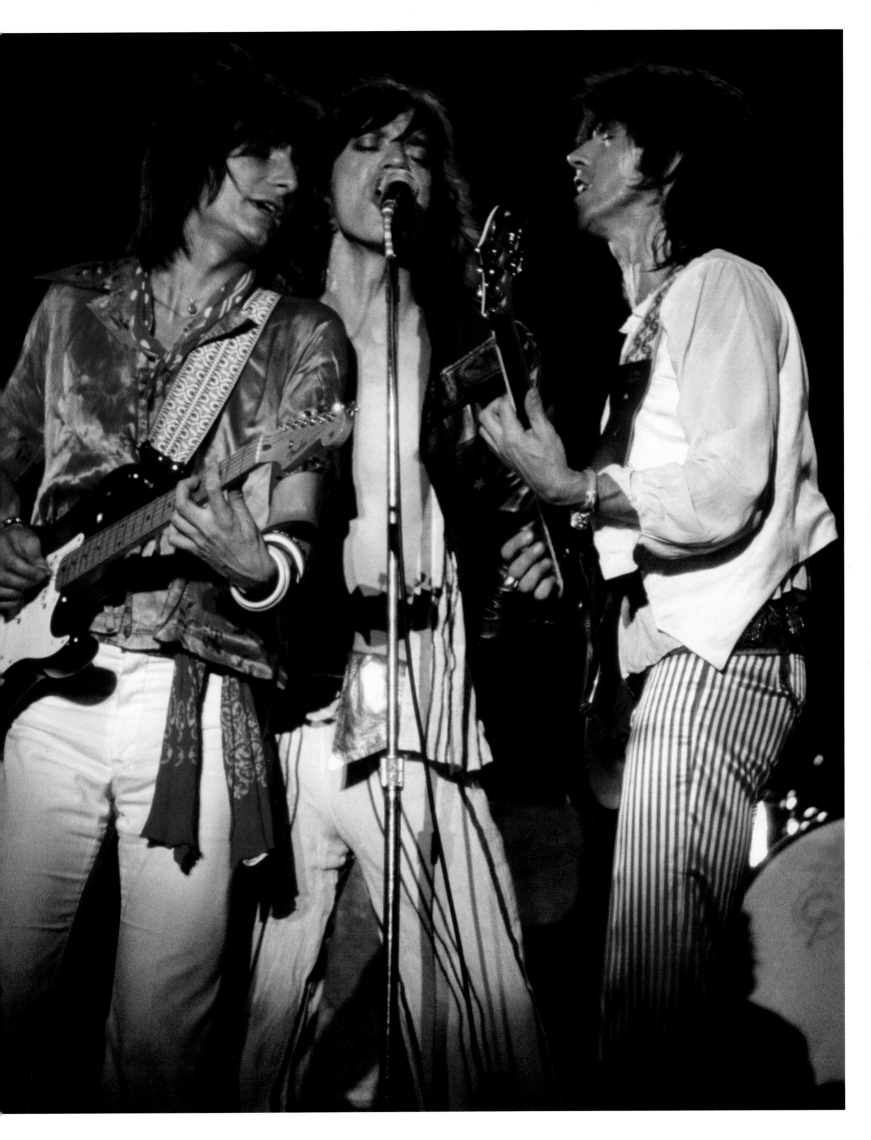

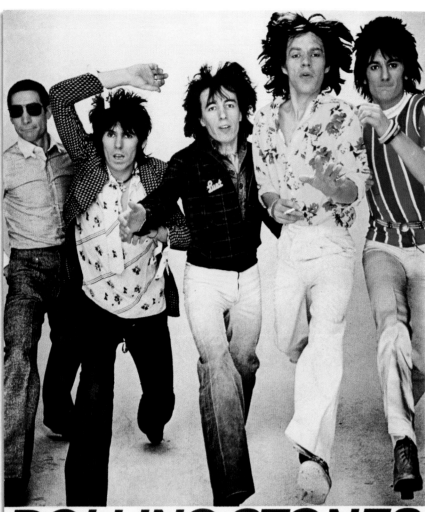

ROLLING STONES
TOUR OF EUROPE 1976 28|29.APR.

Mittwoch, 28. April 76, 20 Uhr
Donnerstag, 29. April 76, 20 Uhr
Frankfurt
Festhalle (Messe)

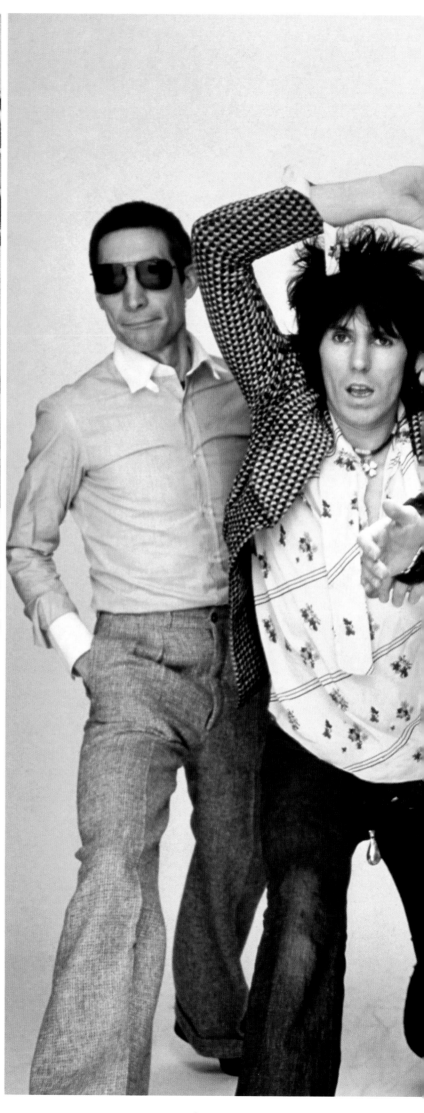

European Tour | 28 April – 23 June 1976

We played to well over half a million people on this tour,
including our first ever shows in Zagreb and Barcelona.

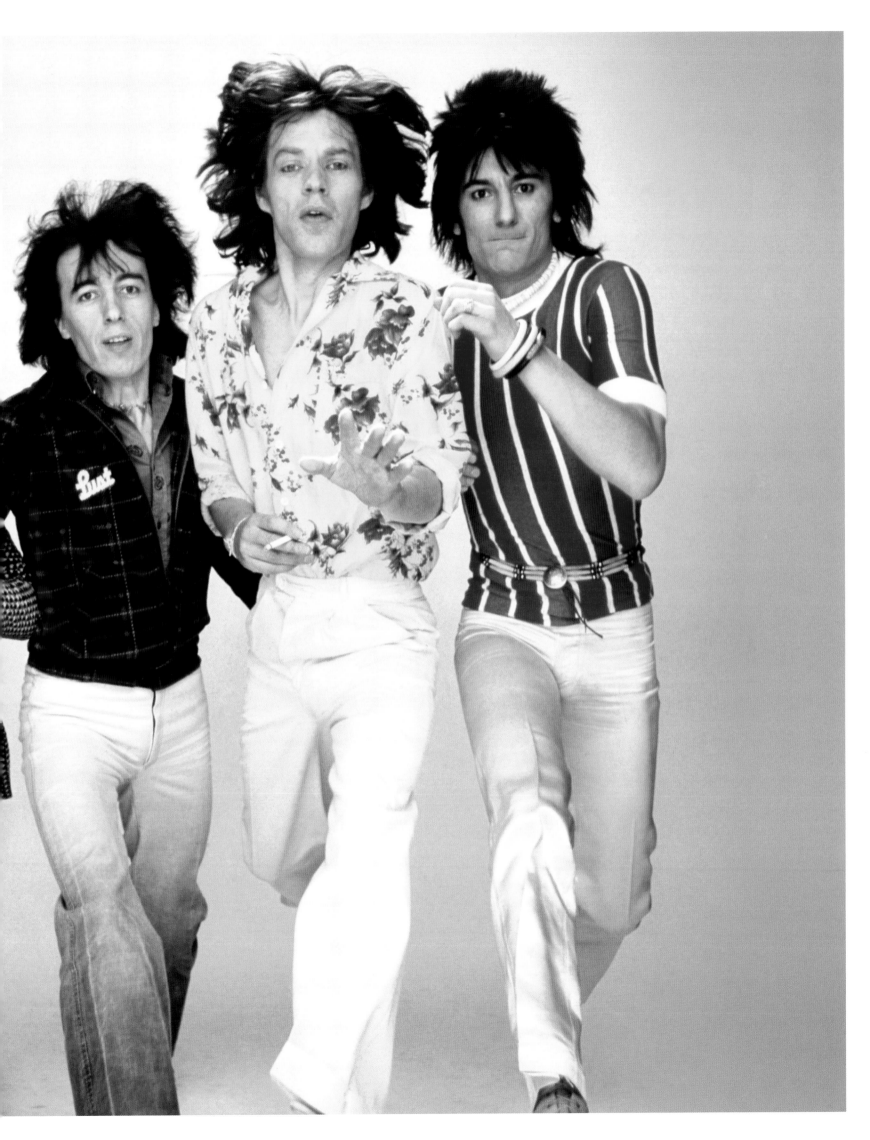

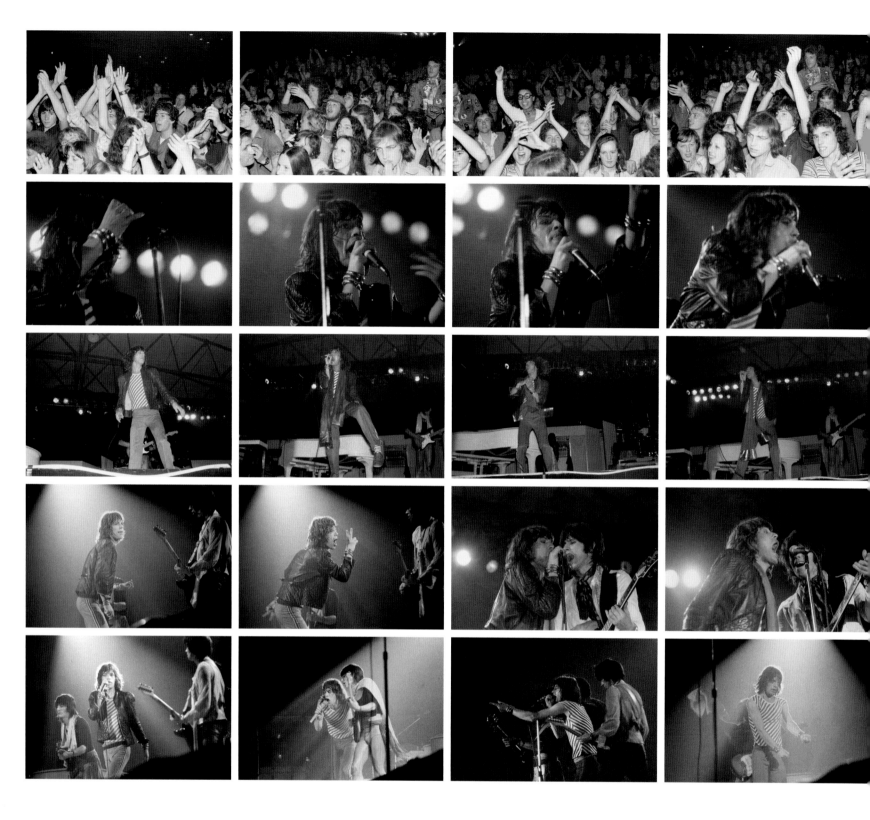

Granby Halls | Leicester, UK | 14 May 1976

Our support band throughout the tour was the Meters,
and tickets for our gig in Leicester were priced from £2 to £4.

opposite and overleaf

Earls Court | London, UK | 21–23, 25–27 May 1976

The photo overleaf shows the vast stage that cost £150,000
and took a team of fourteen to build it at each venue. We had
300 lights that weighed in at sixteen tons, and these were
hung over the stage.

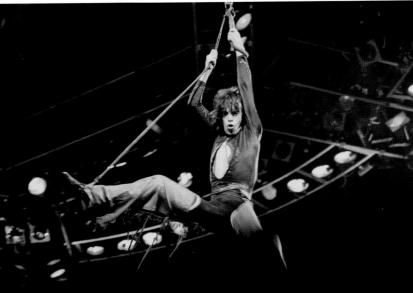

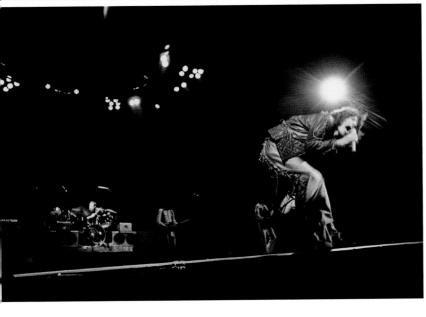

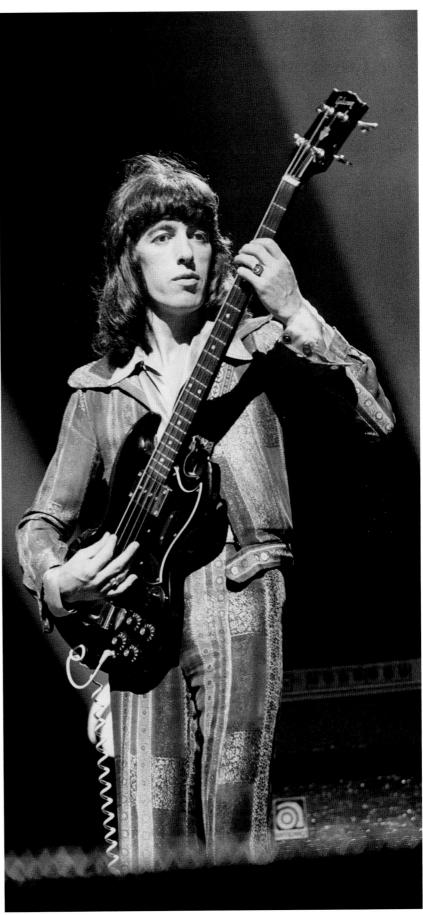

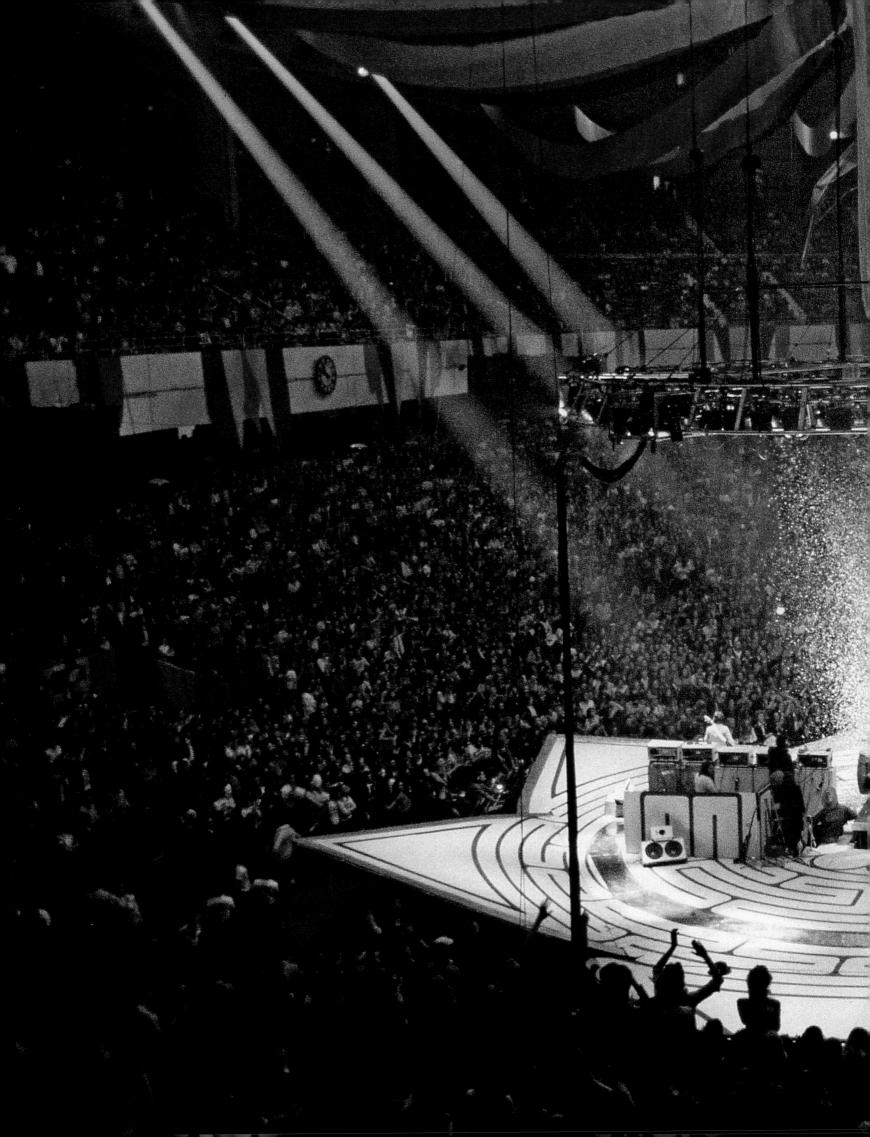

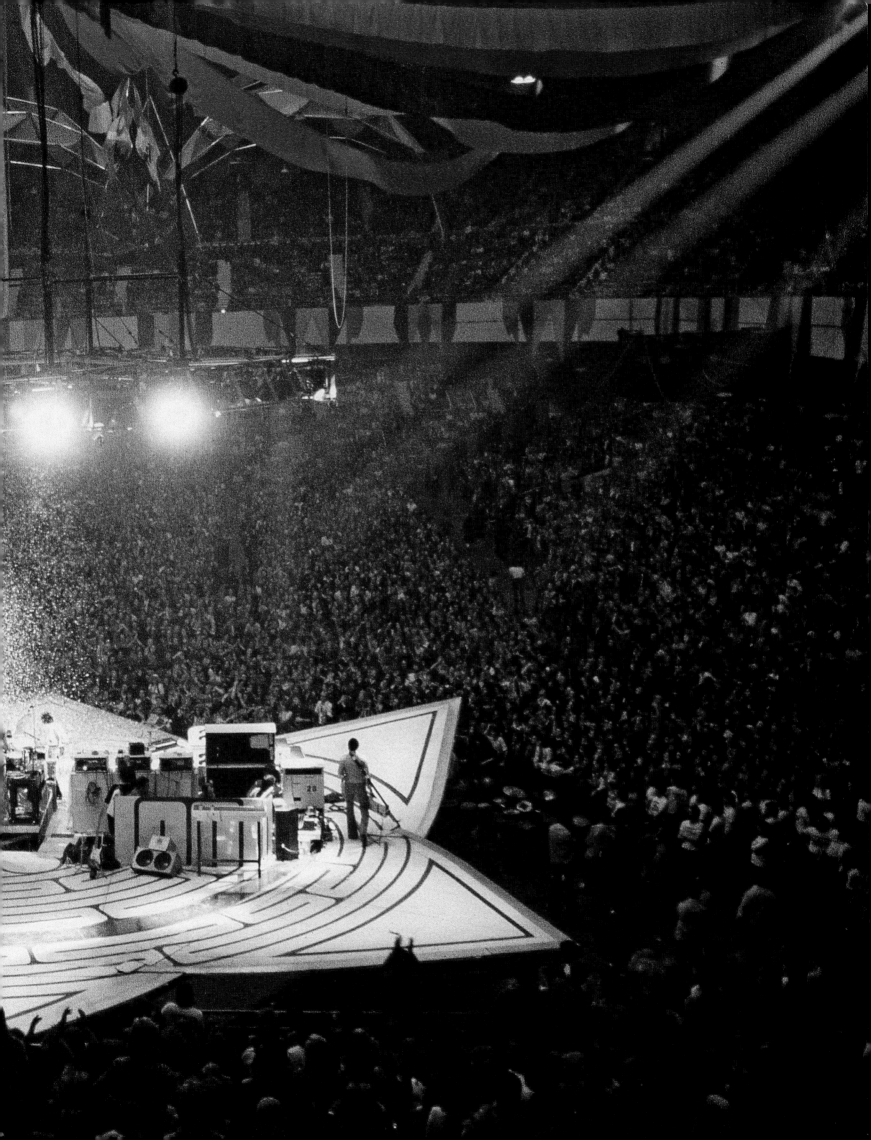

Knebworth House | Hertfordshire, UK | 21 August 1976

We were on a percentage of the gate for this gig and when the promoter told us the number of people there – far less than was being spoken about – we found it difficult to believe. We had a giant aerial photo, much like this one, in the office in the coming weeks as various people attempted to count the number of people at the gig.

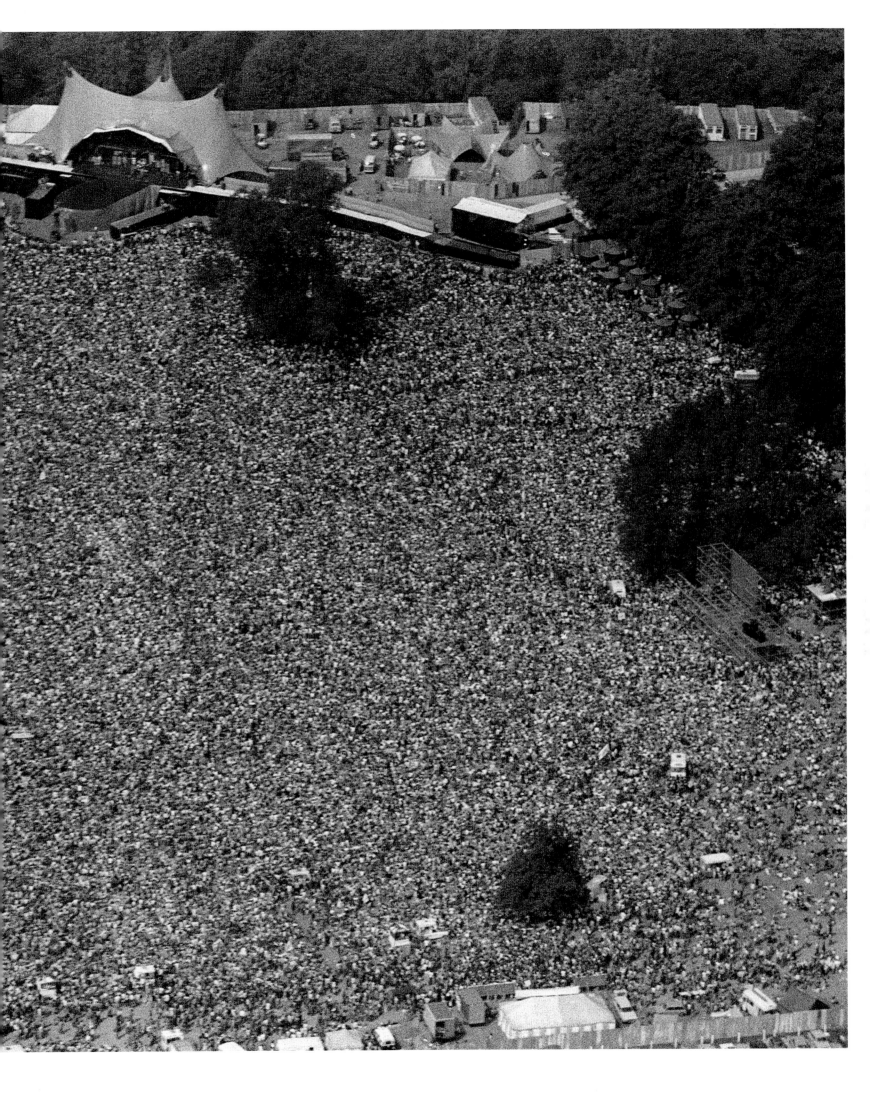

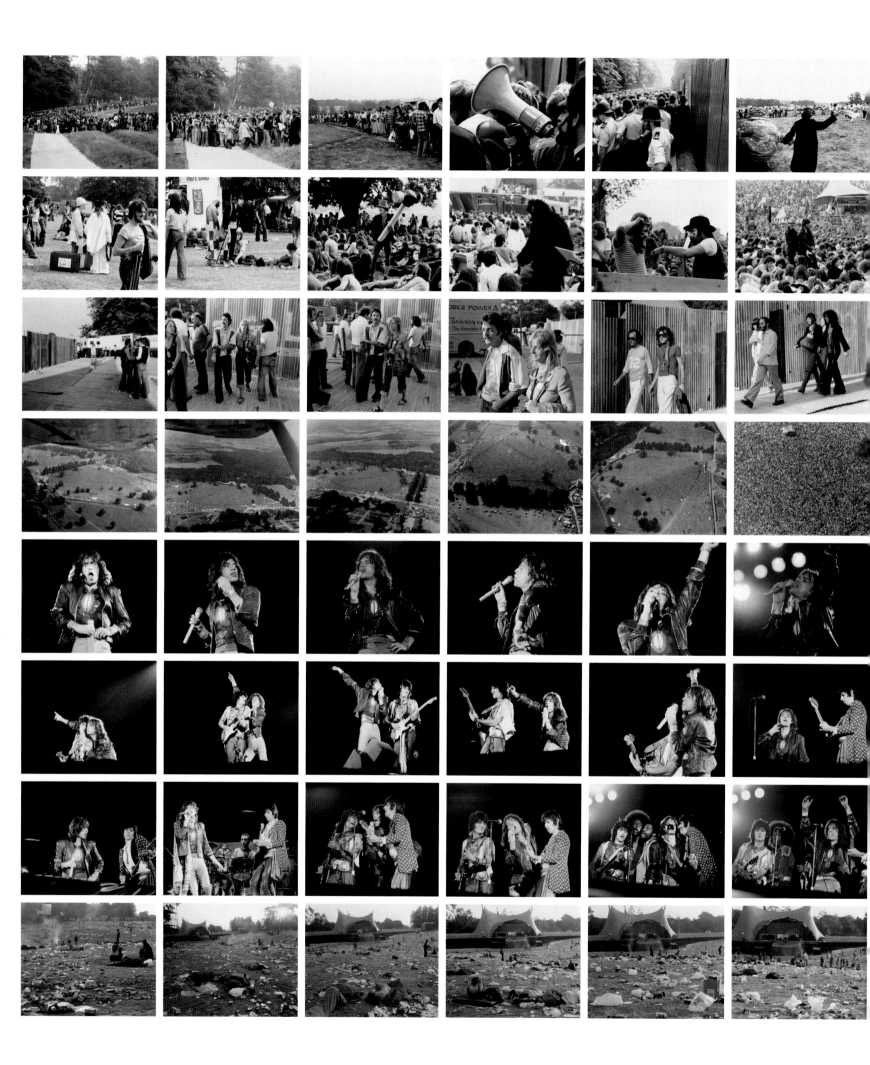

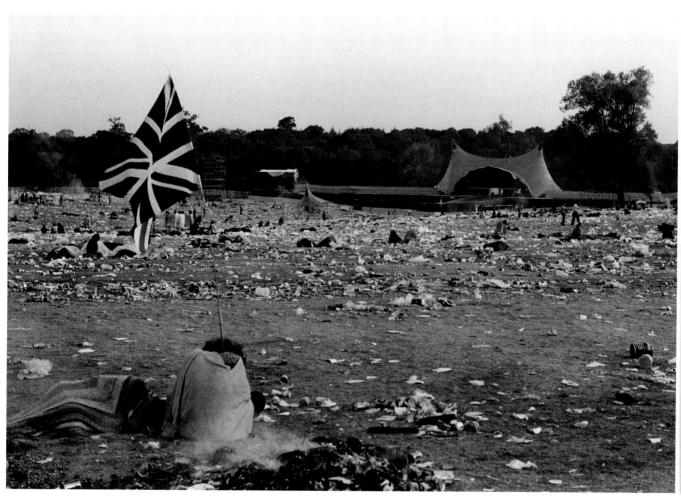

Knebworth House | Hertfordshire, UK | 21 August 1976

*We went on stage about four hours late, after Lynyrd Skynyrd and
Todd Rundgren, because someone had messed with the cables.
We played for over two hours and finished around 2am.*

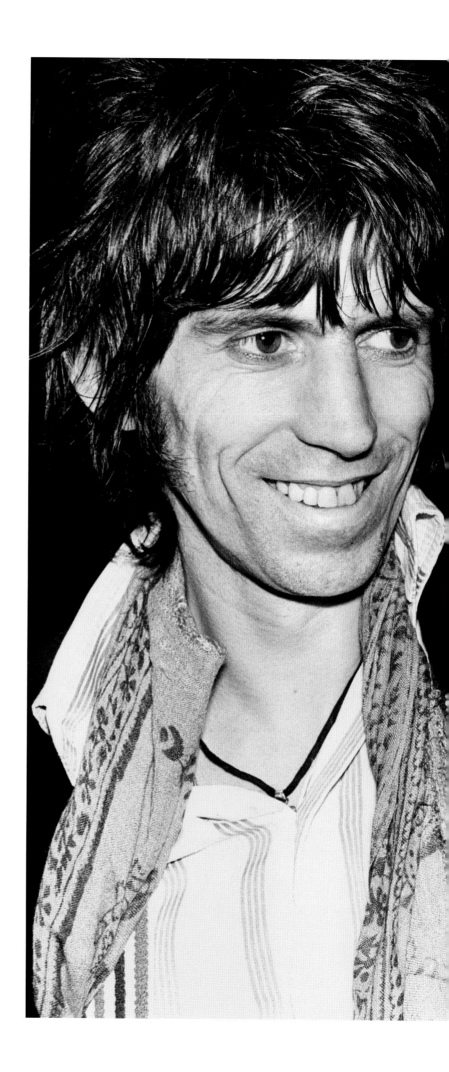

Aylesbury, Buckinghamshire, UK
11 January 1977

Keith was in court to answer charges of possessing LSD and cocaine. He was found innocent of the first charge but guilty of the second, and fined. Keith and Mick have been known as The Glimmer Twins since 1974.

Mick, me and our ladies took a boat to Rio that was full of these upper-class English people, all drinking like mad, pink gins and pink champagne, crowding the bar. I was dressed at the time in a diaphanous djellaba, Mexican shoes and a tropical army hat. After a while they discovered who we were and became very perturbed. They started asking us questions: 'What are you really trying to do?' and 'Do try to explain what this whole thing is about!' We never answered them and, after a few days, one woman stepped forward from the group and said, 'We've been asking you for days and you just won't say. Can't you give us just a glimmer?' Mick turned to me and said, 'We're the Glimmer Twins.' KEITH

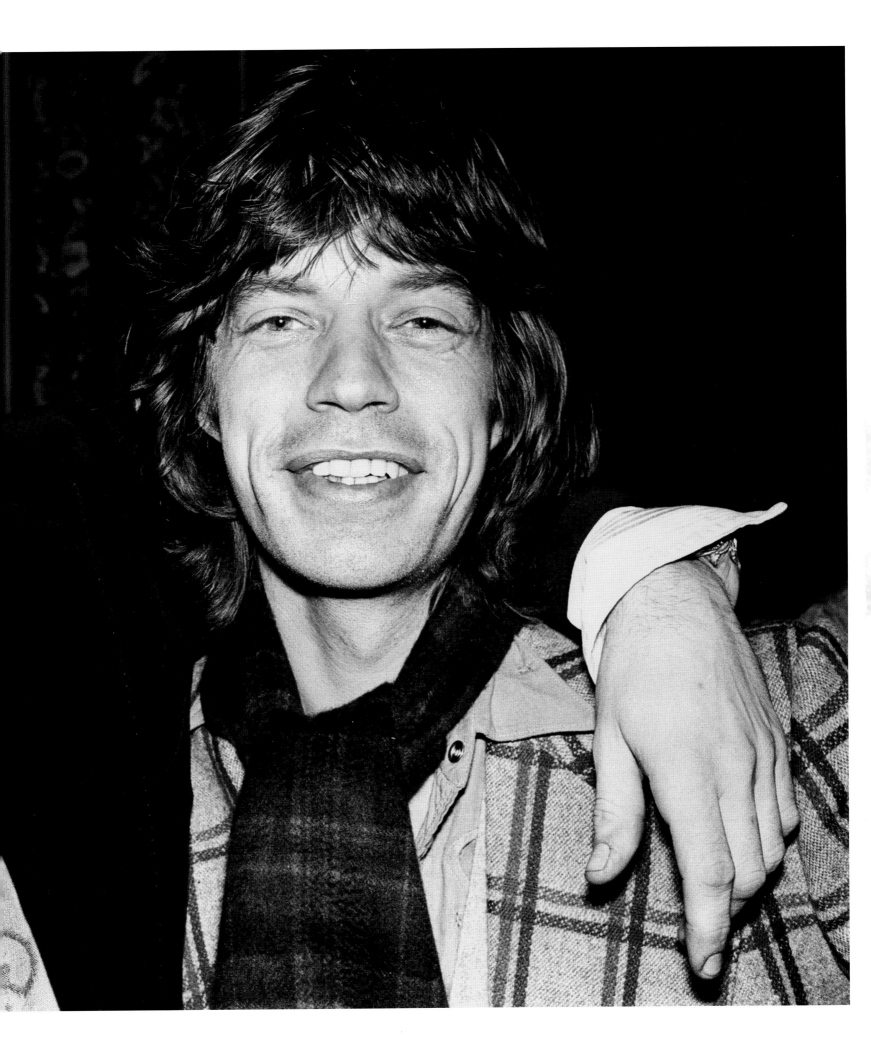

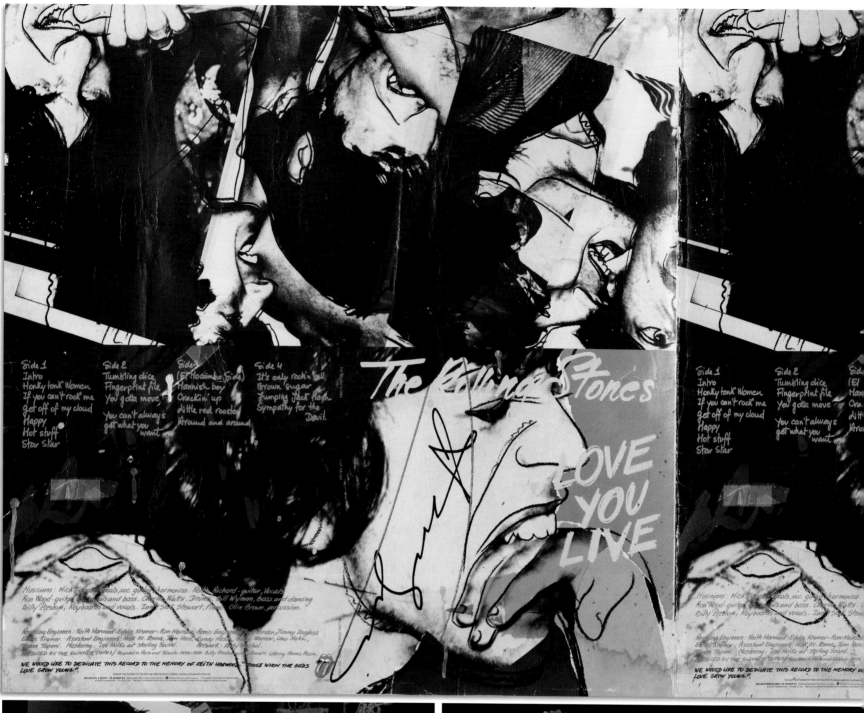

Side 1
Intro
Honky tonk Women
If you can't rock me
get off of my cloud
Happy
Hot stuff
Star Star

Side 2
Tumbling dice
Fingerprint file
You gotta move
You can't always
get what you
want

Side 3
(El Mocambo Side)
Mannish boy
Crackin' up
Little red rooster
Around and around

Side 4
It's only rock'n roll
Brown sugar
Jumping Jack Flash
Sympathy for the
Devil.

The Rolling Stones

LOVE
YOU
LIVE

Musicians: Mick Jagger, vocals, occ. guitar, harmonica. Keith Richard - guitar, vocals
Ron Wood - guitar, vocals and bass. Charlie Watts, Drums. Bill Wyman, bass and dancing
Billy Preston, Keyboards and vocals. Ian Stewart, Piano. Ollie Brown, percussion.

Recording Engineers: Keith Harwood - Eddie Kramer - Ron Nevison. Remix Engineers: ... Jordan, Jimmy Douglass
Eddie Kramer. Assistant Engineers: Mick Mc Kenna, Tom Hold, Randy Hassel, Barry Warner, Lou Hahn,
Jean Taponi. Mastering: Lee Hulko at Sterling Sound.
PRODUCED BY THE GLIMMER TWINS / Recorded in Paris and Toronto 1976-1977. Billy Pinchol ... and H. Lebreing, Hames Passia.
WE WOULD LIKE TO DEDICATE THIS RECORD TO THE MEMORY OF KEITH HARWOOD. "THOSE WHOM THE GODS
LOVE GROW YOUNG."

Side 1
Intro
Honky tonk Women
If you can't rock me
get off of my cloud
Happy
Hot stuff
Star Star

Side 2
Tumbling dice
Fingerprint file
You gotta move

Side 3
(El
Mann
Cra
Little
Aro

Musicians: Mick ... vocals, occ. guitar, harmonica.
Ron Wood - guitar, vocals and bass. Charlie Watts, ...
Billy Preston, Keyboards and vocals. Ian Stewart, ...

Recording Engineers: Keith Harwood - Eddie Kramer - Ron Nevison. ...
Eddie Kramer. Assistant Engineers: Mick Mc Kenna, Tom H...
... Taponi. Mastering: Lee Hulko at Sterling Sound.
PRODUCED BY THE GLIMMER TWINS / Recorded in Paris and To...
WE WOULD LIKE TO DEDICATE THIS RECORD TO THE MEMORY O...
LOVE GROW YOUNG."

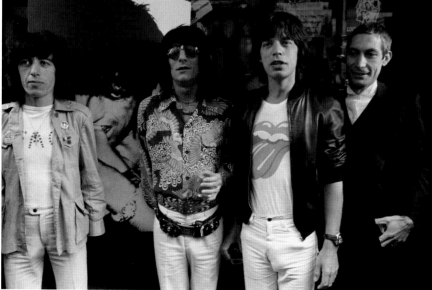

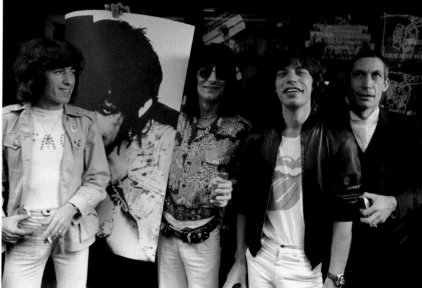

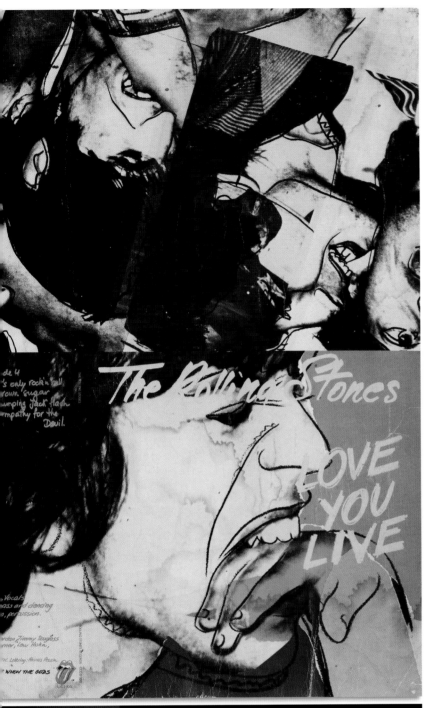

Love You Live album launch | The Marquee Club | London, UK | 14 September 1977

The printer's proof of the artwork for Love You Live *is signed by Andy Warhol, who created it.*

Keith was in America dealing with the fallout from his Canadian drug trial. We couldn't leave him out of things so we had the photo of him blown up and mounted to take along to the press conference to launch our latest album. MICK

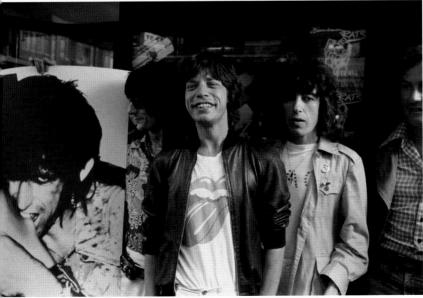

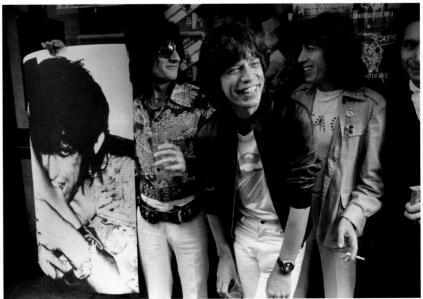

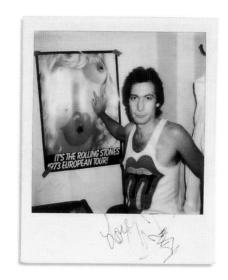

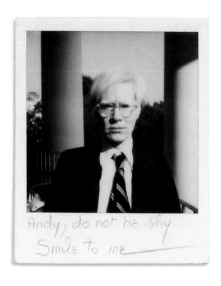

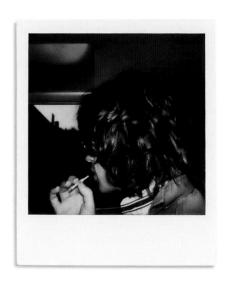

*Various Polaroid photographs
taken on the road in the 1970s.*

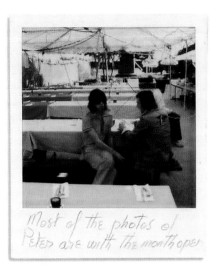

Most of the photos of
Peter are with the mouth open

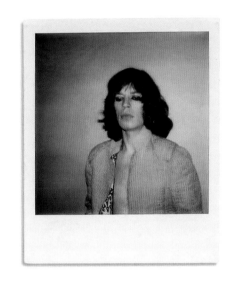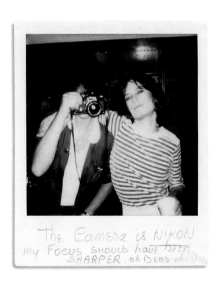

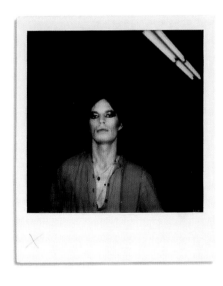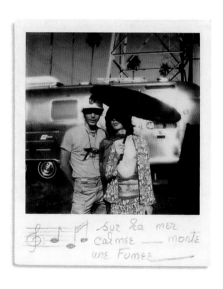

The Camera is NIKON
my Focus should have been
SHARPER. oh Dear oh Dea

Sur la mer
Calmee — monte
une Fumée

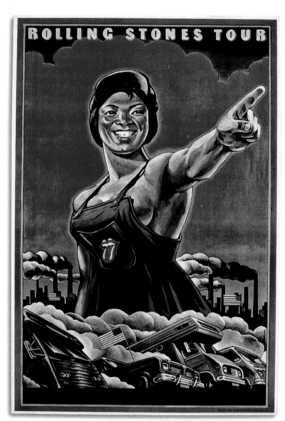

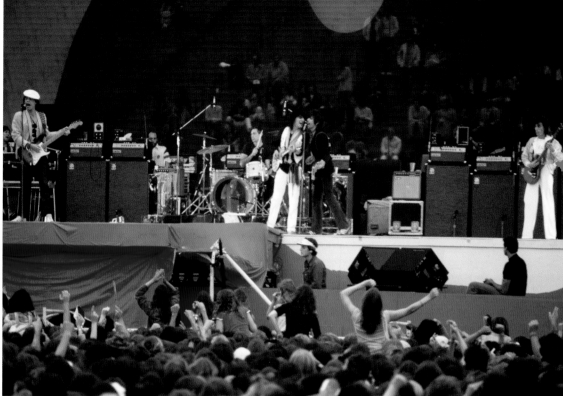

North American Tour | 10 June – 26 July 1978

We played twenty-four cities and did not just do stadium dates, but smaller theatres too. The photo opposite was taken at the Masonic Auditorium in Detroit, Michigan – playing to around 4,000 fans, it was one of the smaller dates. The late Etta James opened for us here, and at a number of other shows on the tour.

Charlie and I came up with this design. It was very fashionable at the time. We called them Charlie's propaganda posters. MICK

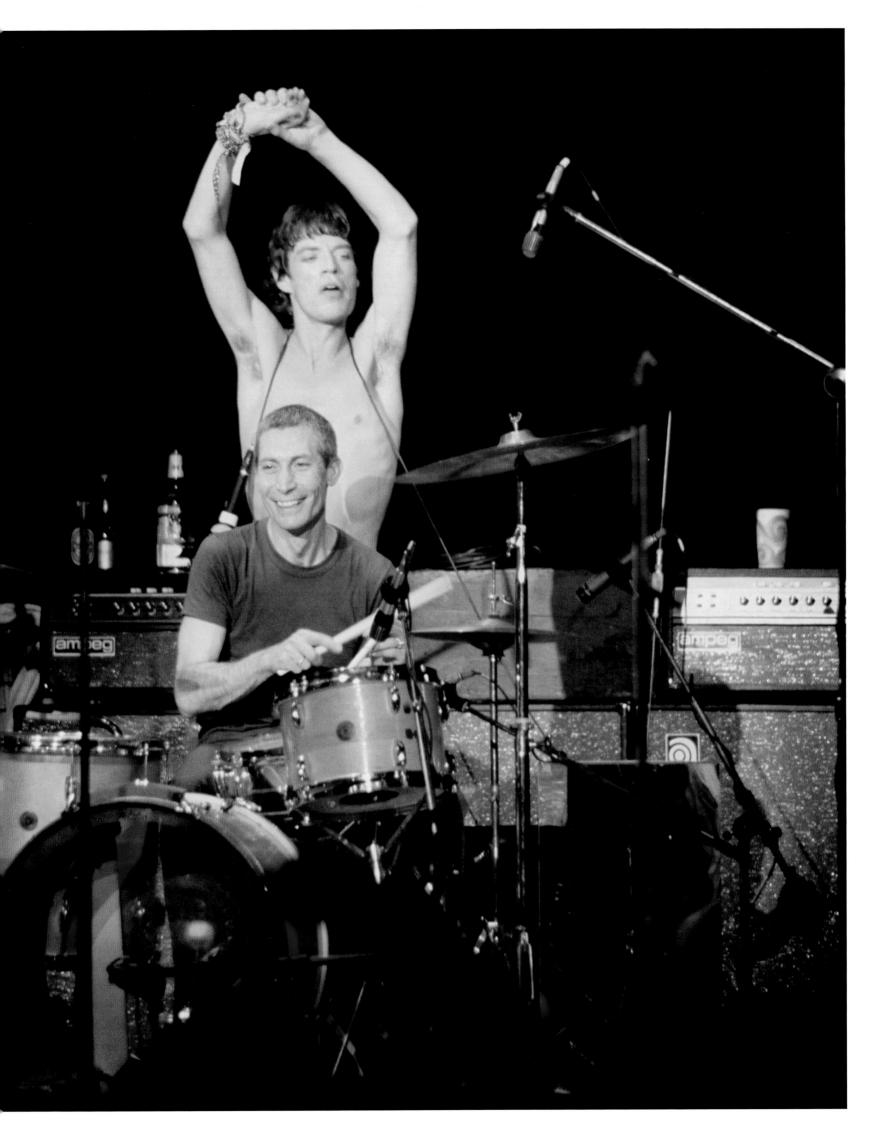

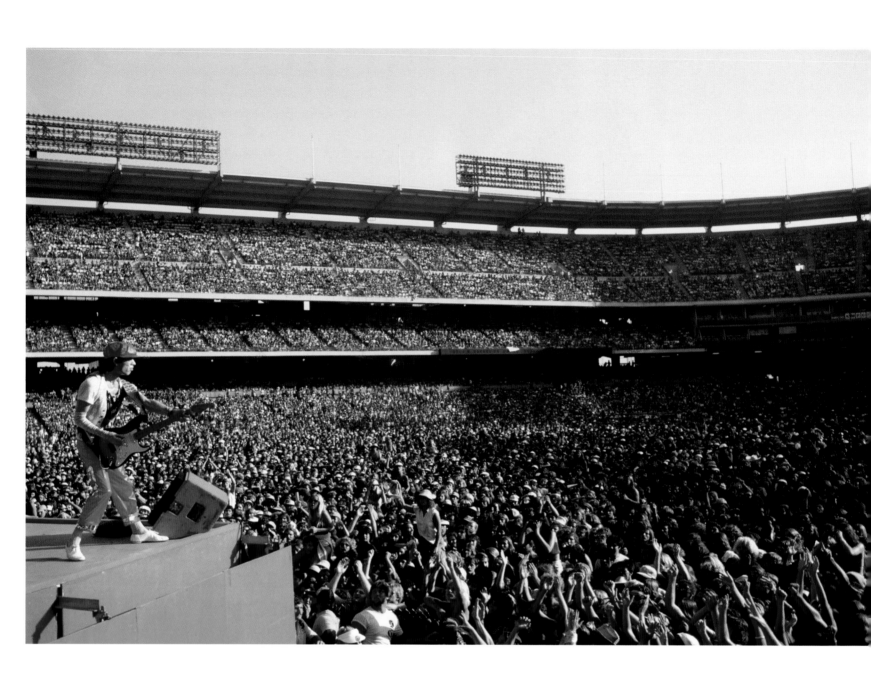

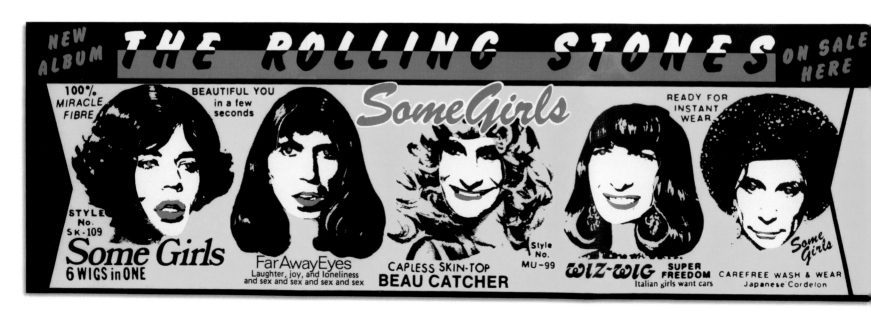

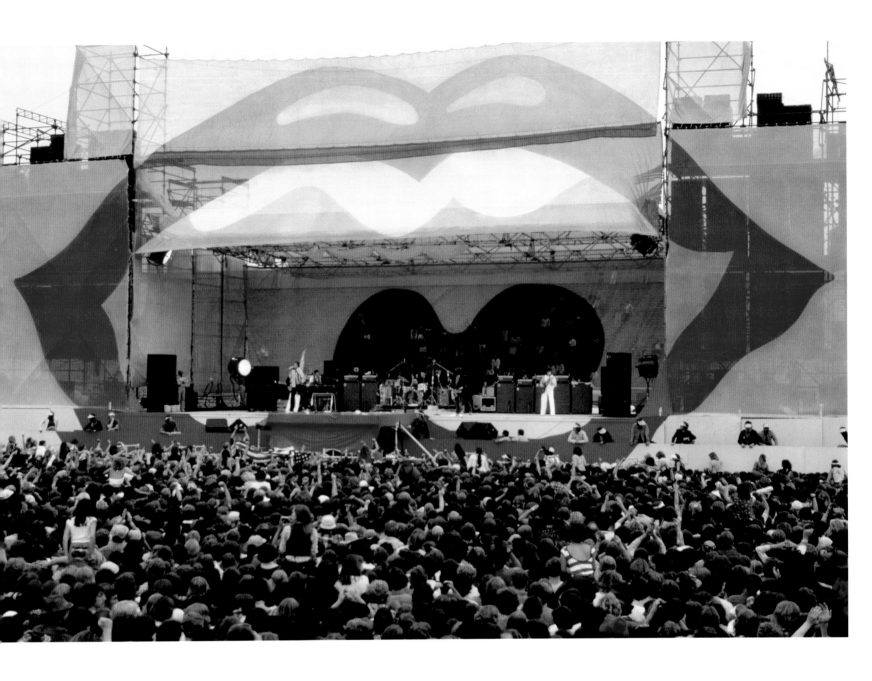

above and opposite above

North American Tour | Anaheim Stadium | California, US | 23 July 1978

At some of the outdoor shows, I wore some weird clothes. I went to these really cheap shops and so, instead of having, like, the designers 'do-you' thing, I bought a load of trashy stuff. All these things are jokey in retrospect, but there are some nasty, plastic, leatherette hats I remember wearing! MICK

opposite below

***Some Girls* | June 1978**

A week into our tour of America, the *Some Girls* album came out. I think the album really stands up. It's a great album in my opinion ... humbly. We played quite a lot of songs from it during this tour. The songs were really new and fresh to us and as the tour progressed they really started to take shape. MICK

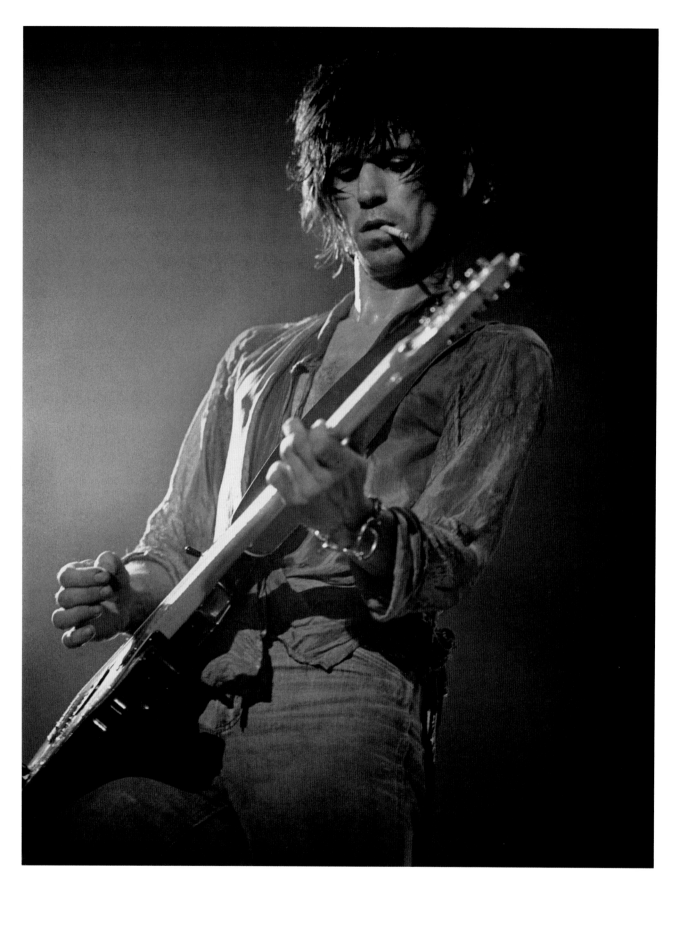

above

North American Tour | Anaheim Stadium | California, US | 24 July 1978

The penultimate gig of the tour, in front of more than 50,000 fans.

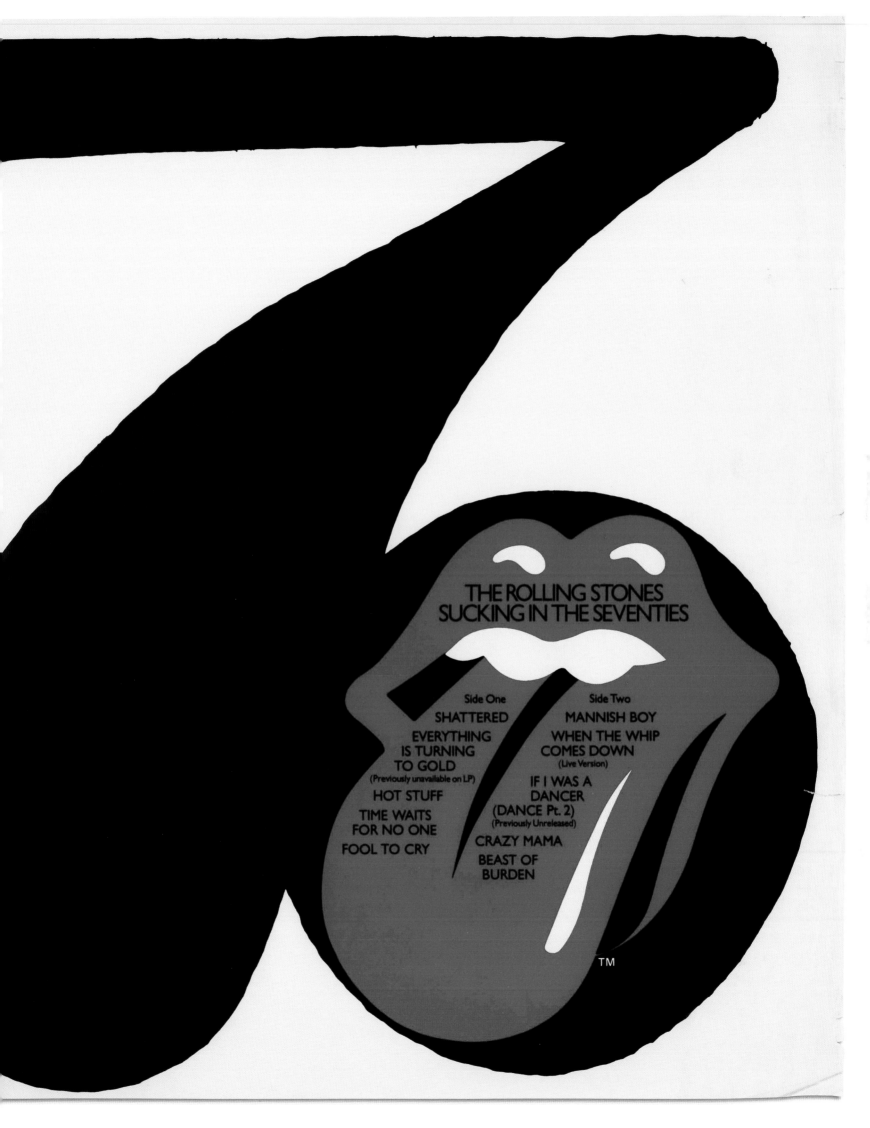

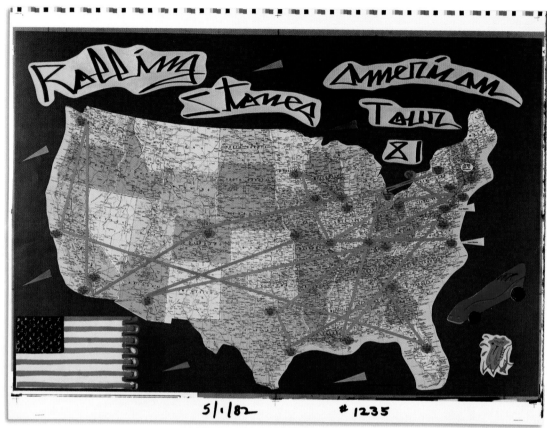

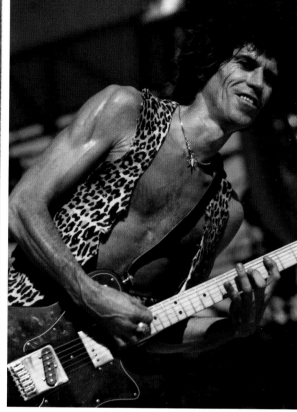

American Tour | 25 September – 19 December 1981

This tour eclipsed every other we had ever done. At our fifty shows we played to almost 2.2 million people. The stadium shows were massive affairs as we criss-crossed America.

We released *Tattoo You* before the tour and played a lot of the new songs from the album, including 'Start Me Up', the hit single that preceded the album. Other songs from the album that we played live were 'Waiting on a Friend', 'Little T & A', 'Hang Fire', 'Tops' and 'Black Limousine'. Prior to the tour, we rehearsed for near enough a month, to hone not just our new songs but also to get a set together that could be sustained throughout such a long tour. These were long shows. Night after night we played for over two hours. MICK

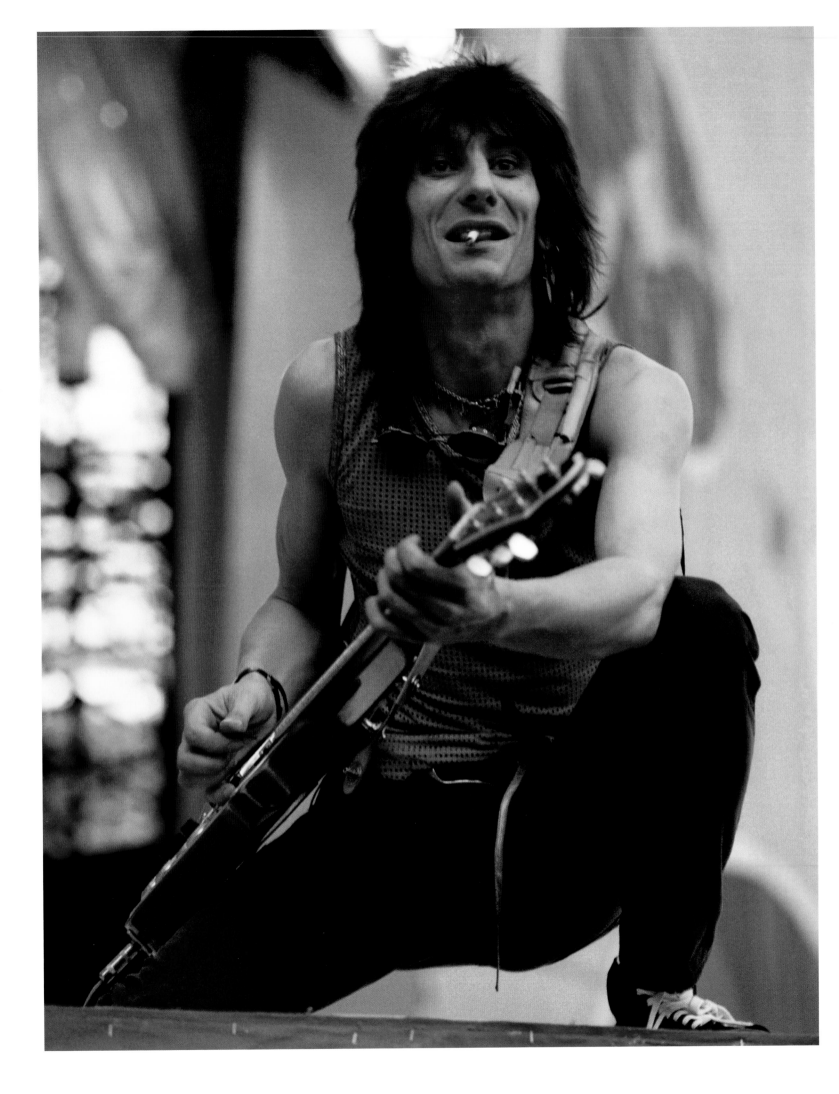

American Tour | 25 September – 19 December 1981

When we played the Hampton Coliseum, a guy ran on stage – security were a bit slow that night. I saw this cat heading towards Mick. As I moved in between the guy and Mick, I was thinking, 'Is he gonna hug him, kiss him or stab him?' All I knew was I had to stop him. Fortunately, I had a weapon in my hands. I whipped off my Telecaster and swung it, smashing the guy, and he fell into the drum kit, but Charlie just kept on playing as the security guys grabbed the intruder. Best of all, I put the guitar back on to carry on playing and the damn thing had stayed in tune. Great advert for Fender. KEITH

overleaf

American Tour | 25 September – 19 December 1981

Our set had a stage that was 65 feet wide. Each wing was a further 80 feet wide. The original paintings used in the design were by Japanese artist Kazuhide Yamazaki.

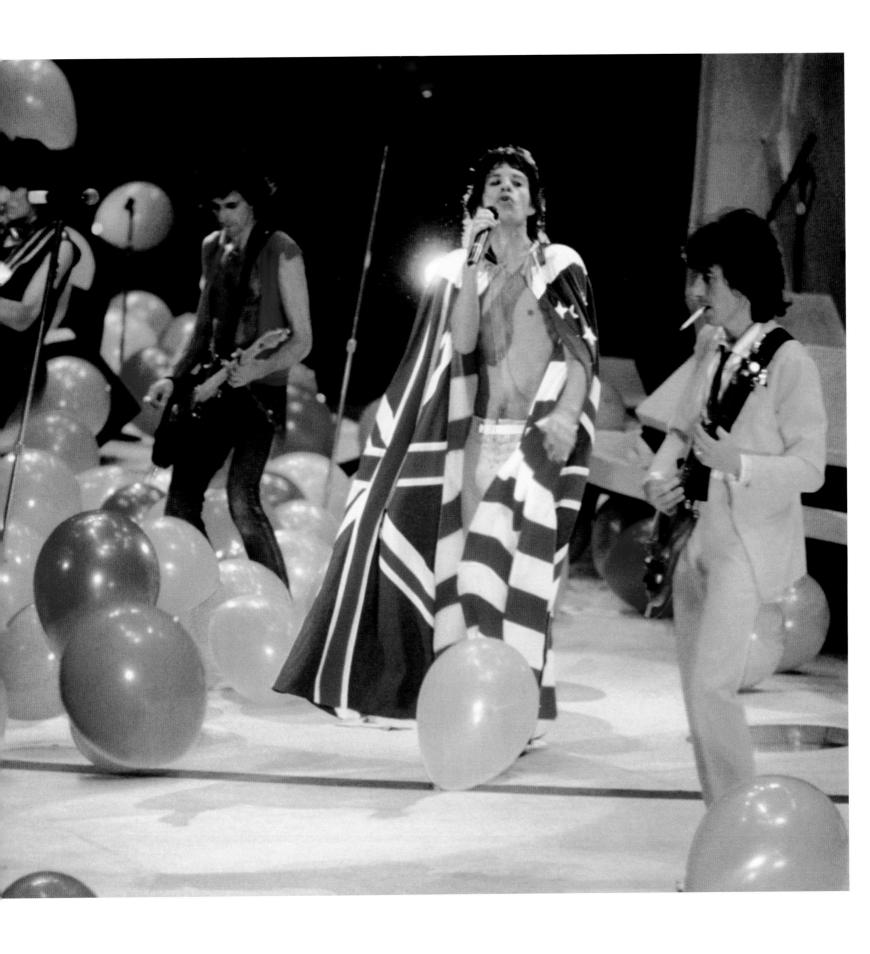

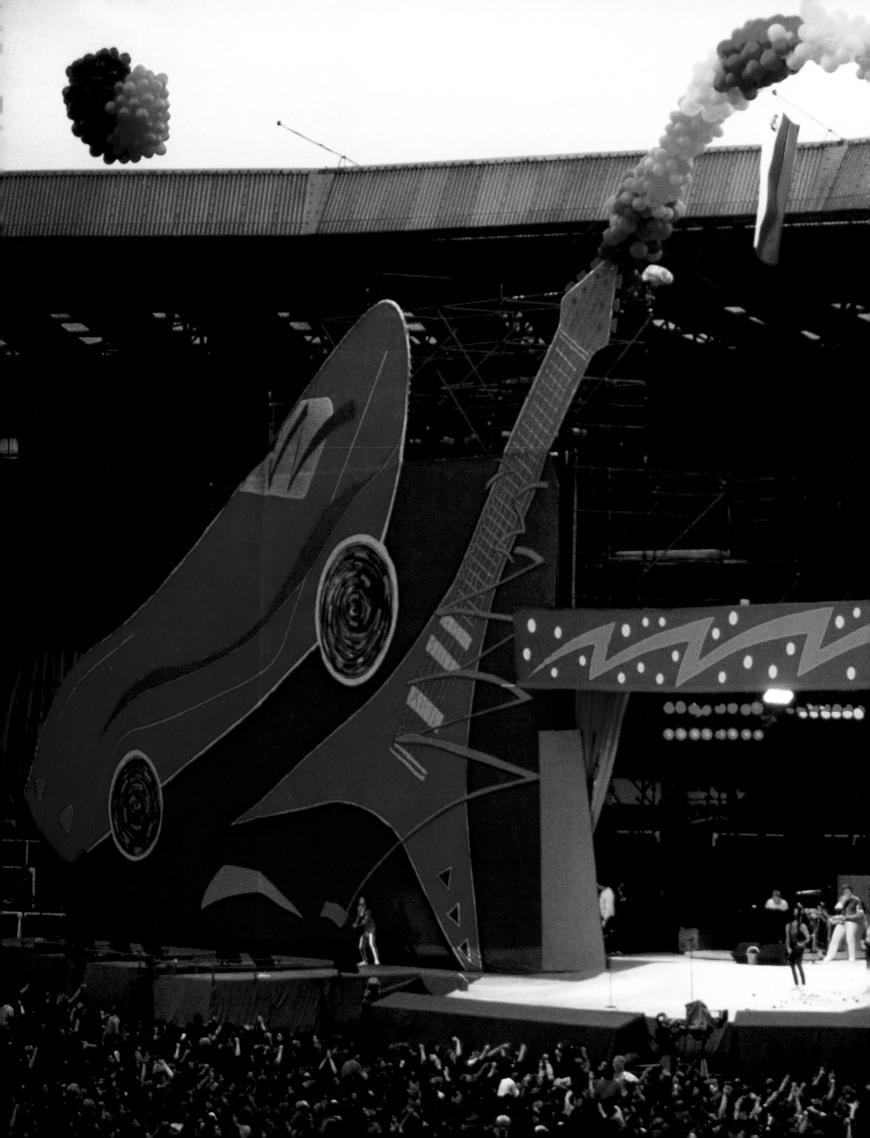

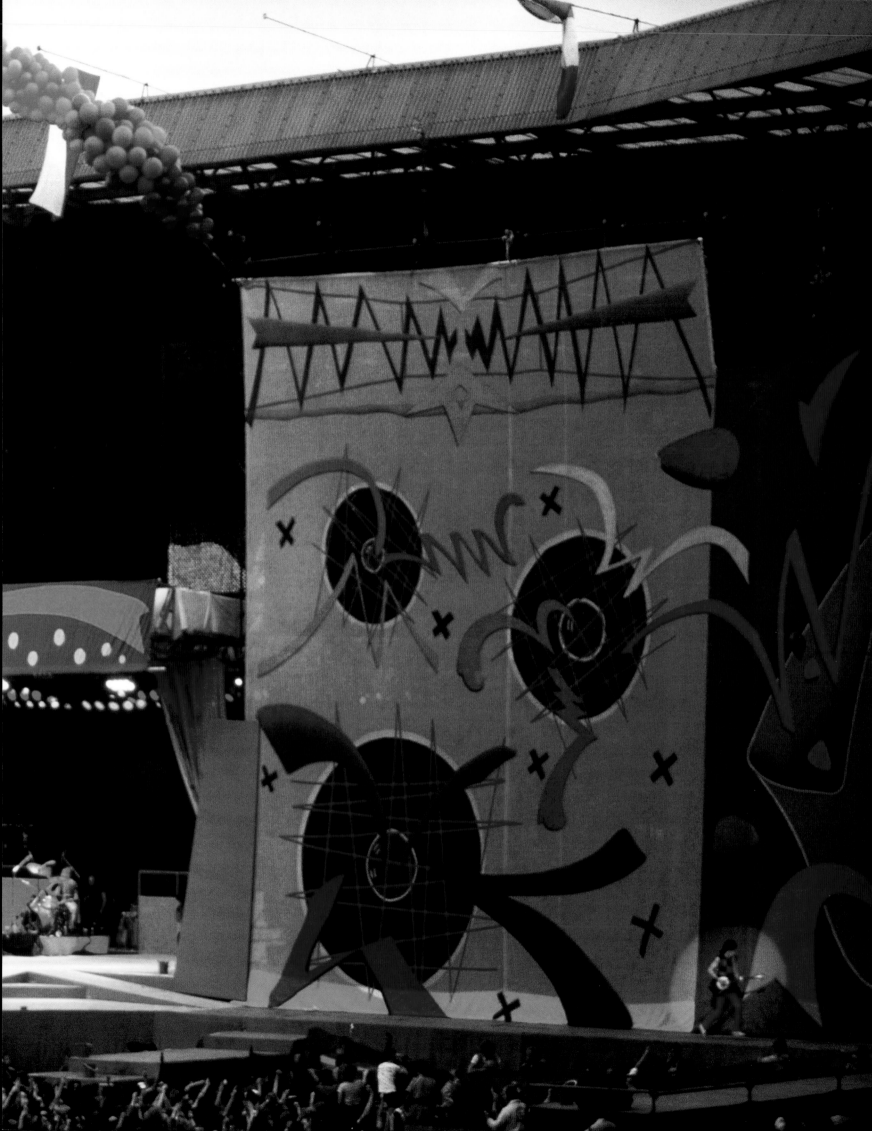

European Tour | 26 May – 25 July 1982

Almost 1.7 million fans turned out for our twenty-three-city European tour. It was very much a reprise of our American tour with a similar set list: we would open with 'Under My Thumb' and usually close with 'Start Me Up', 'Jumpin' Jack Flash' and 'Satisfaction'. For the outdoor stadiums we played throughout mainland Europe and the UK, the stage was similar to the one we used in North America.

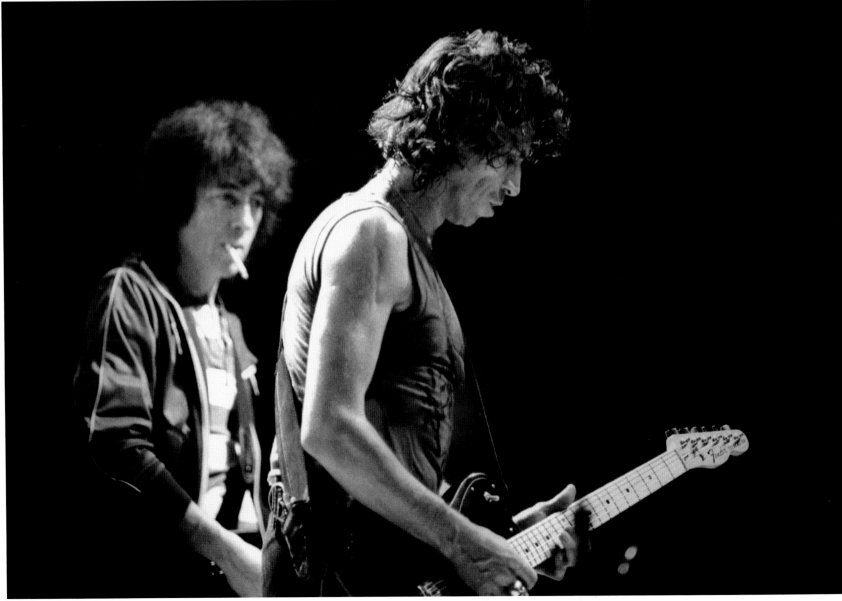

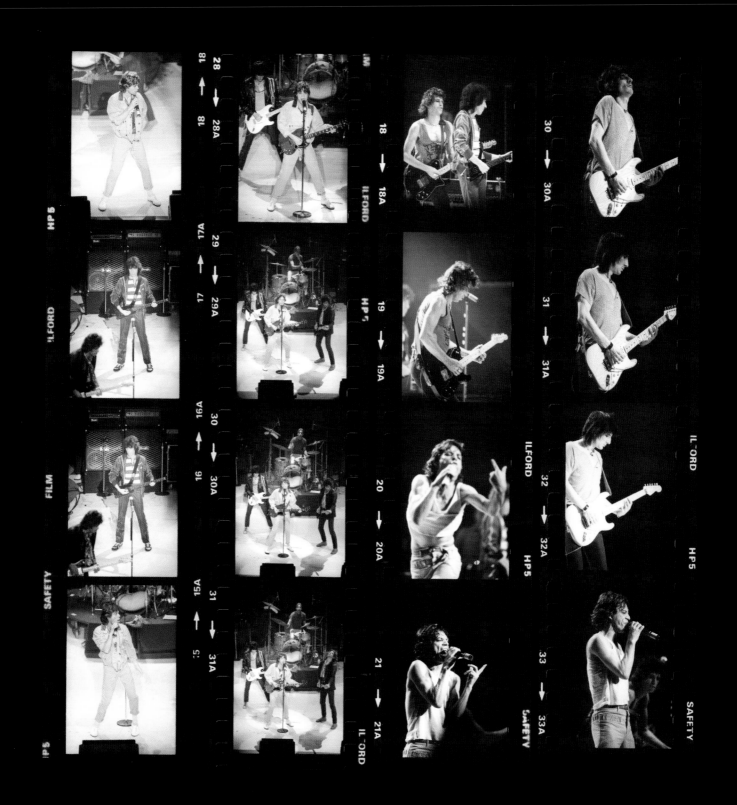

European Tour | Capitol Theatre | Aberdeen, UK | 26 May 1982

*We had not toured either the UK or Europe for six years when we began this tour at
Aberdeen's Capitol Theatre. It was one of three theatre shows in Scotland. The others
were in Glasgow and Edinburgh, after which we played stadium shows.*

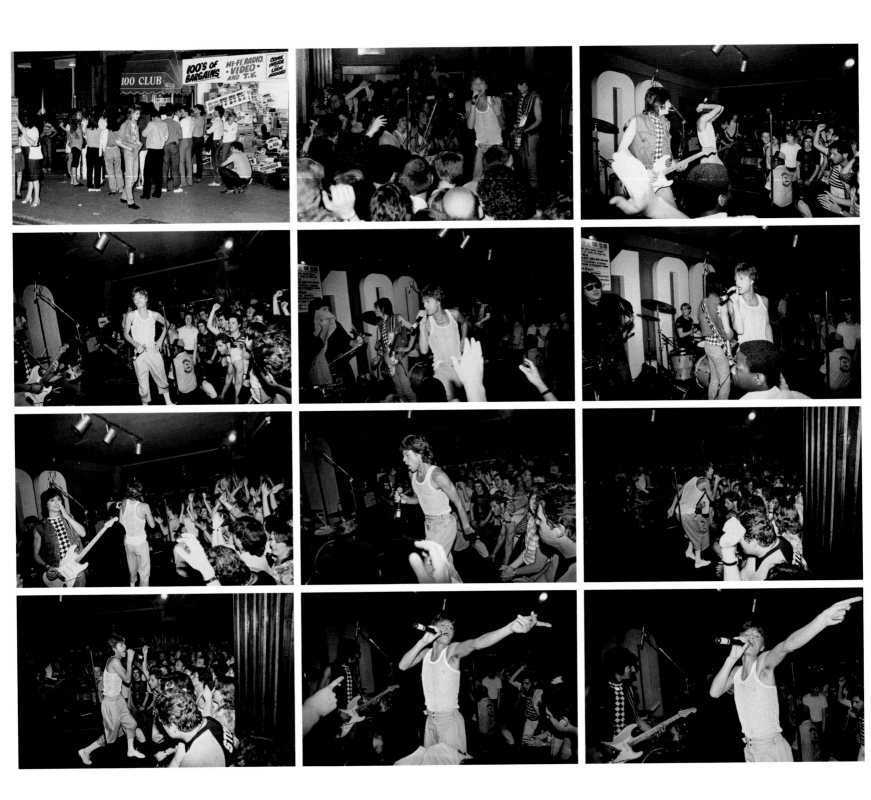

The 100 Club | London, UK | 31 May 1982

*We were billed as Diz and The Doormen for this 'surprise' club
date in London. It was not quite twenty years to the day after our
first ever gig at the Marquee, a little further along Oxford Street,
but close enough. There were around 400 people squeezed into the
club that night and it made for a great atmosphere.*

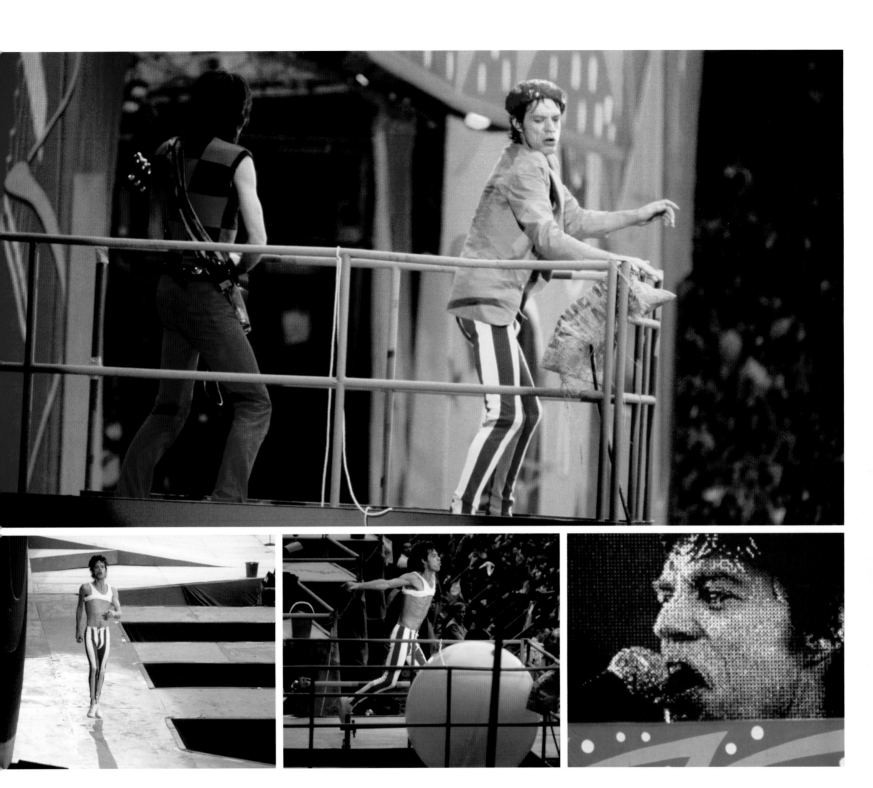

European Tour | Wembley Stadium | London, UK | 25–26 June 1982

The J. Geils Band played the whole tour with us, if I'm not mistaken. It was typical of those summer stadium shows in that we went onstage at 6.30 in the evening, so there wasn't much need for the lights. It was also the last tour on which Ian Stewart played with us. He passed away in 1985 and all of us still miss him very much. MICK

ROLLING STONES STEEL WHEELS

NORTH AMERICAN TOUR 1989

RSP003, ©RUSSDOR B.V. 1988. ® REGISTERED TRADEMARK AND PROPRIETOR THEREIN. MANUFACTURED UNDER LICENSE BY BROCKUM, 739 SEVENTH AVE., NEW YORK, NY 10019. PRINTED IN USA.

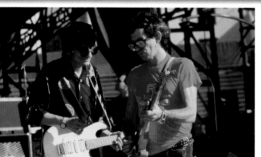
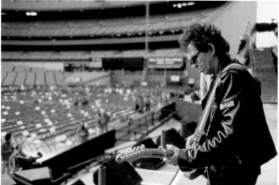
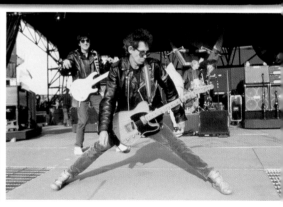

Steel Wheels North American Tour | 31 August – 20 December 1989

Having taken much of the 1980s off, at least from the Rolling Stones, we were certainly back with a vengeance for our first North American tour in eight years. The scale of this tour, even by our standards, was massive. Everything from the size of the set – which took eighty trucks to transport across the country – to the 200 people it took to build it, and the three million fans who came to see the show, made this a very special tour.

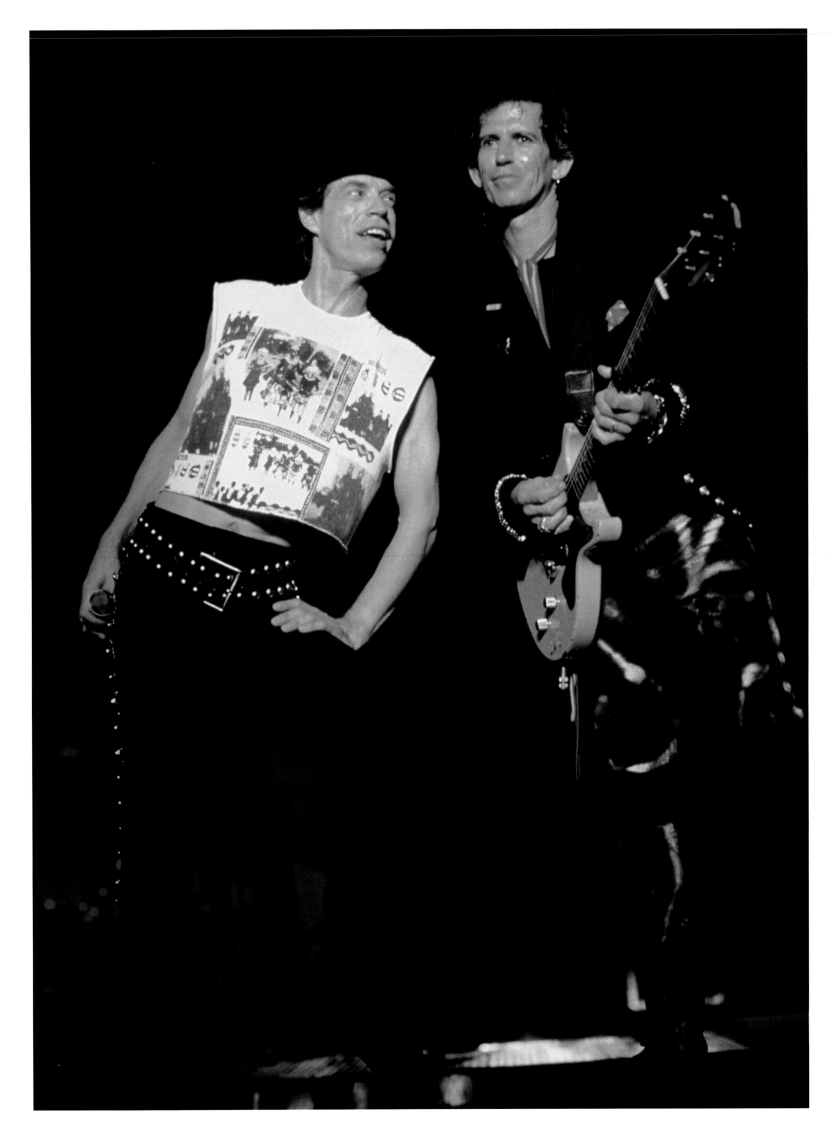

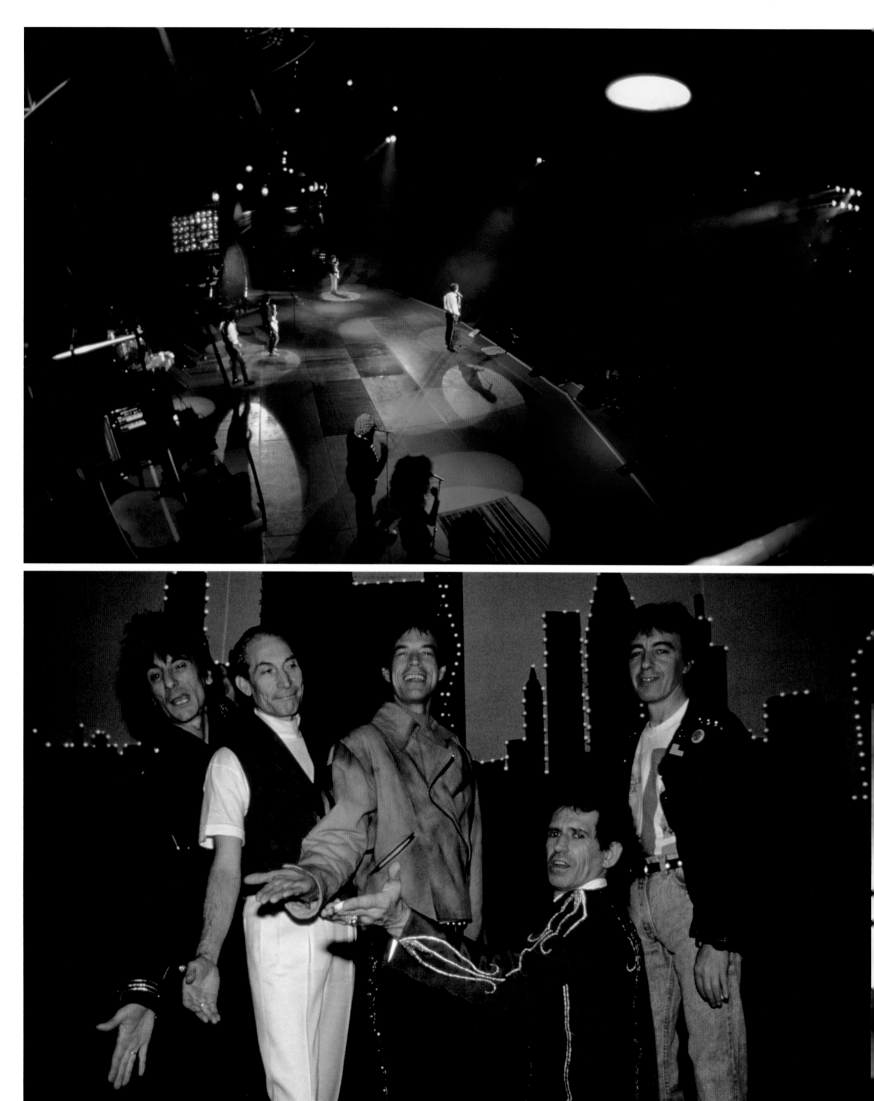

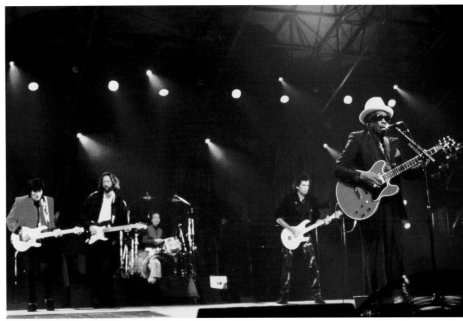

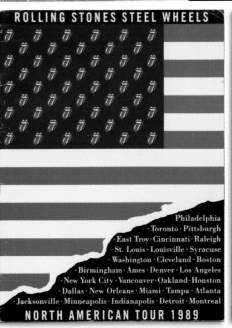

Steel Wheels North American Tour
31 August – 20 December 1989

When we played Atlantic City, New Jersey, on 19 December 1989, we had some very special guests. John Lee Hooker played a couple of numbers with us, as did Eric Clapton. In the top photo, Eric and John Lee can be seen playing 'Boogie Chillen'. The photo to the right shows Eric with us performing 'Little Red Rooster' at New York's Shea Stadium on 10 October 1989.

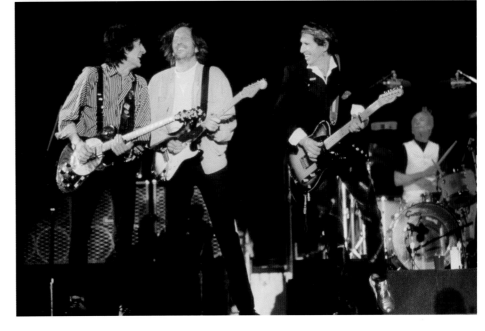

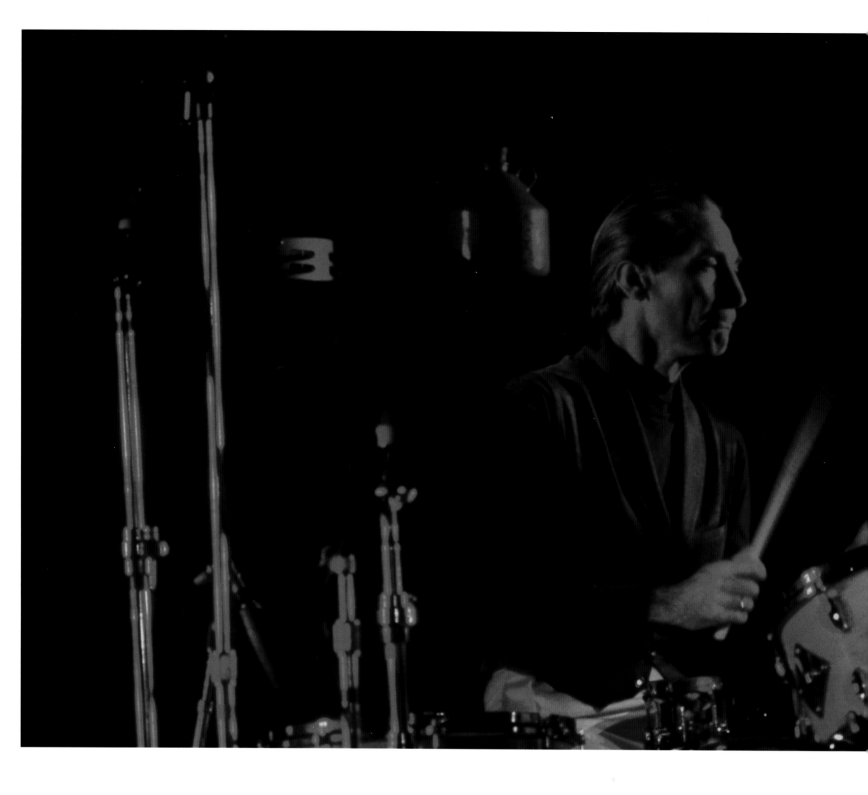

**Steel Wheels Tour | Korakuen Hall, Tokyo Dome | Tokyo, Japan
14–27 February 1990**

We played ten nights in Tokyo and were watched by 500,000 people.

This was our first time playing in Japan. We'd been kept out because of some
of the earlier drug problems and they wouldn't grant us visas. When we finally got
there, it was fantastic – we had a great welcome. This was a very difficult gig to
play; the indoor dome had the effect of creating an echo that made the sound
bounce around. We took our huge Steel Wheels stage with us and played quite a
lot of material from the album: 'Mixed Emotions', 'Sad Sad Sad', 'Rock in a Hard
Place', 'Almost Hear You Sigh' and 'Can't Be Seen'. MICK

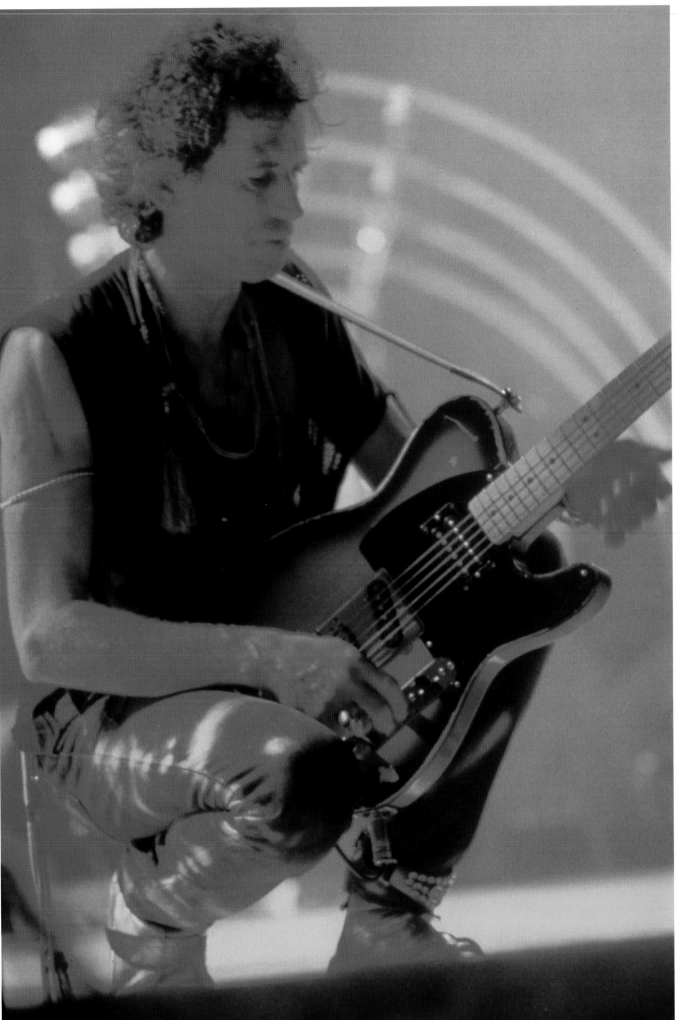

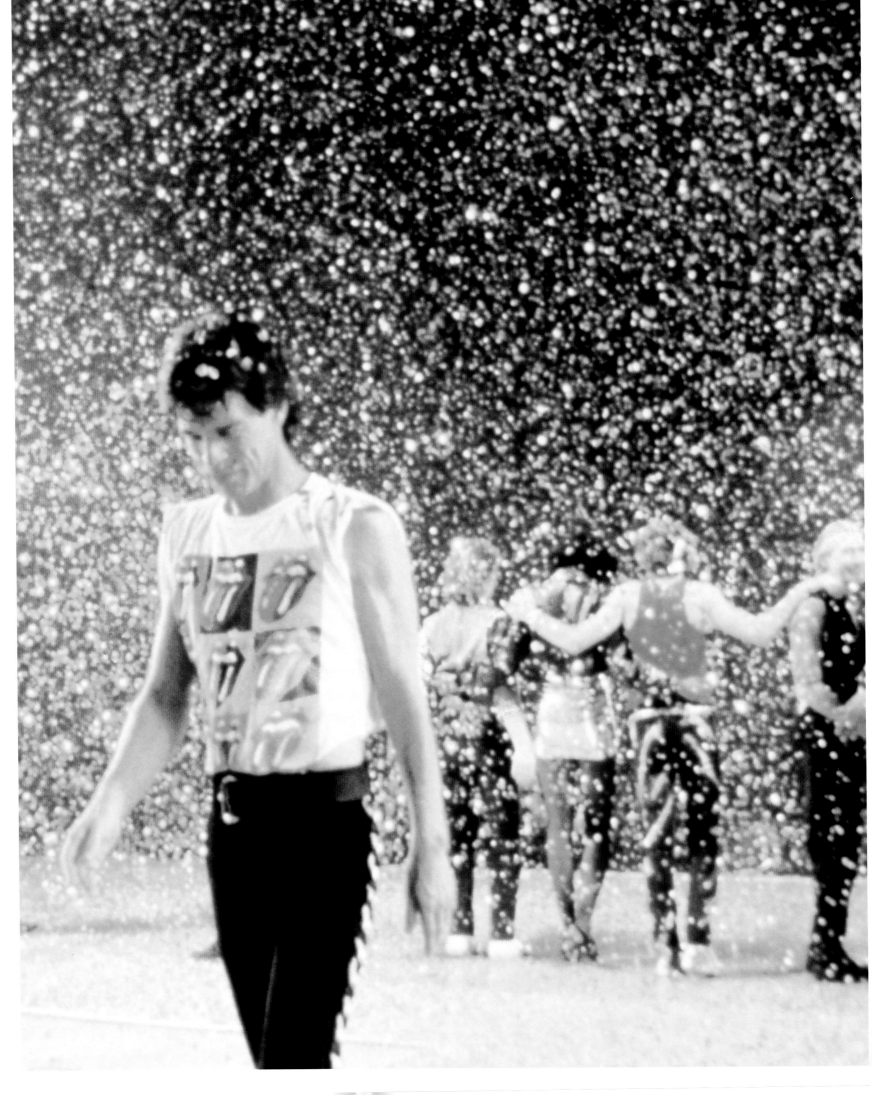

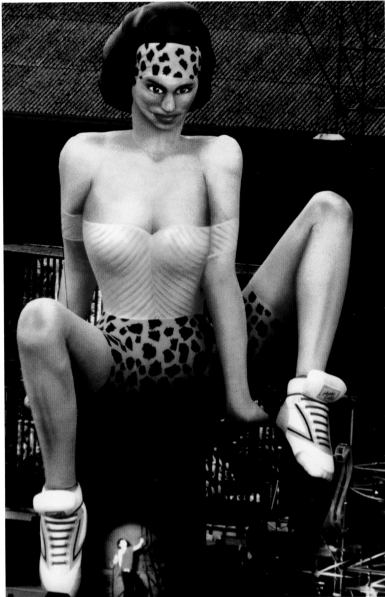

Urban Jungle Tour | 18 May – 25 August 1990

*The Urban Jungle Tour was what we called our European tour. It was
a smaller version of Steel Wheels, because the stadiums were generally
less able to cope with the massive Steel Wheels set. It began in May in
Rotterdam and we finished the tour at London's Wembley Stadium.*

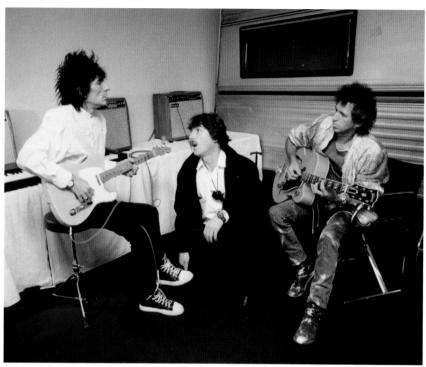

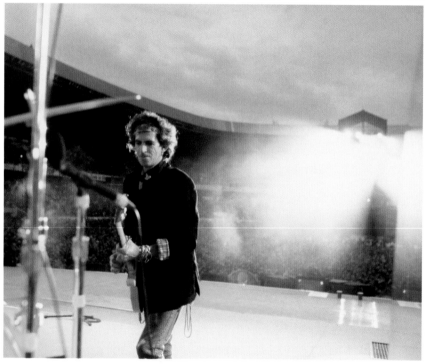

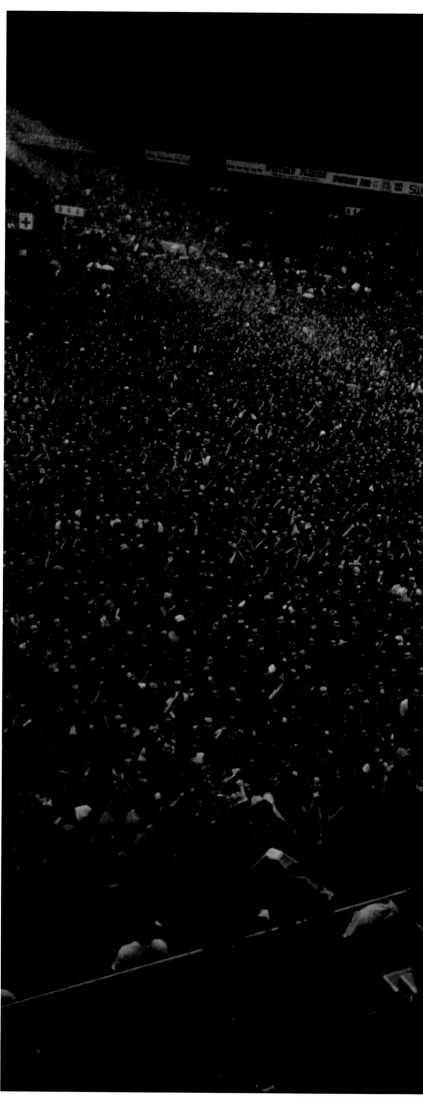

Urban Jungle Tour | Parc des Princes | Paris, France | 22 June 1990

We played three nights in Paris and every night – as we did throughout the tour – we opened with 'Start Me Up'. It had been eight years since we had played Paris and other European cities, and the fans were so receptive.

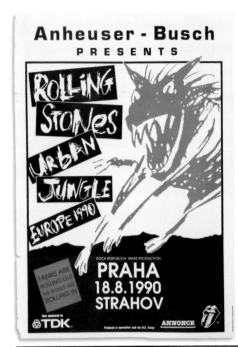

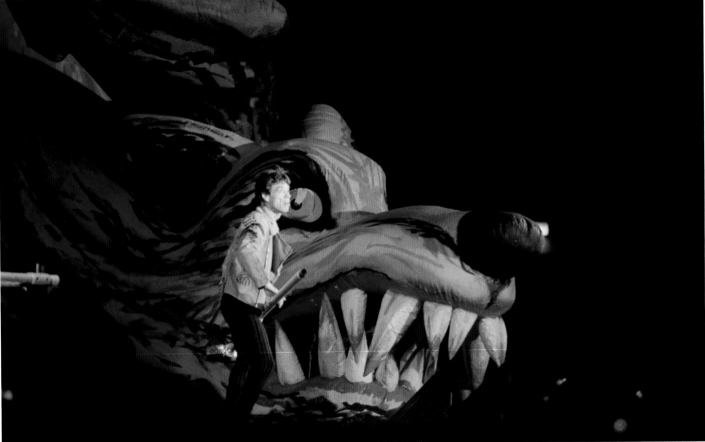

Urban Jungle Tour | Spartakiadni Stadion | Prague, Czechoslovakia | 18 August 1990

We liberated Prague, or so it felt. One in Stalin's eye. We played there soon after the revolution that ended the communist regime. 'Tanks roll out, Stones roll in,' was the headline. It was a great coup for Vaclav Havel. He is the one politician I'm proud to have met. Lovely guy. KEITH

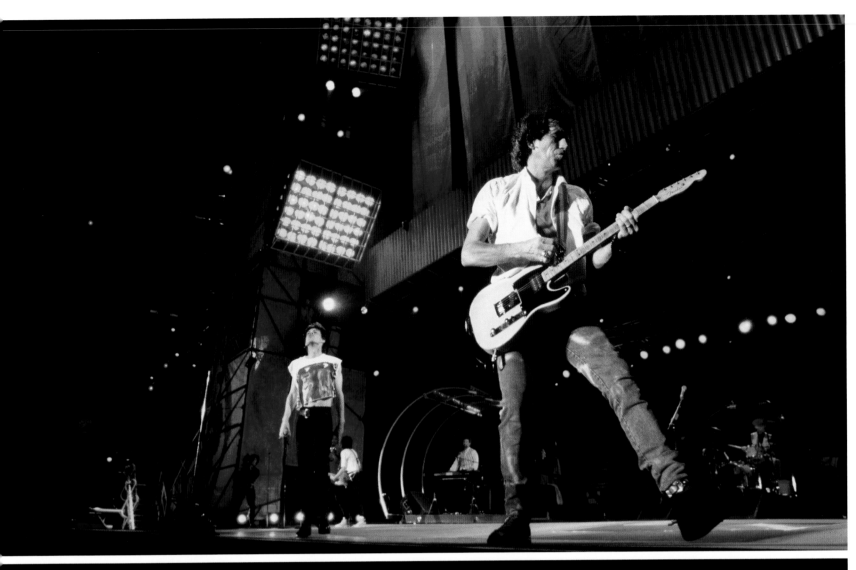

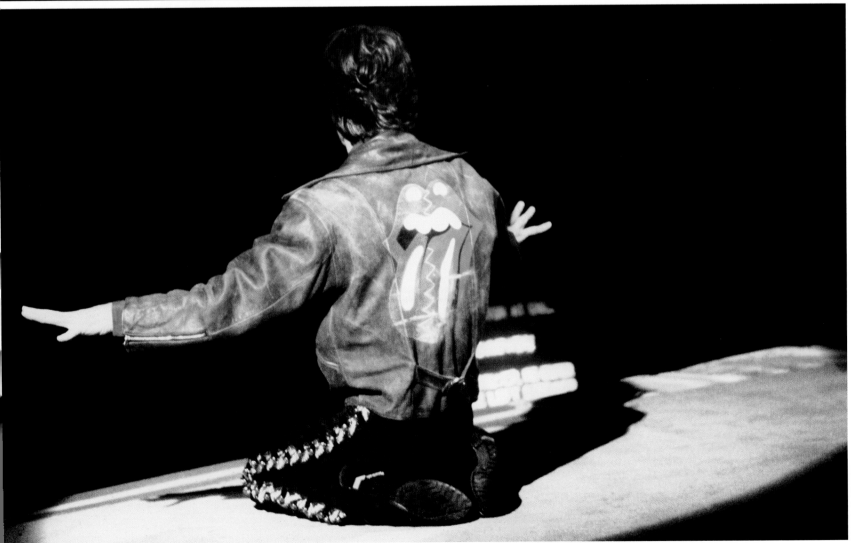

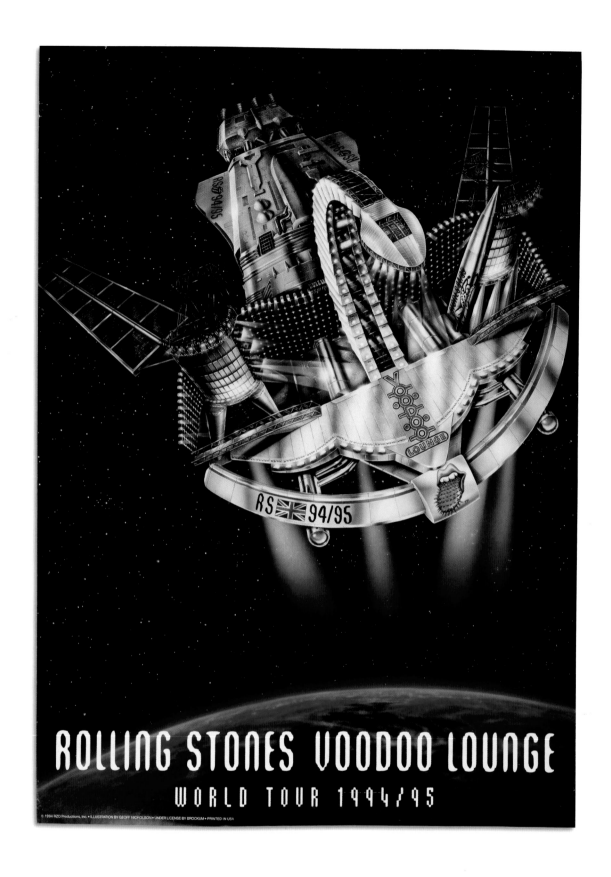

Voodoo Lounge Tour | 1 August 1994 – 30 August 1995

*Our world tour began at the Robert F. Kennedy Memorial Stadium
in Washington, D.C. (opposite). It was another record-breaking tour,
becoming the second-highest grossing in the history of the band. We
played almost 130 shows. This was our first tour without Bill on bass.
Darryl Jones came on board to take over, as he had done on the album.*

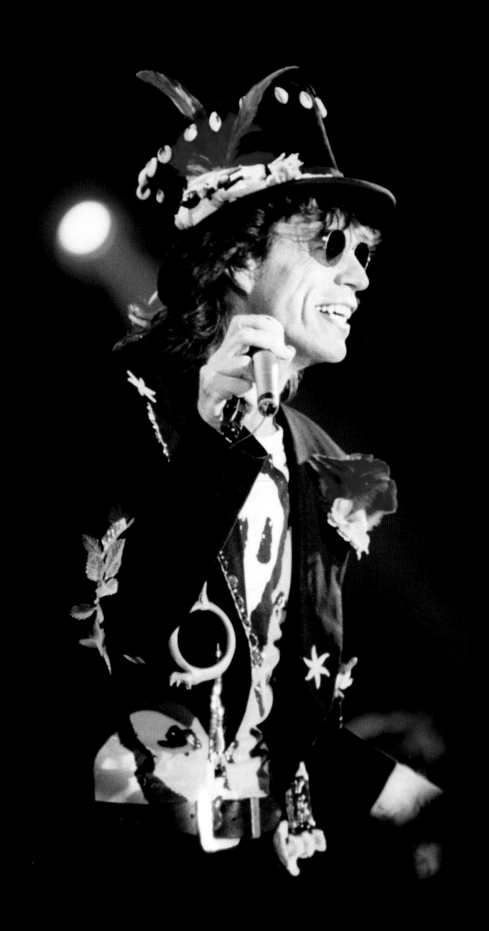

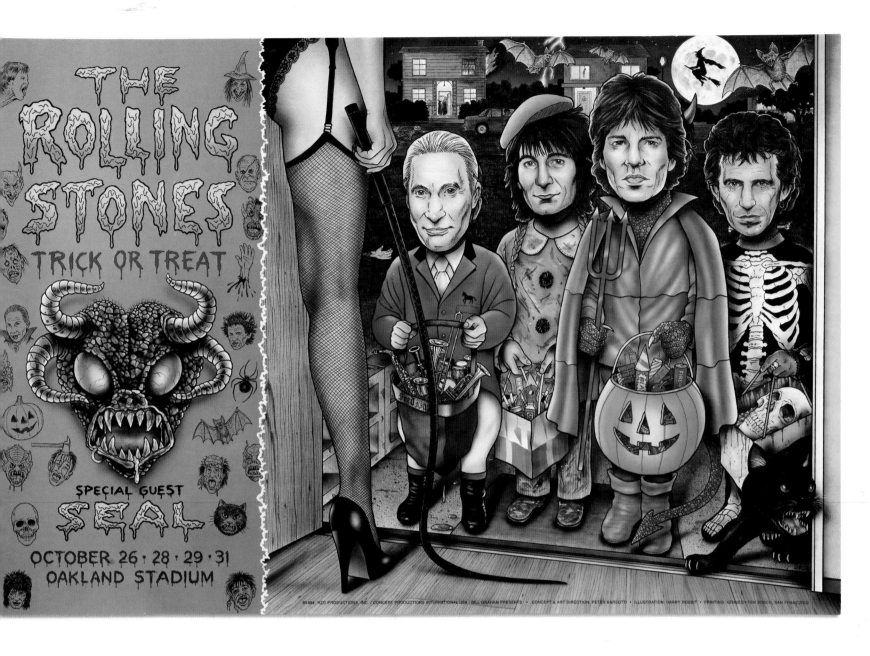

Voodoo Lounge Tour | 1 August 1994 – 30 August 1995

After we played Oakland, we went through Texas, the south, and back through Canada and the western states of the US before we finished the North American part of the tour in Vancouver on 18 December 1994. After New Year, we went to South America for the first time and played Mexico City, São Paulo, Rio de Janeiro, Buenos Aires and Santiago. From there we went to Johannesburg, our first concerts in Africa.

When we were designing the staging for this tour, I said to Mark Fisher, our set designer, 'I want to have a bridge.' Mark didn't think much of the idea. In fact he said it was useless. By the time we got to the Bridges to Babylon tour he had come around to thinking it was a good one, and that was when we really got to grips with the idea of having a B-stage. MICK

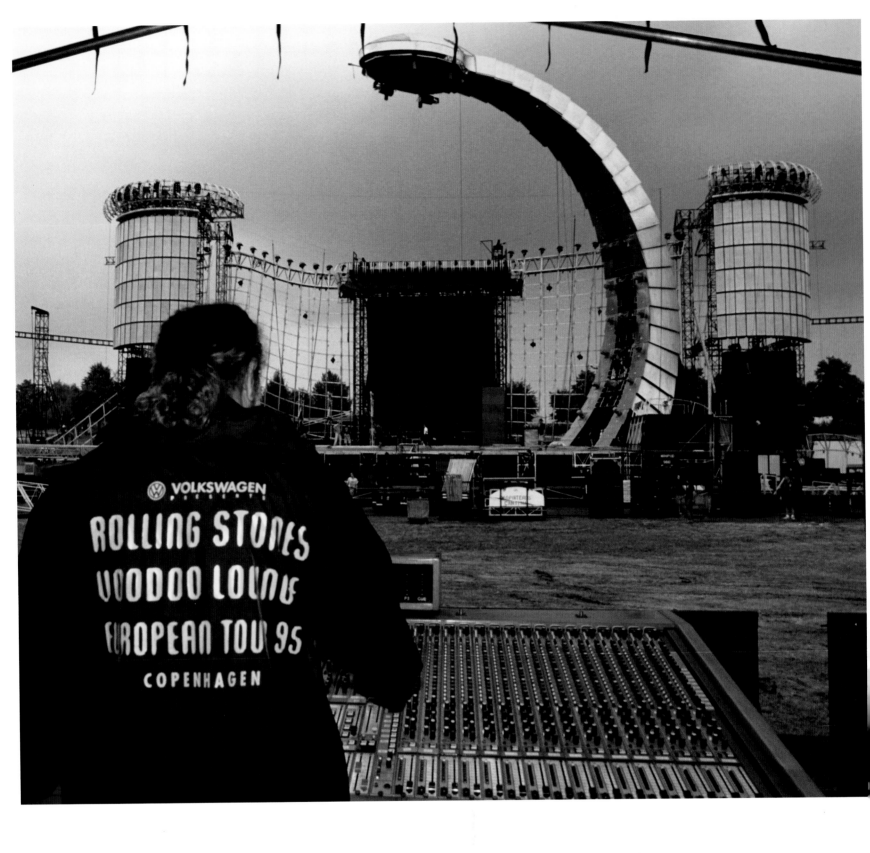

above

Voodoo Lounge Tour | Leipziger Sportforum | Germany | 14 August 1995

After South Africa, we went to Japan in March 1995 and then toured Australia and New Zealand until mid-April. We started the European leg of the tour on 16 May in Amsterdam and finished the whole tour three months later in Rotterdam.

opposite & overleaf

Voodoo Lounge Tour | Wembley Stadium | London, UK | 11 July 1995

We played Wembley for three nights and opened this night, as we did most nights, with 'Not Fade Away'. We followed it with 'Tumbling Dice', 'You Got Me Rocking' and 'It's All Over Now'.

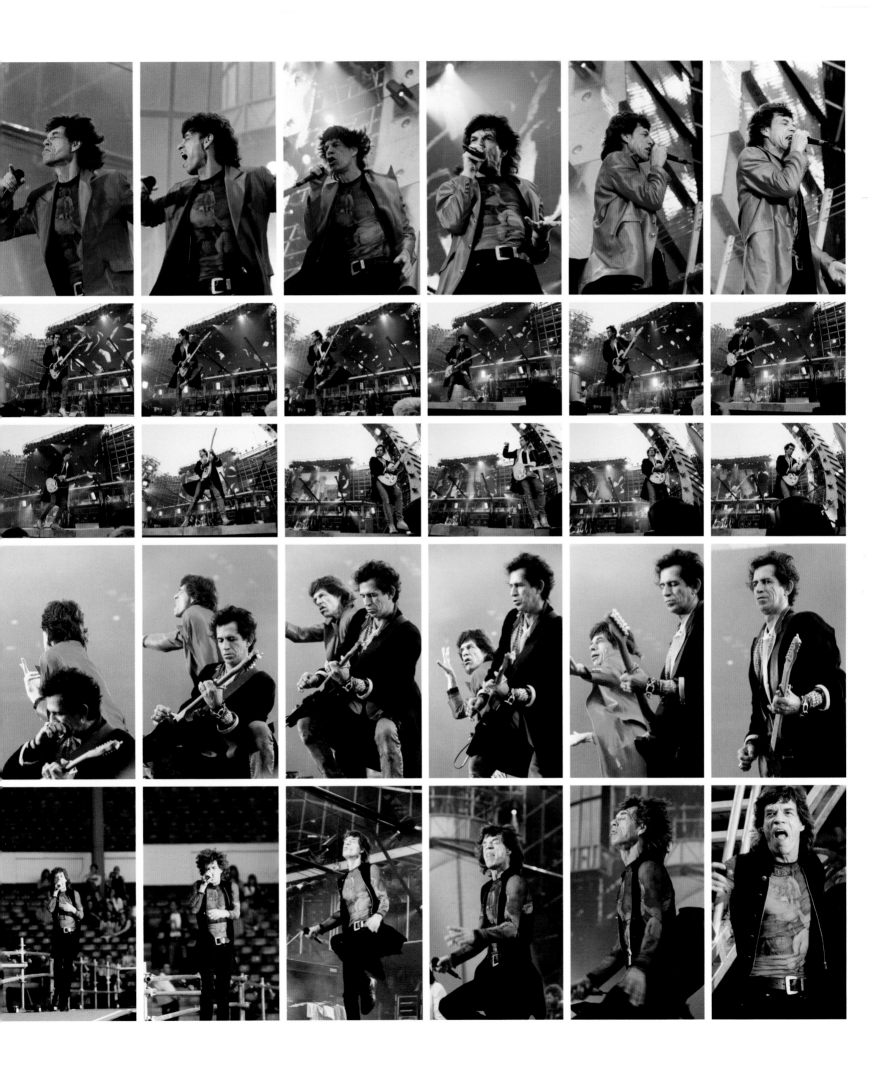

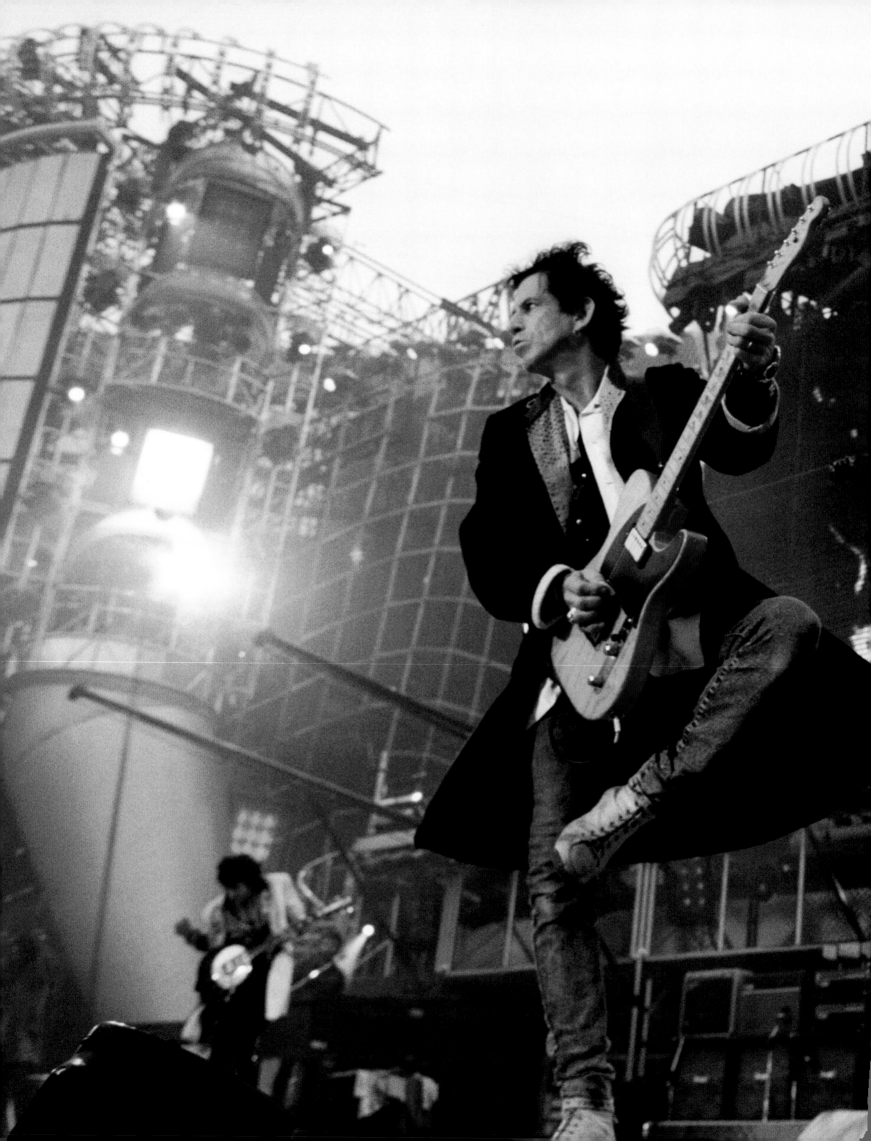

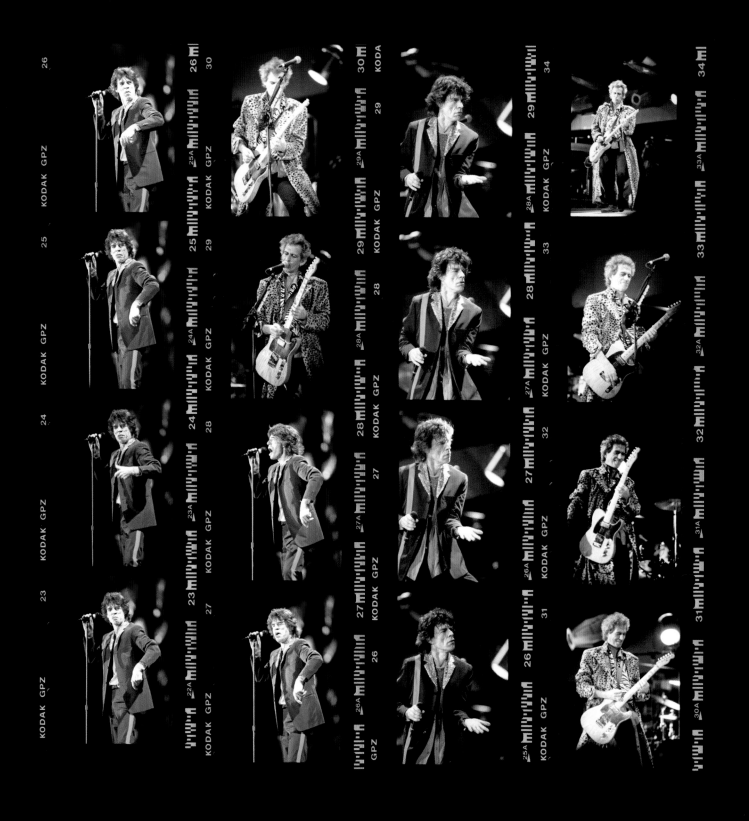

**Bridges to Babylon Tour | The Double Door | Chicago, Illinois, USA
18 September 1997**

*After a warm-up gig in Toronto we played another show to get us in the groove at the
Double Door in Chicago. Our tour officially began on 23 September 1997 at Chicago's
Soldier Field and finished in Cologne, Germany, on 20 June 1999. In January 1999,
we began a stripped-down, three-month tour of North America, playing smaller arenas
rather than the 100,000-seat stadiums of the Bridges to Babylon tour. We called it The
No Security Tour.*

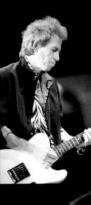
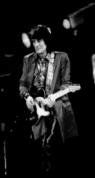
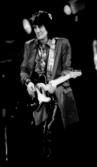
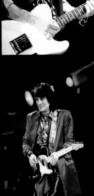

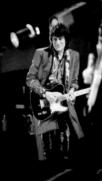
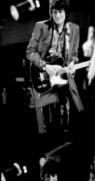
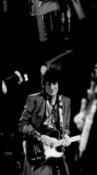
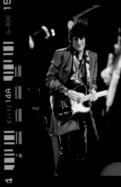

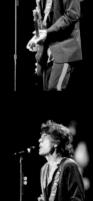

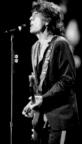

Bridges to Babylon Tour | North America | 23 September – 9 November 1997

This was the first tour on which the B-stage featured at almost every gig and was another massive step forward in terms of the number of people who came to see us: 4.8 million at 108 shows in twenty-five countries.

The bigger shows are harder to play, even though that's what we do most of the time, because we are so locked into lighting systems and computers. The bigger the operation, the more constructed you have to be. When we play on the B-stage or at a club venue, for us it's just like coming back home – sweating it up a bit. KEITH

below right

Vanderbilt Stadium | Nashville, Tennessee, USA | 26 October 1997

bottom

Capital Theater | Port Chester, New York, USA | 25 October 1997

opposite

Soldier Field | Chicago, Illinois, USA | 23 September 1997

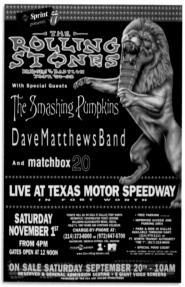

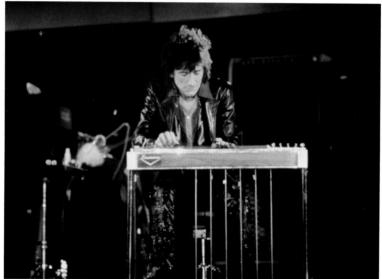

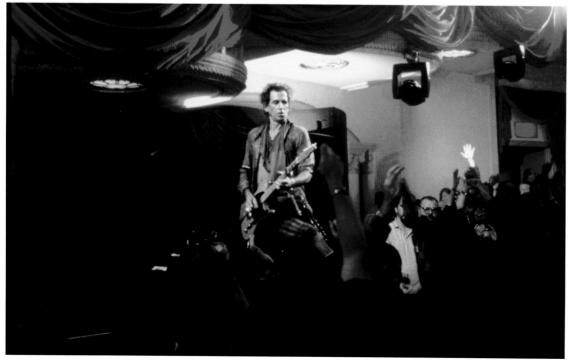

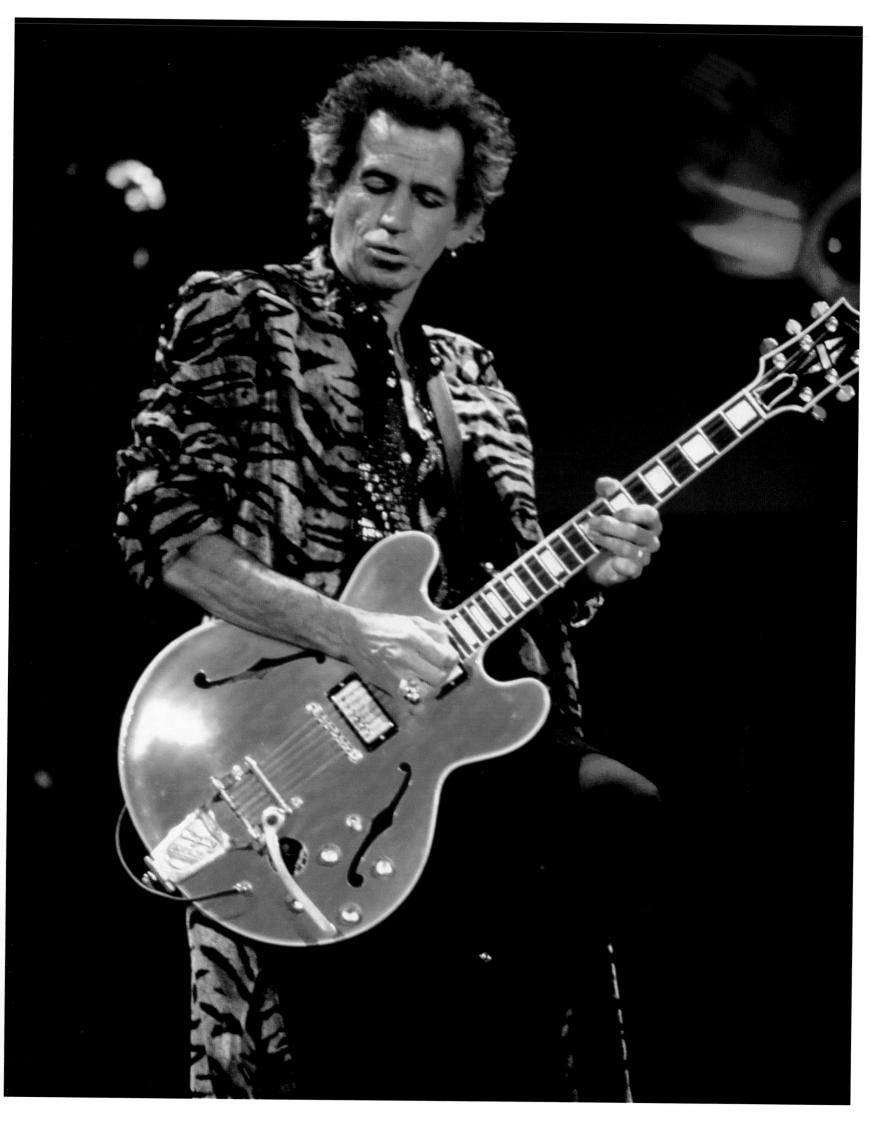

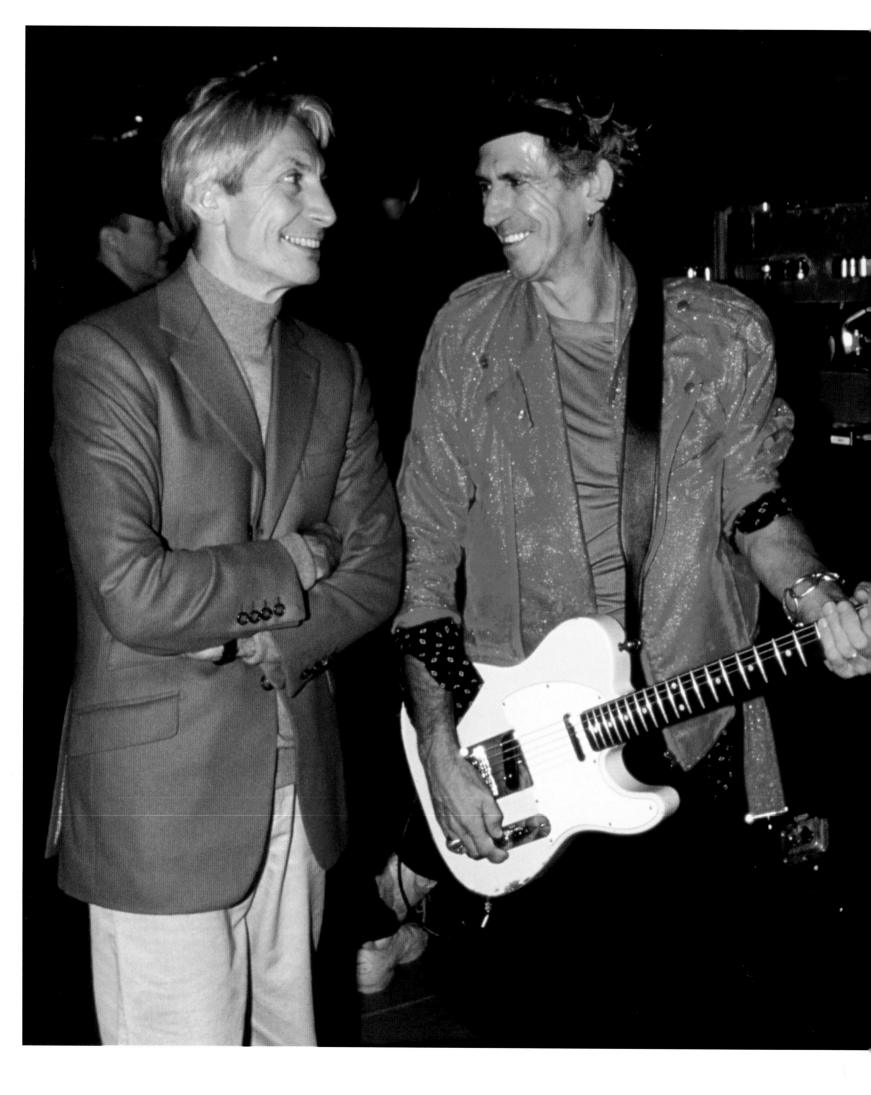

**Bridges to Babylon Tour | Soldier Field
Chicago, Illinois, USA | 23 September 1997**

A lot of what happens in the Stones is down to
a shared experience that Charlie and I have. We
can toss mistakes at each other in the middle of a
show, just to see if the other one will pick it up. It's
like juggling sometimes. KEITH

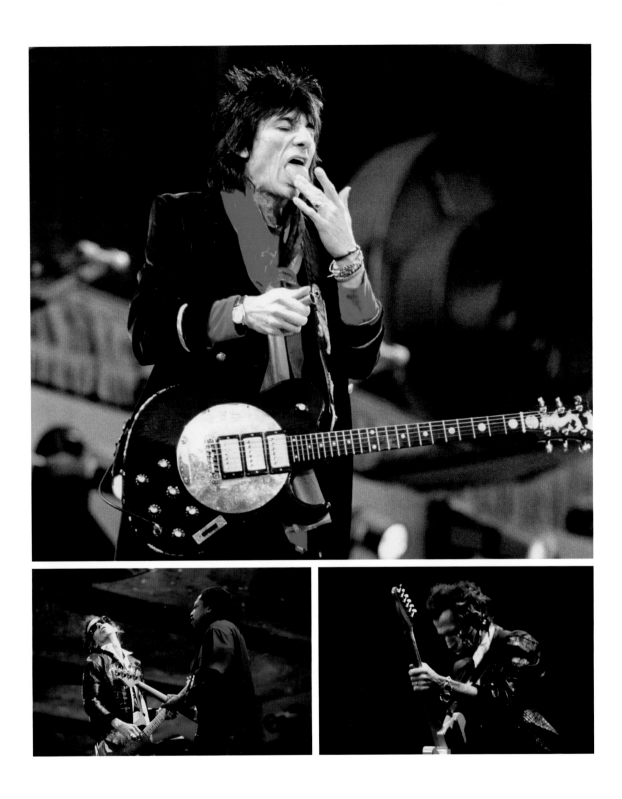

**Bridges to Babylon Tour | Murrayfield Stadium
Edinburgh, UK | 4 June 1999**

The tour title came from looking at the stage. It was going to be
the name of the record as well as the tour, so it all had to fit together.
We were looking at the stage one day and trying to find where we were
with it. What does this design say to us? I came up with the Bridges
idea and a friend of mine came up with the Babylon thing. The bridge
to the B-stage worked perfectly most nights, except when it was too
cold or too hot, and then it had to be sort of manually got together.
It was always my worry that it wasn't actually gonna open. MICK

these & previous pages

Bridges to Babylon Tour | Europe | 13 June 1998 – 20 June 1999

We actually did two halves to the European tour. Starting out in Nuremberg, Germany, in June 1998, we finished on 19 September in Istanbul, before a three-week mini-tour in late May and June 1999.

Bridges to Babylon Tour | The Hague, Netherlands
5 September 1998

There's another guy that joins the band on outdoor stages: God. Either he's benign or he can come at you with wind from the wrong direction and the sound is swept out of the park. The weather normally comes good around showtime … but not always. KEITH

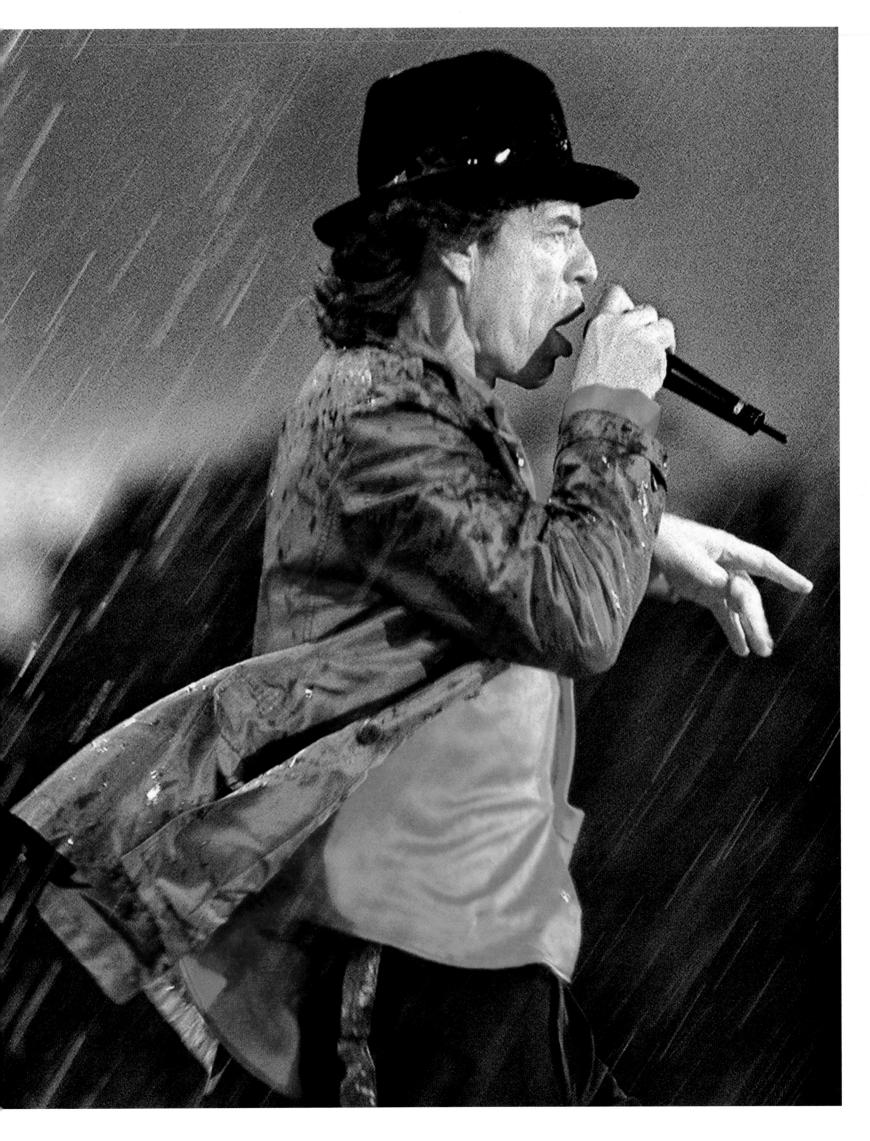

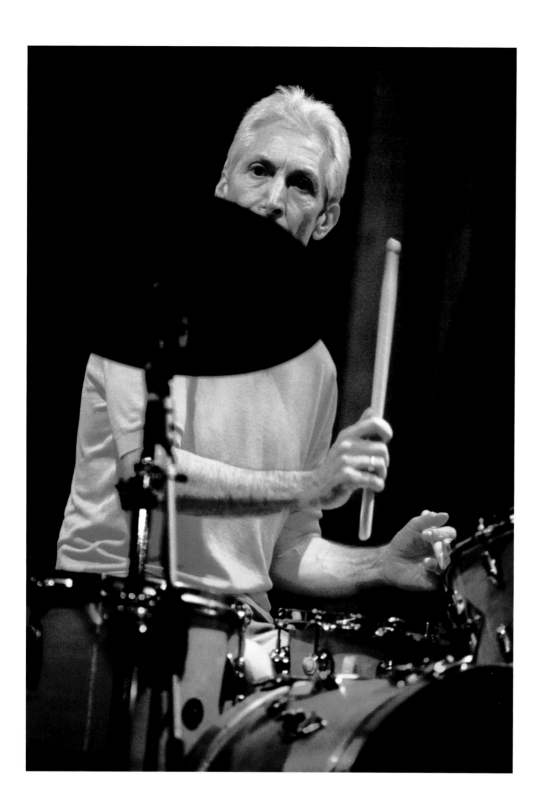

Licks World Tour | 3 September 2002 – 9 November 2003

There was no theme for the Licks Tour. There were three different stages, but no unifying concept, apart from the fact that it was three shows by the Rolling Stones. So we created the artwork with the three tongues and worked with that, and in the end I just said, I really like the stage and the theme is original. MICK

The stage for Licks was very beautiful – a slicker version of what we had for Steel Wheels. We spent a lot of time in Mick's apartment working out what we were going to do on the tour. Fortunately, technology was there to give us a starting point. But there always has to be an association between the technology and the music in order to make the connection with the audience. CHARLIE

People always want to know how many guitars I have. I've had a lot over the years – around 3,000 – but only take around ten with me on the road. There are a lot of Fenders and, of course, Gibsons. The one you can see clearly in this photo is a Gibson ES-355 – these are the axes I used on our Licks tour. KEITH

left

Feijenoord Stadion | Rotterdam, Netherlands | 11 August 2003

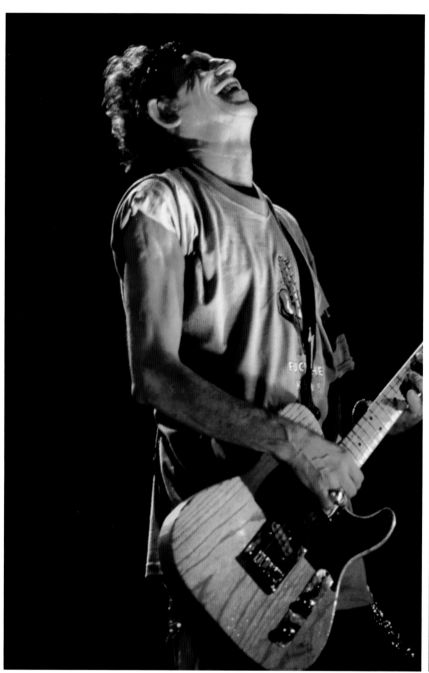

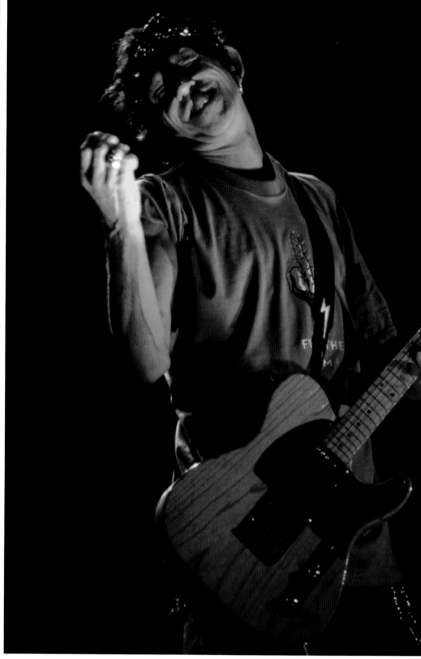

Licks World Tour | Letenska Plan | Prague, Czech Republic | 27 July 2003

I have resigned at the end of every tour since 1969. I thought the Licks tour would be the last one we did of that size and length – wrong again! Keith won't ever stop. He'll always be playing the guitar somewhere. CHARLIE

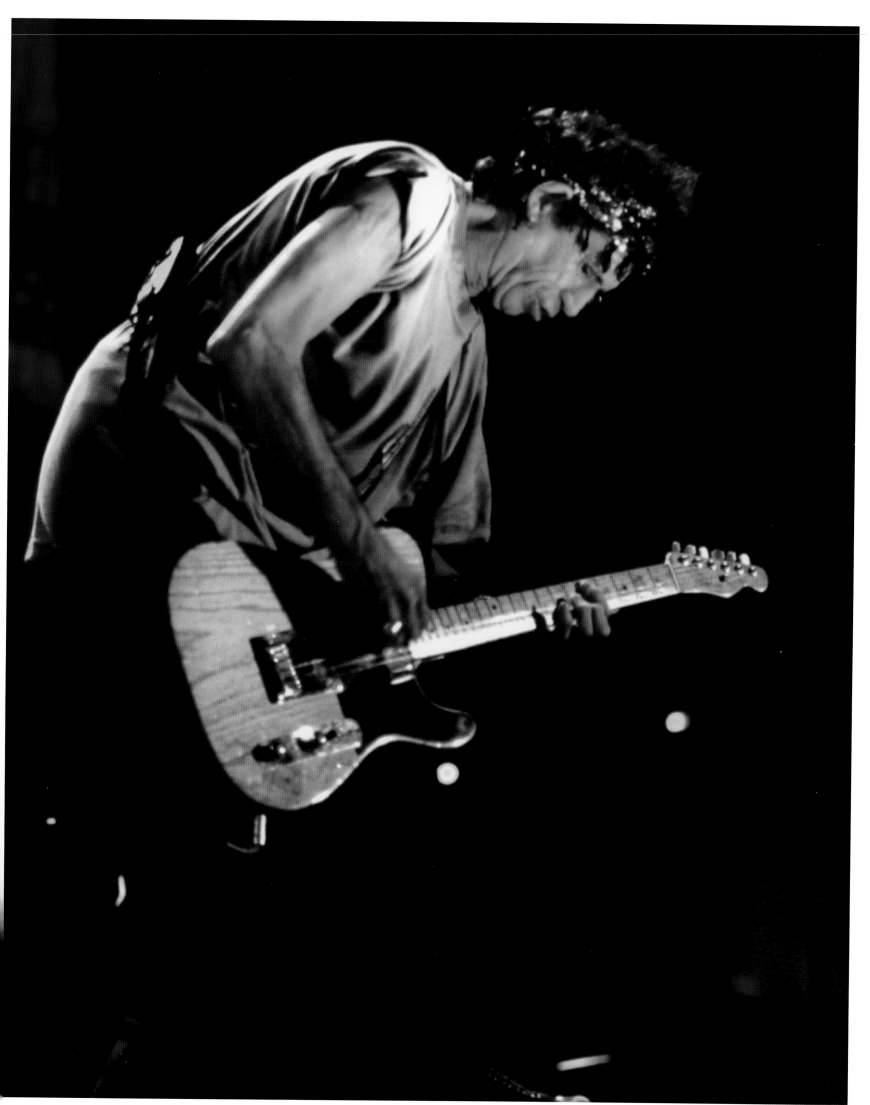

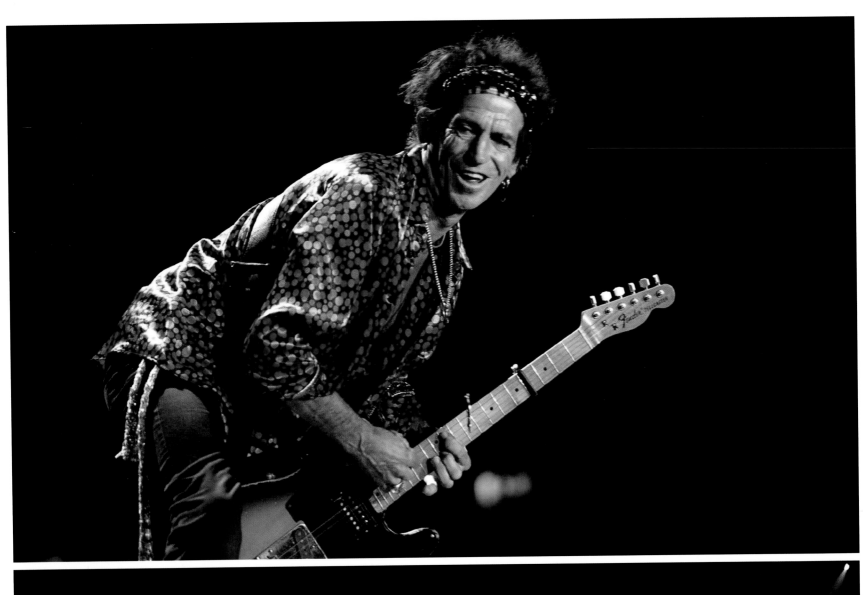

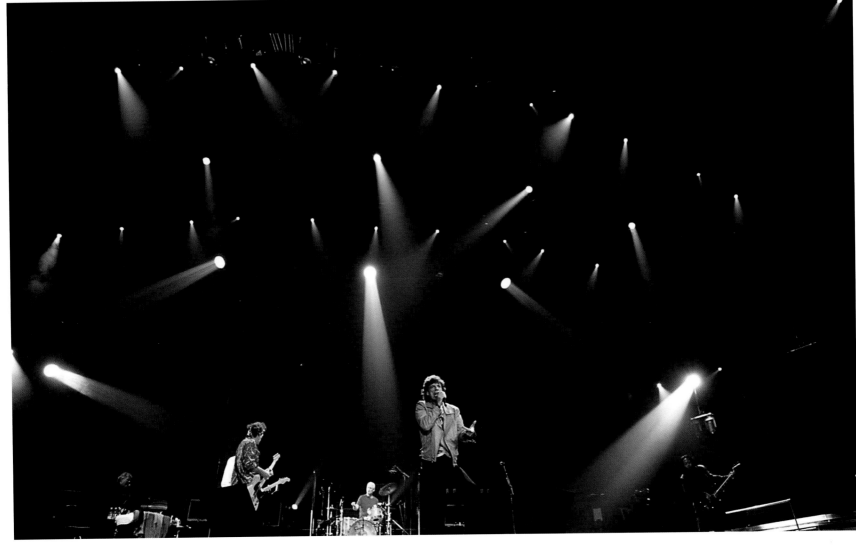

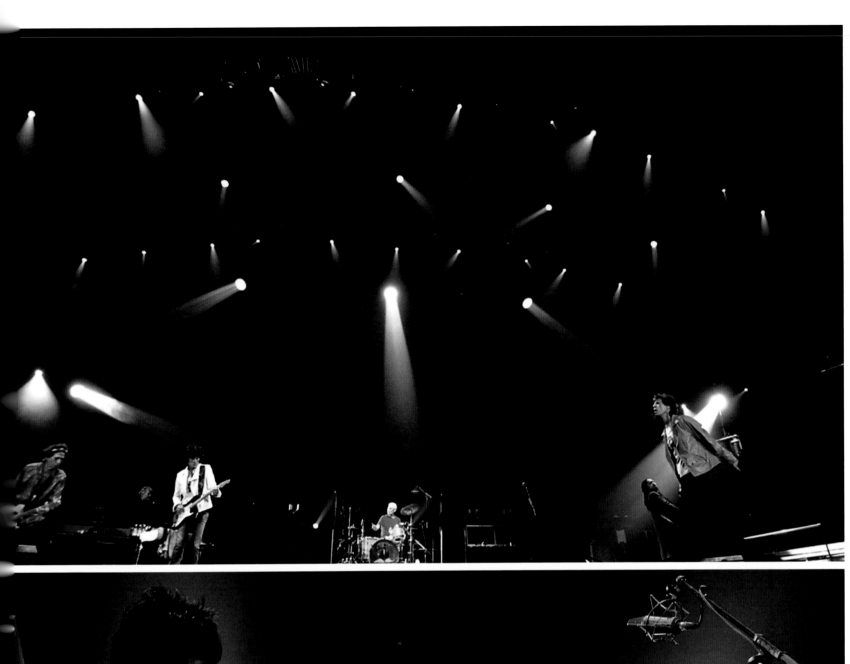
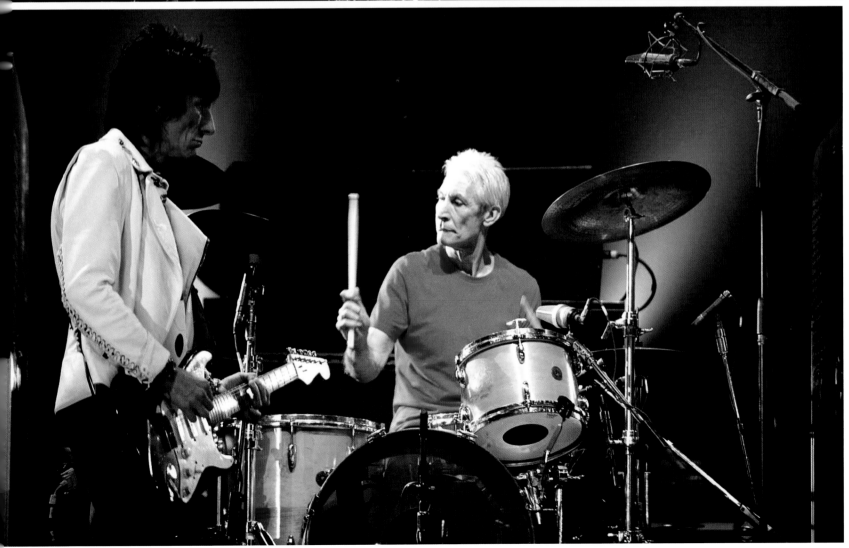

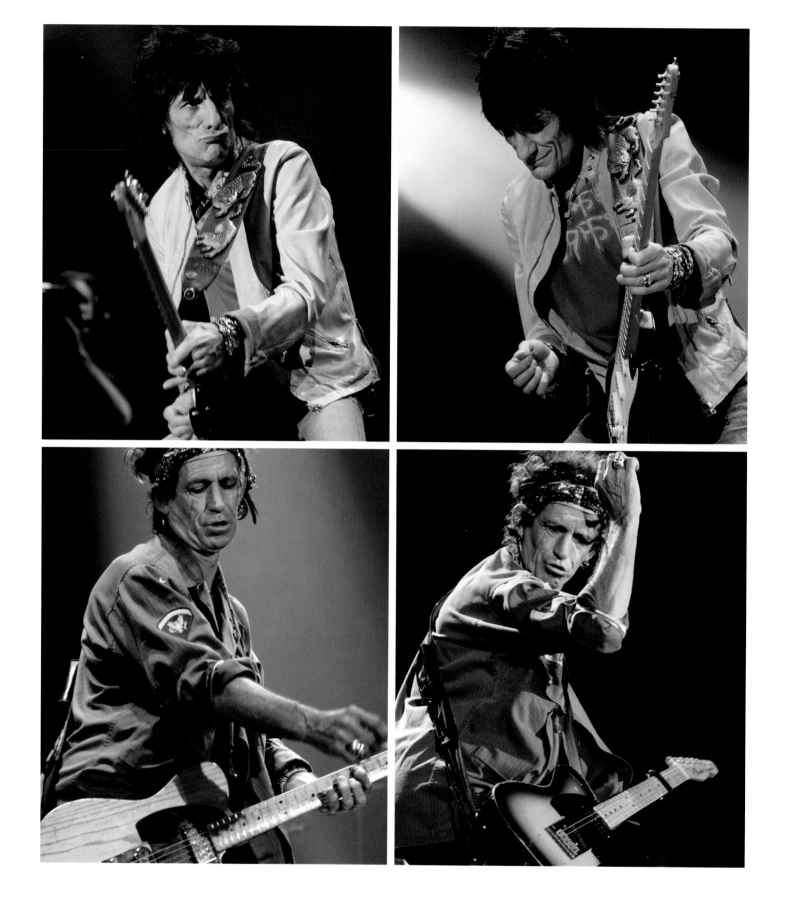

previous pages

Licks World Tour | Wembley Arena | London, UK | 29 August 2003

this page

Licks World Tour | SECC | Glasgow, UK | 1 September 2003

opposite

Licks World Tour | Twickenham Stadium | London, UK | 20 September 2003

Licks World Tour | 16 August 2002 – 9 November 2003

We mixed theatres, arenas and stadium venues during this tour, on which we played
117 shows. After touring America and Canada, we went to Australia, Japan, Singapore
and India, before touring Europe in the summer of 2003. Our last two shows were in
Hong Kong in November 2003.

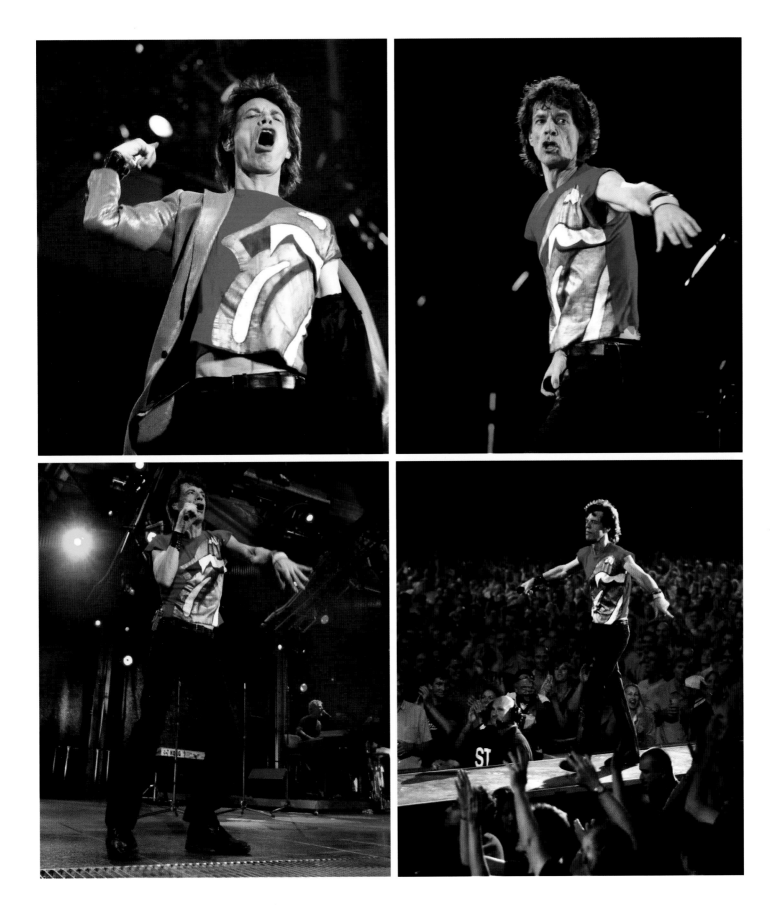

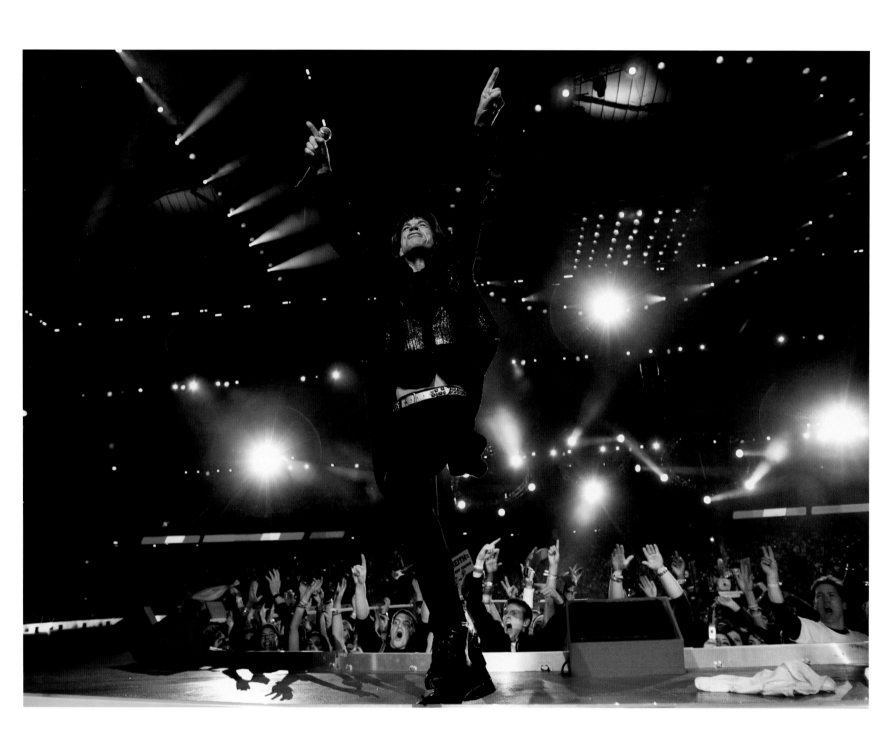

above & opposite

Superbowl XL | Ford Field | Detroit, Michigan, USA | 5 February 2006

We did three numbers – 'Start Me Up', 'Rough Justice' and 'Satisfaction' – on the specially constructed stage during halftime at this iconic sporting event. The broadcaster objected to some of the lyrics of our first two songs so they censored us – not the first time.

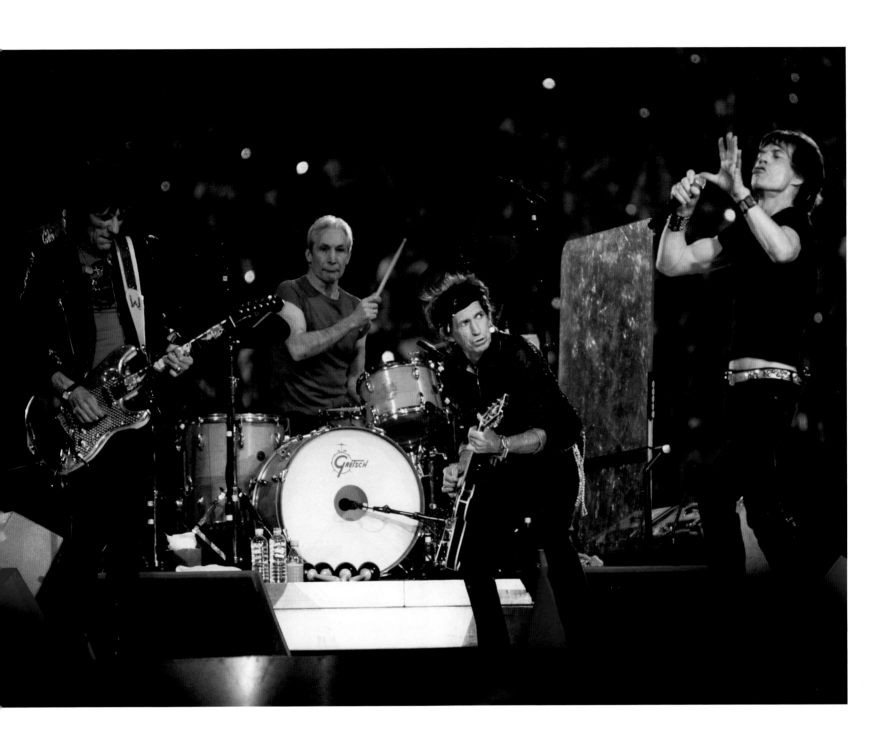

overleaf

Superbowl XL | Ford Field | Detroit, Michigan, USA | 5 February 2006

This photograph of the Superbowl halftime show was the first time I'd seen the stage set. It really does look amazing looking down on it from the crowd's viewpoint. It's what we miss when we're playing on stage. We're stuck in the eye of the storm. CHARLIE

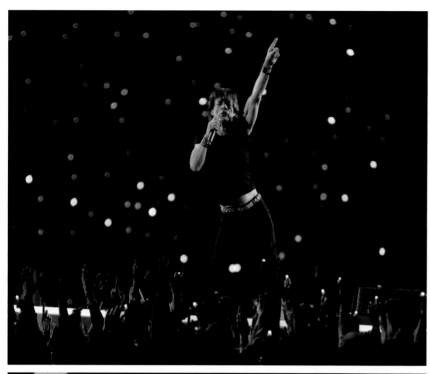

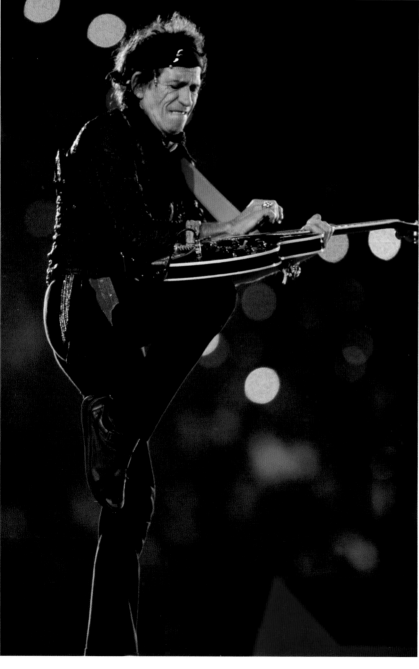

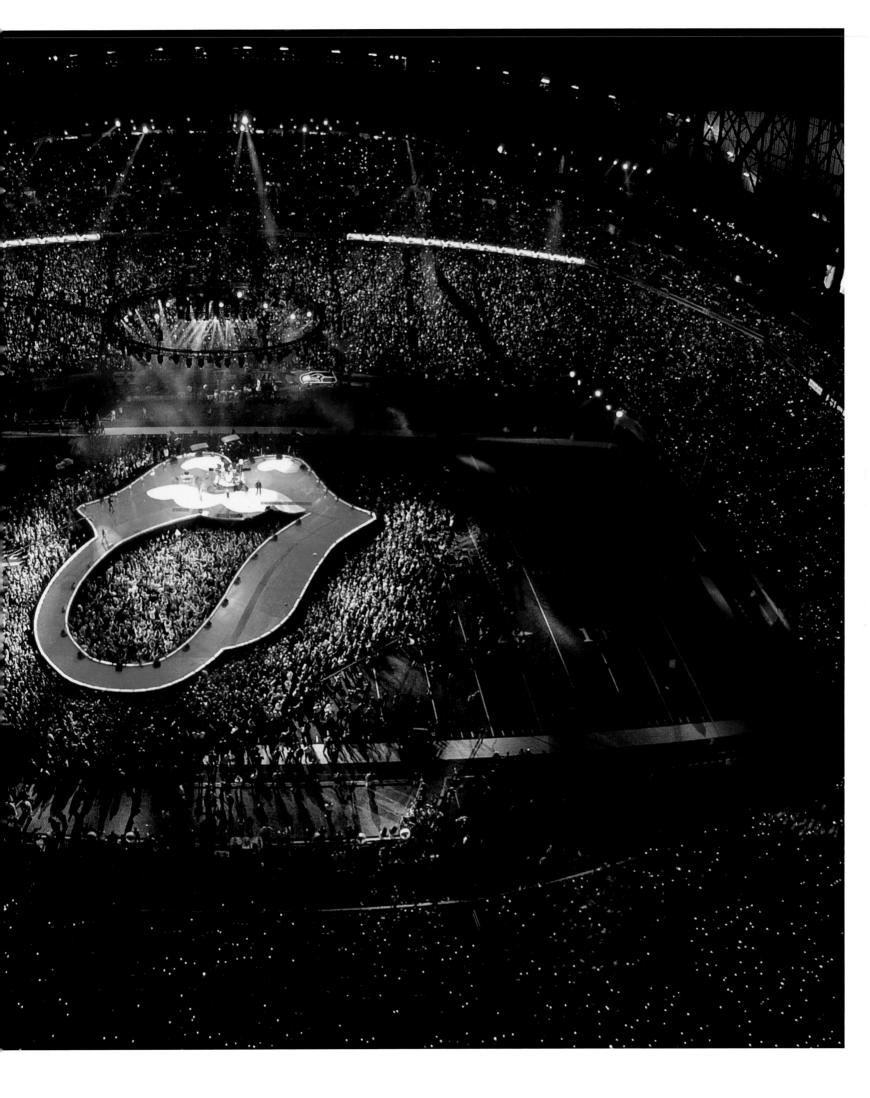

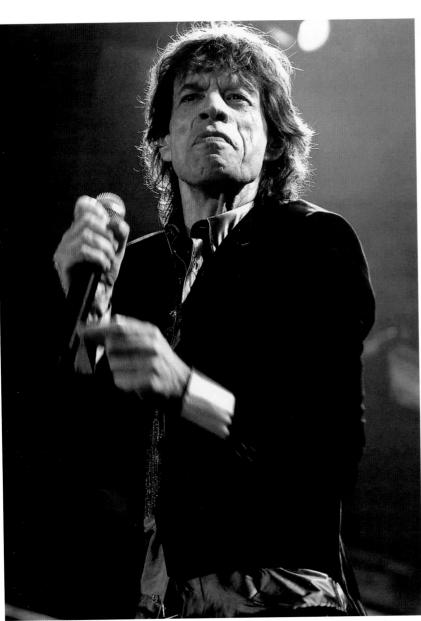 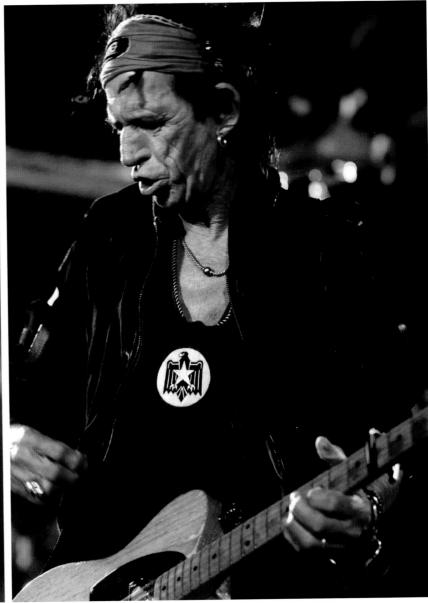

A Bigger Bang Tour | 21 August 2005 – 26 August 2007

Our biggest ever tour – so far. It started out in Boston in August 2005 and finally wound to a halt in London in August 2007.

We're not doing anything much different from what we did in 1963 in the Crawdaddy Club. Our usual set is two-thirds standard Stones numbers – the classics. The only thing different is the audiences have grown and the shows have gotten longer. KEITH

this page
Twickenham Stadium | London, UK | 20 August 2006

THE ROLLING STONES

A BIGGER BANG

WITH SPECIAL GUEST:

SEPTEMBER 26

ticketmaster.ca

(416) 870-8000

NOT JUST A CONCERT

FOR OFFICIAL TOUR INFORMATION, FAN CLUB MEMBERSHIPS,
EXCLUSIVE MERCHANDISE AND MORE, VISIT:
WWW.ROLLINGSTONES.COM

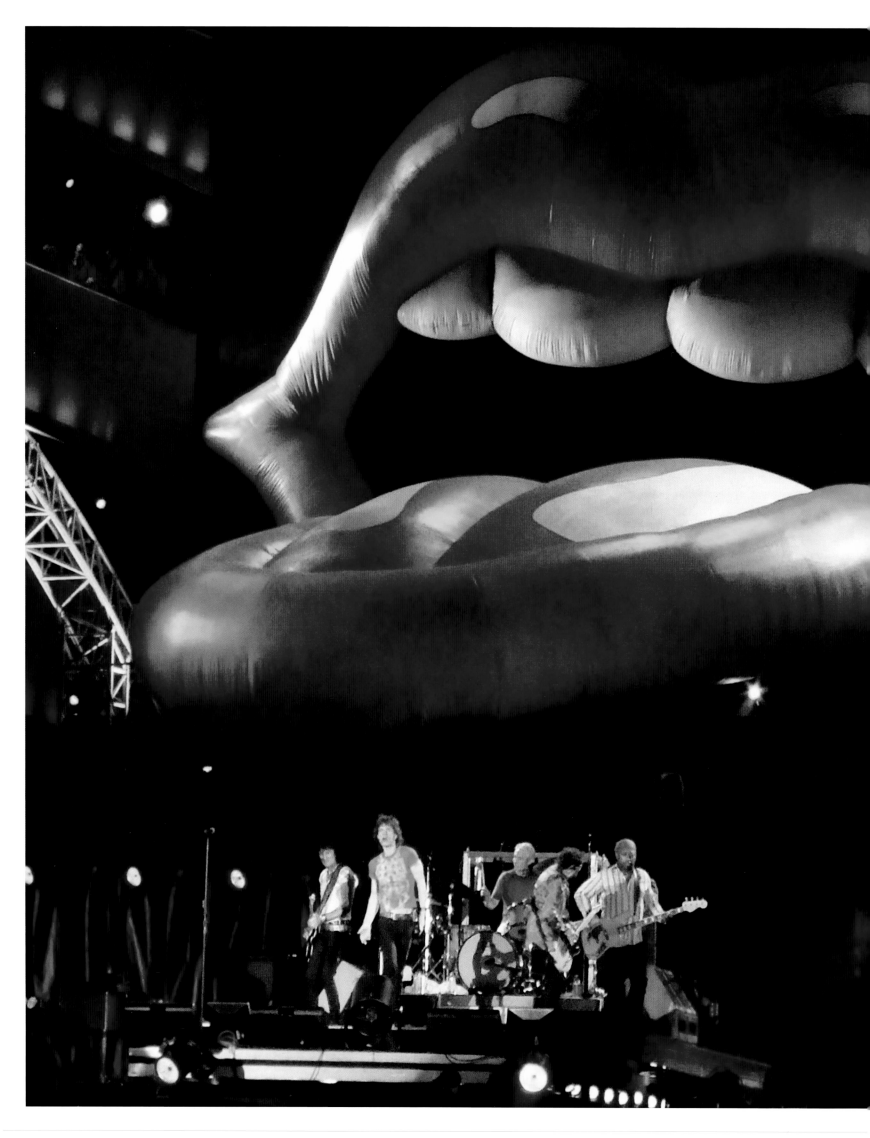

**A Bigger Bang Tour | Stade Charles-Ehrmann –
Palais Nikaia | Nice, France | 8 August 2006**

Touring is the only way to survive. Record royalties barely
pay overheads: you can't tour behind a record like the old
days. Mega-tours are, in the end, the bread and butter
of keeping the machinery running. We're a rarity in that
the show that fills the stadium is still based on the music,
nothing else. KEITH

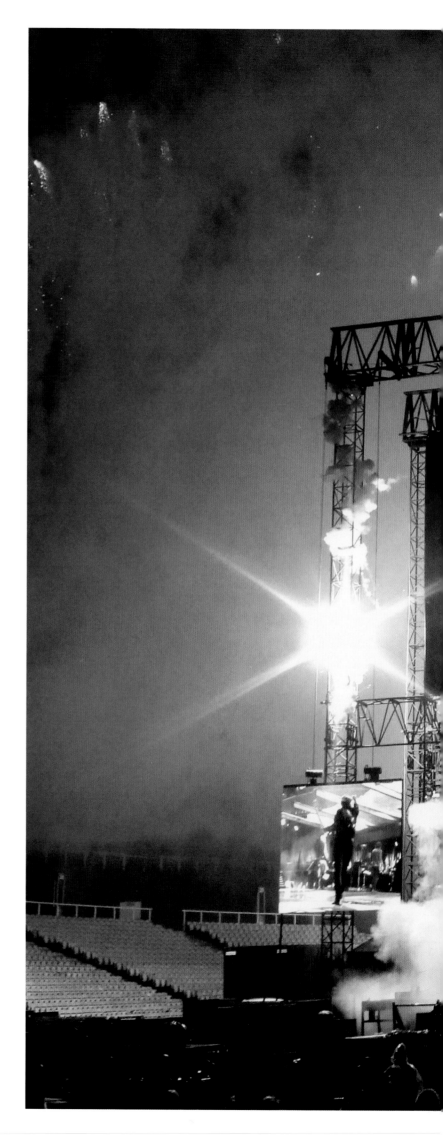

A Bigger Bang Tour | Don Valley Stadium Sheffield, UK | 27 August 2006

We became very aware of not being seen – of just being there like ants. Mick is the one who really has to project himself over the footlights. And when the show gets that big, you need a little extra help. You need a couple of gimmicks, as we call it, in the show: you need fireworks, you need lights. You need a bit of theatre. CHARLIE

overleaf

A Bigger Bang Tour | Copacabana Beach Rio de Janeiro, Brazil | 18 February 2006

We played three concerts in South America: two at the River Plate Stadium in Buenos Aires and one on Copacabana Beach in Rio de Janeiro, on 18 February 2006. There's probably no more spectacular setting for a show anywhere in the world.

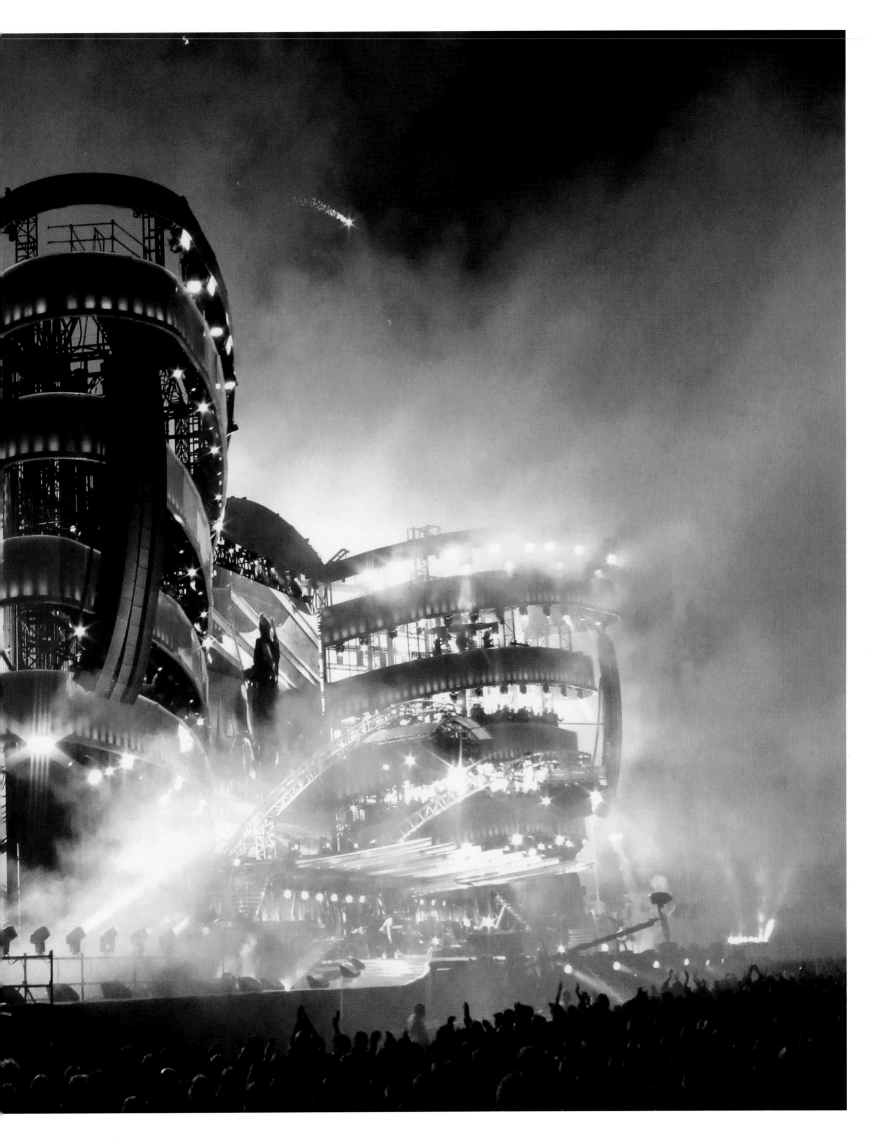

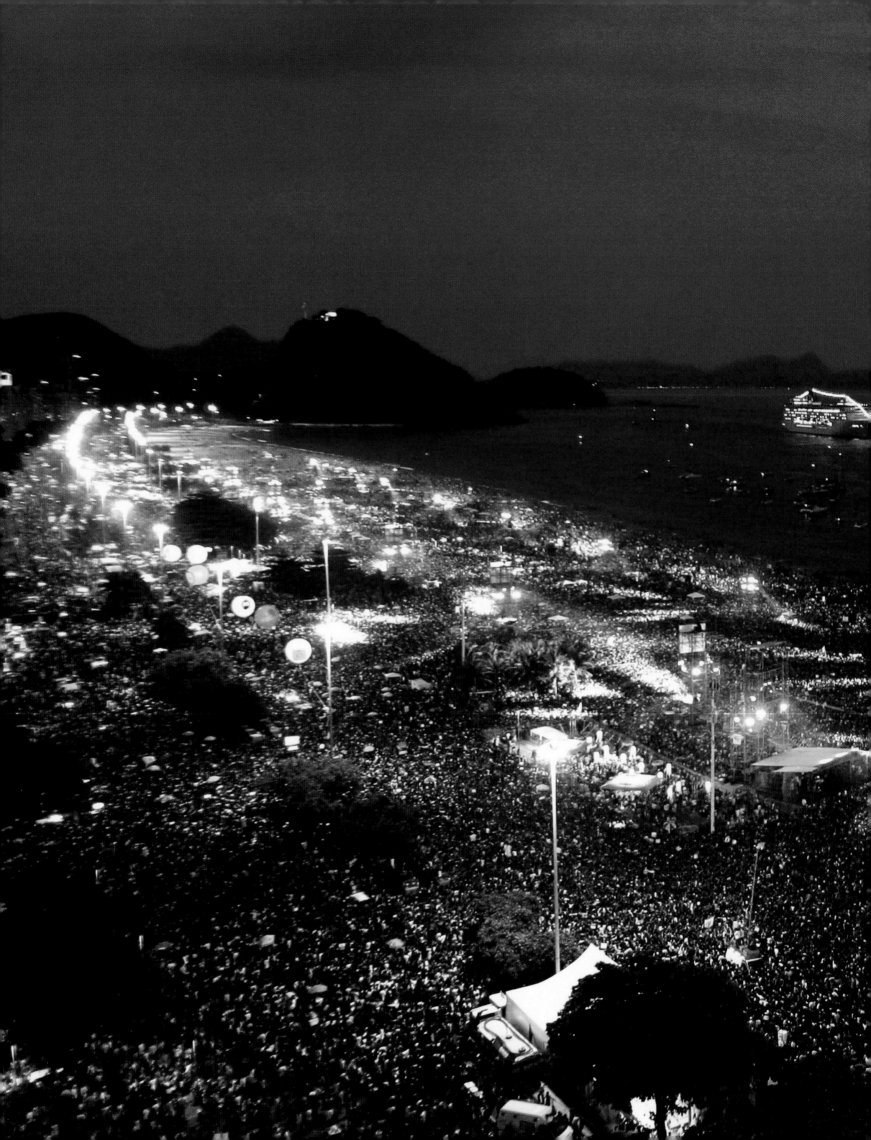

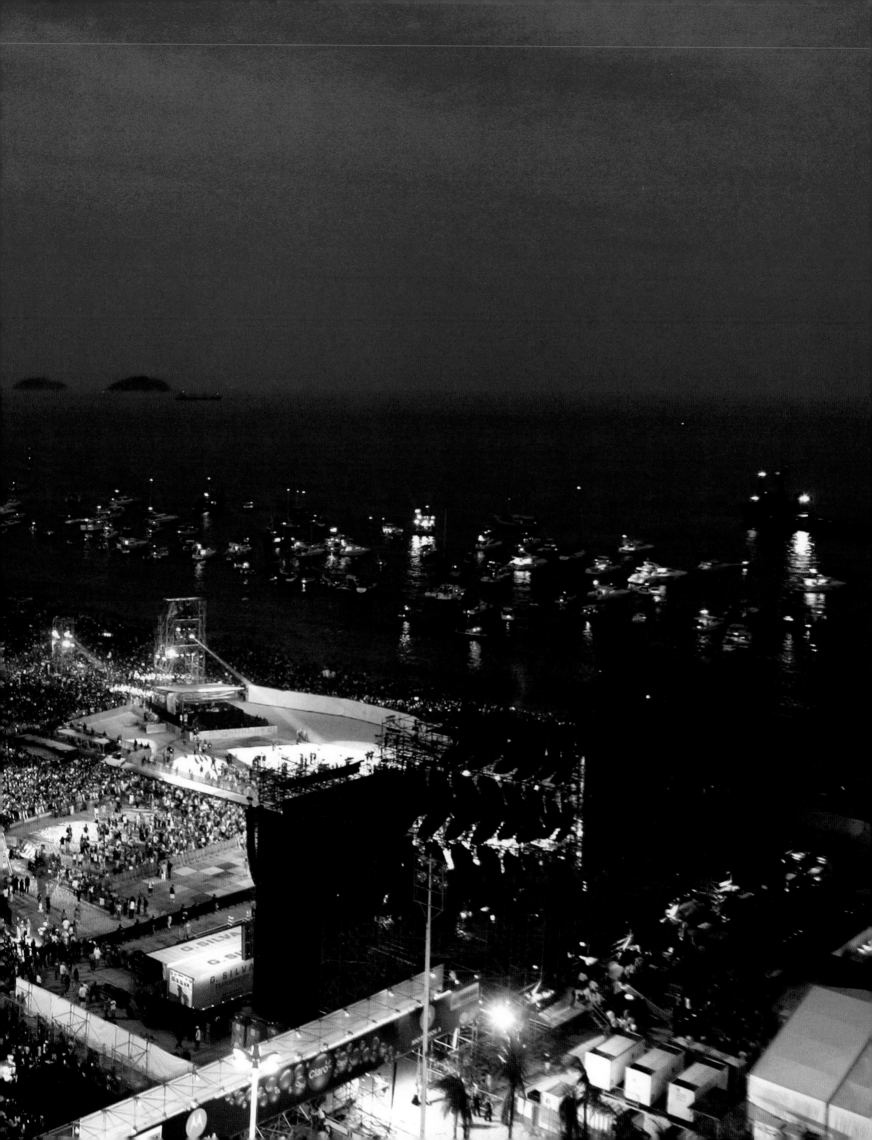

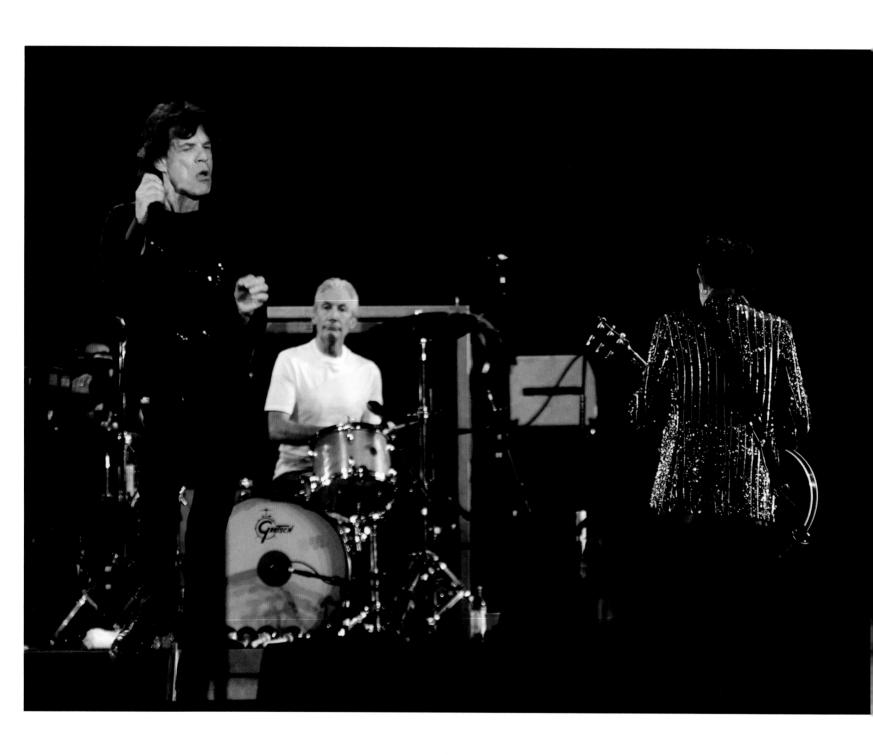

**A Bigger Bang Tour | Isle of Wight Festival
Seaclose Park, Newport, UK | 10 June 2007**

This was our first festival appearance since the sixties.
Coming back home to play is always a bit more special.
When we're on the road, we just carry Britain with us,
really – our little bubble of it. KEITH

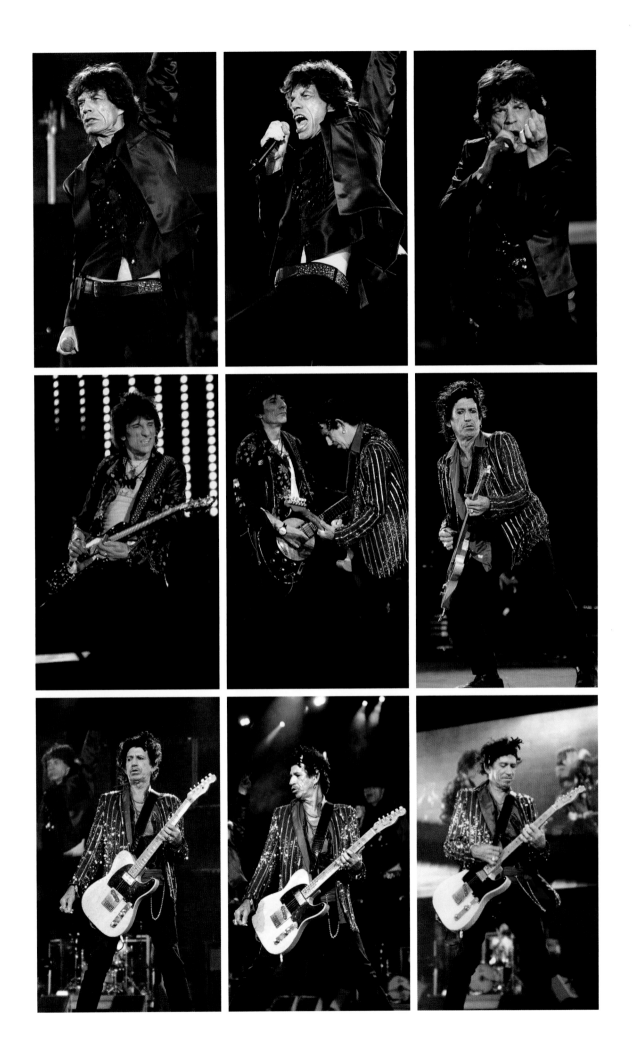

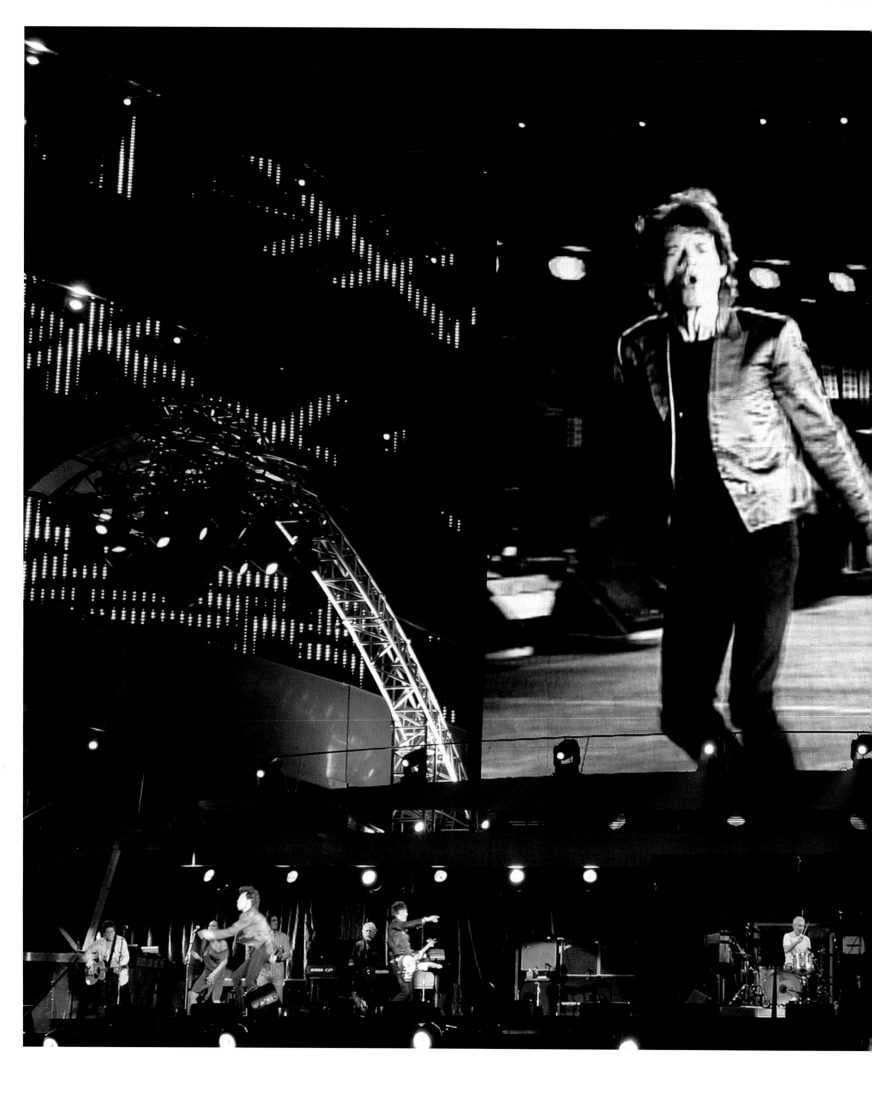

A Bigger Bang Tour | Estadio Municipal de Santo Domingo | El Ejido, Andalusia, Spain 30 June 2007

The whole tour spread over a period of 735 days. We played 32 countries, 118 cities and 147 concerts to over 4.5 million people ... and that's not including the two million people who were on Copacabana Beach.

You know, the smell of the crowd, the roar of the greasepaint and you forget all this other stuff that goes with it. KEITH

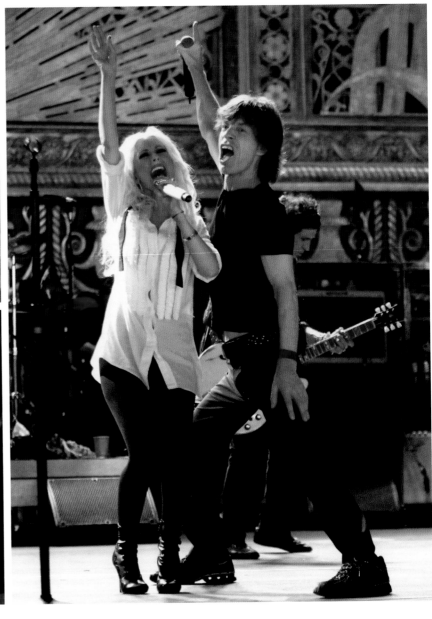

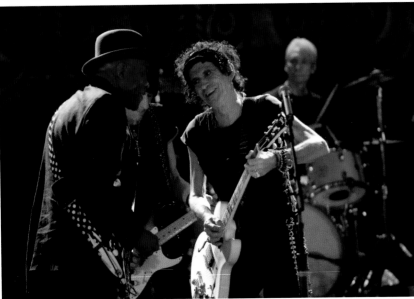

Filming *Shine a Light* | Beacon Theatre | New York City, USA | 29 October & 1 November 2006

Martin Scorsese filmed us at the Beacon Theatre for Shine a Light. *Christina Aguilera guested on 'Live With Me' and Buddy Guy played with us on a Muddy Waters song, 'Champagne and Reefer'. The film had its premiere in February 2008.*

With everything going on that night, with the movie, I just decided to give Buddy one of my guitars on stage. It was actually my favourite one. I just thought, 'This is my respect to Buddy and to Muddy Waters and all the other guys who turned me on.' KEITH

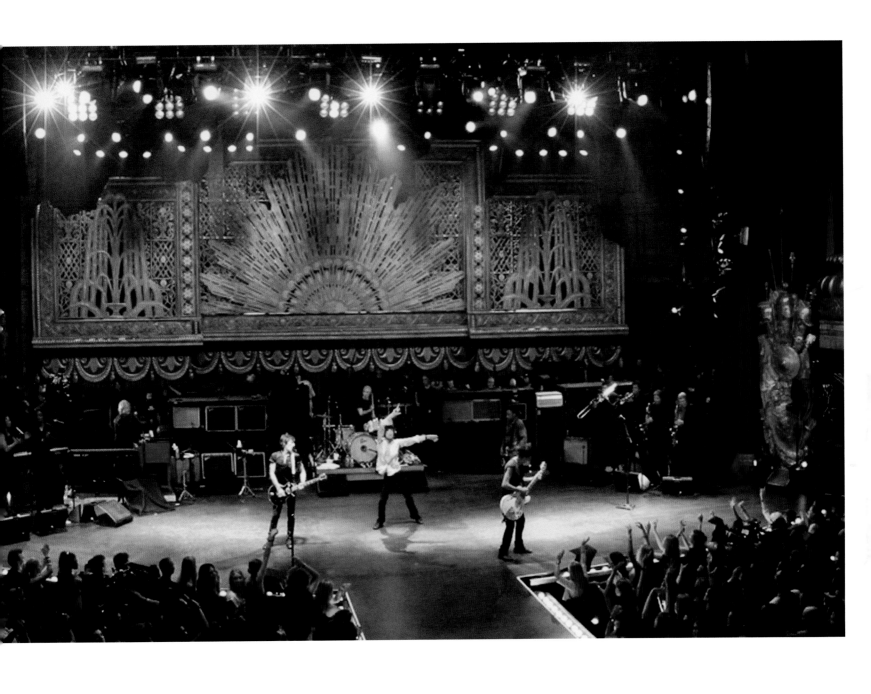

PICTURE CREDITS

'In the half darkness, the guitars and the drums started to twang and bang. A pulsating rhythm and blues. Shoulder to shoulder on the floor stood 500 youngsters, some in black leather, some in sweaters. You could have boiled an egg in the atmosphere.'

And so, with the above words, Patrick Doncaster introduced a young five-piece band called the Rolling Stones to a national audience for the first time via the pages of the *Daily Mirror*.

Half a century later and their story continues to fascinate and delight millions of fans globally; a story that began for the *Daily Mirror* in a hot, dark and crowded room in the Station Hotel at Richmond, Surrey, but which has taken us and our readers all around the world, many times over, ever since.

The result is an astounding archive collection of photographs, interviews and reports, painstakingly and lovingly curated by the expert archivists at Mirrorpix and presented here in this most comprehensive form for the first time.

Mirrorpix proudly manage an exceptional and largely untapped photographic and written collection charting the history of the 20th century and beyond.

All photography supplied by Mirrorpix, except the following:

t = top; **tr** = top right; **r** = right; **br** = bottom right; **b** = bottom; **bl** = bottom left; **l** = left; **tl** = top left; **c** = centre

pp. 6–7 Paul Natkin / The Rolling Stones Archives
pp. 8–9 Steven Klein / The Rolling Stones Archives
p. 20 Pictorial Press Ltd / Alamy
p. 21 Pictorial Press Ltd / Alamy
p. 22 l Dezo Hoffmann / Rex Features
p. 22 r Dezo Hoffmann / Rex Features
p. 23 Dezo Hoffmann / Rex Features
p. 24 Philip Townsend / Camera Press
p. 25 Philip Townsend / Camera Press
p. 26 Philip Townsend / Camera Press
p. 27 t Philip Townsend / Camera Press
p. 27 b Philip Townsend / Camera Press
p. 28 bl Mike Peters / Timothy Graham Gallery
p. 28 br Mike Peters / Timothy Graham Gallery
p. 30 t b Philip Townsend / Camera Press
p. 31 t b Philip Townsend / Camera Press
p. 32 tl Getty Images
pp. 32–33 Pictorial Press Ltd / Alamy
p. 38 tl Philip Townsend / Camera Press
p. 38 bl Philip Townsend / Camera Press
pp. 38–39 Philip Townsend / Camera Press
pp. 40–41 Terry O'Neill / Firepine Ltd / Getty Images
p. 66 r Fred Bauman / Globe Photos
p. 67 l Fred Bauman / Globe Photos
p. 69 t b Frank Monaco / Rex Features
pp. 80–81 Rob Bosboom / V!P's Gallery, www.vipsart.nl
pp. 82–83 Rob Bosboom / V!P's Gallery, www.vipsart.nl
pp. 98–99 Bill Orchard / Rex Features
p. 108 bl r Mitchell Library, State Library of NSW, Australia
pp. 108–109 Mitchell Library, State Library of NSW, Australia

pp. 110–11 Bent Rej
p. 111 tr Bent Rej
pp. 114–15 Jean-Marie Périer / Photo12
p. 124 Allstar / Cinetext
pp. 124–25 ullstein bild / Topfoto
p. 130 t Bent Rej
p. 130 br Bent Rej
p. 131 Bent Rej
pp. 132–33 Jean-Marie Périer / Photo12
p. 135 t b Gamma-Rapho / Getty Images
p. 136 l Colin Jones / TopFoto
pp. 136–37 Monitor Picture Library / Retna Pictures
pp. 140–41 Walter Daran / Time & Life Pictures / Getty Images
pp. 148–49 Gered Mankowitz
pp. 160–61 John Reader / Getty Images
p. 162 t bl far l Niklaus Stauss / AKG-Images
pp. 162–63 Corbis
pp. 170–71 MH / DR / Photo12
pp. 176–77 Getty Images
p. 181 Keystone / Getty Images
p. 197 Michael Ochs Archives / Getty Images
pp. 198–99 AP / Press Association Images
pp. 200–201 AP / Press Association Images
p. 202 bl r Ronald Spencer / Daily Mail / Rex Features
pp. 202–203 Alan Messer / Rex Features
pp. 204–205 Bent Rej
p. 205 t br Jan Persson / Getty Images
p. 206 bl Corbis
pp. 206–207 Dominique Berretty / Getty Images
p. 214 t Corbis
p. 214 bl r Homer Sykes Archive / Alamy
p. 215 Homer Sykes Archive / Alamy
pp. 216–17 AP / Press Association Images
pp. 220–21 Michael Cooper

p. 225 Jean-Marie Périer / Photo12
pp. 226–27 Jean-Marie Périer / Photo12
pp. 232–33 Robert Knight Archive / Getty Images
p. 235 GAB Archive / Getty Images
p. 240 t br Michael Putland / Getty Images
p. 241 Michael Putland / Getty Images
pp. 242–43 Michael Putland / Getty Images
pp. 244–45 Michael Putland / Getty Images
pp. 246–47 Michael Putland / Retna Pictures
pp. 248–49 Pictoral Press Ltd / Alamy
p. 249 br Keystone France / Getty Images
p. 255 Idols / Photoshot
p. 256 Michael Putland / Retna Pictures
pp. 262–63 Nobby Clark / TopFoto
p. 274 r Corbis
p. 275 1978 / 2011 Robert Matheu / Camera Press
p. 276 t Corbis
p. 277 Corbis
p. 278 l Corbis
p. 280 r Corbis
p. 281 Corbis
p. 282 r Corbis
pp. 282–83 Corbis
pp. 284–85 Corbis
p. 290 bl c r Paul Natkin / The Rolling Stones Archives
p. 291 Paul Natkin / The Rolling Stones Archives
p. 292 Paul Natkin / The Rolling Stones Archives
p. 293 t b Paul Natkin / The Rolling Stones Archives
pp. 294–95 Mikio Ariga / The Rolling Stones Archives
p. 296 Photofest / Retna Pictures
p. 298 tl bl Claude Gassian / The Rolling Stones Archive

pp. 298–99 Claude Gassian / The Rolling Stones Archives
p. 300 tr Claude Gassian / The Rolling Stones Archives
p. 301 t b Claude Gassian / The Rolling Stones Archives
p. 303 Duncan Raban / Empics
p. 306 Wolfgang Kluge / DPA / Press Association Images
p. 312 tr b Albert Ferreira / The Rolling Stones Archives
p. 313 George Chin / The Rolling Stones Archives
pp. 314–15 Kevin Mazur / The Rolling Stones Archives
pp. 318–19 KIPA / Press Association Images
p. 321 Corbis
p. 322 Gie Knaeps / Press Association Images
p. 323 t The Rolling Stones Archives
p. 323 b Scarlet Page / Camera Press
pp. 324–25 Olivia Berger / Retna Pictures
pp. 326–27 Suzan / Empics
p. 330 David J. Phillip / AP / Press Association Images
p. 331 David J. Phillip / AP / Press Association Images
p. 332 tl Paul Sancya / AP / Press Association Images
p. 332 bl Corbis
pp. 332–33 A. Messerschmidt / Getty Images
p. 335 The Rolling Stones Archives
pp. 336–37 Starface / Retna Pictures
pp. 338–39 David Moffitt / Wire Image / Getty Images
pp. 340–41 Corbis
pp. 344–45 Corbis
pp. 346–47 The Kobal Collection
pp. 348–49 Corbis

Every possible effort has been made to locate and credit copyright holders of the material reproduced in this book. The author and publisher apologize for any omissions or errors, which can be corrected in future editions.

Aarhus 205
ABC Television Studios, London 178
ABC Theatre, Belfast 102
Aguilera, Christina 348
Alamo, The 251
'All Down The Line' 238
Alexandra Palace, London 68
'Almost Hear You Sigh' 294
Alpha TV Studios, Birmingham 32
Altamont Speedway 201
Anaheim Stadium 277, 278
'Angie' 238, 240
Arizona Veterans Memorial Coliseum 133
'Around and Around' 97, 113
Australian tour 234

Baltiska Hallen 205
Bath, Marquess of 77
BBC Television Centre, London 71
Beacon Theatre, New York 346
Beatles, the 22, 35, 45, 173
Beau Gentry menswear store 62
Beck, Jeff 145
Beggars Banquet 178, 181
Between the Buttons 148, 159
Bigger Bang Tour, A 334, 337, 338, 342, 345
Birds, The 18
'Bitch' 214
Black, Cilla 46
Blues By Six 21
'Boogie Chillen' 293
Bowie, David 247
Braidwood, New South Wales 195
Bravo 125
Bridges to Babylon Tour 305, 310, 312, 315, 317, 320
Brown, James 96
'Brown Sugar' 195, 214, 238, 248
Brussels Affair, The 240

'Can't Be Seen' 294
Capital Theater, New York 312
Capitol Theatre, Aberdeen 287
CBS Studio 50, New York 97
'Champagne and Reefer' 346
Charlie is My Darling 121
Cheech and Chong 230
Chichester 166
Chiffons, the 66
Circus-Krone-Bau, Munich 125
City Hall, Newcastle 129, 208
Civic Arena, Pittsburgh 228
Clapton, Eric 182, 293
'Come On' 27, 32, 33
Copacabana Beach 338, 345
Coventry Theatre 210
Cow Palace, California 139
Crawdaddy Club, Richmond 22, 35, 78, 334
Cutler, Sam 189

Daily Mirror 17, 29, 46, 55, 56, 77, 86, 146, 166, 251
'Dancing With Mr. D.' 238
Davies, Cyril 17
'Dead Flowers' 212, 214
Decca 27, 45
Diddley, Bo 38, 45
Don Valley Stadium, Sheffield 338
'Doo Doo Doo Doo Doo (Heartbreaker)' 238
Double Door, The 310

Ealing Club 17, 22
Eamonn Andrews Show, The 159
Earls Court, London 260
Ed Sullivan Show, The 97, 152
Eel Pie Island 29
Empire Theatre, Liverpool 212
Empire Pool, London 46, 50, 99, 113, 238
Ernst Merck Halle, Hamburg 125
Essex 172
Estadio Municipal de Santo Domingo, Andalusia 345
European tours: 1970: 205, 206, 207; 1973: 240, 244; 1982: 286, 287, 289
Everly Brothers 38, 42
'Everybody Needs Somebody to Love' 113
Exile on Main Street 223

Faces, the 256
Faithfull, Marianne 172
Feijenoord Stadion, Rotterdam 322
Fenton, Shane and the Fentones 35
Fisher, Mark 305
Fitzgerald, Ella 110
Ford Field, Detroit 330, 331
Forest Hills Tennis Stadium, New York 139
Forum, the 229, 230
Fourmost, the 46
Freddie and the Dreamers 46
Free Trade Hall, Manchester 208
Frost on Saturday 178

Garner, Erroll 110
Gather No Moss 96
German tour 125
Gimme Shelter 196, 201; single 238
Glad Rag Ball 99
Goats Head Soup 238
Godard, Jean-Luc 176
Goldsboro, Bobby 66
Gore Hotel, London 181
Granada Studios, Manchester 105, 121
Granby Halls, Leicester 260
Great Pop Prom, The 35
Guy, Buddy 346

Hallenstadion, Zurich 162
Hampton Coliseum 282

'Happy' 238
Hardy, Françoise 113
'Have You Seen Your Mother, Baby, Standing in the Shadow!' 146
Heathrow Airport 149, 152
Hemis Fair Plaza Arena, The 253, 254
Hendrix, Jimi 207
Hollies, the 121
'Honky Tonk Women' 238
Hooker, John Lee 293
Hopkins, Nicky 214

'I Got The Blues' 214
Imperial Ballroom, Lancashire 73
International Center, Honolulu 232
Intertel Studios 182
Isle of Wight Festival 342
'It's All Over Now' 78, 93, 230, 306
'It's Only Rock 'n Roll' 247

James, Etta 274
J. Geils Band 289
John F. Kennedy International Airport 56
Johns, Glyn 154
Jones, Brian 21, 113, 146, 173, 178, 181, 192, 244
Jones, Darryl 302
Joplin, Janis 207
Juke Box Jury 71
'Jumpin' Jack Flash' 173, 212, 238, 286

Keys, Bobby 214, 240
Kirby, Kathy 46
Knebworth House, Hertfordshire 264, 267
Korakuen Dome, Tokyo 294
Korner, Alexis 17, 21
Kramer, Billy J. and the Dakotas 46
Kurhaus, The Hague 81, 83

'Last Time, The' 93, 105, 113
Leipziger Sportforum 306
Lennon, John 182
Letenska Plan 324
'Let It Rock' 212, 214
'Let's Spend the Night Together' 152, 159
Leyton, John 42
Licks World Tour 322, 324, 329
Lindsay-Hogg, Michael 182
'Little Queenie' 212
'Little Red Rooster' 102, 293
Little Richard 38
'Live With Me' 214, 346
London 42, 100, 168, 223; Carnaby Street 25, 32; Fleet Street 168; Great Titchfield Street 142; Green Park 151; Harley House 142; Hyde Park 186, 189, 190, 192; Primrose Hill 148; Thames Embankment 25, 26
London Weekend Television Studios 247
Longleat House, Warminster 76, 77
Love You Live 271

Malibu beach 64
Malmö 205
Man, Isle of 88, 90
Manchester 146
Mankowitz, Gered 148
Mann, Manfred 46
Manning Bowl, Massachusetts 139
Marquee Club, The, London 17, 21, 214, 271
Martin, Dean 62
Masonic Auditorium, Detroit 274
Merseybeats, the 46
Meters, the 260
'Midnight Rambler' 214, 230, 238
'Mixed Emotions' 294
Mod Ball 46
Montreux 48, 118
Moss, Kate 18
Murrayfield Stadium, Edinburgh 317

Nashville 312
National Jazz & Blues Festival, 4th 18, 78
Ned Kelly 195
Nellcôte, Villefranche-sur-Mer 219, 220
New Elizabethan Ballroom, Manchester 85
New Musical Express 33, 50; Poll Winners Concert 113, 173
New York 146; Astor, Hotel 61; Fifth Avenue 248
North American tours: 1965: 116, 131; 1969: 196; 1972: 224, 228; 1975: 248, 251; 1978: 274, 277, 278
'Not Fade Away' 93, 306

Odeon Cinema, Manchester 126
Oldham, Andrew 22, 25, 32, 62, 149, 154, 165
Olympia Theatre, Paris 113, 134
Olympic Studios, London 148, 160, 165, 172, 176
100 Club, the, London 288
One Plus One 176
Ono, Yoko 182
Open House 55

Pacific tour 232
Page, Jimmy 145
'Pain in My Heart' 113
Palace Ballroom, Isle of Man 90
Palace of Culture, Warsaw 162
Palace Theatre, Manchester 52
Parc des Princes, Paris 298
Pasche, John 240
Périer, Jean-Marie 113
Perrin, Les 159, 181
Peterson, Oscar 110
Poole, Brian 45
Preston Public Hall 42
Preston, Billy 240
Price, Jim 214
'Prodigal Son' 212

INDEX | R–Z

Rai Halle, Amsterdam 206
Ratcliffe Stadium, Fresno 116
Rave 107
Ready, Steady, Go! 33, 46, 48, 99, 105, 136
Redlands 166, 236
Reed, Jimmy 45, 66
Richard, Cliff 55
Ricky Tick Club, Windsor 29
Rio de Janeiro 18, 268, 305, 338
'Rip This Joint' 238
River Plate Stadium, Buenos Aires 338
Riverside Studios, Hammersmith 55
Robert F. Kennedy Memorial Stadium 302
'Rock in a Hard Place' 294
Rolling Stones Rock and Roll Circus, The 182
Ronettes, the 42
'Rough Justice' 330
Roundhouse, London 211
'Route 66' 66, 93, 230
Royal Albert Hall 22, 35, 145, 172
Royal Hotel, Copenhagen 110
'Ruby Tuesday' 152
Rundgren, Todd 267

'Sad Sad Sad' 294
Santa Monica Civic Auditorium 96
Santana 230
'Satisfaction' 121, 131, 173, 214, 286, 330

Saville Theatre, London 203
Saville, Jimmy 113
Scene at 6.30 105, 121
Scorsese, Martin 346
Searchers, the 46
SECC, Glasgow 328
Shea Stadium, New York 293
'She Smiled Sweetly' 159
Shine a Light 346
Shrimpton, Chrissie 142
Skynyrd, Lynyrd 267
Soldier Field, Chicago 310, 312, 315
Some Girls 277
Southern Sounds '63 45
Spartakiadni Stadion, Prague 300
Springfield, Dusty 113
Stade Charles-Ehrmann – Palais Nikaia, Nice 337
'Star Star' 238
'Start Me Up' 286, 298, 330
Station Hotel, Richmond 22
Steel Wheels Tour 290, 293, 294, 297, 322
Stewart, Ian 22, 52, 83, 85, 145, 165, 220, 289
Stigwood, Robert 240
'Street Fighting Man' 175, 238
Sullivan, Ed 152

Sunday Night at the London Palladium 154, 156
Superbowl XL 330, 331
Swing Auditorium, San Bernardino 66
Sydney Airport 109
'Sympathy for the Devil' 178, 212

T.A.M.I. Show 96
Taylor, Mick 182, 240, 244
Television House, London 33
Tettenhall Magistrates Court, Wolverhampton 100
Thames Hotel 29
Thank Your Lucky Stars 32
Their Satanic Majesties Request 160, 165
'Time is On My Side' 97
Top of the Pops 105
tour of the Americas 256
Tower Ballroom, New Brighton 45, 86
Townsend, Philip 25
Tremeloes, the 45
Trials of Oscar Wilde, The 172
'Tumbling Dice' 223, 238, 306
Turner, Ike and Tina 145
Twickenham Stadium, London 329, 334

UK package tour (1964) 37, 38, 93
'Under My Thumb' 286
Unwin, Stanley 248
Urban Jungle Tour 297, 298, 300

Valentine 107
Vanderbilt Stadium, Nashville 312
Vejlby-Risskov Hallen, Aarhus 205
Voodoo Lounge Tour 302, 305, 306

'Walkin' the Dog' 93
Wardell, Don 121
Warhol, Andy 271
Waters, Muddy 346
'We Love You' 172
Wembley: Arena 328; Stadium 289, 297, 306; Studios 136
Whitehead, Peter 121, 172
Who, The 182
'Wild Horses' 212
Wonder, Stevie 228
Woodstock 201
Wyman, Bill 42, 154, 178, 214, 302

Yamazaki, Kazuhide 282
Yardbirds, the 145
'You Can't Always Get What You Want' 238
'You Got Me Rocking' 306

ACKNOWLEDGMENTS

Mick, Keith, Charlie and Ronnie would like to thank David Boyne, Tom Bennett, Sherry Daly, Paul Edwards, Richard Havers, Erik James, Jane Rose, Joyce Smyth, Dave Trafford and Ali Zayeri.

Images pages 2–19

p. 2 Glass slides, ABC Theatre, Huddersfield, UK, 10 March 1965
pp. 4–5 The Rolling Stones, London, April 1964
pp. 6–7 The Rolling Stones, New York, October 1989
pp. 8–9 The Rolling Stones, New York, August 2005
pp. 10–11 Gig poster, the Woodstock Hotel, London, August 1962
p. 12 Mick Jagger, London, May 1972
p. 15 Keith Richards, Chicago, September 1997
p. 16 Charlie Watts, New York, June 1964
p. 19 Ronnie Wood, Glasgow, September 2003

First published in the United Kingdom in 2012 by Thames & Hudson Ltd, 181A High Holborn, London WC1V 7QX

The Rolling Stones 50 copyright © 2012 Thames & Hudson Ltd, London

Text copyright © 2012 The Rolling Stones

Layout by Barnbrook

Digital photography and pre-media services supplied by Rhapsody, London

ISBN 978-1-4013-2473-5

Hyperion books are available for special promotions and premiums. For details contact the HarperCollins Special Markets Department in the New York office at 212-207-7528, fax 212-207-7222, or email spsales@harpercollins.com.

FIRST U.S. EDITION

10 9 8 7 6 5 4 3 2 1

Printed and bound in China by C&C Offset Printing Co., Ltd.